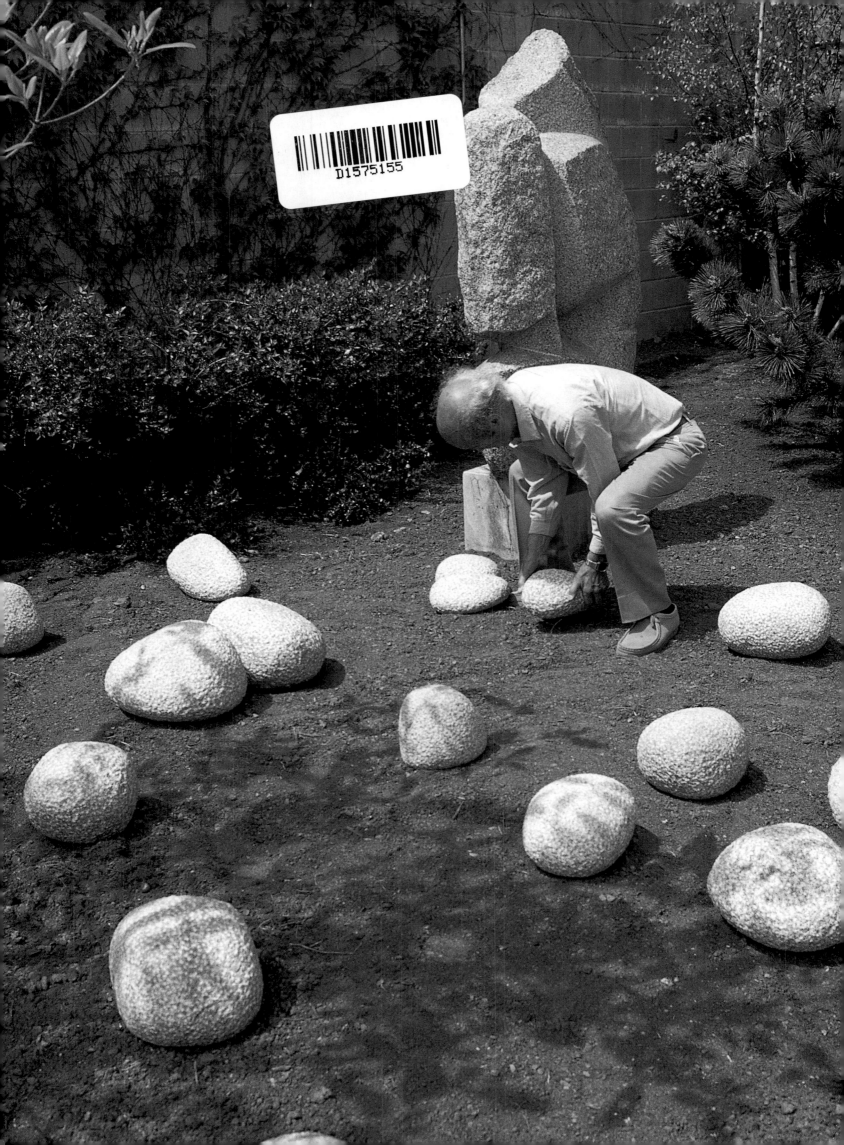

HIRSHHORN ART PUBLICATIONS MANAGER
Audrey Walen

PROJECT EDITORS
Jessica Hodge, Oliver Craske

PRODUCTION MANAGER
Claudia Varosio

COPY EDITORS
Geraldine Christy, Audrey Walen,
Valerie J. Fletcher

PROOFREADER
Richard G. Gallin

INDEXER
Diana Lecore

DESIGN
Pure+Applied, New York

© 2004 Smithsonian Institution, Washington DC,
the Whitney Museum of American Art, New York

*Breaking Ground: The Environmental Works of Isamu
Noguchi* essay and *Contextual Chronology*
© 2004 Whitney Museum of American Art, New York

Sitting Quietly: Isamu Noguchi and the Zen Aesthetic
essay © 2004 The Noguchi Museum, The Isamu
Noguchi Foundation Foundation and Garden
Museum, New York

First published in 2004 by
Scala Publishers Ltd
Northburgh House
10 Northburgh Street
London EC1V OAT
www.scalapublishers.com

Hard cover: ISBN 1-85759-342-1
Soft cover: ISBN 1-85759-364-2

Printed and bound in China.

ENDPAPERS
Detail of *Akari light sculptures.*
Photo © Michio Noguchi, courtesy
The Noguchi Museum, New York.

PAGE 2
Noguchi with components for "Figure," 1946
(published in *Life*, November 11, 1946).
Photo by Julie Wolf, courtesy The Noguchi Museum.

PAGE 5
*Noguchi installing "Practice Rocks in Placement"
near "Indian Dancer" in the Sculpture Garden at
The Noguchi Museum, New York.*
The Noguchi Museum, New York.

Contents

**View of the Sculpture Garden
at The Noguchi Museum,
New York, c. 1988.**
Photo by Sarah Wells,
courtesy The Noguchi Museum.

Foreword

The Hirshhorn Museum and Sculpture Garden and the Whitney Museum of American Art are honored to present this exhibition devoted to the sculptures and related drawings of Isamu Noguchi (1904–1988). Both museums own significant works by the artist. Many of them are included in this project, including the Hirshhorn's rare *Lunar Landscape* and somber *Cronos*. Since the Whitney's first acquisition of a Noguchi sculpture in 1931, its collection has expanded to thirteen sculptures and four works on paper — five of them donated by the artist and his Foundation. Noguchi's works have been featured in more than fifty exhibitions at the Whitney, including four solo shows. In 1968 the Whitney hosted the last major retrospective of the artist's sculptures in the United States. We are therefore particularly pleased that our museums have worked together to co-organize *Isamu Noguchi: Master Sculptor* for the centennial of the artist's birth.

Noguchi is paradigmatic of the modern artist working in America in that his life, training, and career embody the reconciliation of heterogeneous influences and interests. His bicultural upbringing in Japan and the United States, and his subsequent exposure to other cultures, led to original combinations of Western modern and Asian sensibilities in his art. As an apprentice to the quintessential modernist Constantin Brancusi, Noguchi developed a lifelong reverence for craftsmanship and materials. Working in the United States, Noguchi became an experimenter both conceptually (working in diverse modes from monuments to playgrounds to stage sets) and materially (producing sculpture in many media, ranging from clay and plaster to magnesite cement, paper, wood, and stone). His extensive travels around the world from 1949 until the mid-1980s inspired Noguchi to develop many innovative approaches to art through most of the twentieth century.

We wish to express our deep appreciation to the lenders whose generosity has enabled us to gather together many unusual, rare, and fragile works. The Noguchi Museum kindly lent several dozen of their sculptures and works on paper. Almost two dozen individuals and institutions have entrusted us with their Noguchi sculptures so that they may be enjoyed by many thousands of viewers.

Major exhibitions of sculpture have become less frequent in recent years because of the exceptionally high costs of shipping, insurance, installation, and related logistics. The Hirshhorn is therefore especially grateful to the Holenia Trust in memory of Joseph H. Hirshhorn, to Melva Bucksbaum and Raymond J. Learsy, and to the Jim and Barbara Demetrion Endowment Fund. The Whitney extends heartfelt appreciation to the many individual donors who have helped to expand our holdings of Noguchi's art, notably the Howard and Jean Lipman Foundation, Mrs. Robert M. Benjamin, Mr. Sid Sutter, and Jackie and James Rosbash.

This exhibition and the accompanying publication exist today owing in great part to the enthusiasm and dedication of curator Valerie J. Fletcher. An internationally recognized expert in modern sculpture, she has spent more than a decade studying Noguchi's art. Her selection of works for

this exhibition emphasizes the remarkable range of his forms, ideas, and materials. In her essay Valerie brings to light previously unrecognized aspects of his oeuvre and decodes how Noguchi used forms and materials to express philosophic ideas and personal emotions. This exhibition and catalogue offer an insightful summation of the artist's aesthetics and reposition him as one of the first truly global artists of the twentieth century.

Ned Rifkin
DIRECTOR
Hirshhorn Museum and
Sculpture Garden,
Smithsonian Institution,
Washington DC.

Adam D. Weinberg
ALICE PRATT BROWN DIRECTOR
Whitney Museum
of American Art, New York.

Acknowledgments

Organizing a major sculpture exhibition is a severe test of any curator's stamina and dedication. Actually realizing *Isamu Noguchi: Master Sculptor,* however, was accomplished only with the skill and dedication of many individuals at both the Hirshhorn and the Whitney.

From the outset in 2000, Maxwell Anderson and James T. Demetrion, Directors of the Whitney Museum of American Art and the Hirshhorn Museum and Sculpture Garden, decided that the Noguchi project would be a collaborative effort. Subsequently, preparations were stalled and complicated by unexpected events, including the terrorist attacks of September 11, the deaths of both my parents, and the withdrawal of Marla Prather, the then curator at the Whitney, from the project.

As new directors took the helm—Ned Rifkin at the Hirshhorn in 2001 and Adam D. Weinberg at the Whitney in 2003—they affirmed their support for the Noguchi project, even as staff reorganizations and downsizings brought periods of great uncertainty. The directors' enthusiasm and the encouragement of many individuals reignited my determination to bring Noguchi's art to public view. No words can fully express my gratitude to all those individuals. In particular, Kerry Brougher, the Hirshhorn's Director of Art and Programs and Chief Curator, offered timely advice and moral support.

Isamu Noguchi: Master Sculptor owes an enormous debt of gratitude to The Noguchi Museum. From my earliest researches through the opening of the exhibition itself, the staff provided unflagging help and cooperation. Shoji Sadao, former Director, had initiated the project, and current Director Jenny Dixon nudged the project forward at crucial times, gently, with patience and humor. Curator Bonnie Rychlak shared her vast knowledge of Noguchi's art and made time in her hectic schedule to contribute a thoughtful essay on the artist's relationship to Zen. Perhaps the unsung heroine of this project is The Noguchi Museum's registrar Kimberly Dorazewski. Repeatedly, on very short notice, she made many dozens of artworks available for scrutiny and promptly answered every request. Even during 2002–03, while their offices and museum were closed for renovations, she and other staff made special efforts to further the Hirshhorn-Whitney project. The Noguchi Museum also graciously provided many of the photographs in the catalogue, often located by collections assistant Carl Riddle and archivist Amy Hau. These and other staff essentially ensured that the Hirshhorn-Whitney exhibition would become a reality.

Co-organizing this project brought together many talented individuals from various departments at the Whitney and Hirshhorn museums. As I selected works for the exhibition, the Whitney's Associate Curator of Postwar Art Dana Miller served as liaison for communications and coordinated departmental efforts. While the Hirshhorn had primary responsibility for producing the catalogue, Dana contributed an insightful essay on the relationship of Noguchi's landscape projects to those of Earthwork artists. Evelyn C. Hankins—former Assistant Curator at the Whitney and now Curator of Collections and Exhibitions at the Robert Hull Fleming Museum

at the University of Vermont—compiled the "Contextual Chronology" with speed and grace. My thanks to them both for their dedicated efforts.

The Whitney had primary responsibility for assembling the artworks themselves. Chief Registrar Suzanne Quigley and her assistant Larry Giacoletti ensured the safe packing and transport of the artworks. The installation was a truly joint effort: the Whitney's design/construction manager Mark Steigelman and Head Preparator Joshua Rosenblatt worked seamlessly with the Hirshhorn's Exhibition Design and Production Specialist Al Masino and his colleagues Scott Larson and Catherine Satterlee.

Many other talented individuals added their expertise as needed. These included conservators Susan Lake and Lee Aks at the Hirshhorn, and Carol Mancusi-Ungaro and Pia Gottschaller at the Whitney, and senior management, notably Olga M. Viso and Beverly Pierce at the Hirshhorn, and Christine Putnam and Nick Holmes at the Whitney. In New York, Jan Rothschild organized public affairs, ably assisted by Stephen Soba and Meghan Bullock, in cooperation with Gabriel Einsohn from the Hirshhorn. Makiko Ushiba and Robert Allen created elegant graphic designs for invitations and ephemera. Frank Smigiel and his staff at the Whitney, and Linda Powell with Deborah Gaston at the Hirshhorn, developed public programs for audiences of all ages—from young children to senior citizens—as well as outreach material for school teachers.

We are very fortunate to have copublished *Isamu Noguchi: Master Sculptor* with Scala Publishers. Our heartfelt thanks go to Oliver Craske, Jessica Hodge, and Jennifer Wright for their belief in and commitment to this project. Audrey Walen, Art Publications Manager at the Hirshhorn, steered the project past innumerable obstacles from the very beginning. Her counterpart at the Whitney, Rachel Wixom, provided additional guidance, with the assistance of Associate Editor Jennifer MacNair. My gratitude to Paul Carlos and Urshula Barbour of Pure+Applied for the ingenuity and patience they brought to overcoming the challenges inherent in producing a book of this magnitude and complexity. They created a truly dynamic catalogue design.

Last, but certainly not least, are the talented behind-the-scenes people, including archivists, copy editors, curatorial assistants, photographers, and development specialists (notably Donna Rim at the Hirshhorn, and Scott Elkins and Mark Gordon at the Whitney). Perhaps most invisible are the interns who searched libraries and databases, checked details, photocopied images, and brought youthful enthusiasm to the process. Among them, Erin Clay, Amy Hammond, Jessica Kantor, Kate Markoski, Heewon Ra, and Victoria Scott provided particularly valuable assistance.

These are only a few of the people whose efforts combined to make *Isamu Noguchi: Master Sculptor* a reality. To those not mentioned by name, you have my sincere thanks.

Valerie J. Fletcher
CURATOR

Lenders

Mr. and Mrs. Charles Diker, New York

Milly and Arne Glimcher, New York

Mr. and Mrs. Paul Immo Gulden, Jr., Rumson, New Jersey

Hirshhorn Museum and Sculpture Garden,
Smithsonian Institution, Washington DC

Susan Lloyd

Virginia and Herbert Lust, New York

Memorial Art Gallery of the University of Rochester, New York

National Gallery of Art, Washington DC

National Trust, Rockefeller Estate, Kykuit, Westchester, New York

Nelson-Atkins Museum of Art, Kansas City

Neuberger Museum of Art, State University of New York

The Noguchi Museum, New York

Private collection

Private collection, Denver, Colorado

Private collection, New York

Private collection, Portland

Sogetsu Art Museum, Tokyo

Solomon R. Guggenheim Museum, New York

Toledo Museum of Art

University of Virginia Art Museum, Charlottesville, Virginia

Walker Art Center, Minneapolis

Frederick R. Weisman Art Foundation, Los Angeles

Whitney Museum of American Art, New York

Isamu Noguchi

Master Sculptor

Valerie J. Fletcher

Isamu Noguchi was one of the most versatile artists of the modern era. In a career spanning six decades he explored many areas of art and design, including sculpture, drawing, ceramics, photographs, theater stage sets, playgrounds, furniture, and garden environments.[1] Insatiably curious and perennially restless, Noguchi liked to work in several different modes simultaneously, and he changed direction often: "I get...discontented with my situation and want to break out."[2] Whenever he felt he had sufficiently developed a concept, style, or medium, he veered off to examine something else:

> To break away is very important to me.... I shift very rapidly because that's the only way I can get away from myself. As far as the art world and your identity in it are concerned, it would be much better if I didn't do this.... But for my own development it's better that I do...at least you have escaped that trap which limits your life.

This extraordinary versatility, arising from deep within Noguchi's psyche, anticipated the attitudes and practices of many postmodernists.

This exhibition and publication investigate Noguchi's sculptures as the nexus of his creativity.[3] The mental and physical processes of planning and making sculptures provided the artist with the challenges and satisfactions that sustained him personally and professionally: "I considered myself a sculptor...I tended to think that what I did in [other disciplines] was peripheral.... My real art remained the solitary work of a sculptor with all the limitations that implied."[4]

Although Noguchi created nearly a thousand sculptural works, there have been few museum exhibitions devoted to them.[5] Certain difficulties impose restrictions. Many early and fragile works have not survived, and proposals for various monuments have never been implemented. A number of his greatest sculptures are multicomponent site-specific installations and environments that cannot be uprooted—the only way to see them is to visit them. His freestanding stone carvings can be prohibitively heavy, weighing as much as 8,000 pounds each. These limitations effectively prevent any museum from presenting equally the diverse aspects of Noguchi's sculptural oeuvre. Instead, the Hirshhorn–Whitney project features works that provide variety and depth while developing certain themes.

One of the artist's most fervent aspirations was for his sculptures to communicate with and benefit many audiences; impressing the elite did not particularly interest him. A utopian optimist with a strong social conscience, Noguchi believed that art could be a catalyst for individual insight and change. Without aiming to transmit specific messages or narratives, he hoped that his sculptures might convey, on subliminal levels of perception and intuition, nonverbal experiences. Often he strove to create uplifting or reassuring effects to offset the demands, ennui, and tribulations of daily life. The artist usually refrained from defining in words exactly what his intended effects might be; they depend to a large extent on the viewers themselves. A worried person might experience a sense of peace; an overworked employee might be prompted to take a few minutes' rest and regain personal perspective. Children might laugh with sheer joy, prompting parents to smile and enjoy the moment.

Yet Noguchi was no Pollyanna looking at the world through rose-colored glasses. Acutely aware of social and political events, he was stunned and appalled by World War II. An introvert who suffered from bouts of melancholia and self-doubt, he sometimes found relief and catharsis by expressing somber, aggressive, and painful emotions in his sculptures. Yet even these might ultimately help others by offering empathy or consolation to viewers who struggle with their own sorrows, anger, and fear. Whenever a sculpture arose from Noguchi's state of mind, he strove to manifest it in visual terms that could speak to audiences that have no inkling of the initial motivation for the work. He chose titles carefully as clues to his intentions; occasionally a sculpture may have two or more titles offering different avenues of access. An extremely complex individual himself, Noguchi invited viewers to perceive his art in many different ways.

Noguchi was an ardent believer in the power of the visual to express a broad variety of ideas and emotions, and he strove to develop a personal yet accessible aesthetic language. A principal consideration was the physical reality of each sculpture: its size, material, shapes, colors, and textures. What different responses might be suggested by pristine white marble as distinct from those prompted by jagged black granite? A rough basalt boulder taken from a mountain and left in its natural state might elicit conscious and unconscious associations quite unlike those prompted by industrial metals or glowing electric lights. Along with his thoughtful selection of materials, Noguchi believed that the methods used to transform them into art added to their potential meaning. Carving stone by

hand with only a chisel and mallet conveys a personal touch, an expression of the artist, whereas stainless steel ordered from a factory and modified with a blowtorch inevitably implies the technological, impersonal, and urban. Materials such as cardboard, string, and glass are inherently fragile; sculptures assembled from those elements contrast with the sturdiness of bronze or iron. As Marshall McLuhan famously said, "the medium is the message."[6] Noguchi's comments, drawings, preliminary models, and documentary photographs reveal how he conceived and developed his sculptures. The processes of sculpting offered Noguchi an incomparable mental-corporeal-emotional interface, in which his analytical mind, volcanic emotions, and refined intuition dovetailed effortlessly with the actions of his hands and tools.

In addition to exploiting every nuance of materials and methods, Noguchi accepted the revolutionary modernist idea that abstraction can convey ideas ranging from the most basic concepts to abstruse metaphysics. Mathematically precise geometric shapes are associated with calm reason, disciplined science, clarity, permanence, absolutes. Amorphous and fluid forms have affinities with nature and life of all kinds, from organisms that spontaneously morph to the residues of slow decay. Noguchi used both crisp geometry and biomorphic forms, at times in harmony, other times in opposition to each other. He learned from ideas originated by others, particularly artists with utopian or idealistic intentions, and he believed as they did (rather unrealistically) that general audiences would eventually come to understand this language of abstraction.

Noguchi looking for stones in Tokushima, Japan, 1957.
Photo by Jun Miki,
courtesy The Noguchi Museum.

Throughout his career Noguchi approached art with the mind of a philosopher. In his youth he discovered an affinity for dualistic thinking and henceforth delighted in using—simultaneously or alternately—opposing ideas, styles, compositions, materials, and methods. In the 1930s he eagerly explored the language of abstraction while also making many portrait heads. In works produced in later years he treasured the appearance of stone as it is found in nature, while also favoring industrially manufactured steel for the production of other sculpture. A sculpture about the promise of life would be counterbalanced by another about the closure of death; a work expressing his private emotions would be offset by a proposal for a public monument. As he commented in 1962, "What is the point of soft without hard, or weight without lightness?" Noguchi cultivated these dialogues, delving into one thing, then exploring its antithesis. His goal was never stasis; through the decades these dialogues engendered more subtle, complex, and paradoxical thought. In later years Noguchi sought ways to merge thesis and antithesis: could a sculpture about light consist entirely of black, could a fully enclosed space embody the vastness of the universe, could a static monolith convey the passage of time?

This pattern of thinking and working in oppositional modes is highlighted in this exhibition. Noguchi maintained an ongoing dialogue between two basic compositional formats. Vertical sculptures allowed him to allude to figures and human emotions in astoundingly varied ways: a modernized classical goddess, a brutally executed man, a pair of lovers, a dismembered war hero, a divine Hindu triad, a flightless bird, even a humanoid cockroach. Horizontal compositions serve as visual metaphors

for place and space: imaginary landscapes, symbolic environments, a magical place, a distant galaxy. He also used many other arrangements of forms, but the vertical/totemic figure and horizontal/metaphoric landscape formats proved exceptionally fertile.

A central goal of this publication is to situate Noguchi's art in a wider historical context and to redefine him as one of the first truly global artists. Noguchi himself helped to create and later bemoaned the stereotype of himself as a Japanese American who participated in both cultures but remained an outsider, uncertain of his identity.[7] While the stereotype is not wholly inaccurate, it devalues the range of Noguchi's knowledge and experiences. In more recent years the artist's biographer and others have expanded the parameters to encompass a much broader East–West dialogue. Still, even this characterization limits our understanding of Noguchi's art. For example, to say that he was influenced by Buddhism—while true—glosses over the tremendously different variations of that religion in East Asia. The exquisitely ritualized Zen tea ceremony in

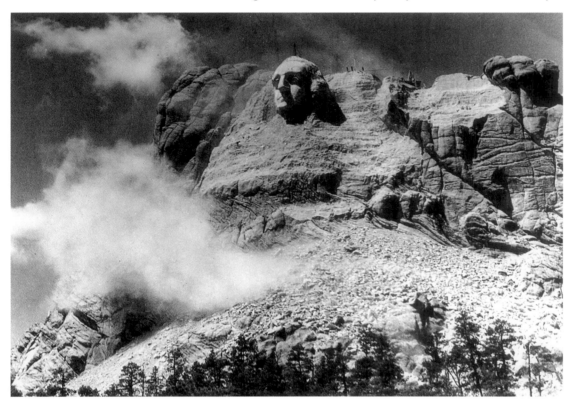

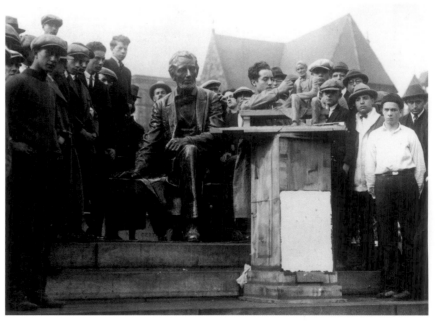

ABOVE
Gutzon Borglum. *Mount Rushmore Monument: George Washington, the first of the four sculptures depicting Presidents Washington, Jefferson, Lincoln, and Theodore Roosevelt,* **1926–27. Stone: H. 60 ft. The National Park Service, U. S. Department of the Interior, Black Hills, South Dakota.**
Photo courtesy Time-Life Pictures/Getty Images.

RIGHT
Noguchi copying Gutzon Borglum's "Abraham Lincoln Seated," **1922.**
Photo by I. M. Boris,
courtesy The Noguchi Museum.

Japan has little in common with the incense-infused offerings and exuberant ornamentation of Chinese temples.

Certainly Noguchi's parentage and childhood were bicultural. Born in Los Angeles in 1904, he was the son of an American woman, Leonie Gilmour (1873–1933), and a Japanese poet, Yonejiro Noguchi (1875–1947).[3] Yonejiro moved to Tokyo shortly before Isamu's birth; Gilmour followed in 1906. For two years they lived as a family, until the relationship foundered. The resolutely independent Gilmour earned a living working as a teacher while supervising an eclectic education for the young Isamu. He attended the local school in Chigasaki and then a French Jesuit middle school in Yokohama for two years while Gilmour taught him about European literature and Greco-Roman mythology. In 1917, concerned about rising nationalism and xenophobia in Japan, Gilmour sent her son—alone at age 13—to Indiana where he abruptly shifted into American life under the name Sam Gilmour. Even in the heartland of America his education continued to be unorthodox: he attended a progressive high school, was mentored by its visionary founder, and briefly resided with a family of Swedenborgians.[9] Thus, before the age of 18, Noguchi had already come in contact with an exceptionally diverse array of cultures and religions: Jesuitical Catholicism, European classical gods and heroes, the animist pantheism of Shinto, the Buddhist concepts of reincarnation and release, and Emanuel Swedenborg's visionary belief that humans and divine spirits coexist in reality. Although too young to understand the implications of so many differing ideas, Noguchi developed at a young age an avid curiosity and an international perspective. Throughout his life Noguchi studied many cultures and religions that would profoundly inform his life and art.

Noguchi belonged to a new generation for whom aesthetics was almost synonymous with multiculturalism. During the 1920s and 1930s a number of artists and writers began to challenge the dominance of European cultural criteria. Latin Americans, in particular, asserted the validity of their own traditions and histories. Diego Rivera abandoned Paris to paint murals glorifying Mexico's ancient civilizations (which up to that time were scarcely known except to archaeologists). Joaquín Torres-García returned from Europe to Uruguay specifically to teach his aesthetics of fusion, combining geometric abstraction with Incan motifs. In Havana, Cuba, Wifredo Lam (whose parentage was Chinese and African-Spanish) invented a remarkable hybrid imagery from a blend of French Surrealism and ideas and symbols from Afro-Cuban religions. These and other artists launched campaigns to raise non-European ethnicity from inferior to elevated status.[10]

As a young artist Noguchi studied in New York, Paris, London, Beijing, and Kyoto. Later, in addition to establishing studios in the United States and Japan, he regularly worked in Italy. He traveled to many other countries including Greece, India, and Indonesia. By 1942 Noguchi defined his art as "one of universality—it is a hybrid…of America, Europe, and Asia."[11] By 1950 he asserted that globalism was necessary: "The modern world is now being formed in a new society that is arising outside the bounds of nationalism…. All artists belong to the world at large."[12] Noguchi's efforts and success helped pave the way for the multicultural artists who would emerge internationally in the 1980s.

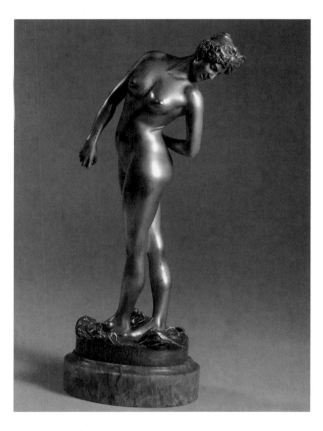

Jean-Léon Gérôme.
The Boules Player, 1901. Gilt bronze; 10 3/4 x 5 x 3 1/4 in. (27.3 x 12.7 x 8.3 cm). Hirshhorn Museum and Sculpture Garden, Smithsonian Institution, Washington DC; gift of Joseph H. Hirshhorn.
Photo by Lee Stalsworth.

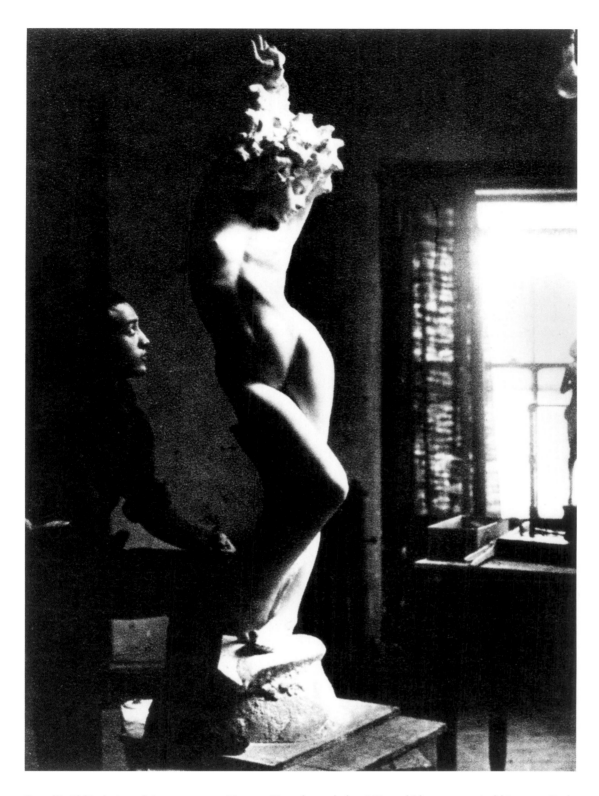

Noguchi with his plaster sculpture
"Undine," 1926.
Photo courtesy The Noguchi Museum.

Many writings by and about Noguchi have presented him as entirely apart from the mainstream of the art world. To some extent this is true; he was an independently minded loner who shunned group involvements and pursued his own goals regardless of changing trends. However, he knew many of the most important artists of his time and was always aware of developments in the art world (whether he liked them or not). My approach in this essay is to examine his sculptures per se while placing them specifically in the context of his contemporaries. At times Noguchi's creativity soared as he learned from others' ideas, and what he did with those sources of inspiration was uniquely his own.

From Apprentice to International Artist

While completing high school in Indiana, Noguchi had his first experience with the profession of sculpture. In the summer of 1922 he traveled to Connecticut to join the studio entourage of Gutzon Borglum, an artist renowned for realistic portraits of famous persons, especially, later, the monumental presidential likenesses on Mount Rushmore. Although Borglum had no time for him, Noguchi learned from the other assistants and discovered his own talent for portraiture. He then enrolled at Columbia University in New York for premedical studies before deciding to become a sculptor—a decision supported by his mother, who had recently settled in New York. In a minor art school in a ramshackle building, Noguchi became the protégé of an Italian immigrant named Onorio Ruotolo, who showed him sophisticated academic techniques of drawing and modeling figures in clay and plaster. Many of his delicate pencil studies have classical names such as *Passifae*, placing Noguchi firmly in the European tradition based on classical Greco-Roman art and mythology. His life-size plaster statue of the water nymph *Undine* attests to Noguchi's remarkable mastery of idealized anatomy and pose. This kind of seductive nude—ostensibly erudite, but actually catering to prurient male audiences—had been popularized in France in the previous century and then migrated to America. *Undine* suggests that its maker had a healthy libido. This female image cannot be described as shy, passive, or modest; exuberant and titillating would be more accurate.

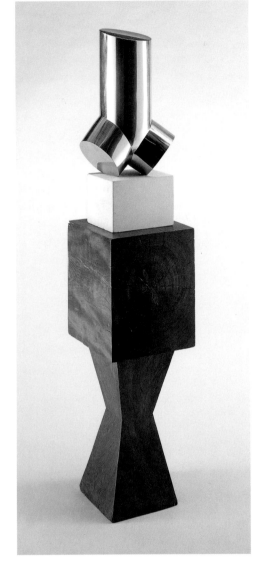

Constantin Brancusi.
Torso of a Young Man, 1924.
Brass on limestone on wood; overall
48 $^1/_2$ x 11 $^1/_2$ x 11 $^1/_2$ in.
(123 x 29.2 x 29.2 cm);
brass only: 18 x 11 $^1/_2$ x 9 in.
(45.7 x 29.2 x 22.8 cm).
Hirshhorn Museum and Sculpture
Garden, Smithsonian Institution,
Washington DC.
Photo by Lee Stalsworth.

Noguchi's skill could have led to a successful career as an academic sculptor, but he sought out more innovative approaches. During the 1910s in New York only a few galleries exhibited European modern art, but by the 1920s such exhibitions were proliferating. In 1926 alone the sculptures of Constantin Brancusi—a Romanian working in Paris—were featured in two gallery exhibitions: at the Wildenstein Gallery in February–March and at the Brummer Gallery in November–December. Simultaneously the Société Anonyme presented a large exhibition of vanguard art at the Brooklyn Museum, which attracted more than 52,000 visitors (an enormous number for that time). Wanting to become part of the international artistic ferment, Noguchi obtained a two-year travel stipend from the Guggenheim Foundation and set off, intending to work in Paris and then to travel to India, China, and Japan.

When Noguchi arrived in April 1927 Paris was teeming with many new and exhilarating approaches to art. Rejecting traditional norms of subject, style, and media was almost mandatory; experimentation and invention became the new aesthetic criteria. Artists dissolved the boundaries between painting and sculpture, sculpture and architecture, fine art and commercial design. Entirely new categories of art came into existence, such as collage and assemblage. Art could now incorporate almost anything—a scrap of newspaper, the newest industrial materials, or objects found in daily life (such as Marcel Duchamp's use of a bicycle wheel and a urinal). Some artists were intrigued primarily by visual novelty, while others believed that materials could express philosophical ideas or sociopolitical beliefs.

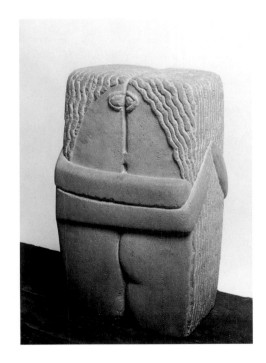

Constantin Brancusi. *The Kiss*,
1912. Limestone; 23 x 13 x 10 in.
(58.4 x 33 x 25.4 cm).
Philadelphia Museum of Art,
The Louise and Walter Arensberg
Collection.

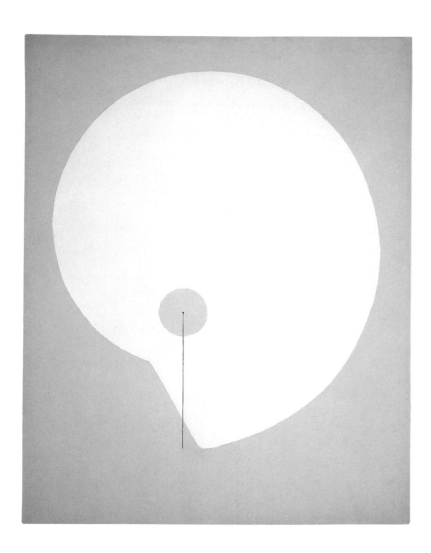

Paris Abstraction, 1927–28.
Gouache on paper; 25 3/4 x 19 3/4 in.
(65.4 x 50.2 cm).
The Noguchi Museum, New York.
Photo by Kevin Noble.

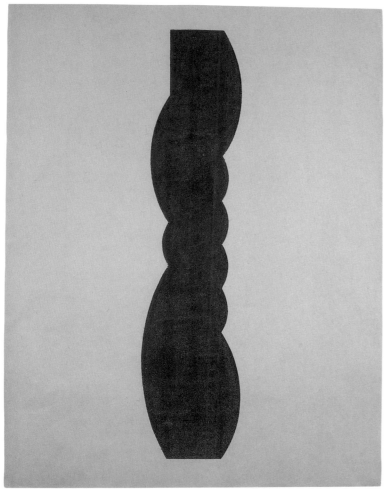

Paris Abstraction, 1927–28.
Gouache on paper; 25 3/4 x 19 3/4 in.
(65.4 x 50.2 cm).
Whitney Museum of American
Art, New York; gift of The
Isamu Noguchi Foundation, Inc.
Photo by Geoffrey Clements.

Paris Abstraction, 1927–28.
**Gouache on paper; 25 3/4 x 19 3/4 in.
(65.4 x 50.2 cm).
Whitney Museum of American Art,
New York; gift of The Isamu Noguchi
Foundation, Inc.**
Photo by Geoffrey Clements.

Paris Abstraction, 1927–28.
**Gouache on paper; 25 ³/₄ x 19 ³/₄ in.
(65.4 x 50.2 cm).
Whitney Museum of American Art,
New York; gift of The Isamu Noguchi
Foundation, Inc.**
Photo by Sheldan C. Collins.

Paris Abstraction, 1927–28.
**Gouache on paper; 25 3/4 x 19 3/4 in.
(65.4 x 50.2 cm).
The Noguchi Museum, New York.**
Photo by Kevin Noble.

Paris Abstraction, 1927–28.
Gouache on paper; 25³/₄ x 19³/₄ in.
(65.4 x 50.2 cm).
The Noguchi Museum, New York.
Photo by Kevin Noble.

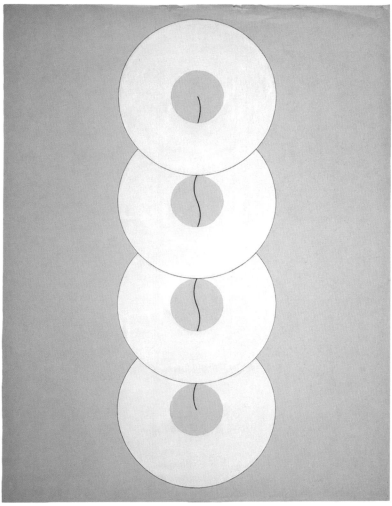

Paris Abstraction, 1927–28.
Gouache on paper; 25³/₄ x 19³/₄ in.
(65.4 x 50.2 cm).
The Noguchi Museum, New York.
Photo by Kevin Noble.

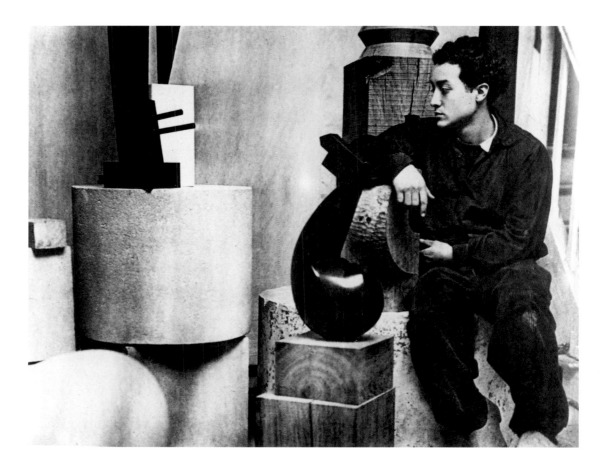

Noguchi with "Foot Tree" and other sculptures in his Paris studio, 1928.
Photo by Atelier Stone, courtesy The Noguchi Museum.

Aleksandr Rodchenko.
Spatial Construction, 1918–19. Metal. No longer extant.
Photo © Rodchenko & Stepanova Archive.

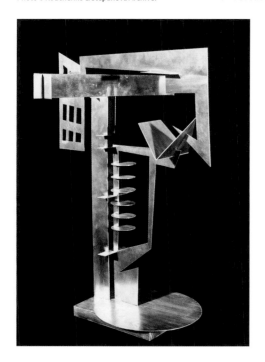

One new approach to sculpture was *taille directe* (direct carving), which emerged as a reaction against academic methods. For centuries European sculptors had created original models in clay, wax, or plaster, which studio assistants would meticulously reproduce in marble or bronze. The invention of new technologies for bronze casting and enlarging three-dimensional works had enabled nineteenth-century sculptors to market their works in greater numbers. Auguste Rodin earned a fortune from the sale of bronze editions of *The Thinker* in several sizes; the quality of those casts varies from superb to shoddy. Making sculpture had become suspiciously similar to commercial mass production. Direct-carve artists asserted that every sculpture should be carved and finished personally by the artist. This reestablished the uniqueness of each work of art and gave the sculptors themselves a better understanding of materials and processes. The "truth to materials" corollary of direct carving proposed that sculptors should work in harmony with the intrinsic nature of each material, devising their compositions to enhance the specific texture, grain, density, and color of the material. Some of these ideas emerged from a growing appreciation of non-European arts, particularly from Africa and the Pacific islands. In 1906 a memorial exhibition of Paul Gauguin's works revealed his wood carvings of exotic subjects in a style blending sophistication with folk arts. Almost immediately a number of young artists began making deliberately primitivist sculptures with boldly simplified forms and rough-hewn surfaces. A few politically oriented artists believed that direct carving and a primitivist style also implicitly rejected European colonialism and racism.

Noguchi met Brancusi, the champion of direct carving, within a few days of arriving in Paris. The young American became a studio assistant for six months, gaining practical experience in carving and polishing. He also studied the works in Brancusi's studio, which ranged from the early

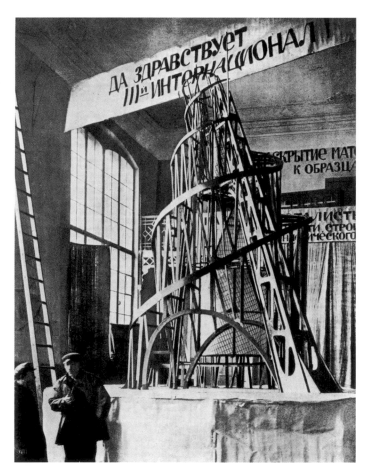

Vladimir Tatlin. *Model for the "Monument to the Third International,"* 1920. Wood and mixed media. No longer extant.

primitivism of *The Kiss* from 1908 to the exquisite refinement of *Torso of a Young Man* from 1924 (see page 21). Consisting of three differently shaped geometric components made from three contrasting materials, this sculpture epitomizes Brancusi's mature aesthetics. The gleaming golden brass, the porous white limestone, and the red-brown wood with its strong circular grain enhance each other. There is no clear demarcation of sculpture from base; Brancusi's bases tend to be sculptures in their own right. Although he preferred wood and stone, Brancusi addressed bronze with the same "truth-to-materials" credo. Instead of creating a chemically induced patina of black, browns, and greens, he polished the surface to a mirrorlike gloss. In fact, Brancusi often used brass, a similar but less expensive copper-based alloy that can be polished more effectively to a golden sheen.[13] Thus, while championing a handcrafted process, Brancusi achieved a result congruent with the Machine Age aesthetic—a rare feat that would have long-lasting ramifications for Noguchi's aesthetics.

Many artists considered *taille directe* insufficiently revolutionary for the Machine Age. As new technologies were beginning to improve the lives of millions of people, utopian artists advocated related materials and methods. Italian Futurists, Russian Constructivists, and the Bauhaus school in Germany praised technology as the new paradigm for art and ultimately for society:

> Futuris[t art] is grounded in the complete renewal of human sensibility brought about by the great discoveries of science. Those people who today make use of the telegraph, telephone, phonograph,... automobile [and] airplane...do not realize that these...have a decisive influence on their psyches.[14]

Indeed, "the vitality, the uniformity, the monumental quality, the accuracy, and perhaps the beauty of the machine are an exhortation to the artist."[15] Thus, sculptures made from industrial and other modern materials proclaimed the artists' belief in social progress. During the heady early years of the Soviet Union, Constructivist sculptors—Vladimir Tatlin, Aleksandr Rodchenko, Naum Gabo, Antoine Pevsner, the Sternberg brothers, and others—built open-form structures as conceptual prototypes for visionary architecture. Gabo and Pevsner utilized newly invented plastics, while Tatlin and Rodchenko incorporated metal components in their works. But few Constructivists in poverty-stricken Russia could afford steel or structural glass. Instead, their sculptures tried to indicate how they should be made in the future: wood painted white or gray was intended to suggest steel girders, black lines were the equivalent of metal wires, translucent gouache indicated

Paris Abstraction, 1927–28. Gouache on paper; 25 3/4 x 19 3/4 in. (65.4 x 50.2 cm). The Noguchi Museum, New York. Photo by Kevin Noble.

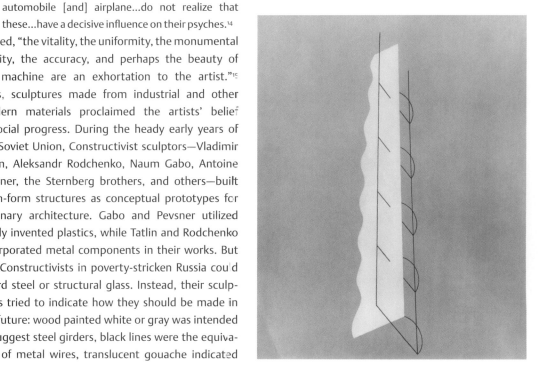

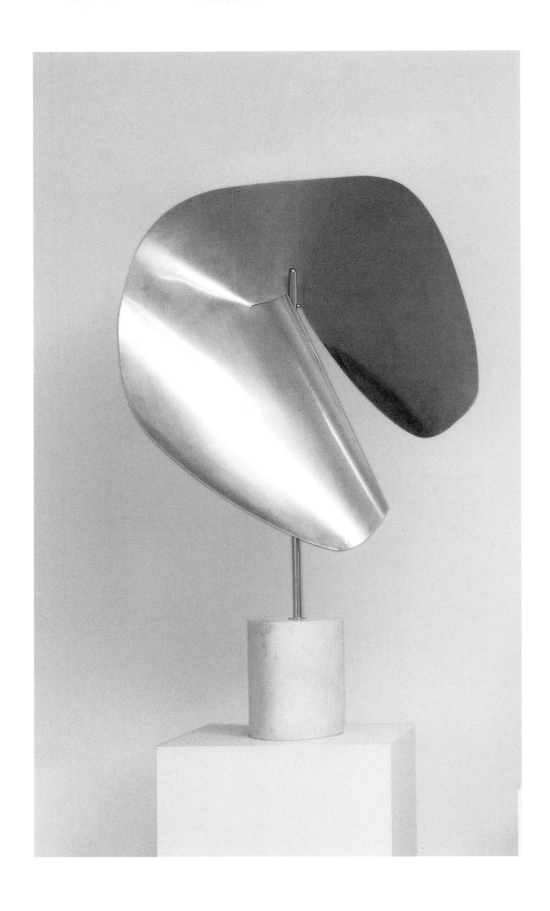

Positional Shape, 1928. Brass
(later gilded), 23 x 21 x 8 3/4 in.
(58.4 x 53.3 x 22.2 cm).
The Noguchi Museum, New York.
Photo by Shigeo Anzai.

Abstraction (Leda), 1928.
Brass (later gilded; ring element
refabricated); 23 ³/₈ x 14 ¹/₄ x 11 in.
(59.4 x 36.2 x 27.9 cm), on artist's
marble base 1 ¹/₂ x Diam. 15 in.
(3.8 x Diam. 38 cm).
The Noguchi Museum, New York.
Photo by Kevin Noble.

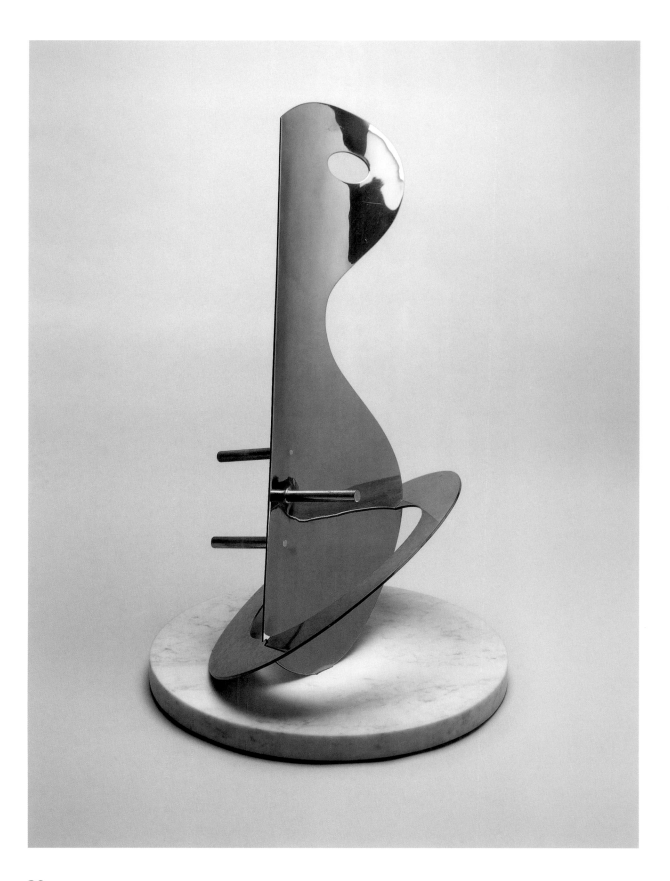

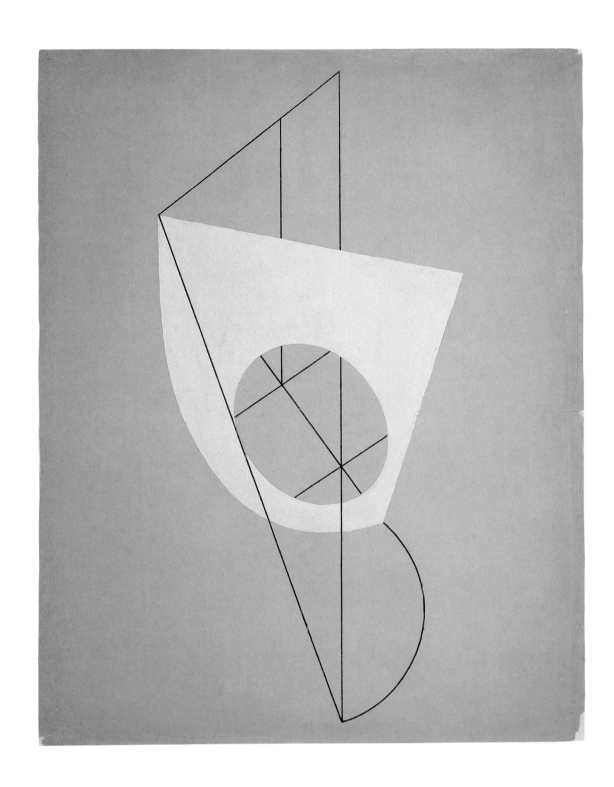

Paris Abstraction, 1927–28.
Gouache on paper; 25 3/4 x 19 3/4 in.
(65.4 x 50.2 cm).
The Noguchi Museum, New York.
Photo by Kevin Noble.

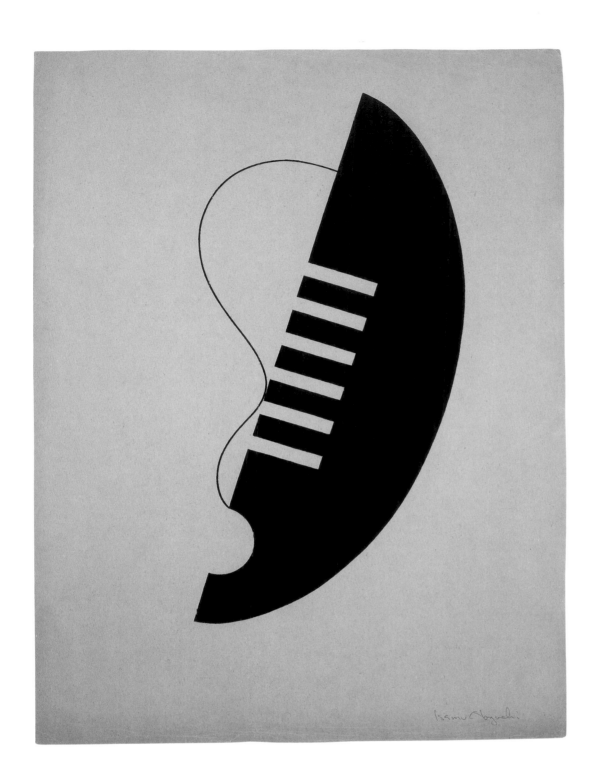

Paris Abstraction, 1927–28.
Gouache on paper; 25 3/4 x 19 3/4 in.
(65.4 x 50.2 cm).
The Noguchi Museum, New York.
Photo by Kevin Noble.

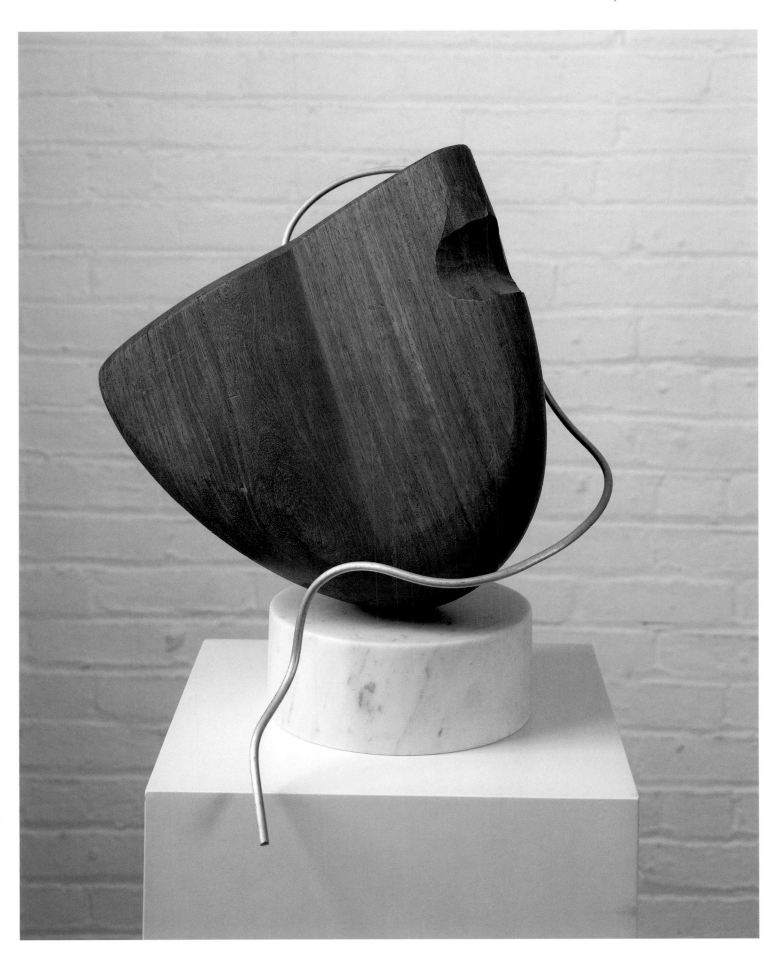

Red Seed, 1928. Teak wood, metal rod (rod refabricated 1985), and marble; 17 $\frac{1}{2}$ x 13 $\frac{1}{2}$ x 10 $\frac{3}{4}$ in. (44.4 x 34.3 x 27.3 cm). The Noguchi Museum, New York. Photo by Kevin Noble.

Power House (Study for Neon Tube Sculpture), 1928. Zinc; H. 14 in. (35.6 cm). No longer extant.
Photo by Atelier Stone, courtesy The Noguchi Museum.

glass. Although made from scrap lumber, Tatlin's *Model for the "Monument to the Third International"* showed how the work was to be constructed of steel and glass on an enormous scale. Tatlin's abstract, diagonally spiraling structure became a symbol of the socialist utopia envisioned by idealists of many nationalities.

Materials were only part of the utopians' new visual language. Geometric abstract styles proclaimed a new era in which reason would triumph over irrational emotions. By emulating the rigorous and objective standards of mathematics and engineering, artists hoped to create a rational and peaceful environment conducive to a better life—both physically and spiritually. A teacher at the Bauhaus proclaimed that "abstract art...projects a desirable future order [and] creates new types of spatial relationships, new inventions of forms, new visual laws—basic and simple—as the visual counterpart to a more purposeful, cooperative human society."[16] Utopians considered abstraction in art as equivalent to new scientific languages such as Morse code, radio wave frequencies, and chemical formulae—or computer codes today. New theories of structural linguistics, semiotics, and Gestalt perceptual psychology were beginning to demonstrate how shapes, color, and other elements of sight and sound might possess meaning independent of their cultural context. These discoveries encouraged utopians in their belief that abstract forms and technological materials in art would be understood by emerging generations capable of thinking in more complex and sophisticated ways.[17]

At the time of Noguchi's arrival in Paris, these ideas had reached their apogee. Seemingly without hesitation, he made a quantum leap from his old academic ways to abstraction and Constructivism.[18] In the *Parisian*

Abstractions, a series of more than 70 gouaches, he developed a vocabulary of geometric forms. Employing a deliberately restricted range of colors—subtly varied tones of black and white on buff paper—Noguchi created boldly simplified shapes and strong linear patterns. Some compositions consist of elements tightly interlocked in puzzle-like configurations: one features penile and breastlike forms (see page 25). Noguchi designed delicate structures inspired by the architectonic approach of Russian Constructivism. One gouache features a massive palette-shaped form perched with exquisite tension atop a short vertical line (see page 22). In another, four small spheres shine like beacons on a scaffold, while yet another has four white rings overlapping a sinuous axis (see page 26).

Emboldened by his experimental compositions in gouache, Noguchi made several sculptures from sheets of brass that he molded into elegant shapes curving through space, as in *Abstraction* (later retitled *Leda*; see page 30). Some incorporated contrasting materials, while others had variable or kinetic components. *Positional Shape* (see page 29) originally was supported by wires passing through holes in the top and sides; this allowed the sculpture to have several different orientations (it is now mounted immovably on a rod). *Abstraction in Almost Discontinuous Tension* consisted of brass components held together by string suspended from the ceiling.[19] The solid mass of reddish cocobolo wood in *Red Seed* (see page 33) is offset by a lightweight metal rod meandering into the surrounding space.[20] Although made of zinc rods, *Power House (Study for Neon Tube Sculpture)* (see page 34) was a model for a never-executed larger version using neon-gas tubes—a new kind of lighting invented by a French physicist in 1902. Noguchi's prototype anticipated by four decades the tubular fluorescent light sculptures of Dan Flavin.

The vitality in Noguchi's Parisian works reflected his euphoric sense of belonging to a community of bohemian artists from many nations, many of them proud of their outsider status: "Paris was a fantastic experience.... I suddenly came upon...people who were either like me or that I could accept, or who would accept me." Unlike the racially divisive attitudes widespread in the United States, cosmopolitan Paris valued ethnic differences. The permissive attitudes and exuberant joie de vivre of Paris transformed Noguchi: he attended wild parties with other artists (including Alexander Calder) and enjoyed several sexual liaisons, including an affair with the vivacious model Kiki of Montparnasse. Noguchi discovered that satisfying his libido could contribute substantially to his artistic creativity; henceforth many intelligent and passionate women would help to sustain him and his work.

While in Paris, Noguchi discovered dualist philosophy, which defines existence as the relationship of fundamental opposites. Physical reality may be characterized in terms such as light/dark, large/small, mass/void, hard/soft, male/female, self/other, and so on. Intangibles too can be defined as paired or mutual complements: love/hate, joy/sorrow, courage/fear,

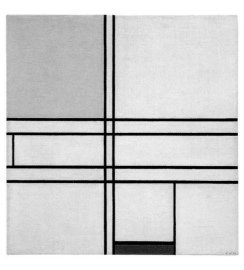

Piet Mondrian. *Composition with Blue and Yellow*, 1935. Oil on canvas; 28 3/4 x 27 1/4 in. (73 x 69.2 cm). Hirshhorn Museum and Sculpture Garden, Smithsonian Institution, Washington DC; gift of the Joseph H. Hirshhorn Foundation. Photo by Lee Stalsworth.

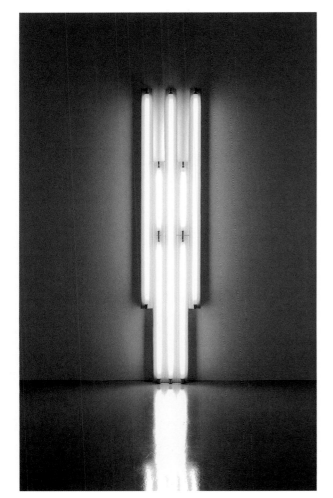

Dan Flavin. *"monument" for V. Tatlin*, 1967. Fluorescent tube lights; 96 x 19 3/4 x 5 in. (243.8 x 50.2 x 12.7 cm). Hirshhorn Museum and Sculpture Garden, Smithsonian Institution, Washington DC; Joseph H. Hirshhorn Bequest Fund. Photo by Lee Stalsworth.

optimism/pessimism, active/passive, connection/separation. Reality consists of the changing interactions between inseparable opposites. Neither can exist without the other; together they constitute a coherent whole. Changes great and small in the universe and in an individual can be defined as shifts in the proportional relationship of opposites. Dualist philosophies have emerged in many cultures at various times in history. In East and South Asia they date from at least 6000 BCE and have continued to flourish to the present. Perhaps the most familiar now is the Chinese concept of *yin/yang*. Noguchi probably encountered dualistic philosophy through the art and ideas of the Dutch De Stijl artists active in Paris during the 1920s. Led by Piet Mondrian, these artists devised compositions of severely minimal geometric components, usually rectangular planes of white or the primary colors bound by black vertical and horizontal lines. De Stijl

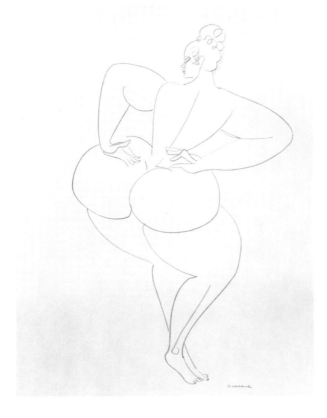

Gaston Lachaise. *Study of a Nude*, late 1920s. Pencil on paper; 23 x 17 in. (58.4 x 43.2 cm). Hirshhorn Museum and Sculpture Garden, Smithsonian Institution, Washington DC; gift of Joseph H. Hirshhorn.
Photo by John Tennant.

artists strove to achieve balance or harmony between these opposing elements: "The struggle of one [thing] against the other forms the tragedy of life...the greatest tragedy is due to the inherently unequal dualism of spirit and nature [and] disequilibrated mutual relationships...between male and female, between society and individual." De Stijl artists therefore aimed to "express the relationship of opposition in complete harmony."[21] Harmony was understood not as a single static solution but rather as a dynamic state that evolves through the life and consciousness of individuals and societies. This philosophy would provide Noguchi with a flexible framework for his ideas, experiences, and aesthetics; he later described himself as "always thinking in opposites."

Noguchi left Paris for a month to read about Asian philosophies and religions at the British Library in London. There he discovered and studied English-language texts by Daisetz Suzuki, the leading Japanese scholar of Zen Buddhism. He probably also read Madame Blavatsky's book on Theosophy, her amalgam of Hinduism, Buddhism, and various occult traditions derived from medieval Europe. Theosophy inspired many European modernists including Wassily Kandinsky and Piet Mondrian. Books by the Indian scholar Ananda Coomaraswamy broadened Noguchi's understanding of Buddhism to include its origins and differing interpretations

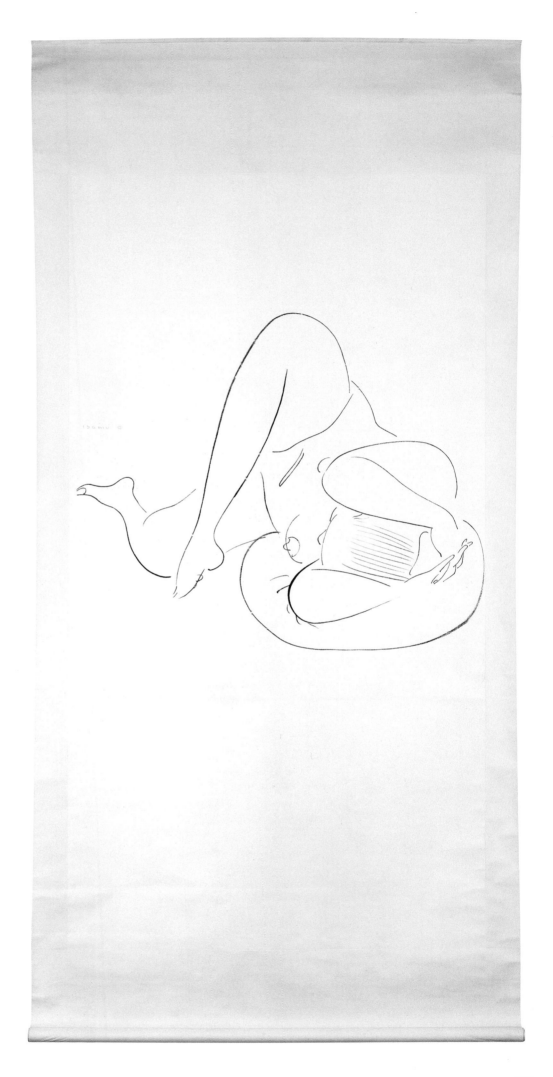

Beijing Scroll: Reclining Female
Nude Holding Head, 1930.
Ink on rice-paper scroll;
80 1/4 x 43 3/4 in. (203.8 x 111 cm).
The Noguchi Museum,
New York.
Photo by Kevin Noble.

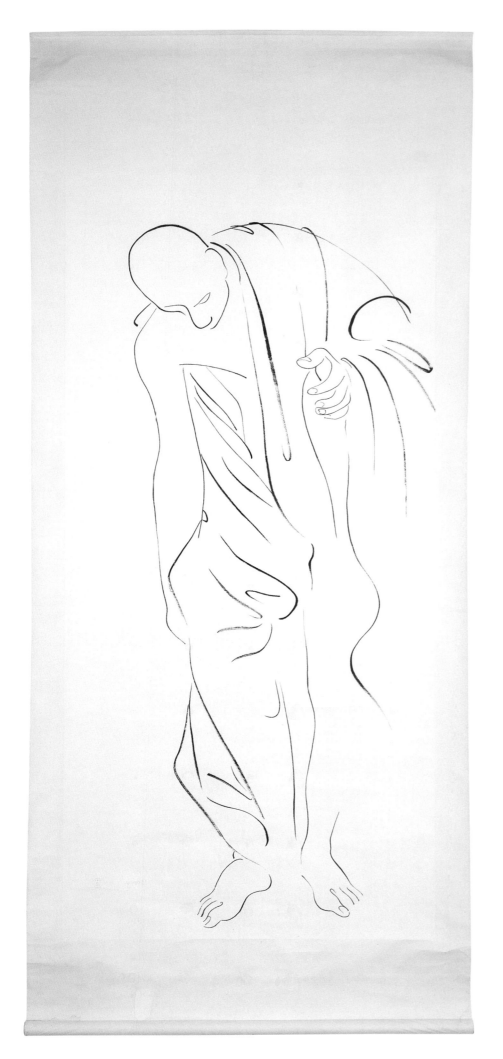

Beijing Scroll: Slouching Monk,
1930. Ink on rice-paper scroll;
87 x 38 1/8 in. (221 x 96.8 cm).
The Noguchi Museum, New York.
Photo by Kevin Noble.

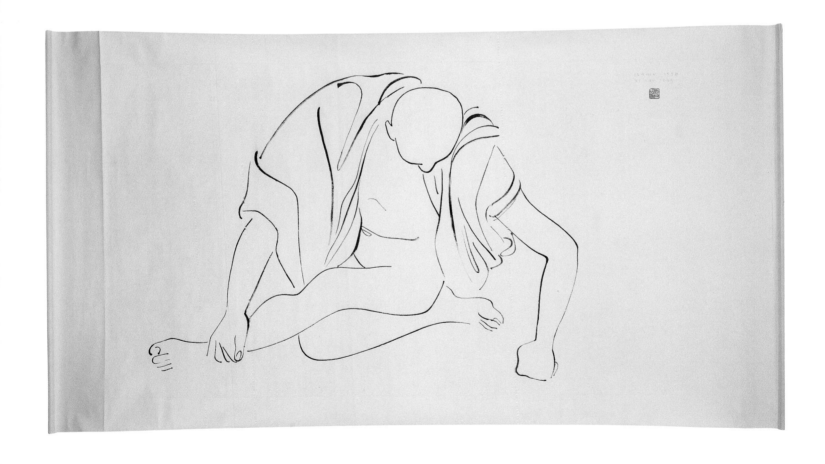

Beijing Scroll: Seated Monk, 1930.
Ink on rice-paper scroll;
44 3/4 x 83 in. (113.7 x 210.8 cm).
The Noguchi Museum, New York.
Photo by Kevin Noble.

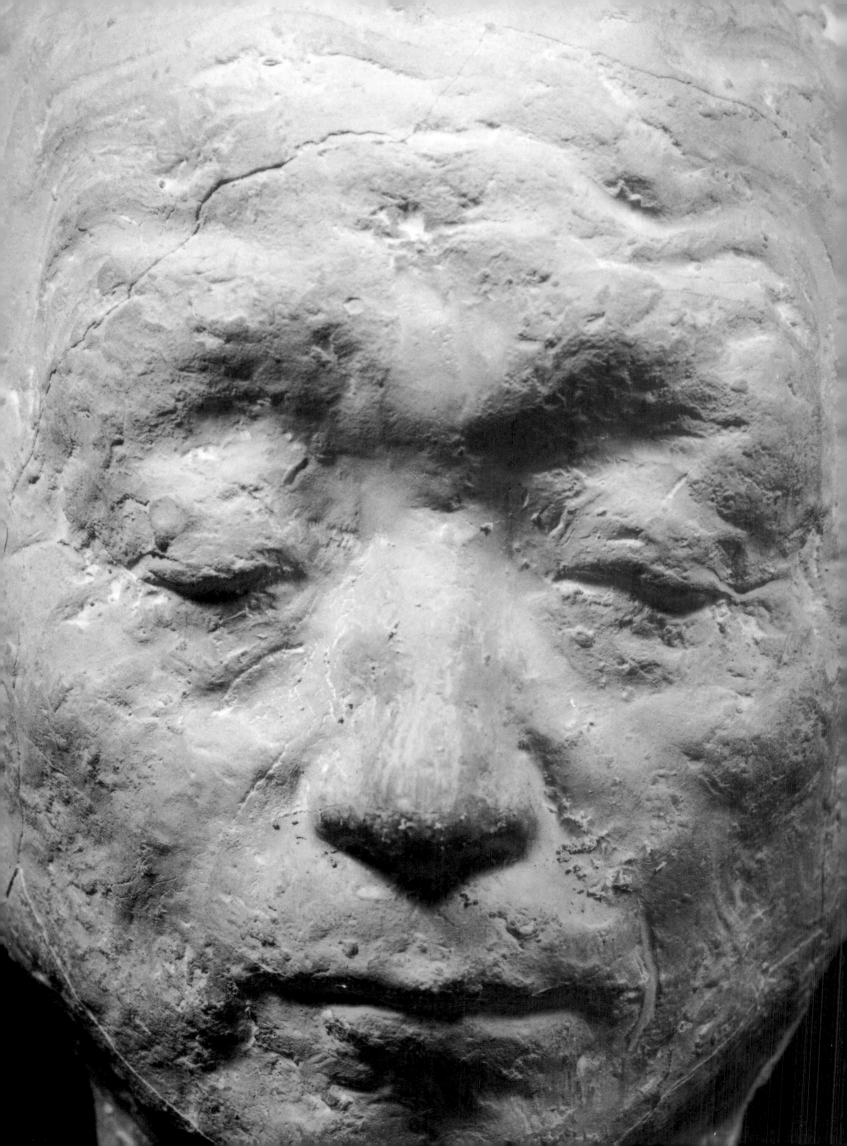

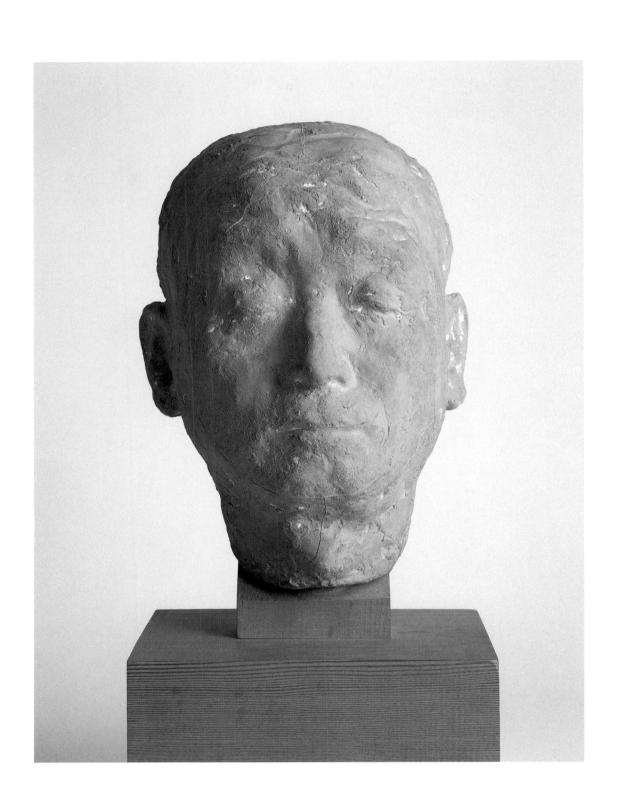

OPPOSITE AND ABOVE
Portrait of Uncle Tagaki, 1931.
**Terracotta with plaster
(edition of 4); 12 $^1/_4$ x 7 $^3/_4$ x 8 in.
(31 x 19.7 x 20.3 cm).
The Noguchi Museum, New York.**
Photo by Kevin Noble.

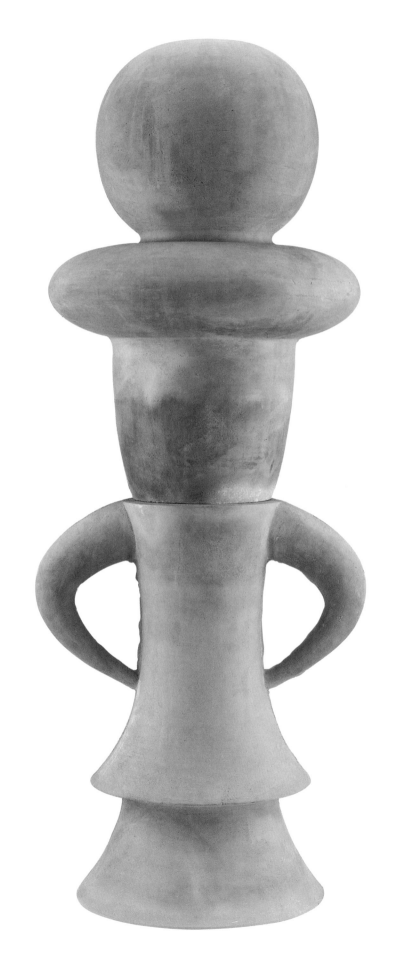

The Queen, 1931. Terracotta
(two elements); 45 ¹/₂ x 16 x 16 in.
(115.6 x 40.6 x 40.6 cm).
**Whitney Museum of American Art,
New York; gift of the artist.**
Photo by John Tsantes.

in South and Southeast Asia. In *History of Indian and Indonesian Art* (1927), Coomaraswamy emphasized the spiritual purpose of Hindu works of art, defining them primarily as transmitters of philosophical and religious content. Apparently Noguchi's research in London satisfied his curiosity about Asian cultures, for he decided to continue working in Paris instead of traveling to India, China, and Japan as originally intended.

In early 1929, running out of funds, Noguchi returned to New York. Brimming over with new ideas, he was discouraged to find that his Parisian works attracted little interest and few purchasers. Falling back on his academic skills, he sculpted portraits to earn money. His models included the photographer Berenice Abbott, composer George Gershwin, impresario Lincoln Kirstein, and dancer-choreographer Martha Graham. Most of these portraits were vaguely Rodinesque in style, but a few used sleek forms and bold stylizations. Most were modeled in plaster and cast in bronze.[22] Pocketing the proceeds, Noguchi hurried to Paris in April 1930. The utopian ideals he had encountered and admired during his previous visit remained strong, motivating him to go to Moscow to see Tatlin's *Model for the "Monument to the Third International."* He was disappointed to learn that Joseph Stalin had suppressed Constructivist art as counterrevolutionary, and Tatlin's model had disappeared.

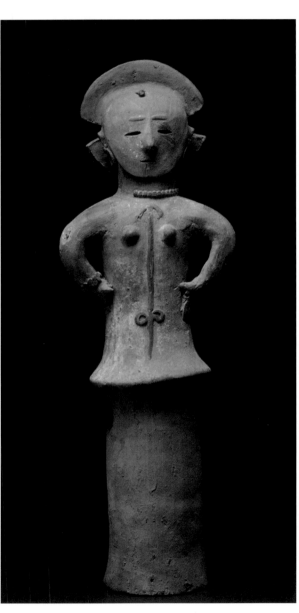

Fulfilling his earlier plan to visit East Asia, Noguchi traveled on the Trans-Siberian Railroad to Beijing. One of the least modern cities in the world at that time, Beijing offered an environment utterly different from Europe and America. For seven months Noguchi studied traditional brush-and-ink methods and made dozens of large-scale drawings on rice paper. Some of his energetic strokes made with a wide brush anticipate the later gestural aesthetics of American Abstract Expressionist painters such as Franz Kline, but most of his Beijing drawings were inchoate and awkward. He achieved more graceful and coherent results with a single-contour style that was more European in flavor. His *Reclining Female Nude Holding Head* and *Slouching Monk* (see pages 37–38) compare favorably with the elegance of contemporaneous drawings by Gaston Lachaise, Henri Matisse, and Elie Nadelman.

In early 1931 Noguchi traveled to Tokyo, hoping to establish a relationship with his father. A prominent academic, with a wife and children, Yonejiro steadfastly refused to acknowledge Isamu. However, Yonejiro's brother, a Zen monk, took him in. The young sculptor responded with the *Portrait of Uncle Tagaki.* The sensitive modeling and downcast eyes suggest meditation and inner peace—a state of mind that eluded Noguchi. He soon moved to Kyoto, the nexus of traditional Japanese art, where he studied the culture of his childhood, visiting monasteries and gardens. The quirky pre-Buddhist funerary figures called *haniwa* inspired him to sculpt the bizarre yet compelling work—later titled *The Queen*—which seems to refer as much to a character in Lewis Carroll's *Alice's Adventures in Wonderland* or Max Ernst's Surrealist sculptures as it does to *haniwa*.[23]

Burial figure (Haniwa), Japanese, 4th–6th century. Terracotta; 30 1/8 x 10 x 6 1/2 in. (76.5 x 25.4 x 16.5 cm). **Seattle Art Museum, Eugene Fuller Memorial Collection.** Photo © Seattle Art Museum/Corbis.

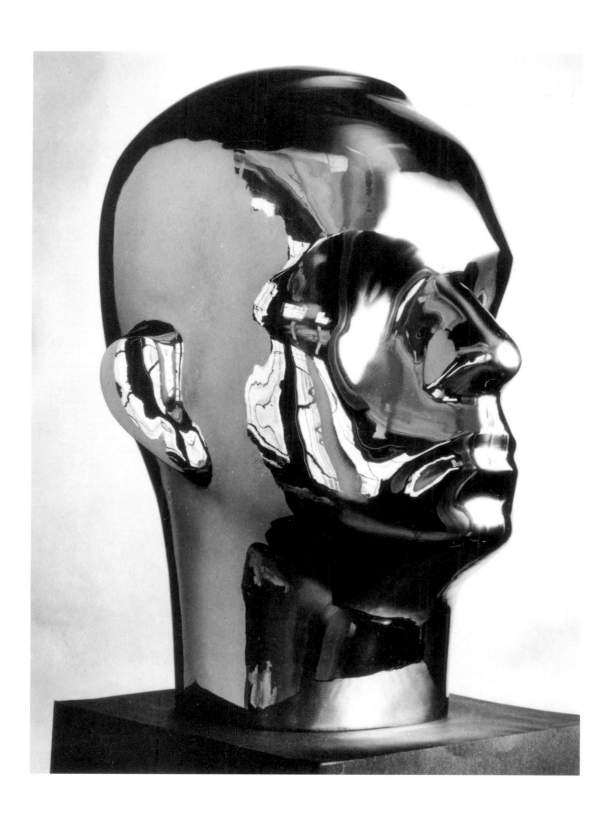

Portrait of R. Buckminster Fuller,
1929. Chrome-plated bronze
(edition of 2); 13 x 7 x 9 $^{1}/_{2}$ in.
(33 x 17.8 x 24.1 cm).
**Private collection, Portland, courtesy
the Buckminster Fuller Estate.**
Photo by F. S. Lincoln,
courtesy The Noguchi Museum.

In October 1931 Noguchi returned to New York, where his Chinese scroll drawings and Japanese terracottas elicited no more financial support than his *Parisian Abstractions* had two years earlier. Although the city had absorbed millions of immigrants, very few were Asian, and the art world was still dominated by the WASP elite. Appreciation of Asian arts was limited to a few cognoscenti, while popular forms of entertainment presented unflattering stereotypes of Orientals as exotic, ignorant, inscrutable, devious, sexually enticing, or decadent. Noguchi again resorted to sculpting portraits to earn a living. As the Great Depression deepened, he became discouraged and uncertain about his future. Fortunately his optimism was revitalized through his new friendship with the charismatic futurist R. Buckminster Fuller. They had met in 1929, two years after Fuller had published *4D Timelock* and announced his "World Town Plan" for a global society. Fuller expressed his ideas and theories in metaphoric terms, mixing philosophy and science. In contrast to literal rationalists, Fuller believed—as Noguchi did—that intuition can surpass logic, that paradox can reveal complex truths, and that humans have an unlimited potential for evolution and social transformation.[24] Drawing upon the advances of engineering and technology, Fuller posited architecture and commercial design as the best means for improving the human condition.

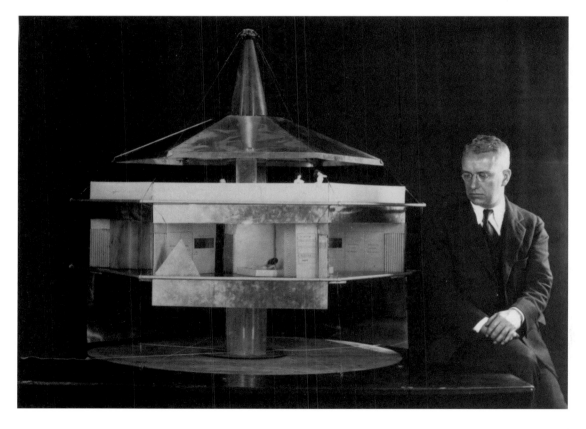

Fuller probably introduced Noguchi to the philosophy of dialectics, an open-ended and interactive way of experiencing reality. Straightforward dualism seeks to achieve balanced and harmonious relations of complementary opposites; the opposing forces themselves do not fundamentally change. Dialectics proposes a more dynamic relationship that can lead in many unexpected directions without having a predefined goal. Instead of merely coexisting, two opposites affect each other. A thesis actively addresses and engages its antithesis, thereby changing. Evolution (of ideas, individuals, societies) consists of a perpetual process from thesis to antithesis and finally to synthesis. Fuller summed up dialectics in the term *synergy*: a whole can become greater than the sum of its parts. Such thinking provided Noguchi with a more sophisticated intellectual framework for

Buckminster Fuller with model for "Dymaxion House," 1932.
Photo © Conde Nast Archive/Corbis.

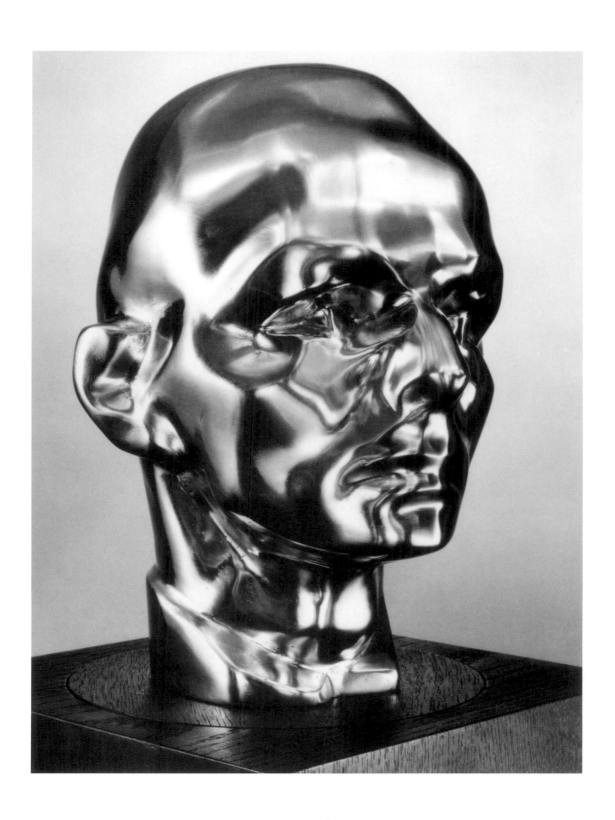

Portrait of Immo Gulden, 1934.
Stainless steel; H. 12 in. (30.5 cm).
Mr. and Mrs. Paul Immo Gulden, Jr.,
Rumson, New Jersey.
Photo by F. S. Lincoln,
courtesy The Noguchi Museum.

his restless need to try one thing and then another: eventually synthesis would become his measure of personal and artistic progress.

Fuller's visionary enthusiasm and scientific knowledge encouraged Noguchi to try new things and expand his horizons. Although seemingly modest at first, these steps would have long-lasting ramifications for the artist. For example, Fuller persuaded him to paint his entire studio silver—long before the Flash Gordon and Buck Rogers films popularized the idea of metallic-looking interiors. Although the glittering studio proved impractical for the artist (it magnified sunlight and multiplied reflections to an almost blinding intensity), the "look" entered Noguchi's sculptural vocabulary. He chrome-plated the bronze *Portrait of R. Buckminster Fuller* (see page 44)—a radical idea for that time. Electroplating involves immersing an object in a liquid, which is electrically charged, in order to add a thin layer of metal (such as brass, bronze, gold, or nickel) to it. Electroplating had been utilized since the mid-nineteenth century for commercial objects. During the 1910s and 1920s a few artists experimented with this technique, notably Alexander Archipenko, László Moholy-Nagy, and Elie Nadelman—all modernists seeking to develop a Machine Age appearance for their sculptures. Noguchi seems to have been the first artist to use

 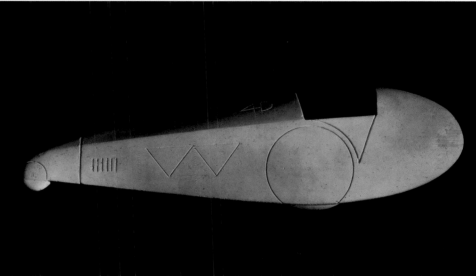

chrome-plating, which had been primarily associated with the automobile industry. Chromium increases the strength of steel and reduces tarnishing (excellent for bumpers and radiators). The startlingly futuristic look of the portrait of Fuller expressed the model's faith in technology as a means toward the positive transformation of the world. Noguchi was so pleased with the look of this shiny head that he later used stainless steel for the portrait of a neighbor, Immo Gulden.[25]

In late 1931 Noguchi became actively involved in his friend's ambitious projects. Fuller's architectural designs—many of which existed only as drawings—exceeded the stylistic daring and technological sophistication of contemporaneous European utopians Walter Gropius and Le Corbusier, among others. Fuller's *Ten-Deck Building* and *Dymaxion House* were predicated on a central frame of lightweight and sturdy aluminum tubes held by tension cables, which could be erected almost anywhere. *Dymaxion House* was intended to be mass-produced as housing for homeless families. Fuller was one of the first designers to recognize the potential applications of aluminum.[26] In December 1931 Noguchi modeled *Miss Expanding Universe* in plaster and subsequently made two aluminum casts. Aluminum being an exceptionally light alloy, only one-third the weight of copper, bronze, or steel, the artist could hang this sculpture from his studio ceiling like a figural airplane. A photograph from 1932

Buckminster Fuller and Isamu Noguchi, Rear and side views of *Model for "Dymaxion Car,"* 1927. Plaster; dimensions unrecorded. No longer extant.
Photos by F. S. Lincoln, courtesy Estate of Buckminster Fuller.

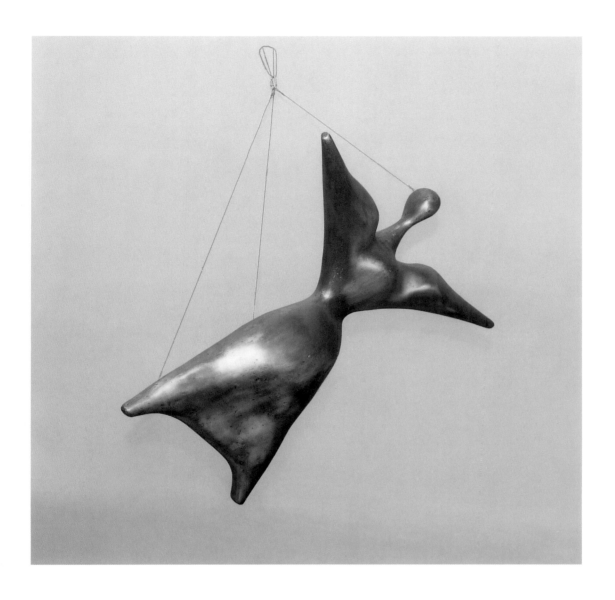

Miss Expanding Universe, 1931 (cast
1932). Aluminum (edition of 2);
40 7/8 x 34 7/8 in. (103.8 x 88.6 cm).
Toledo Museum of Art.
Photo courtesy the Art Institute of Chicago.

OPPOSITE
Miss Expanding Universe, 1931. Plaster;
40 7/8 x 34 7/8 in.
(103.8 x 88.6 cm). No longer extant.
Photo by Isamu Noguchi,
courtesy The Noguchi Museum.

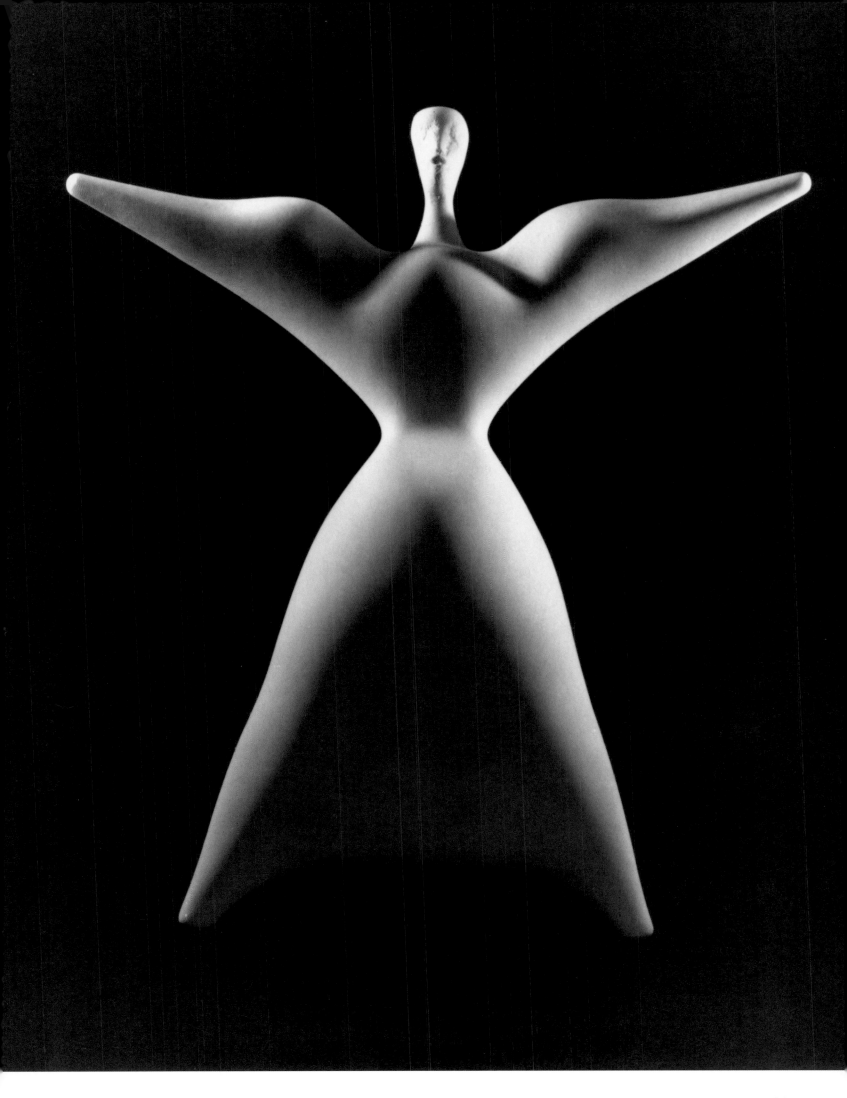

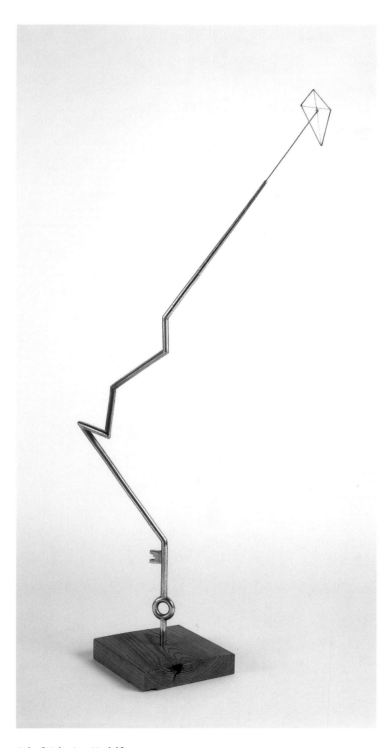

*Bolt of Lightning: Model for
"Monument to Benjamin Franklin,"*
1933. Stainless steel and painted
brass; H. 52 in. (132 cm).
The Noguchi Museum, New York.
Photo by Kevin Noble.

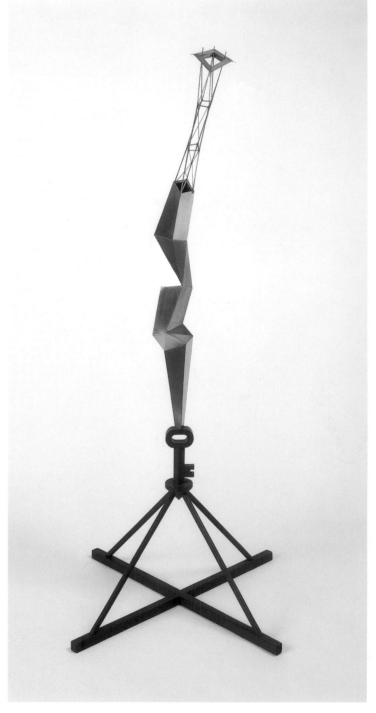

*Bolt of Lightning: Model for
"Monument to Benjamin Franklin,"*
1933, revised 1981–83. Stainless steel
and painted brass; 51 x 17 $\frac{1}{2}$ x 17 $\frac{1}{2}$ in.
(129.5 x 44 x 44 cm).
The Noguchi Museum, New York.
Photo by Sarah Wells.

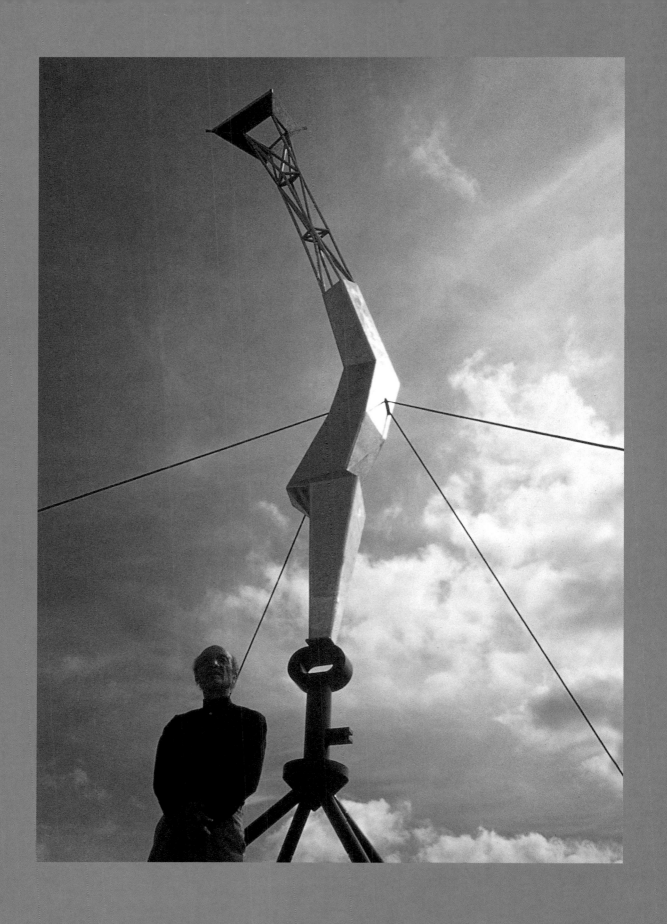

shows him holding the sculpture aloft and looking up at it almost in adoration, with the caption "To him she is full of hope." The elegantly streamlined forms of *Miss Expanding Universe* resemble, to some extent, the aerodynamic glass windscreen Fuller had designed for *Ten-Deck Building* and the plaster models that Noguchi made for Fuller's *Dymaxion Car*. The title *Miss Expanding Universe* pays homage to Fuller's theories of cosmic energy and unlimited evolutionary potential, while also alluding to their mutual friend (and Noguchi's mistress), the dancer Ruth Page, who choreographed and performed "The Expanding Universe" in New York in January 1933.[27] Noguchi did not lack a sense of humor: both Page and Fuller were, in different ways, energizing him.

Recognizing the futility of trying to change people's ideas and attitudes directly, Fuller intended to influence them by reforming their environment (though few of his architectural proposals were implemented, with the notable exception of the geodesic dome in the 1950s). He encouraged Noguchi to create commercial designs in order to reach a wider audience and to join the art division of the New Deal employment program. In 1933 (a pivotal year in which he had an exhibition in London and his mother died in New York), Noguchi made three astoundingly innovative proposals. For New York's Central Park he designed a sculpted-earth playground (see page 169). For Philadelphia he proposed a *Monument to Benjamin Franklin*. The artistically conservative city boasted many traditional portrait statues, and Noguchi could easily have submitted a realistic image of the American inventor/writer-statesman, perhaps seated to write his *Poor Richard's Almanack* or standing with the Declaration of Independence in hand. Instead, Noguchi submitted a model for a very tall zigzag line representing a bolt of lightning with a kite on top and a key at its base. He intended this unprecedented proposal to be fabricated of stainless steel, a radical mate-

Model for "Monument to the Plough," **1933. Plaster and metal; dimensions unrecorded. No longer extant.** Photo by Berenice Abbott, courtesy The Noguchi Museum.

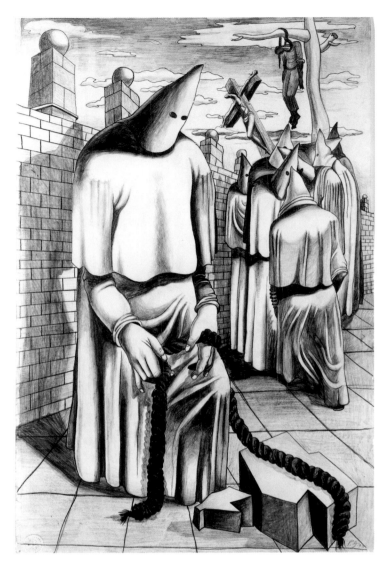

Philip Guston. *Drawing for
"The Conspirators,"* 1930.
Pencil, ink, colored pencil,
and crayon on paper;
22 $^1/_2$ x 14 $^1/_2$ in. (57.1 x 36.8 cm).
Whitney Museum of American Art,
New York; purchase with funds
from the Hearst Corporation and
the Norman and Rosita Winston
Foundation, Inc.
Photo by Geoffrey Clements.

rial for art at that time. Noguchi's design would have required extremely
advanced engineering to remain upright, especially during bad weather.
When the full-scale monument was finally erected in 1985, Noguchi had to
modify its proportions and add safety wires; these necessary alternations
somewhat diminished the slender verticality of the original but did not
lessen its astonishingly futuristic impact.

Even more radical was Noguchi's proposal in honor of American agri-
culture, *Monument to the Plough*. Intended to be located at the geographic
center of the United States, this was to have been a vast, asymmetrical
earthen pyramid. One slope would be plowed into furrows, indicating the
work necessary to produce food as well as the promise of future growth.
Another side would be planted in wheat, which would represent physical
and spiritual nourishment. The third side would be left fallow, symbolizing
the need for rest and replenishment. At the apex of the pyramid an abstract
form in stainless steel would represent a plow as a triumphant symbol of
America's industrial and agricultural power. Conceived as the Dust Bowl
drought was destroying farms and thousands of families were becoming
homeless migrant laborers, this proposal embodied Noguchi's dogged
hopes for a better future—a heroic earthbound version of Tatlin's soaring
tower. The low-lying asymmetrical pyramid form would become a recur-
rent symbol of earth and eternity in Noguchi's later landscape projects.
Although never implemented, Noguchi's proposal anticipated by many
years the Earthwork projects of Robert Smithson, Michael Heizer, Dennis
Oppenheim, and others in the 1960s and 1970s.

In contrast to the visionary optimism of his three proposals for public
art (which were all rejected by government authorities), Noguchi's

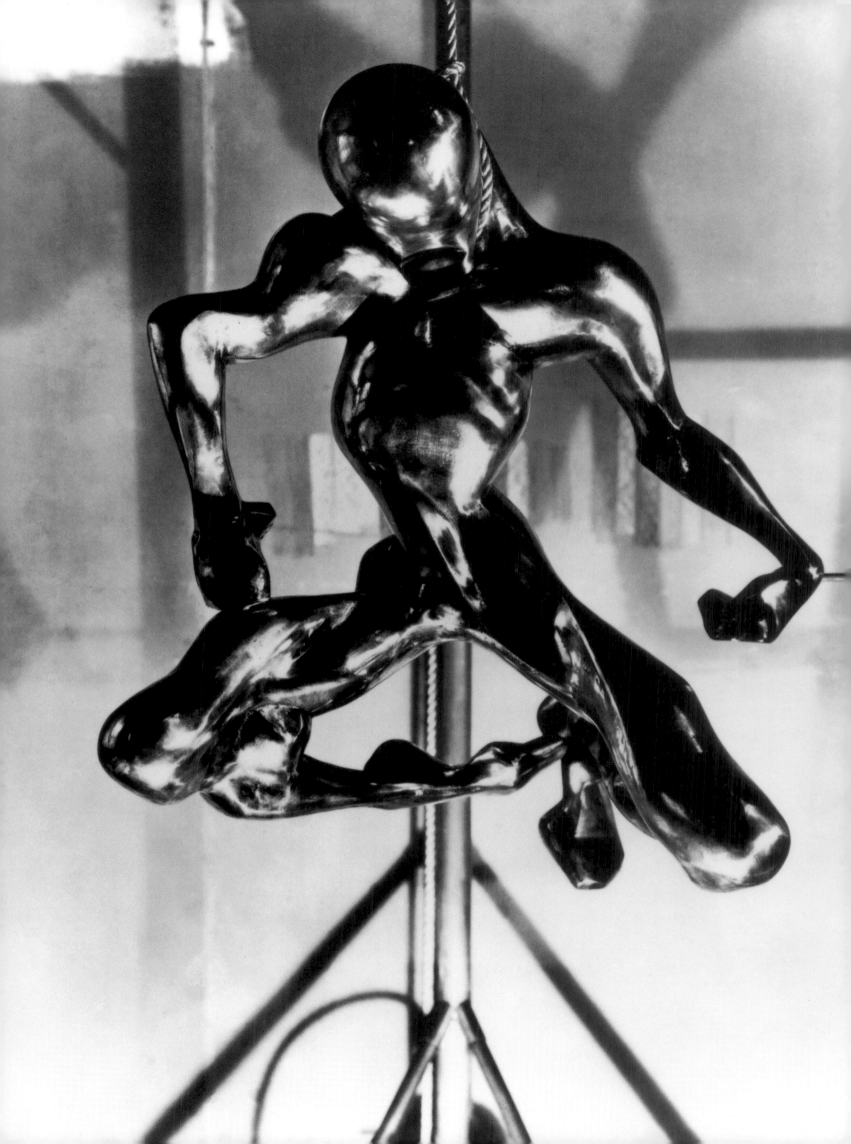

Death (Lynched Figure), 1934.
Monel metal with rope; figure
39 x 29 5/8 x 21 in. (99 x 75.2 x 53 cm)
with artist's original metal
mount, dimensions unrecorded.
The Noguchi Museum, New York.
Photo by Berenice Abbott,
courtesy Estate of Berenice Abbott.

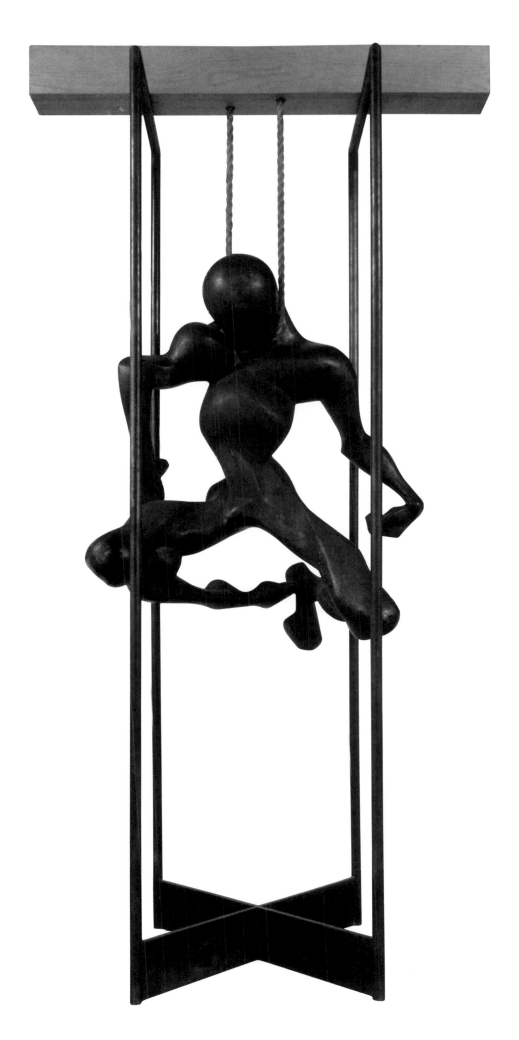

RIGHT
Death (Lynched Figure), 1934.
Monel metal with rope; figure 39 x
29 5/8 x 21 in. (99 x 75.2 x 53 cm)
with artist's later wood and painted
steel mount, H. 89 in. (226 cm).
The Noguchi Museum, New York.
Photo by Shigeo Anzai.

Death (*Lynched Figure*) of mid-1934 presented the antithesis of optimism. Conscious of his own status as only part-Caucasian, in this work Noguchi savagely criticized the violent acts of American white supremacists. At the time photographs of lynched black men were occasionally printed in magazines, including one that Noguchi likely saw in *International Labor Defense* in 1930. Such appalling images prompted Noguchi's friend, the painter Philip Guston, to sketch *The Conspirators*, in which Ku Klux Klan figures were the focus while the hanged man was placed discreetly in the background. For his sculpture Noguchi chose to emphasize the victim rather than the perpetrators. The sculpted victim has a tremendously confrontational physical presence. Instead of a limp corpse, it is contorted in a grotesquely exaggerated death spasm, forcing viewers to acknowledge the gruesome evil of lynching. Originally the "body" was hung by a real rope suspended from a narrow vertical support so that it dangled within the viewers' actual space. Noguchi cast the figure in Monel Metal, a nickel-copper alloy with a gleaming silvery appearance that had been invented 15 years earlier. [28] (Over the years the metal has oxidized to a darker tone, diminishing the

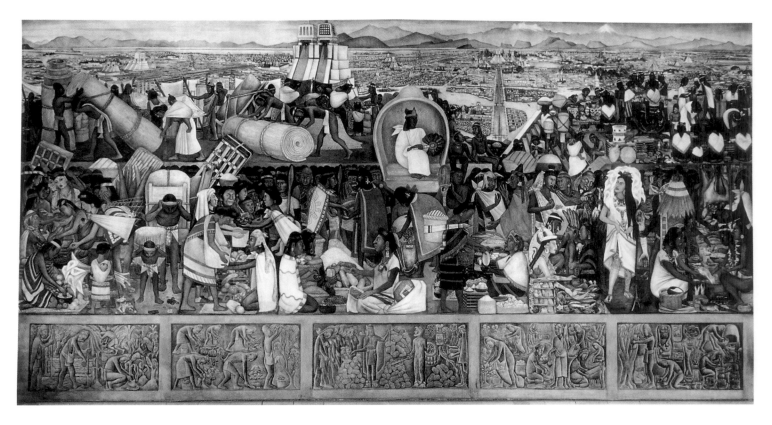

original effect.) One critic wrote: "[I]f there is anything to make a white man feel squirmy about his color, he has it in this gnarled chromium victim juggling under the wind-swayed rope." [29] In Noguchi's visual language the contrast between optimistic material and horrific subject was intentionally ironic. Instead of making a hollow cast, as is usually done for sculptures, Noguchi made the figure of solid metal. Weighing nearly 800 pounds, it strains the rope and offers an effective simulacrum of "dead weight." Museum staff who install the sculpture literally reenact the awkward process of hanging an uncooperative victim. In almost every way, *Death* is the appalling opposite of *Miss Expanding Universe*—deliberately contrasting images of hope and despair. [30]

Denied the opportunity to create art that would "better the frame of life," [31] Noguchi left the United States to join the public art program in Mexico in 1935. Initiated by a revolutionary minister of education in 1921, Mexico's ambitious public art program was intended to educate the illiterate about their little-known Precolumbian past and to foster support

for a democratic socialist future. In many public buildings painters were covering acres of walls with exhortatory, politically reformist images. Diego Rivera's densely complex compositions attained international fame and were emulated by younger Mexican artists. Noguchi had previously met Rivera and José Clemente Orozco in New York in 1931–32 and was welcomed by them in Mexico City. Noguchi was assigned the interior of a former convent in Mexico City that had become a market frequented by the poor. The work he created, *History of Mexico*, extends 72 feet on four walls. Noguchi carved the upper half of the massively thick brick walls, which he then covered with colored cement—an ordinary, inexpensive material suited to a poverty-ridden country. Although virtually unknown today, it was the first public sculpture Noguchi ever realized. In keeping with the pictorial standards established by Rivera, the sculptor deftly fitted together revolutionary Marxist motifs with popular and folkloric references. Part of one wall is dominated by a raised fist (symbolizing the power of the proletariat), set against towering smokestacks and construction cranes (representing the industrially based wealth of capitalists). In

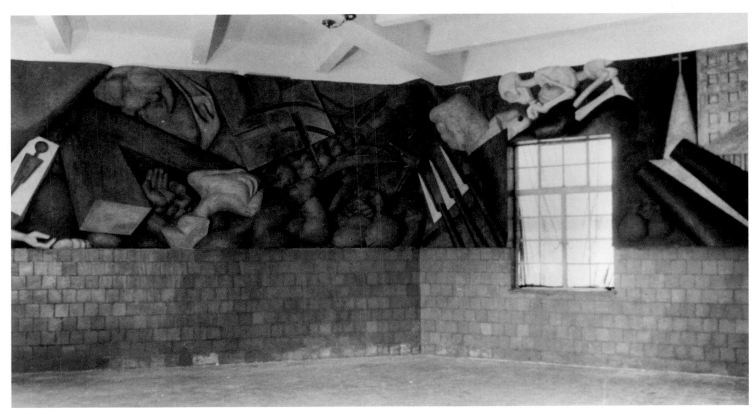

one corner a skeleton hovers near a row of bayoneted rifles (symbolizing the military might of capitalist oppression). On an adjoining wall peasants wield scythes as weapons; the dense, turbulent forms of fallen bodies and raised weapons convey the violent upheaval of class warfare. The imagery in *History of Mexico* alludes not only to Mexico's hard-won revolution but probably also to the civil war in Spain that began in 1936. The political passion and forcefully distorted figures in this dramatic relief anticipate Pablo Picasso's *Guernica* painted a year later. The compositional coherence of Noguchi's relief is so strong that in photographs it looks like a painting. In reality, however, the deep carving and three-dimensional rhythm of the forms convey an exuberant physical power. Their vitality expresses the artist's revolutionary fervor, perhaps enhanced by his concurrent passion for the painter Frida Kahlo. Although Noguchi later downplayed his leftist political beliefs, *History of Mexico* immortalized them.

When Noguchi returned to New York in mid-1936, he discovered that Surrealist art was gaining prominence. Originating in Paris in the mid-

Partial view of *History of Mexico*, 1935–36. Colored cement over carved brick; 6 x 72 ft. (1.8 x 21.9 m). Abelardo Rodriguez Market, Mexico City.
Photo by Isamu Noguchi, courtesy The Noguchi Museum.

1920s, Surrealism rejected the utopian rationalism of geometric abstraction in favor of subjective, inwardly focused art. The group's manifesto proclaimed their goal as achieving, through art, a heightened awareness or state of mind, which they termed "the marvelous." Surrealist artists explored their own psyches—deeply personal dreams, memories, emotions, and desires. Accepting Sigmund Freud's theories about the power of the subconscious mind and Carl Jung's concepts of primal archetypes and the collective unconscious, Surrealists created artworks intended to liberate themselves and viewers from the limitations of mundane reality. They portrayed imaginative realms, irrational narratives, and bizarre imagery. Self-exploration, including previously taboo topics of sexuality, was the norm. Like a Rorschach test, a Surrealist painting or sculpture could mean many things. The Surrealists used free association in the creation of their works and expected viewers to let their own imaginations run free as they contemplated the art.

The style most associated with Surrealist art was biomorphism. In 1916 the painter and sculptor Jean Arp had devised organically shaped forms inspired by sources in nature such as clouds, water, rocks, amoeba,

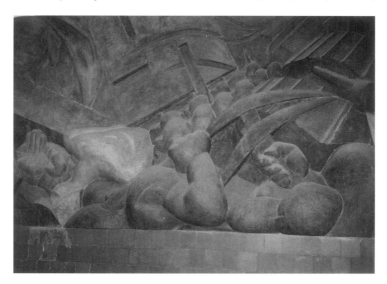

Details of *History of Mexico*, 1935–36. Abelardo Rodriguez Market, Mexico City.
Photos by Isamu Noguchi, courtesy The Noguchi Museum.

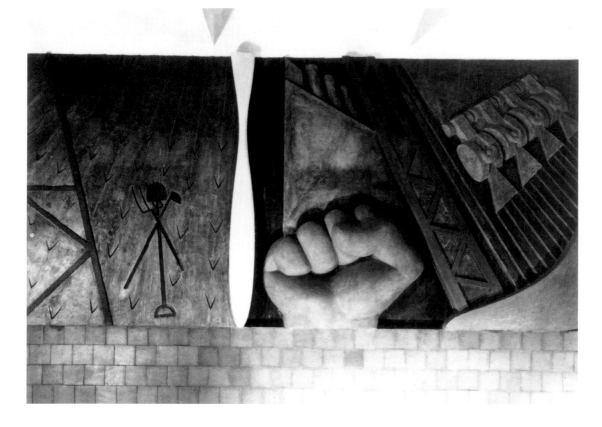

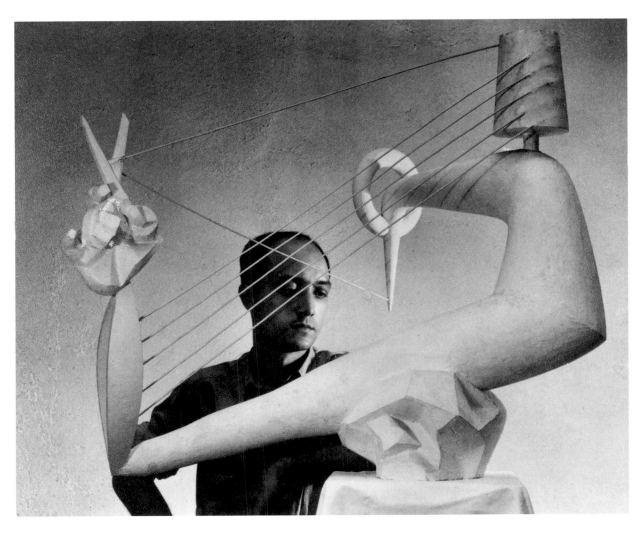

Noguchi with "Model for 'United Hosiery Workers' Memorial,'" 1933–34. Plaster; dimensions unrecorded. No longer extant.
Photo courtesy The Noguchi Museum.

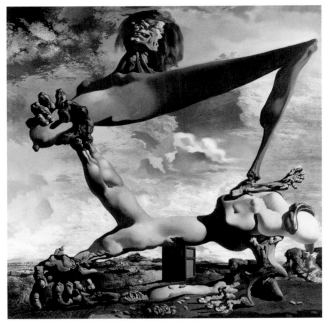

Salvador Dalí. *Soft Construction with Boiled Beans*, 1936. Oil on canvas; 39 3/8 x 39 3/8 in. (100 x 100 cm). Philadelphia Museum of Art, The Louise and Walter Arensberg Collection.

plants, animals, and so on. His compositions emphasized imagination, growth, and change by merging life-forms and objects in bizarre ways intended to intrigue and challenge audiences: *Man-Bird*, *Nose and Armchair*, *Flower-Mirror*, *Head with Annoying Objects*. Soon other artists adapted this style to their own needs. Yves Tanguy and Salvador Dalí depicted squirmy organic forms in vast landscape settings, while Joan Miró painted humorous, fantastic creatures. By the mid-1930s exhibitions of Surrealist art were being presented in cities around the world. Julien Levy's gallery in New York specialized in Surrealism, starting with an exhibition of Calder's sculptures in 1932, followed by a show of Dalí's paintings. Noguchi probably first saw Arp's works in 1934 at the John Becker Gallery (where Noguchi had earlier shown some of his own works). That same year Levy's gallery exhibited Alberto Giacometti's radically innovative sculptures.

On the whole, Noguchi was not initially impressed with the self-oriented ideas of Surrealism. Nonetheless, echoes of biomorphic forms appear in his *Model for the "United Hosiery Workers' Memorial"* from 1933–34, which was intended as a monument honoring union activist Carl Mackley. The plaster model seems to merge the muscular figurative style of American Social Realism with the hallucinatory inventiveness of European Surrealism. This bizarre composition consists of a partial rendering of a sewing machine

(needle, spool, and thread) morphing into a human arm and hand in the act of cutting the thread with scissors. While championing the nobility of factory labor, the overall image epitomizes the Surrealists' emphasis on metamorphosis and seems to lampoon one of their favorite definitions of a Surrealist experience ("the chance meeting of a sewing machine and an umbrella on an operating table").[32] Noguchi's composition has affinities with some of Dalí's paintings such as *Soft Construction with Boiled Beans* from 1936. Though some of Noguchi's ideas of the mid-1930s are congruent with Surrealism, they still cling to a socially responsible purpose: "Let us...[d]raw on the form content so plentiful in science, micro-and macrocosmic; life from dream-states to the aspirations, problems, sufferings and work of the people."[33] In purely visual terms, biomorphism was not far removed from the abstract curved forms of Noguchi's earlier *Abstraction (Leda)* and *Red Seed*.

New York in 1936 hosted many exhibitions of Surrealist art. Levy showed paintings and drawings by Ernst and Tanguy, while Calder's sculptures attracted fans at the new Pierre Matisse Gallery. The movement's acceptance became official with the *Fantastic Art, Dada, Surrealism* exhibition at The Museum of Modern Art, which included Miró's *Personage Throwing a Stone at a Bird*, Picasso's *Metamorphosis (Bather)*, Tanguy's *Extinction of Unnecessary Lights* and *Heredity of Acquired Characteristics*. Arp was represented by 15 painted wood reliefs and several freestanding *Human Concretion* sculptures.[34]

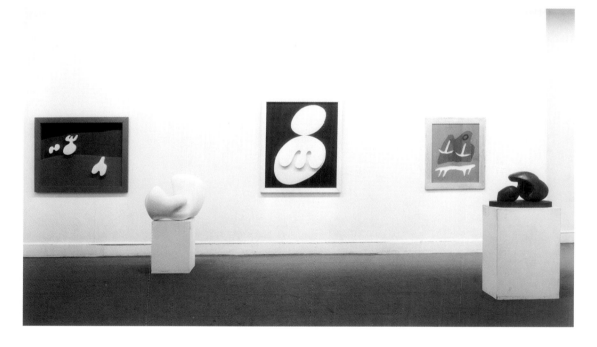

Installation of sculptures by Jean Arp in the exhibition "Fantastic Art, Dada, Surrealism" at The Museum of Modern Art, New York, December 7, 1936–January 17, 1937.
Digital image © 2003 The Museum of Modern Art, New York.

In contrast to the playfulness of Arp's style, Giacometti's sculptures introduced disturbing psychological and sexual innuendoes. The Swiss sculptor devised his Surrealist works as metaphors for his memories, fantasies, and nightmares. Several compositions from 1929 ambiguously express his obsession with sexual desire, violence, pain, and death. The abstract linear forms of *Three Figures Outdoors*, 1929, suggest a scene of aggression seen through a window: the central zigzag figure seems to squirm as it is grasped or penetrated by two long pointed forms. In *Reclining Woman Who Dreams* (see page 215) he used phallic forms for the bedposts, while two undulating planes suggest a pleasantly erotic reverie. Semiabstract portrayals of attraction/repulsion and male aggression/female passivity—degenerating sometimes to perversion and sadism—characterized many works by other Surrealists, notably Dalí (who liked to shock audiences with titles such as *The Great Masturbator*). This

blatant and puerile aspect of Surrealism may account in part for Noguchi's disdain for the movement during the 1930s; he would revisit Surrealism as relevant to his own life and art in the mid-1940s.

One of the unprecedented approaches that Giacometti introduced in sculpture was the metaphorical or imaginary landscape. In *Head-Landscape* he merged a profile face with the mountainous landscape of his country, Switzerland. *No More Play* (see page 78) consists of a slab of white marble carved into a lunarlike landscape of craters in which two tiny wood figures stand, one with arms raised as if in supplication. In the center two covered graves contain serpentine forms. At first glance the sculpture resembles a game with movable pieces, though on further examination it seems more like a battlefield or cemetery; the ominous title hints that the fun and games of life end permanently in death. Although Noguchi probably saw the exhibition of Giacometti's Surrealist sculptures at the Julien Levy Gallery in 1934, the works exerted no immediately discernible influence on him. The format of sculpture as conceptual or metaphoric land-scape would, however, inspire him a decade later. Noguchi certainly knew *No More Play*, as it remained for many years in Levy's personal collection in New York.

In the late 1930s Noguchi continued to earn income by sculpting portraits and by making his first commercial designs for mass production, notably the baby intercom known as *Radio Nurse*, and models for playground equipment. He also created his first two stage sets for the Martha Graham dance company. To accommodate her dramatic choreography he

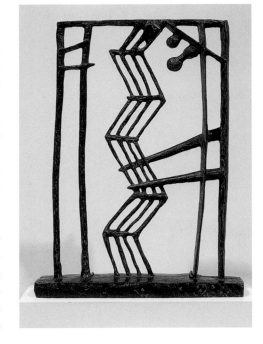

Alberto Giacometti. *Three Figures Outdoors*, 1929. Bronze; 21 ¹/₂ x 15 ¹/₈ x 3 ½ in. (54.6 x 38.3 x 8.8 cm). Art Gallery of Ontario, Toronto.
Photo by Valerie J. Fletcher.

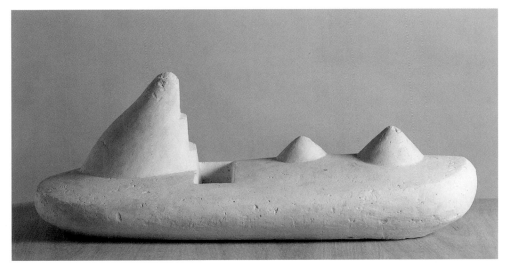

Alberto Giacometti. *Head-Landscape (Sleeping Figure)*, 1932. Plaster; L. 27 in. (68.6 cm). Musée National d'Art Moderne, Centre Georges Pompidou, Paris.
Photo by Philippe Migeat, courtesy Art Resources, New York.

designed very open spaces with few props; this experience prompted him to consider the power of space itself.

Soon Noguchi became involved with planning for the avowedly utopian World's Fair planned for New York in 1939.[35] The fair's theme was "the world of tomorrow" and its goal was to offer hope to millions of visitors as the Great Depression dragged on and the violence of Fascism in Europe expanded. The fair's centerpiece consisted of two dramatically abstract white structures: the Trylon pointing upward to the cosmos and the Perisphere housing a model of an idealized future city. Around that symbolic center were corporate showcases for American technology and commerce where visitors could see demonstrations of toasters, radios, ovens, refrigerators, washing machines, and even prototypes for television and a robot. The General Motors Building displayed detailed plans for America's future system of interstate highways. Noguchi submitted three proposals, includ-

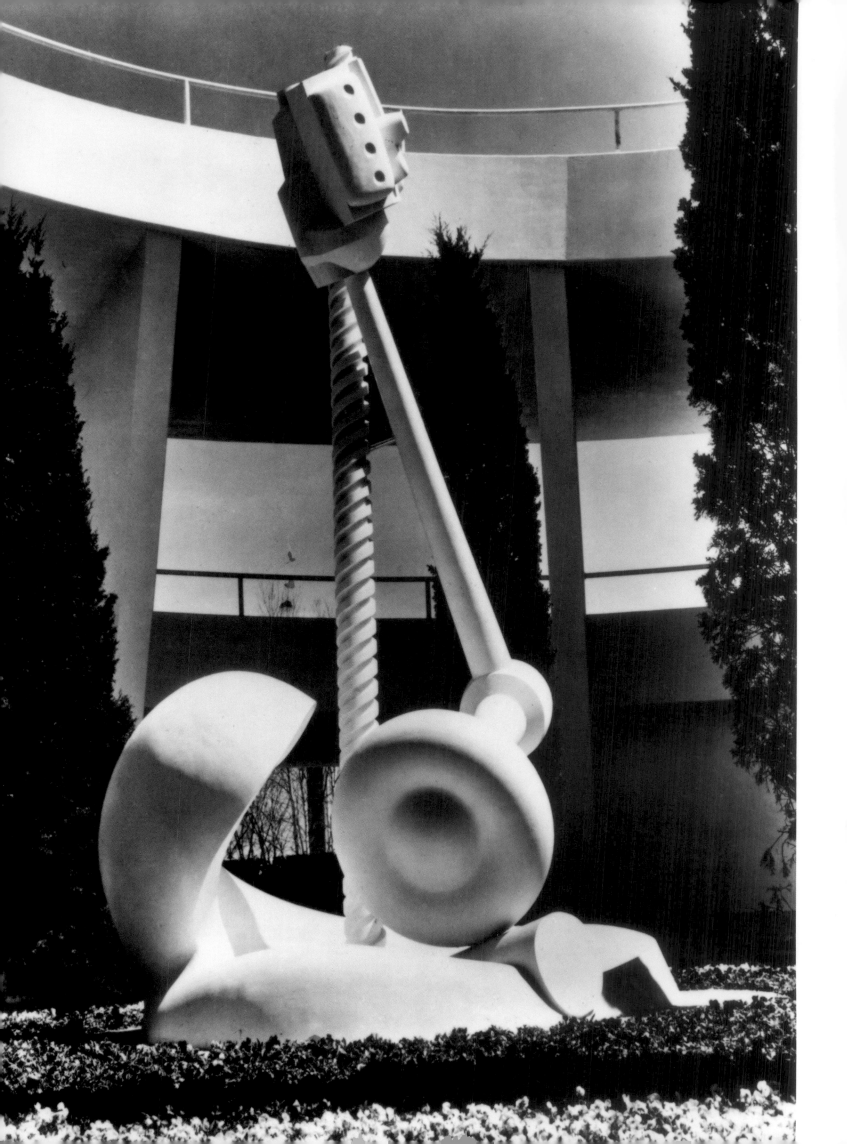

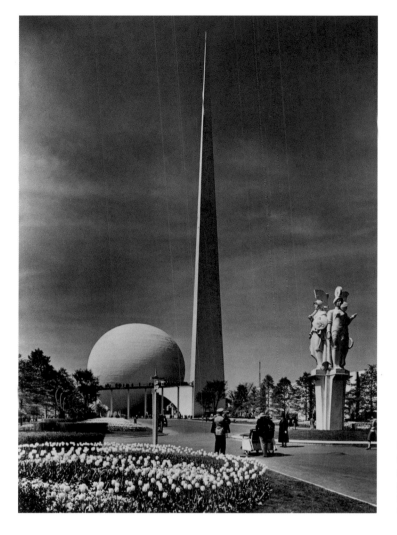

Wallace Harrison and J. André
Foulihoux (architects). *Theme
Center: Trylon and Perisphere at the
New York World's Fair,* 1939.
Photo courtesy the Museum of the City
of New York.

ing a relief symbolizing medical sciences and a pavilion based on Fuller's
Constructivist principles. Only his proposal for the *Chassis Fountain* for
Ford Motors was accepted. Standing 18 feet tall, this composition features
the wheel of a car supporting an axle and driveshaft; the wheel rests in its
fender with splashing water—a far cry from the muscular heroes and maid-
ens of most sculptures at the World's Fair. Although steel would have been
the most appropriate material for glorifying automobiles, it was too expen-
sive and permanent for an artwork that would exist for only a few months.
Instead Noguchi had the sculpture constructed of a new cement-like mate-
rial, magnesite, which could be cast in a mold and was heat-
resistant.[36] Intended for ceilings, flooring, and oven linings,
magnesite fulfilled Noguchi's goal of using new materials
in art: "We must become familiar with the modern ways of
handling plastic and crystalline matters (the spray-gun, pneu-
matic hammer, etc).... The scientific method is necessarily the
cheap method.... Why not paper or rubber sculpture?"[37]

*Ford Motors Building at the World's
Fair, New York,* 1939.
Photo © Underwood and Underwood/Corbis.

Noguchi completed only one other large public sculpture
before World War II: a relief for one of the buildings in the
ambitious new Rockefeller Center. This complex of skyscrap-
ers in mid-Manhattan, designed and built in the depths of
the Depression, was intended to declare the worldwide
importance of America's financial system. Rockefeller
Center included site-specific commissions by various artists
including a mural by Rivera (who was dismissed after he
included a Communist hero in his mural) and a sculpture by
Paul Manship (the gilded *Prometheus* in the sunken central
courtyard). Noguchi proposed *News* for an area measuring 27
by 20 feet above the entrance to the Associated Press offices.

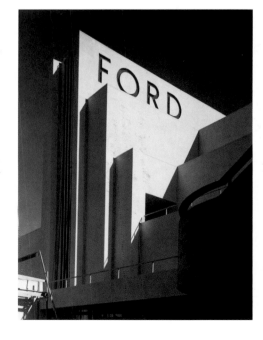

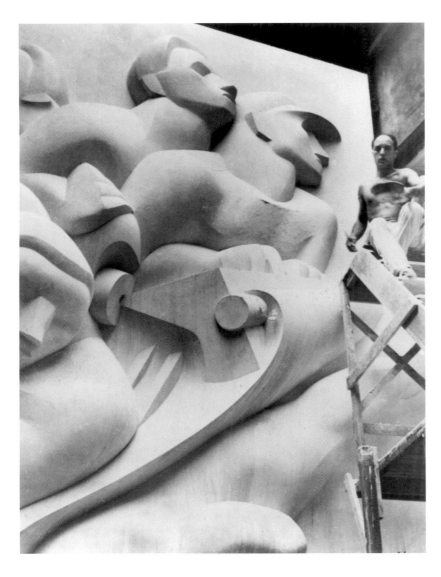

Noguchi working on the plaster original of "News," 1938–39. Plaster; 20 x 17 ft. (6.1 x 5.2 m). No longer extant.
Photo courtesy The Noguchi Museum.

As in *History of Mexico*, Noguchi devised a tightly woven composition of heroic workers. Represented only by their heads and arms, a reporter intently listens to a telephone, a typesetter and press operator look meaningfully out at unseen horizons, and a photographer peers through a camera. Receiving the commission in November 1938, Noguchi single-handedly sculpted the huge work in plaster, but resisted the mandate to cast it in bronze. Not only did he dislike bronze as too traditional and academic, it was also very expensive. Instead he obtained permission to cast *News* in stainless steel. At the General Alloys industrial foundry in Boston, Noguchi spent more than a year in 1939–40 repairing flaws and polishing the surface. When finished, *News* was the largest sculpture ever made in stainless steel. Whether the Rockefeller Center authorities realized it or not, Noguchi's choice of material expressed their faith in a better future.

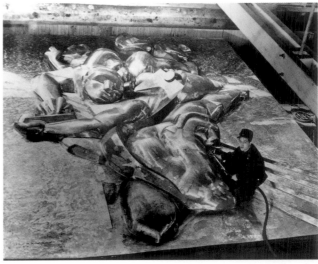

Noguchi polishing the stainless-steel cast of "News," 1939–40. Stainless steel; 20 x 17 ft. (6.1 x 5.2 m). Associated Press Building, Rockefeller Center, New York.
Photo courtesy The Noguchi Museum.

OPPOSITE
MacDougal Alley studio with "Bucky," "Tortured Earth," and Driftwood Sculptures, c. 1945.
Photo by André Kertész, courtesy The Noguchi Museum.

World Crisis: Withdrawal into Self

The social optimism expressed in Noguchi's sculptures for the World's Fair and Rockefeller Center ran counter to reality. The escalating war in Europe could no longer be ignored after the Nazis' rapid conquest of Denmark, Norway, the Netherlands, Belgium, and France by mid-1940. The exodus of artists from Europe brought many Surrealists to the United States, especially to New York. Matta and Tanguy arrived in June 1939; Ernst, André Breton, and others followed. Americans soon gained a greater depth and understanding of Surrealism as numerous exhibitions of Surrealist art were organized in 1940–41. The Pierre Matisse Gallery began presenting annual exhibitions of Calder's biomorphic constructions, and The Museum of Modern Art had shows featuring the works of Miró and then Dalí. [38] Drawings and paintings with titles such as *Psychological Morphology* by Chilean-born Roberto Matta exhibited at the Julien Levy Gallery in April–May 1940 excited much interest. He called his compositions "inscapes"—semi-abstract landscapes expressing the artist's state

Roberto Matta. *Endless Nudes*, 1940. Oil on canvas; 28 1/2 x 36 1/4 in. (72.3 x 92 cm). **Private collection.**
Photo by Lee Stalsworth.

of mind. That idea was not original or unique to Matta, but his fluency in English and his compelling personality attracted many artists to his studio. William Baziotes began to make "Surrealist pictures—straight from the unconscious." [39] Automatist methods and Jungian psychoanalysis were transforming Jackson Pollock's art from symbolic compositions to instinctive motions with paint. Noguchi's friend Arshile Gorky had begun using Surrealist biomorphic forms in the mid-1930s, especially in the series entitled *Nighttime, Enigma, and Nostalgia*—one of which he gave to Noguchi. Gorky persuaded Noguchi to try automatism in several drawings made in Gorky's studio (in the manner of the *Exquisite Corpse* group drawings pioneered previously by Breton). Automatist drawing did not engage Noguchi's interest, though he tried its sculptural equivalent: found objects.

After a visit to Hawaii in 1939, Noguchi began to experiment with driftwood, which appealed to him as a double product of nature. Its evocative shapes could suggest a figure with flailing arms or a fantastic creature. It may also have had metaphoric appeal: it was essentially flotsam pushed around and turned into something by the ocean's currents, having no specific home or control over its direction. *Sculpture with Driftwood* combines organically shaped wood with a Constructivist framework. Noguchi used a similar approach for *Bucky*, 1940–43, which consists of a biomorphic wood element suspended within a linear polyhedron (visible in the photograph on page 65). In his visual language these two abstract sculptures have

OPPOSITE
Sculpture with Driftwood, 1940–41. Wood, painted wood, and metal rods; 56 x 12 x 12 1/2 in. (142.2 x 30.4 x 31.7 cm). **Mr. and Mrs. Charles Diker, New York.**
Photo by Ellen Page Wilson, courtesy PaceWildenstein.

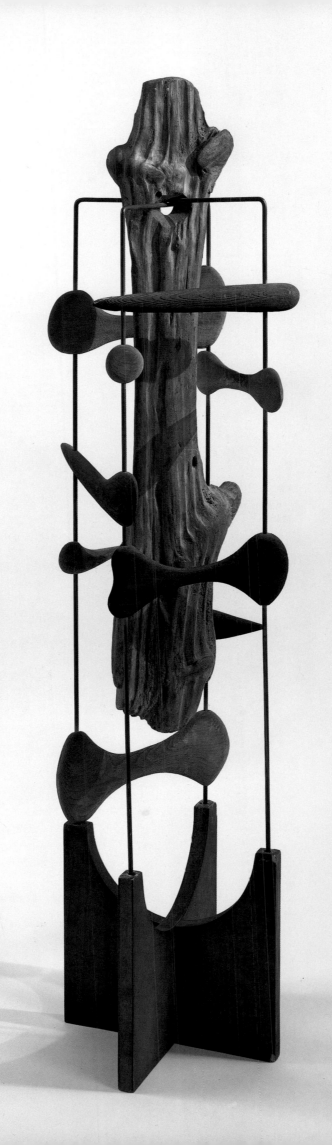

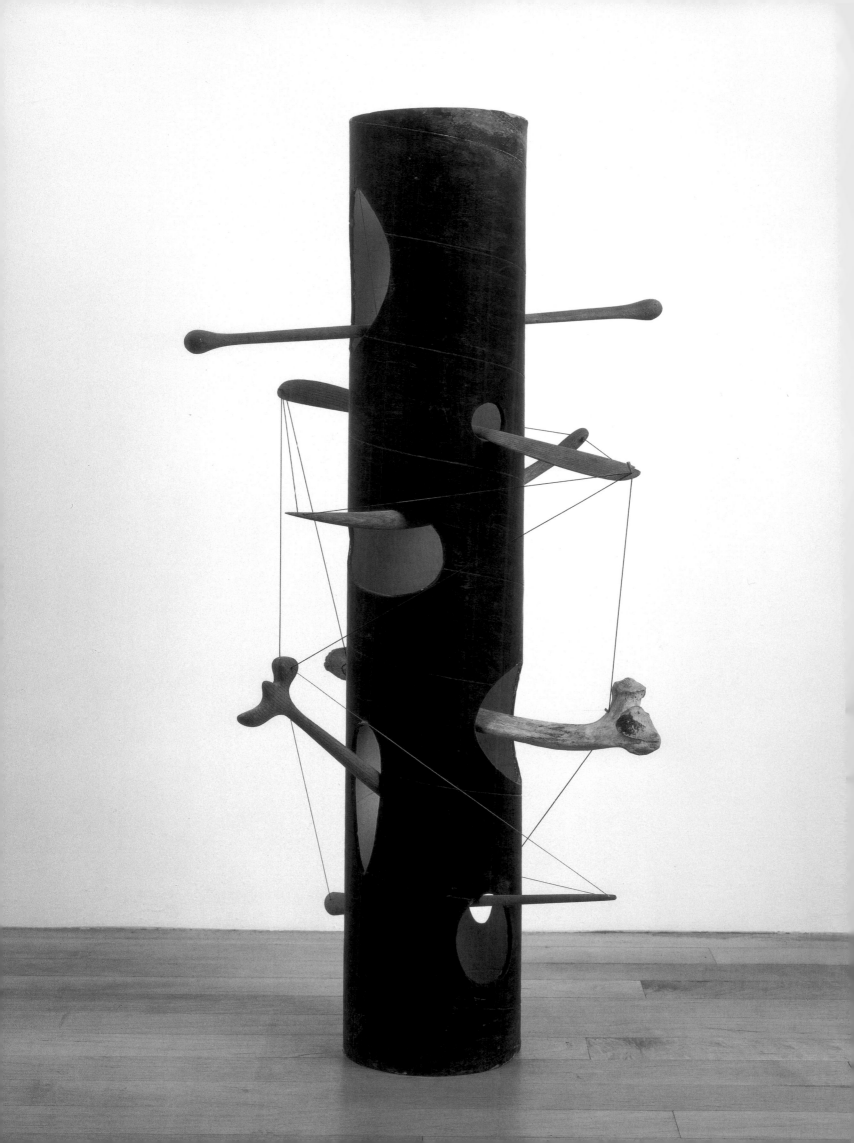

meaning; they indicate that the organic forces of nature coexist with or are bettered by the rational human intellect as manifest in architecture and engineering. In *Bucky* and *Sculpture with Driftwood* Noguchi aimed at the integration of opposites; at this point in his career the components are stylistically and spatially distinct, but in later years the synthesis would be more subtle.

In September 1941 Noguchi drove to California with Gorky, whose works were being shown there at the Museum of Modern Art of San Francisco (where Noguchi hoped to have his own exhibition soon thereafter). En route they talked endlessly about art. In one discussion Noguchi insisted that natural forms like clouds are perceived simply as clouds, while Gorky advocated the power of subconscious free association, saying that clouds are best used as a means of "seeing" other things. Noguchi might have maintained his point of view if his life had not undergone an unexpected and frightening change.

USS Shaw explodes at Pearl Harbor, Hawaii, December 7, 1941.
Photo © Corbis.

When the Japanese attacked Pearl Harbor on December 7, 1941, Noguchi had the misfortune to still be in California. The West Coast was declared a military zone and there was rising fear of invasion and anti-Japanese sentiment. Instead of fleeing back to New York, Noguchi spoke out in defense of the loyalty and civil rights of the *Nisei* (American citizens of Japanese ancestry). With disturbing speed new federal laws began to force thousands of *Nisei* into internment camps situated in the desert regions of the Southwest. Concerned that he might face internment despite his exemption status as a resident of the East Coast, Noguchi flew to Washington DC on March 27 to advocate for internees. There he was persuaded that his design expertise could improve the internees' living conditions.

In May 1942 he voluntarily entered the relocation center in Poston, Arizona. While there he carved a few sculptures, including a relief called *Fighting for Freedom*. To relieve the unrelenting grid of the temporary housing at Poston, Noguchi created a plan for irrigated parks for recreation,

OPPOSITE
Monument to Heroes, 1943.
Cardboard, paint, wood, bone, and string; 28 1/4 x 15 1/2 x 14 in. (71.7 x 39.3 x 35.5 cm).
The Noguchi Museum, New York.
Photo by Kevin Noble.

echoing his *Model for "Contoured Playground"* from mid-1941. Discouraged by the authorities' refusal to consider his proposals, the artist left Poston to return to New York in September 1942—one full year after he had departed that city with Gorky in high spirits.

Although he later tended to downplay the emotional and psychological impact of those months in California and Arizona, Noguchi was profoundly shaken to find that his mixed parentage could cause many of his fellow citizens to consider him an enemy alien. The experience of racism and internment left him bitterly disillusioned and depressed. Settling into a studio at 33 MacDougal Alley in Greenwich Village, Noguchi immersed himself in work. Anxious about events in the outside world, he now appreciated Breton's statement: "Living and ceasing to live are imaginary solutions. Existence is elsewhere."[40] He adopted the Surrealist agenda of exploring one's own psyche and using art to express hidden emotions and subjective perceptions. The concept of metamorphosis became

personally meaningful: the morphing of one entity into another emphasizes the process of change and highlights the possibility of reconciling dissonant or antithetical elements. In many literary, religious, and mythological sources—as well as in nature—metamorphosis often signals transformation in a hopeful way: larvae emerge as butterflies, carbon compresses into diamonds, a frog changes into a prince, a dead man rises from the grave, a shaft of light becomes an angel. Such miraculous changes serve as reminders of human potential for mental and spiritual transcendence. Noguchi's desire to change his thoughts, perceptions, art, and even identity may be likened to the goal of enlightenment in metaphysical philosophies

ABOVE
Housing for evacuees of Japanese ancestry at the War Relocation Authority internment center at Poston, Arizona, as seen from the water tower, 1942.
Photo courtesy the National Archives, Washington DC.

RIGHT
Noguchi with plaster original of "Contoured Playground (Proposal for Central Park, New York)," 1941.
Photo courtesy The Noguchi Museum.

and religions. Metamorphosis of sculptural forms became a lynchpin in Noguchi's struggle to express aspects of himself and to find a new direction after the collapse of his utopian beliefs.

During Noguchi's yearlong absence from New York, many new Surrealist works were exhibited and discussed. *View* magazine devoted an issue to the subject in November 1941 and published individual issues on Ernst and Tanguy in April and May 1942, shortly after the *Artists in Exile* show at the Pierre Matisse Gallery. In October–November 1942 the *First Papers of Surrealism* exhibition featured works by Arp, Baziotes, Calder, Ernst, Giacometti, Lam, Matta, Miró, André Masson, and Tanguy. Noguchi soon learned about the Surrealist art that had emerged during his absence, and he looked with fresh eyes at works by artists he had previously dismissed. Among them, Noguchi had the most direct and frequent contact with Gorky. As before, the sculptor often visited the painter's studio, where he could observe from start to finish how Gorky devised his biomorphic compositions. Gorky's nostalgic and painful memories of his native Armenia had inspired his art for many years, and he encouraged Noguchi to explore and express his own emotions and states of mind—a practice the sculptor had previously shunned, but now adopted. In rural Virginia during the summer of 1943, Gorky made abstract biomorphic drawings from nature, culminating in his 1944 masterpiece painting *The Liver Is the Cock's Comb.* Invigorated and enthused by this experience, Gorky prompted Noguchi to experiment with biomorphic forms for their evocative possibilities.

Several sculptures from late 1942 through 1944 expressed Noguchi's despondency after his internment. "The war weighed heavily on my mind after my escape from that reality to the safety and remoteness of New York." Like Hans Bellmer's grotesque *Doll* sculptures, Noguchi created an untitled plastic work suggestive of a violently upended and dismembered

Detail of *Plan for Park and Recreation Area at Internment Camp, Poston,* 1942. Ink and pencil on paper; 7 x 36 in. (17.8 x 91.4 cm). The Noguchi Museum, New York.
Photo by Kevin Noble.

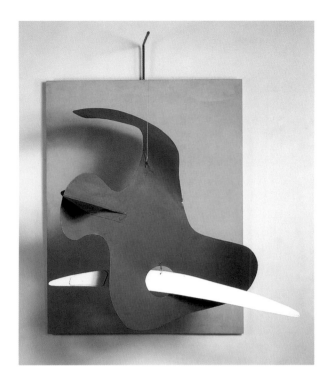

Alexander Calder. *Form on Yellow Ground*, 1936. Hydrocal plaster, painted wood, rod and wire; 48 x 32 x 30 ¹/₂ in. (121.9 x 81.2 x 77.4 cm). **Hirshhorn Museum and Sculpture Garden, Smithsonian Institution, Washington DC; gift of Joseph H. Hirshhorn.**
Photo by Lee Stalsworth.

body (see page 83). Made of molded and colored plastic, the abstract forms in themselves seem innocuous but are readily understood as anatomical: a breast, a leg, a penis, a torso bent painfully backward with mouth agape.

In his *Monument to Heroes* (see page 68), Noguchi offers a bitterly ironic mimicry of classical commemorative columns, such as the Roman-era Column of Trajan. He took an ordinary cardboard tube, stood it on end, painted it black, and suspended inside several elements: an animal bone discarded by the American Museum of Natural History and several bonelike and bladelike carved wood forms that protrude through openings in the column. As in *Death (Lynched)* a decade earlier, Noguchi wanted *Monument to Heroes* to convey a gruesome shock. Instead of celebrating victory and glorifying fallen heroes, as commemorative columns were supposed to do, Noguchi highlights only the barbarism of war, from the Stone Age (when bones were both weapons and battle trophies) to the modern era (where armaments can burn flesh from bones in an instant). Years later, during the Vietnam War, Noguchi envisioned making a version of *Monument to Heroes* as a public sculpture: "I could see it as a large cylinder on a mountain top with the wind blowing through it and things dangling there like skeletons. It was a dirge for futile heroes who killed themselves—for what?"[41] In the late 1930s Noguchi had easily portrayed revolutionaries and newspapermen as heroes, but by 1943 he could not bring himself to glorify warriors, even those engaged in a worthy cause. In contrast to the immense vitality apparent in *History of Mexico* and *News*, *Monument to Heroes* is devoid of life: "this is what you sacrifice your life for and this is all that remains."

Noguchi looked attentively at Calder's sculptures, which were exhibited in 1943 at the Pierre Matisse Gallery and in a large retrospective at The Museum of Modern Art. Dynamic, colorful, often humorous, and

Arshile Gorky. *Study for "The Liver Is the Cock's Comb,"* c. 1942–43. Crayon and pencil on paper; 20³/₄ x 27³/₄ in. (52.7 x 70.4 cm). **Hirshhorn Museum and Sculpture Garden, Smithsonian Institution, Washington DC; gift of Joseph H. Hirshhorn.**
Photo by Christopher Smith.

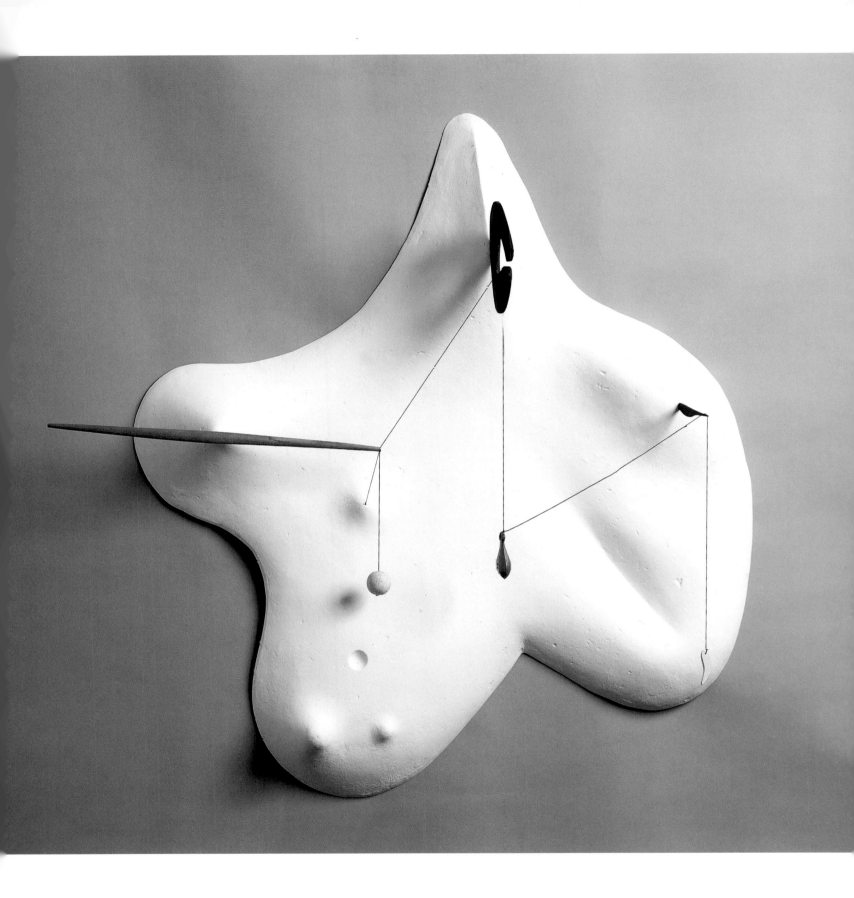

Yellow Landscape, 1943 (partially reconstructed 1995).
Painted bronze, wood, and string;
29 x 27 x 3 ¹/₂ in. (73.7 x 68.6 x 8.9 cm).
The Noguchi Museum, New York.
Photo by Kevin Noble.

Lunar Fist, 1943–44. Magnesite
cement, plastic resin,
and electric light; 8 x 9 x 7 in.
(20.3 x 22.8 x 17.7 cm).
The Noguchi Museum, New York.
Photo by Michio Noguchi,
courtesy The Noguchi Museum.

OPPOSITE
Lunar, 1943. Magnesite cement,
electric light, colored plastic,
wood, string; $4^3/_4$ x $15^5/_8$ x 21 in.
(12 x 39.6 x 53.3 cm).
**Virginia and Herbert Lust,
New York.**
Photo by Patty Wallace,
courtesy The Noguchi Museum.

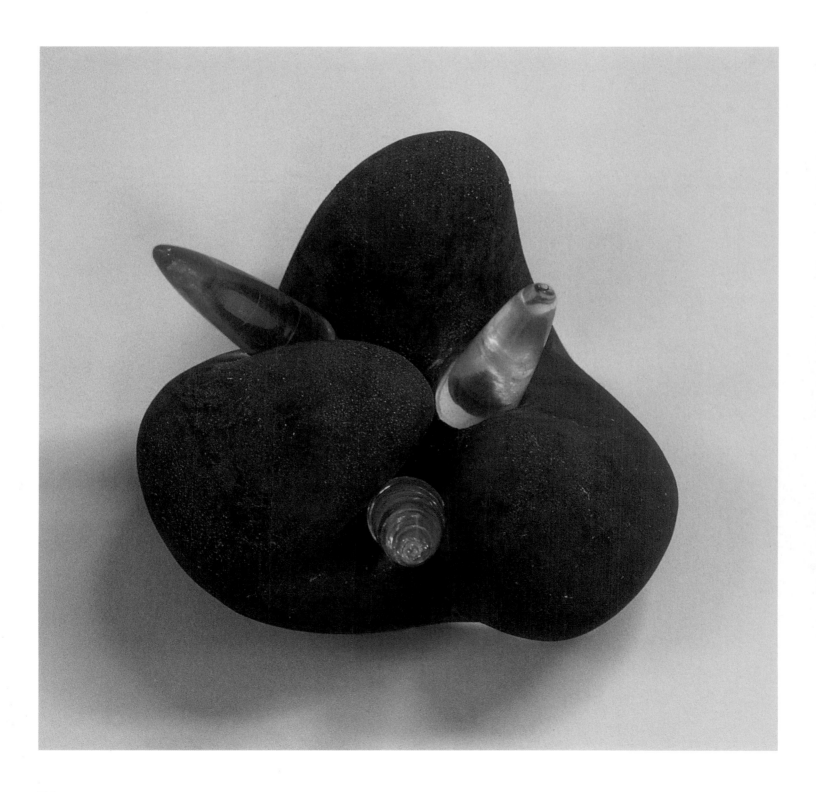

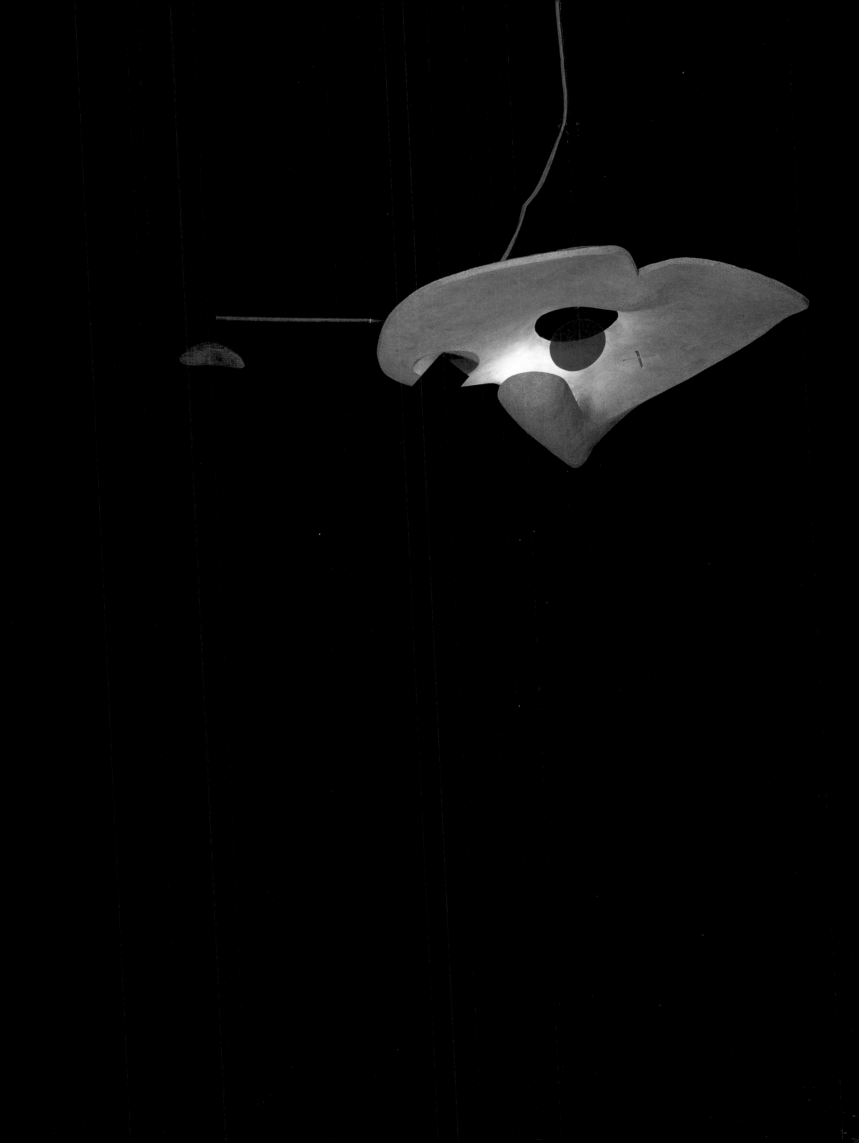

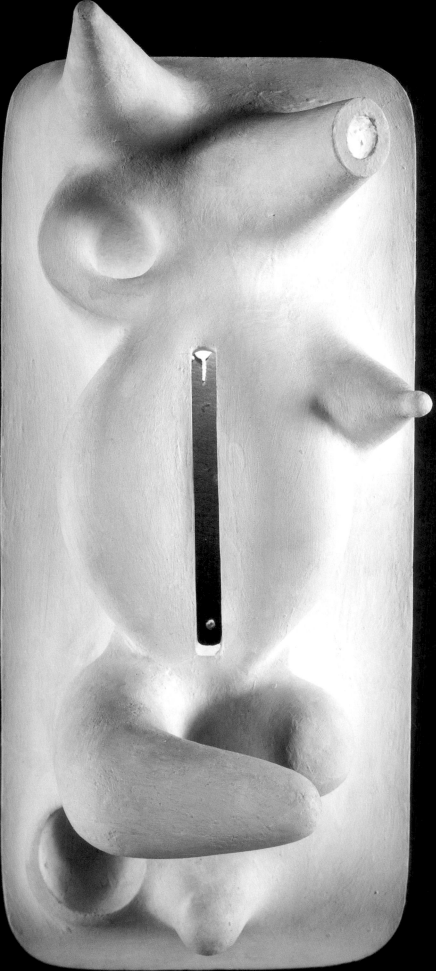

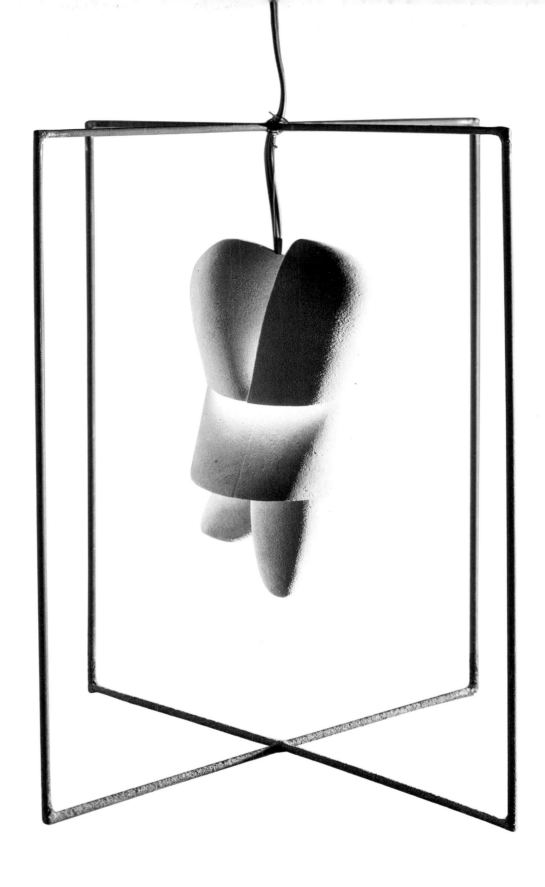

Lunar Infant, 1943–44.
Magnesite cement, electric light with
cord and metal; 22 $^1/_2$ x 16 x 16 in.
(57 x 40.6 x 40.6 cm).
The Noguchi Museum, New York.
Photo by Michio Noguchi.

sometimes subtly ominous, Calder's painted wood and sheet-metal compositions offered welcome relief from the somber realities of World War II. One of Noguchi's first deliberately biomorphic abstractions was *Untitled* from 1943 (visible in the photograph on page 94). The contour of the main form has affinities with Calder's contemporaneous *Fish*, while the placement of a small "amoeba" on top recalls Arp's *Head with Annoying Objects*. Noguchi's delicate wall-mounted *Yellow Landscape* (see page 73), made from plaster, wood, and string in 1943, probably had its origins in Calder's wall-mounted *Constellation* sculptures from that year.

Never interested in merely emulating another artist's style, Noguchi began a series of sculptures that he called *Lunars*. Molding magnesite cement into organic shapes, he created abstract compositions and included electric light as a symbol of hope. One or more lightbulbs are secreted in each *Lunar*, hidden from direct view so that only their luminosity is visible. The title of *Lunar Fist* (see page 74) suggests the artist's anger and desire to strike out. Crystalline plastic shafts emerge from the blood-red *Lunar Fist*. The lightbulb inside causes the shafts to glow red or white, depending on the color of the bulb used; light bursts forth either in fury or in triumph over darkness. In most cultures the dualism of light and dark engenders positive and negative connotations. Darkness signifies the unknown, danger, fear, evil, and death, while light symbolizes knowledge, safety, action, divinity, and life. Noguchi defined his *Lunars* as sculptures of imaginary domains that had "more to do with interstellar space than with [lamps]."[42] The series was short-lived, as no gallery would exhibit them.

Lunar Infant (see page 77) offers ambiguous interpretations. The biomorphic magnesite baby is suspended inside a metal frame, and the whole hangs from the ceiling. As in *Bucky*, Noguchi placed one idea inside its antithesis. A newborn symbolizes optimism: new beginnings, renewal, growth, potential of all kinds. The light emanating from within this infant presumably offers a beacon of hope. The cagelike frame, however, may indicate that the baby is imprisoned, alone, and perhaps helpless—feelings that Noguchi himself had recently experienced. *Lunar Infant* embodies his memories of hope during imprisonment. Hanging in his studio, this work acknowledged that life's experiences might not be definable in terms of absolutes.

Lunar and *Lunar Landscape* present fantastic topographies, expanding on the landscape forms of his park design for Poston and his *Model for "Contoured Playground."* The surging cone-shaped forms in *Lunar*, glowing from within, suggest a primordial volcanic domain still in the process of being formed. *Lunar Landscape* reveals Noguchi's familiarity with Giacometti's *No More Play*. Both are mysterious metaphoric landscapes arising from the artists' memories, but the sculptures have different messages. The title and tiny graves of *No More Play* clearly refer to death. The title of *Lunar Landscape* alludes to the moon's distant surface of mountains and valleys and changing effects of light. The cork spheres (fishing floats suspended by fishing line) suggest hovering satellites. Noguchi later explained this work:

> The memory of Arizona was like that of the moon, a moonscape of the mind.... Not given the actual space of freedom, one makes its equivalent—an illusion within the confines of a room or box—where

OPPOSITE
Lunar Landscape, 1943–44. Magnesite cement, electric lights, acetate, cork, and string; 34 1/2 x 24 3/4 x 7 7/8 in. (87.6 x 62.8 x 20 cm). Hirshhorn Museum and Sculpture Garden, Smithsonian Institution, Washington DC; gift of Joseph H. Hirshhorn.
Photo by Lee Stalsworth.

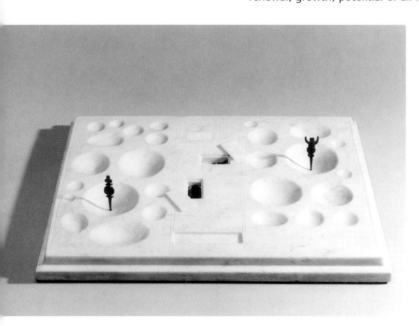

Alberto Giacometti. *No More Play*, 1931–32. White marble with wood and bronze; 1 5/8 x 22 7/8 x 17 3/4 in. (4 x 58 x 45 cm). The Patsy R. and Raymond D. Nasher Collection, Dallas.
Photo by David Heald.

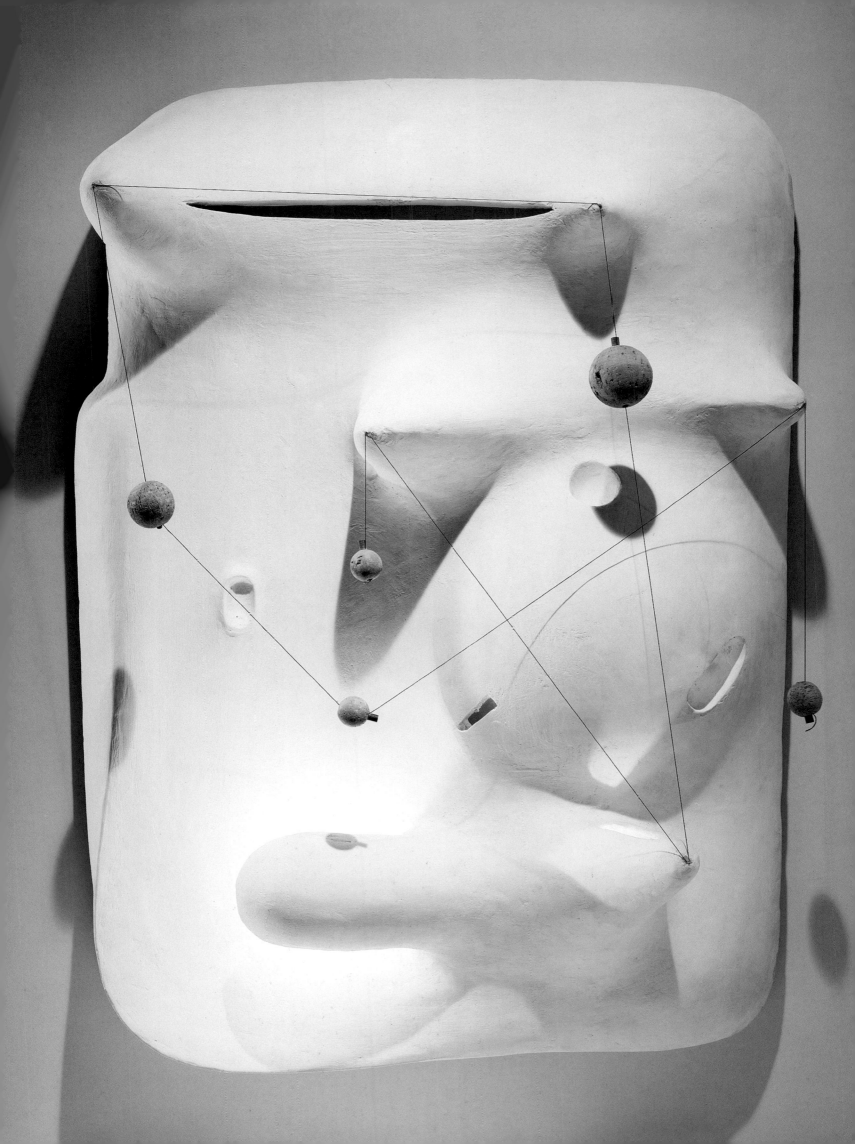

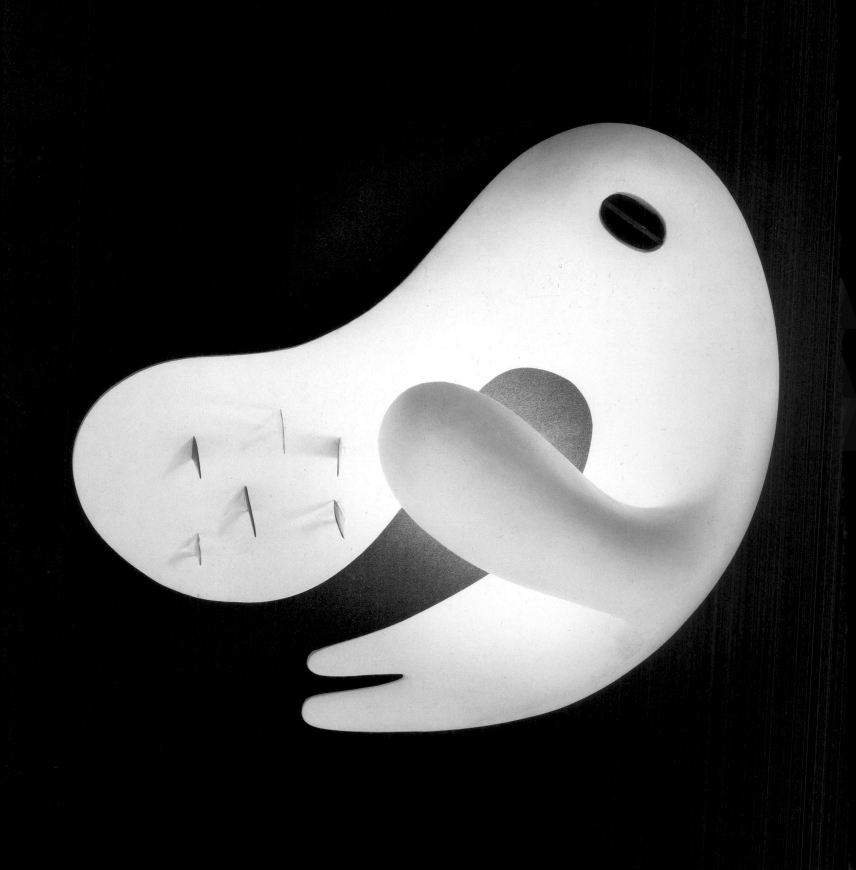

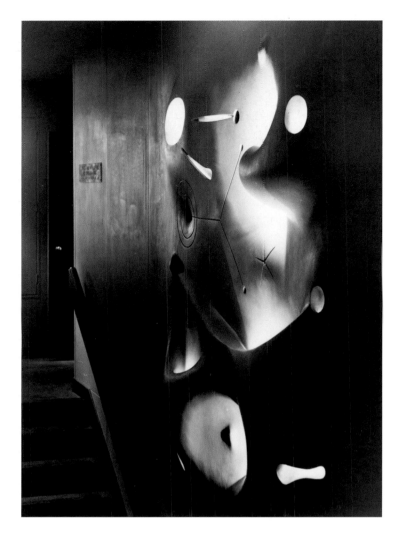

"Lunar Voyage" for SS Argentina,
1947. Magnesite cement and electric
lights; dimensions unrecorded.
No longer extant.
Photo by Rudolph Burckhardt,
courtesy The Noguchi Museum.

the imagination may roam to the further limits of possibilities, to the
moon and beyond.[43]

Noguchi designed *Lunar Landscape* for vertical installation on a wall, where
it asks to be considered intellectually and imaginatively rather than as a
model for a real place.

Lunar Landscape features Noguchi's most varied and complex lighting
scheme up to this point. Placing ordinary white lightbulbs inside the three
main convex forms, the sculptor inserted sheets of colored acetate that
function like the filters in theater spotlights. The similarity was not coinci-
dental: Noguchi was becoming more involved in theater work. In 1944 he
designed four stage sets for Martha Graham's dances, including *Imagined
Wing* and *Herodiade*.[44] At the top of *Lunar Landscape* the horizontal slit
glows magenta, like a burning cleft in the earth or perhaps a reference to
vaginal heat. At the bottom, the bulb in the projecting phallic-shaped ele-
ment casts white light on the ground below. On the right, blue, yellow, and
pink lights peek through three small openings in the mound, which itself
suggests both a hill and a pregnant abdomen; above it are two pointed
hillocks or breasts. The varicolored lights illuminating the hills, valley, and
pierced holes suggest a sensuous, mysterious dreamworld—a non-existent
place to which the artist yearned to flee. Noguchi reiterated the "travel to
another world" theme in *Lunar Voyage*, a contoured illuminated relief on
the passenger ship SS *Argentina*. On the other hand, *Lunar Landscape* may
represent a terrain rendered lifeless by war. The cork spheres and dramatic
lighting may be interpreted as airborne mortar shells and spectacular
explosions. *Lunar Landscape* thus summarized Noguchi's feelings of fear
and desire for escape. The *Lunars* represent a state of mind in between the
absolutes of pure light and pure dark. Thesis and antithesis yield ambigu-
ity, not synthesis.

OPPOSITE
Light Sculpture (Lunar), 1944.
Magnesite cement, electric light,
colored plastic, and wood;
19 $^1/_2$ x 27 $^1/_2$ x 5 in. (49.5 x 69.8 x
12.7 cm). Private collection,
New York.
Photo by Beth Phillips.

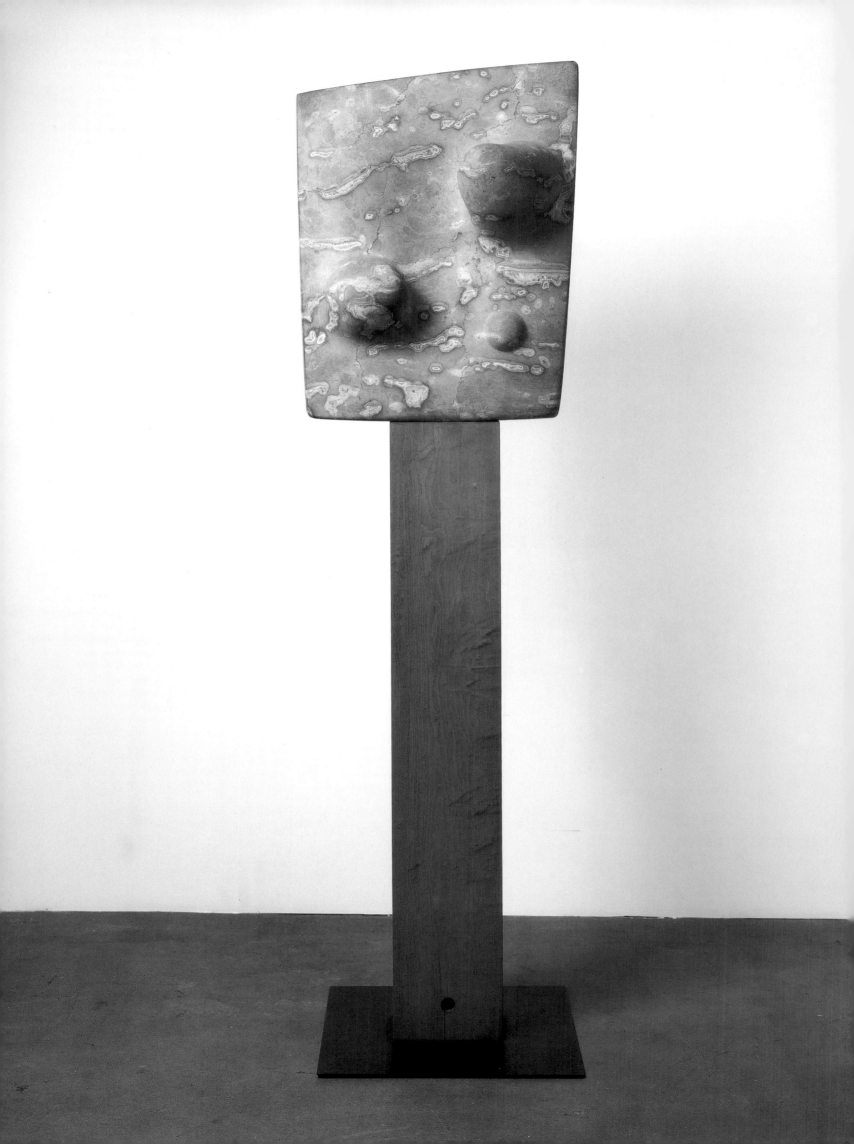

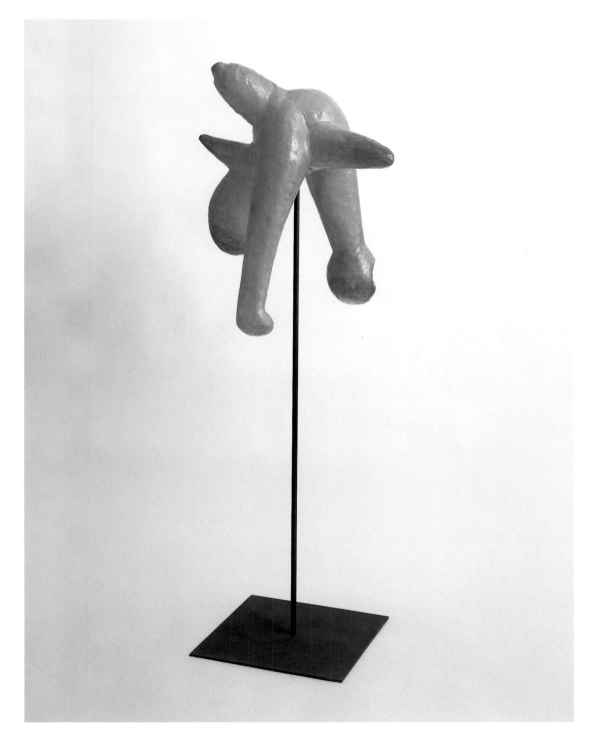

The understated suggestion of turmoil in *Lunar Landscape* became overt and specific in *This Tortured Earth* (see pages 84, 167). Inspired by an aerial photograph of a North African desert after heavy bombing, this undulating topography represents a devastated, cratered earth. Noguchi later suggested that *This Tortured Earth* might serve as model for a large-scale project in which the ground would be shaped entirely by bombing—a morbid proto-Earthwork intended to give pause to viewers who had not themselves experienced the London blitz or the Dresden firestorm.

As Noguchi settled into the discipline of work, he moved beyond despair: "I found my way back from the uncertainties...to a more secure sense of my work." The physical act of carving was reassuring: "straight carvings were to me the sure things of sculpture, long-lasting (locked against time's erosion), sculptural sculpture." Selecting a beautiful piece of pale rose marble, he carved *Time Lock* (see page 82) in high relief on both front and back. The surging rounded forms suggest undulating hills or sea swells. The physical nature of this particular stone reinforces the impression of landscape: the delicate gray grain is irregularly patterned throughout the pink, suggesting the interaction yet independence of different entities (like oil and vinegar). While the forms and material allude to nature, the title refers to Fuller's utopian manifesto from 1927; in the midst of war the sculptor needed to persuade himself that such hopes were still valid and relevant.

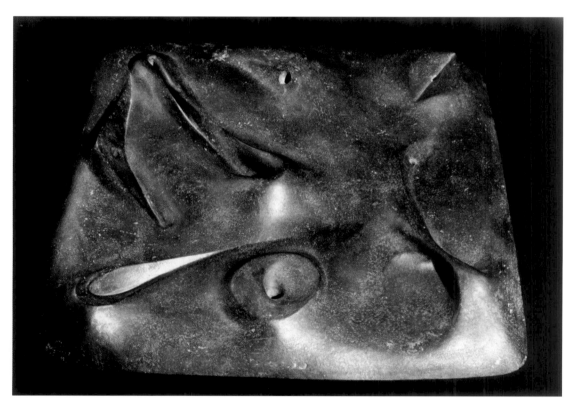

This Tortured Earth, 1943.
Bronze (edition of 3); 28 x 28 x 4 in.
(71 x 71 x 10 cm).
The Noguchi Museum, New York.
Photo by Walker Art Center.

Time Lock was the antithesis of *This Tortured Earth*; together they express the opposing extremes of optimism and pessimism.

In the post–Pearl Harbor sculptures, Noguchi no longer completely predetermined a sculpture's forms and meanings. He began to model, carve, and modify forms according to the multiple associations that his conscious mind made as he created the works, in a process that emulated the free association and intuitive techniques developed by the Surrealists. He began using more poetic, evocative, and referential titles in order to help convey his thoughts about each sculpture: "after...you've done [the sculpture] you want to suggest something of what you had intended...it's a kind of identification [to] start people thinking in that direction."

In 1944 two commissioned designs set Noguchi on a new path. First the art dealer Julien Levy commissioned him and other artists (including

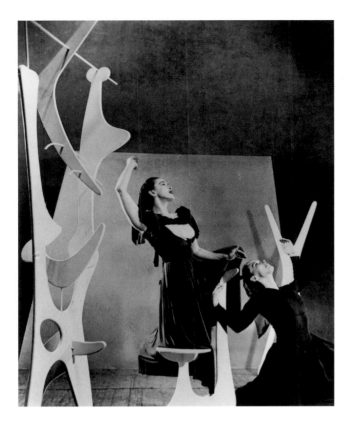

Martha Graham and dancer in "Herodiade" with stage designs by Noguchi, 1944.
Photo courtesy The Noguchi Museum.

Duchamp, Ernst, and Man Ray) to design chess sets. For his set Noguchi made his first interlocking constructions cut from plastic and fit together like three-dimensional jigsaw puzzles. Intrigued by this pragmatic method, Noguchi applied it to the stage sets he designed for Graham's *Herodiade.* He assembled the props from sheet plywood in configurations stable enough to serve as supports for the dancers' limbs. The three-legged mirror may be read as two fantastic biomorphic figures facing each other across the almost empty space of the mirror. The success of these designs encouraged Noguchi to develop this approach further in a series of new sculptures.

Noguchi's interlocking biomorphic compositions from 1944 to 1948 clearly owe debts to innovations by other artists, including Picasso's famous *Anatomy* drawings published in the first issue of *Minotaure* (February 15, 1933). Although Picasso did not translate these compositions into sculpture, Tanguy took the next step. He began to paint his biomorphic forms in a more sculptural way, modulating the forms to appear three-dimensional in their illusionistic space. A number of Tanguy's compositions exhibited in New York from 1941 through 1946 feature squirmy interlacing creatures situated in apparently vast spaces. In *The Five Strangers* and *En lieu de peur* from 1941, and *Flotsam, Le prodigue ne revient jamais* and *Indefinite Divisibility* from 1942, as well as the cover design for *View* in May 1942, his fantastic "figures" consist of overlapping and interpenetrating forms that anticipate Noguchi's interest in such forms for his new sculptures. Although he always denied any influence from Tanguy's contemporaneous paintings, the similarity of forms cannot be ignored.[45]

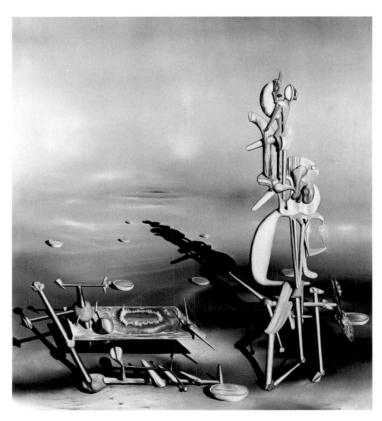

Yves Tanguy. *Indefinite Divisibility*, 1942. Oil on canvas; 40 x 35 in. (101.6 x 88.9 cm). Albright-Knox Art Gallery, Buffalo, NY, Contemporary Art Fund.
Photo by Greenberg-May Prod., Inc.

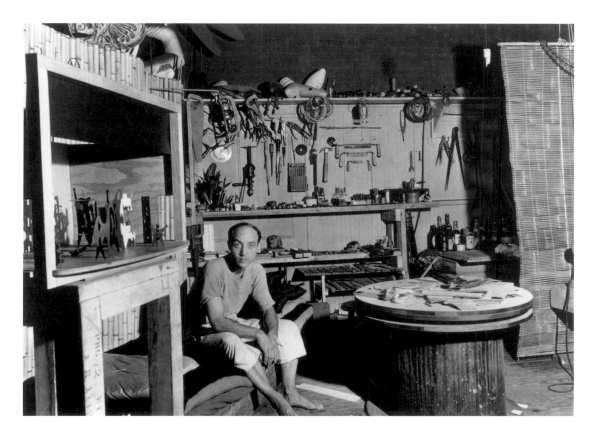

Noguchi in his MacDougal Alley studio, 1946.
Photo by Eliot Elisofon, courtesy The Noguchi Museum.

Noguchi's anthropomorphic constructed sculptures from 1944 through 1948 are among his most evocative works. As he later told an interviewer, all these sculptures refer in some way to human experience:

> A purely cold abstraction doesn't interest me too much. Art has to have some kind of humanly touching...quality. It has to recall something which moves a person—a recollection, a recognition of his loneliness or tragedy or whatever...things that happen at night, somber things.[46]

Noguchi developed his biomorphic vocabulary in drawings, models, and collages, which culminated in stone and wood sculptures assembled from flat pieces. First he drew the individual components and cut them out of ordinary black craft paper, the kind used by children to make cutouts in kindergarten. He assembled these components into small freestanding models. These enabled him to examine the compositions from all angles, to change their shapes easily with scissors, and to test their physical stability. Few of the paper models survive; many were disassembled and mounted on graph paper so that he could calculate the precise measurements for enlargement. Most of these *Worksheets for Sculptures* did not result in sculptures. Often Noguchi would draw revisions on and around the cutout forms, adding specific motifs that reveal much about his moods and motivations. He favored bonelike shapes, some resembling a tibia or femur, and a boomerang-like shape that suggests a bent arm. Another recurrent shape resembles the open end of a crescent wrench—a versatile motif that may be interpreted as a gaping mouth or grasping hand. Like many Surrealists, he pursued self-expression through sexual fantasies. Numerous *Worksheets for Sculptures* feature phallic and vaginal motifs approaching each other or achieving coitus. Despite their presentation as elegant abstract forms, most of the worksheets and some

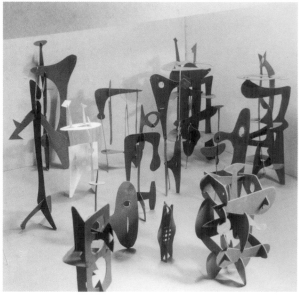

Paper Models for Interlocking Sculptures, 1945–46. Black and white craft paper; dimensions unrecorded. No longer extant.
Photo by André Kertész, courtesy The Noguchi Museum.

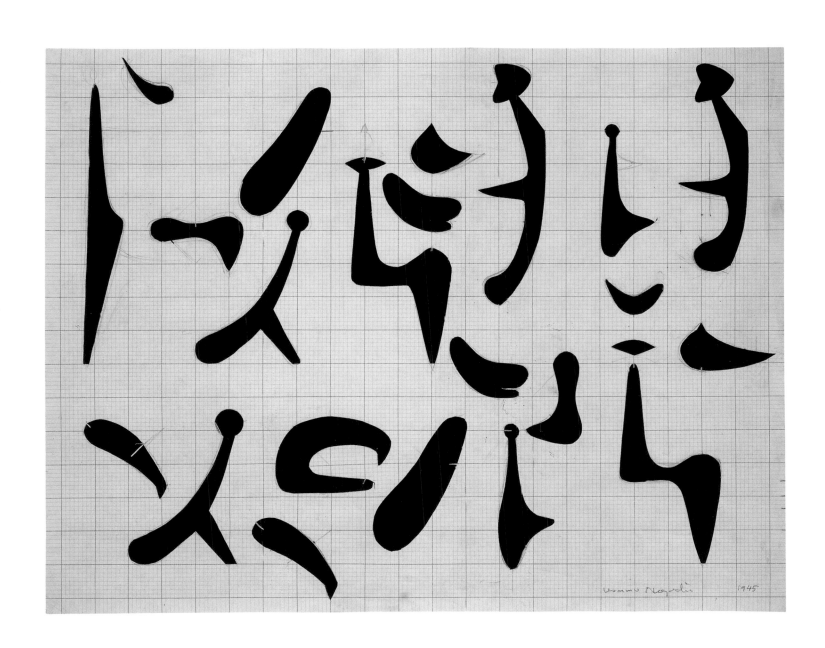

Worksheet for Sculpture, 1945–46.
Black craft paper and pencil on graph paper; 20 ¹/₂ x 20 in. (52 x 50.8 cm). The Noguchi Museum, New York.
Photo by Kevin Noble.

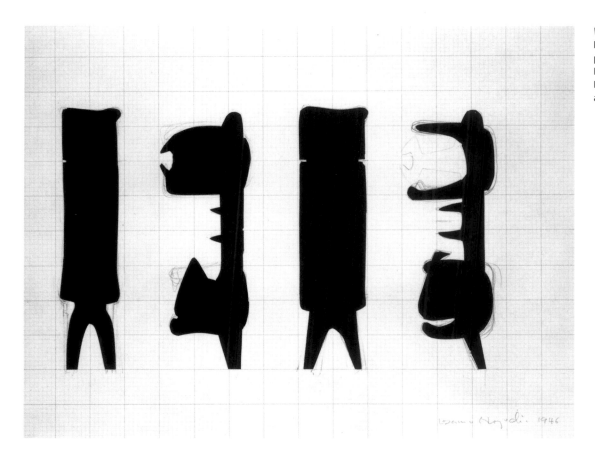

Worksheet for Sculpture, 1946.
Black craft paper and pencil on graph
paper; 13 1/8 x 17 1/4 in. (33.2 x 43.8 cm).
National Gallery of Art, Washington
DC; gift of Regina Slatkin, Carole
and Laura Slatkin.

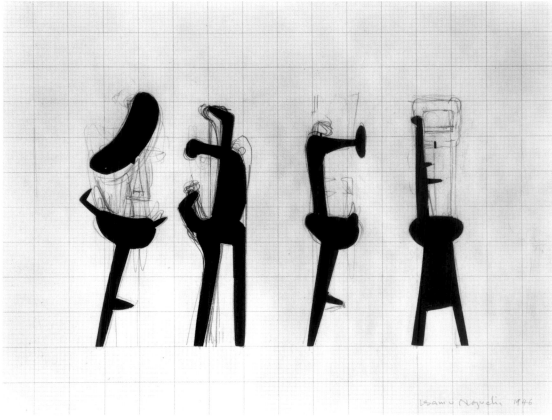

Worksheet for "To the Sunflower,"
1945 (later signed 1946).
Black craft paper and pencil
on graph paper; 12 x 16 in.
(30.4 x 40.6 cm).
The Noguchi Museum, New York.
Photo by Kevin Noble,
courtesy The Noguchi Museum.

sculptures strongly suggest erotic anticipation, titillation, frustration, pleasure, and aggression. Indeed, many worksheets reveal anger and hostility, with forms resembling thorns, knife blades, and sharpened teeth. The bristling details have remarkable affinities to Wifredo Lam's contemporaneous paintings in Havana and to the drawings of Spanish sculptor Julio González. Although Noguchi may have known Lam's images, he could not have seen González's because the Spaniard was working in seclusion in Nazi-occupied France at the time.

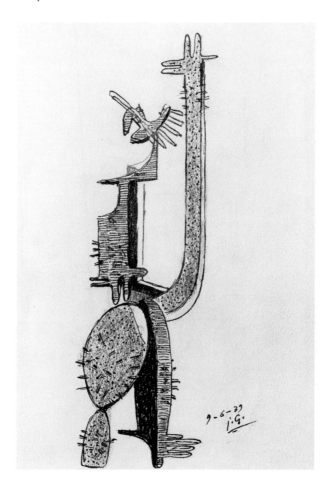

Julio González. *Study for "Cactus Man I,"* 1939. Pencil, china ink, and pastel on paper; 10 3/8 x 7 1/4 in. (26.5 x 18.5 cm).
Hirshhorn Museum and Sculpture Garden, Smithsonian Institution, Washington DC; gift of Joseph H. Hirshhorn.
Photo by Lee Stalsworth.

Noguchi developed only a few studies into actual sculptures. Mostly he used thin slabs of slate or marble, which were readily available during the war for the floors and facades of buildings. Noguchi's process was first to extrapolate each component from the graph paper to larger sheets of paper. Then, like a seamstress using a paper pattern for marking and cutting cloth, he traced the contours of the now-enlarged shapes onto the stone slab as it lay horizontally on sawhorses in his studio courtyard. The artist used a circular saw with an eight-inch blade connected by a flexible shaft to a portable generator. This setup allowed him to maneuver easily, cutting out the forms precisely along the penciled lines. He then used the same power tool with a polishing attachment to bevel and smooth the edges. The direct-carve approach had now been translated into industrial terms: powertools were faster and more effective.

The components of the interlocking sculptures ranged from three to nine in number, notched to fit together. Using no dowels or glue, Noguchi wanted his creatures to hold themselves together through their interpenetration and suspension. This method suggests precariousness, accentuated by the brittleness of the thin stone slabs. Perched on two or three legs that have minimal purchase on the ground, many of the interlocking sculptures have been accidentally knocked over and broken. Noguchi used materials and methods to express the fragility of the human psyche and

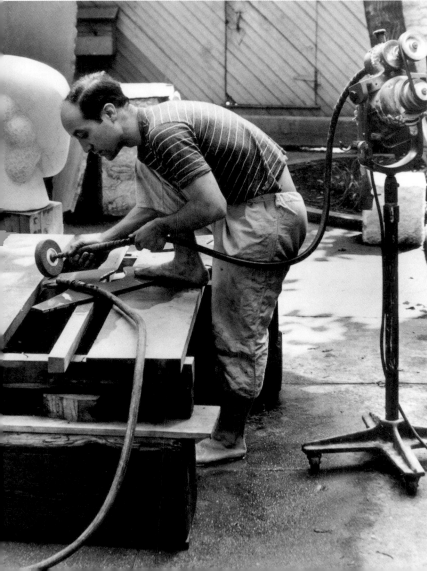
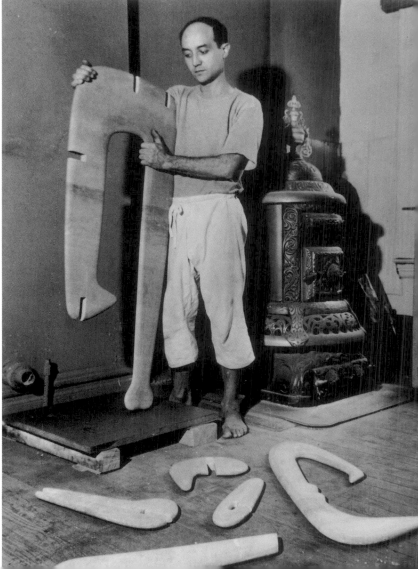

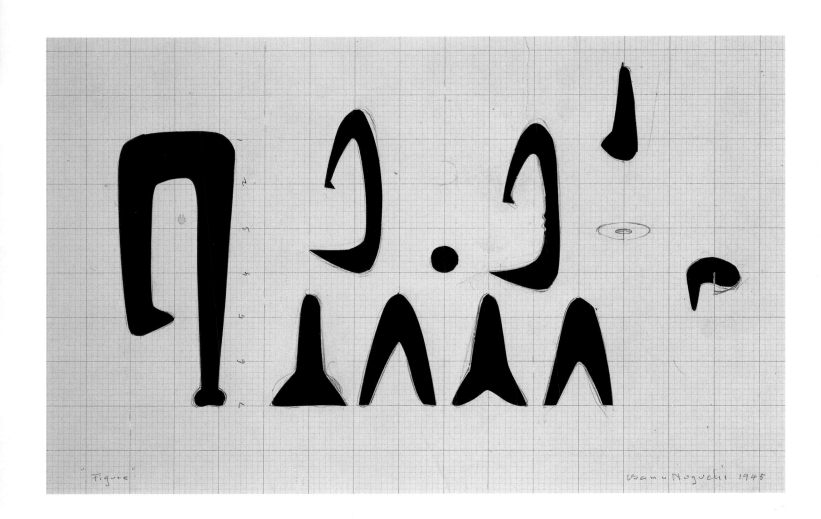

Worksheet for "Figure," 1945.
Black craft paper and pencil on graph paper; 10 1/2 x 16 5/8 in. (26.7 x 42.2 cm).
The Noguchi Museum, New York.
Photo by Kevin Noble.

VALERIE J. FLETCHER

Worksheet for Sculpture, 1945–47.
**Black craft paper and pencil on graph paper; 17 x 22 in. (43 x 55.8 cm).
The Noguchi Museum, New York.**
Photo by Kevin Noble.

the tenuousness of personal relationships and national alliances: "The very fragility gives a thrill.... It's like life—you can lose it at any moment."[47] Yet it should be remembered that his interlocking sculptures hold together quite well. Despite their delicacy, they express a sense of connection (albeit painful at times). This cohesion of forms in precarious balance offers a metaphor for the artist's state of mind and for the world at war.[48]

Noguchi described his new works as memories of humanity, "transfigurations, archetypes, and magical distillations." Although anthropomorphic, these entities appear more alien than human. Their titles invite many interpretations; some refer to specific literary or religious sources as well as generalized references to transformation. *Remembrance*—one of the first interlocking compositions—recalls to some extent Dali's melting clocks in *The Persistence of Memory*, 1931. Noguchi's limp forms drape forlornly over the "frame," like used towels on a rack. While working in semiseclusion in his studio, the sculptor wrestled with the unpleasant memories of internment, and like millions of other people during the war, he recognized the importance of remembering how the disaster happened, the sacrifices made, and the persons lost.

Each biomorphic sculpture has a distinct character. Many have erotic aspects; some are overtly sexual. *Untitled: Construction No. 2* portrays a standing male figure with arms curving outward to embrace a standing female figure. Although the arms remain independent of the woman, two small pointed elements penetrate her head and pelvis. The

Sculptures in the MacDougal Alley studio (including "Fishface" and two untitled wood carvings), 1945.
Photo courtesy The Noguchi Museum.

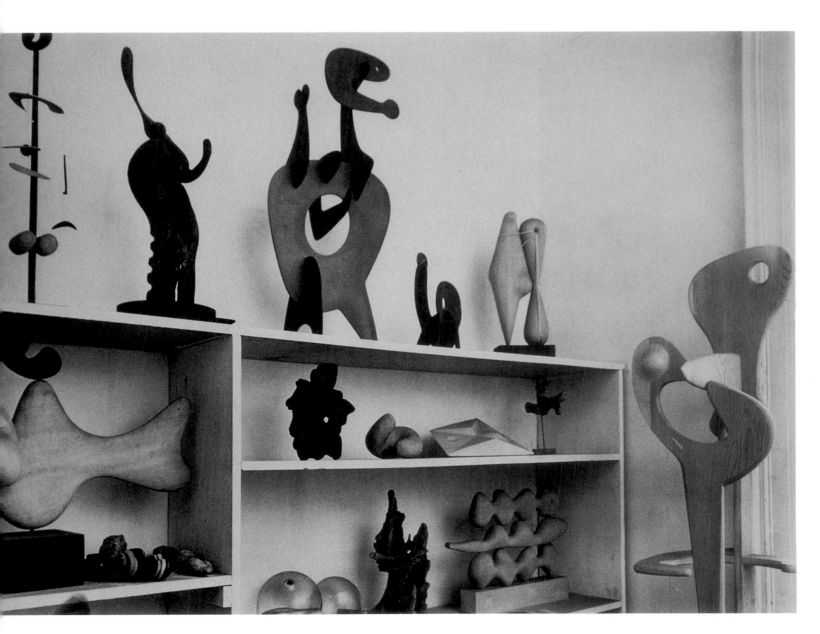

sculpture thus seems to express a yearning for copulation. *Man* (see pages 98, 99) has no one to embrace but himself. The left hand, consisting of an open crescent-wrench form, reaches out to grasp nothing, only void—an appropriate metaphor for the existentialist angst of the 1940s. But something else is going on here. This figure has an empty head and enormous genitals supporting an erect penis. As a viewer walks to the side of the sculpture, the changing angle creates an illusion of the left hand "moving" toward the penis. In other words this sculpture is an homage to masturbation, something Noguchi previously would never have considered appropriate for art. This sculpture declares the artist's sense of self-liberation as well as his strong libido. Unlike the ominous and aggressive overtones of some Surrealist works, notably the sadism evident in Bellmer's photographs and Giacometti's *Woman with Her Throat Cut*, Noguchi's sculptures usually express the pleasure, joy, and fulfillment of human sexuality.

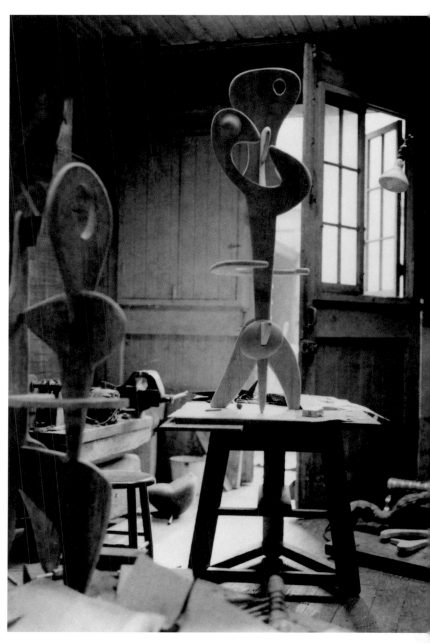

"Untitled: Construction No. 2" in the MacDougal Alley studio," 1945.
Photo by André Kertész,
courtesy The Noguchi Museum.

Despite the gloom of the war, Noguchi regained his sense of humor and joie de vivre. As he would later tell an interviewer, "There are many sides of me I want to express—the loneliness, the sadness, and then something...precise and dry.... I wouldn't want to express only my serious side—I'm also playful sometimes—and then again completely introspective."[49]

The sculpture initially titled *To the Sunflower* (see pages 100, 101) was a reference to the spirit of longing expressed in a poem by William Blake from 1794:

"Ah, Sunflower! weary of time
Who countest the steps of the sun
Seeking after that golden sweet clime
Where the traveller's journey is done..."

Viewers need not know this specific verse, as the title and composition suffice to summon the image of the tall gawky plant that gently turns from east to west every day, seeking always to face the sun and drooping when it cannot. After making the *Lunars*, Noguchi here was expressing his longing for all that the sun symbolized—warmth, inspiration, life itself. The sculpture stands on three long thin "stalks" that suggest legs more than plant stems, and the slanting central element may be interpreted as a head as well as the tilting face of the sunflower. *To the Sunflower*, like all of Noguchi's mature sculptures, may be interpreted in many different ways, depending on the viewer. Surrealist biomorphism had become a widely used visual language and many in the New York art scene could "see" his intentions

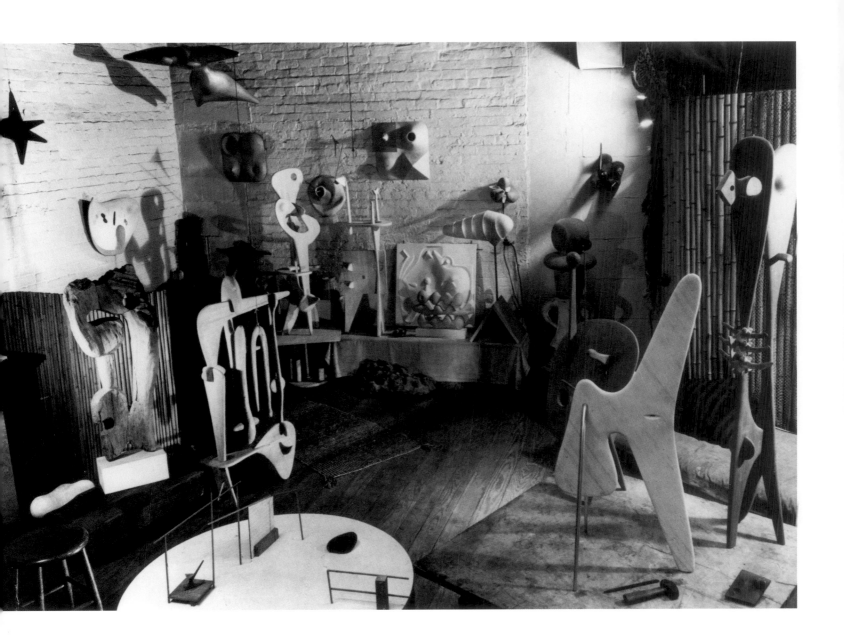

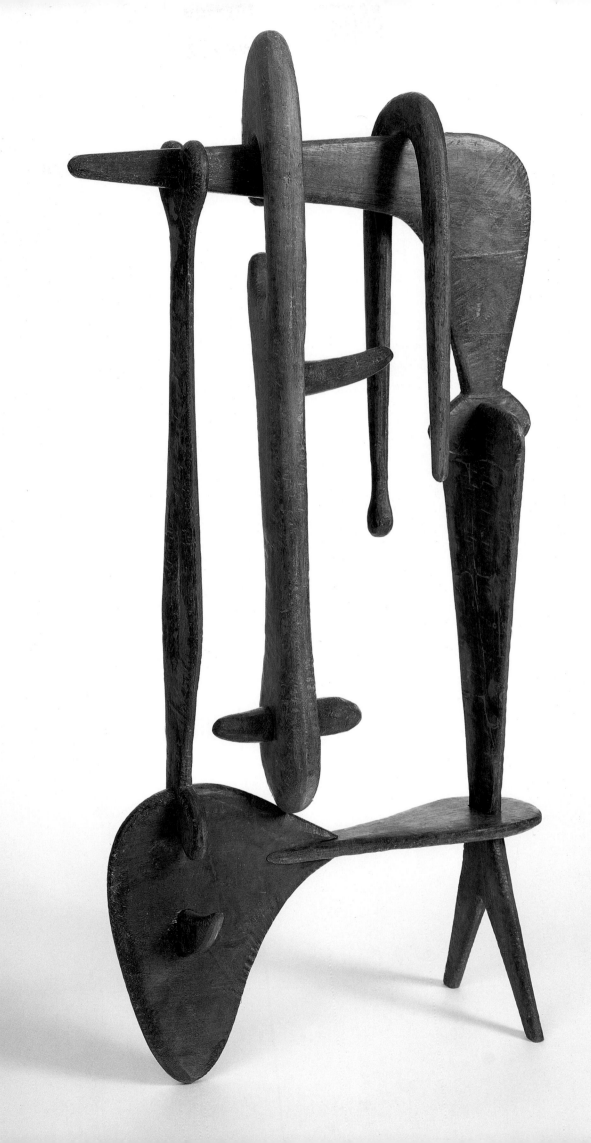

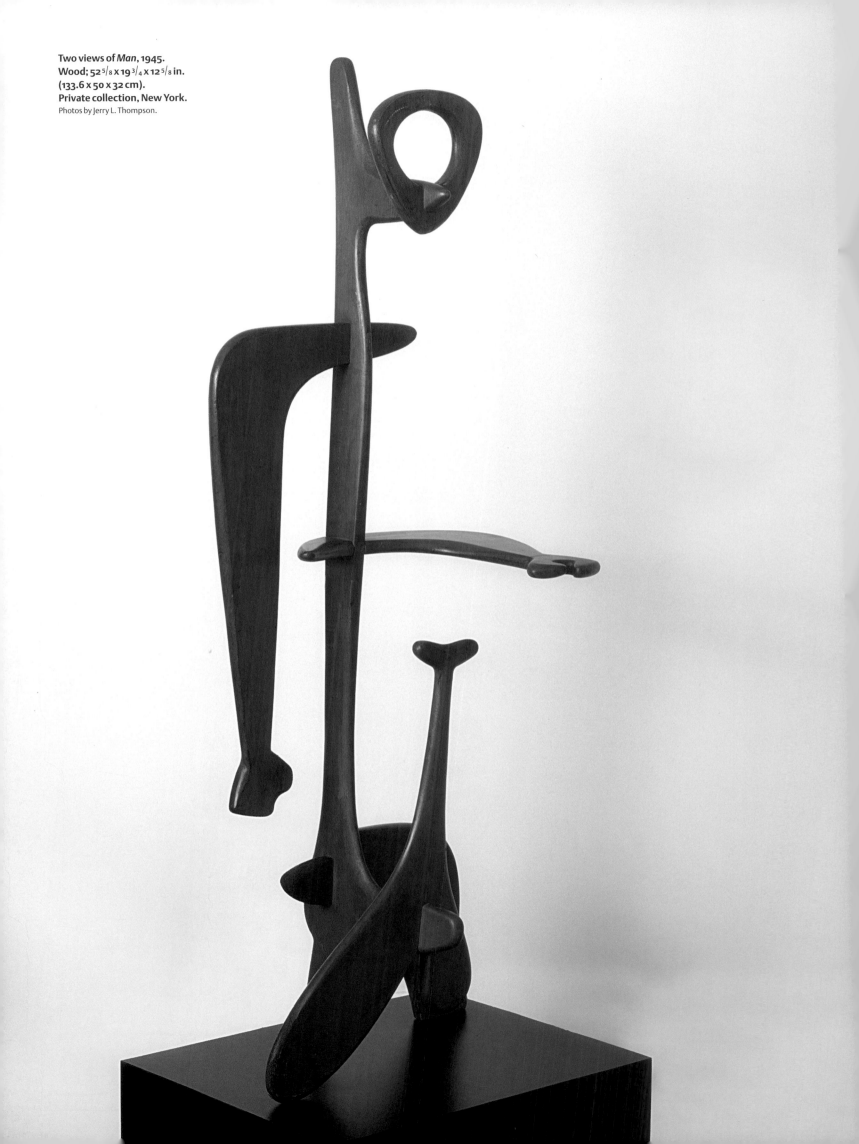

Two views of *Man*, 1945.
Wood; 52 5/8 x 19 3/4 x 12 5/8 in.
(133.6 x 50 x 32 cm).
Private collection, New York.
Photos by Jerry L. Thompson.

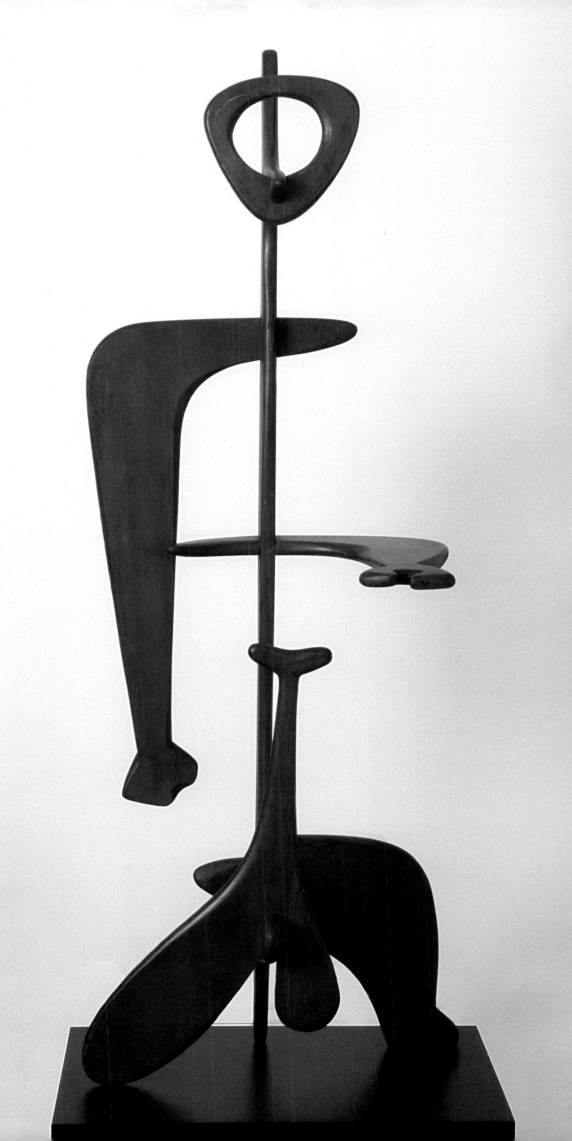

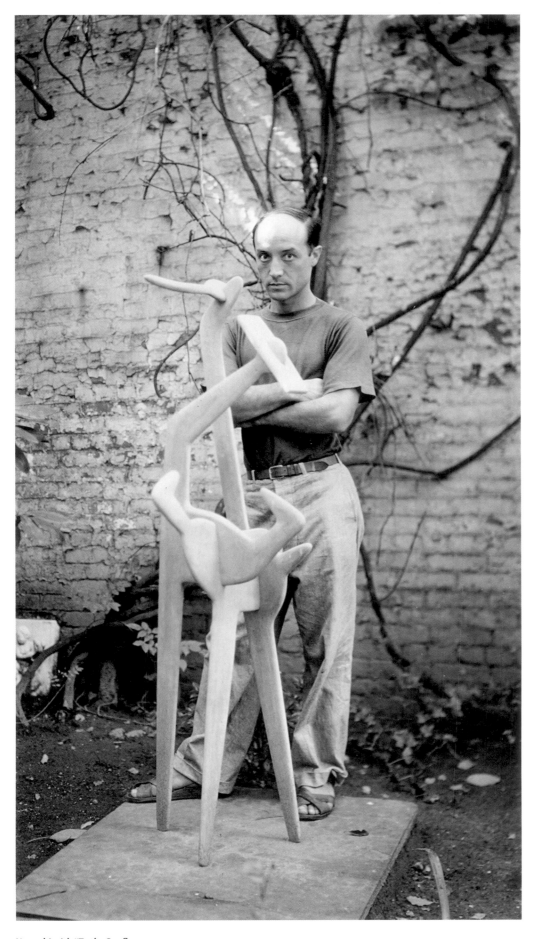

*Noguchi with "To the Sunflower
(Strange Bird)" in the MacDougal Alley
studio courtyard*, 1945.
Photo courtesy The Noguchi Museum.

OPPOSITE
Strange Bird (To the Sunflower),
1945. Green slate (5 elements);
55 3/4 x 22 1/2 x 20 in.
(141.6 x 57 x 50.8 cm).
The Noguchi Museum, New York.
Photo by Kevin Noble.

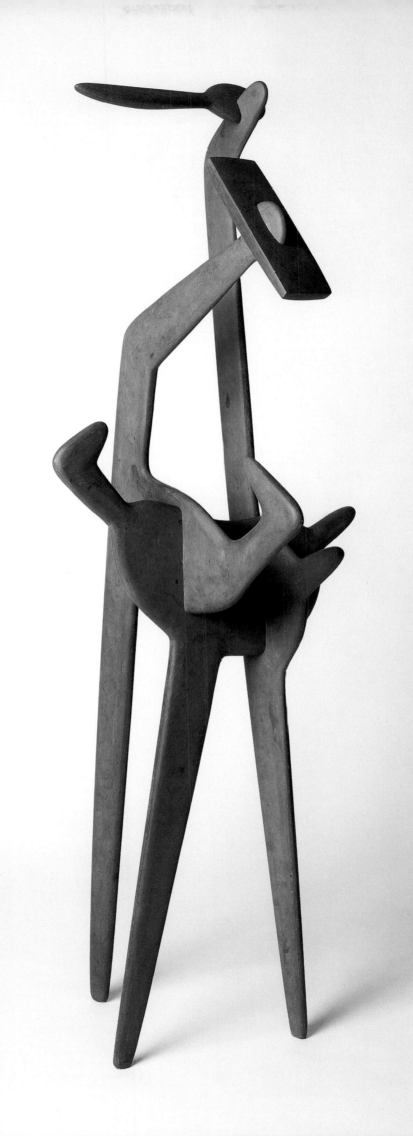

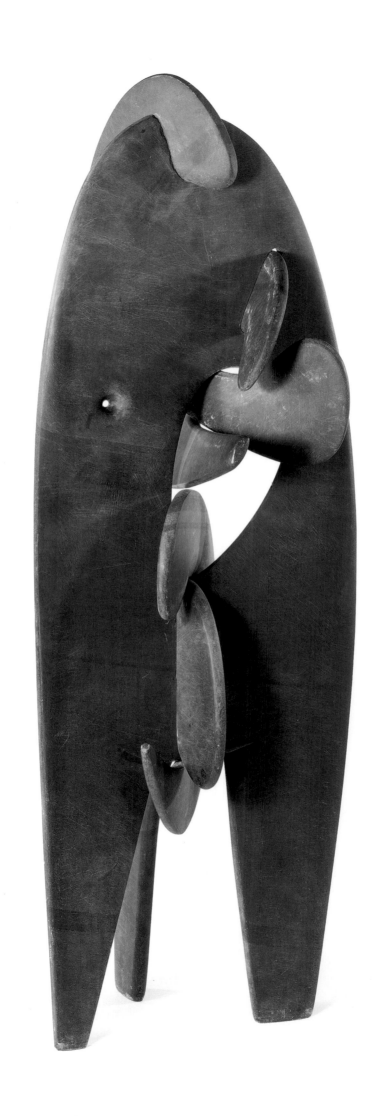

and intuit various meanings. Indeed, Noguchi reveled in multiple interpretations. *To the Sunflower* soon acquired the auxiliary title of *Strange Bird*, perhaps in reference to an entirely imaginary creature like Miró's *Lunar Bird* and *Solar Bird* from 1944–46. An avian motif invokes the possibility of flying away to discovery or escape; Noguchi's bird, however, seems to resemble most strongly an emu or ostrich, which are flightless. *Strange Bird* may thus be understood as a metaphor for frustration.

Some of the interlocking sculptures express the artist's pessimism. The title and the forms of *Humpty Dumpty* (essentially an ovoid form with legs akimbo) refer to the familiar children's rhyme:

> Humpty Dumpty sat on a wall
> Humpty Dumpty had a great fall
> All the king's horses
> And all the king's men
> Couldn't put Humpty together again.

At first, this apparently lighthearted work suggests nostalgia for the innocence of childhood, but the rhyme has a cautionary moral: when a fragile whole is shattered, it can never be the same again. Like the apocryphal egg-man, Noguchi had resumed his life in New York, but his experiences in California and Arizona had changed him; he was "put together again" differently. The appeal of *Humpty Dumpty* is not limited to the artist's state of mind; the message applies to millions of people. Who has not felt broken at some point? Very few individuals make it through life without a few scars of one sort or another. Noguchi's sculpture may also refer to historical events: after World War II the geopolitical globe may be reassembled but not as it was before, not without permanent damage.

Perhaps Noguchi's most somber interlocking sculpture is *Gregory (Effigy)* (see page 104). The subtitle suggests violence: by definition an effigy is a representation of a person, often one that is destroyed by a mob. The forced internment of thousands of Japanese Americans was, in its own way, a form of legalized mob rule. According to Noguchi, the main title refers to the character Gregor Samsa in Franz Kafka's *The Metamorphosis*, published in 1915 and translated into English in 1930. Gregor awoke one morning to find himself transformed into a giant cockroach or similarly repulsive insect. Much of the novella dwells on how he and others cope with this hideous transformation. He must remain sequestered in his bedroom, an outcast from society and from his family, forcing other family members to earn the household's income. Gregor's father repudiates his son, refusing to see or speak to him. One day when Gregor breaks out of his room, his father throws rotten apples to chase him away; one lodges deep in his body, becomes infected, and causes Gregor's death. Although the sculpture does not illustrate this hallucinatory narrative, its rectangular torso can be interpreted as the carapace of a cockroach, painfully pierced by multiple hooked forms. Like Kafka's fictional character, Noguchi struggled to come to terms with being rejected by his father, and he lived in relative seclusion as an "alien" during the war.

Most of the interlocking sculptures are vertical and may be defined primarily as abstract compositions about suspension, balance, fragmentation, and fragility. They also evoke ancient fertility deities, tribal totems, and other ritualistic icons. Many artists at this time hoped to achieve in their works some of the powerful presence of African fetishes and ancestor figures from Pacific island cultures, as well as the ancestor totems of the Native Americans along the Northwest coast of the United States. (During the mid-1940s, like Adolph Gottlieb and several other American painters, Noguchi studied the arts of Native Americans.) Earlier Surrealist examples include Jacques Lipchitz's massive, ominously staring *Figure* from 1928–30 and Giacometti's *Invisible Object* (*Hands Holding the Void*) from 1934–35.

OPPOSITE
Humpty Dumpty, 1946.
Gray ribbon slate;
59 x 20³/₄ x 17¹/₂ in.
(149.9 x 52.7 x 44.5 cm).
Whitney Museum of American Art,
New York; purchase with funds
from the Howard and
Jean Lipman Foundation, Inc.
Photo by Jerry L. Thompson.

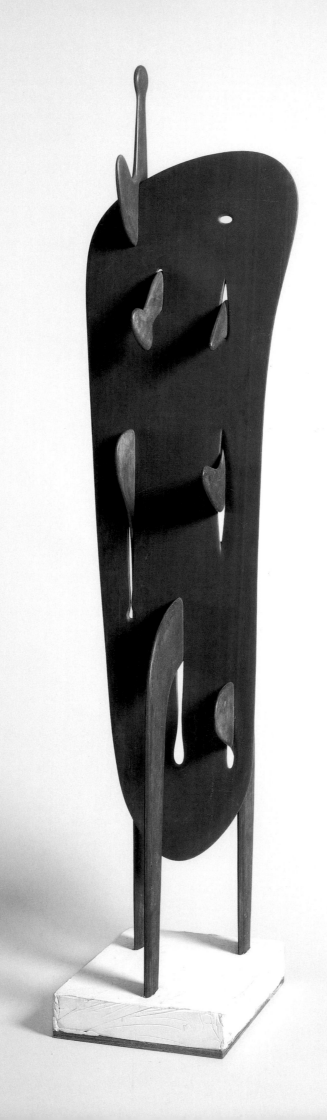

Gregory (Effigy), 1946. Black slate
(7 elements) on artist's plaster and
wood base; 67 1/2 x 15 3/4 x 12 in. (171.4 x
40 x 30.4 cm). The Noguchi Museum,
New York.

Photo by Kevin Noble.

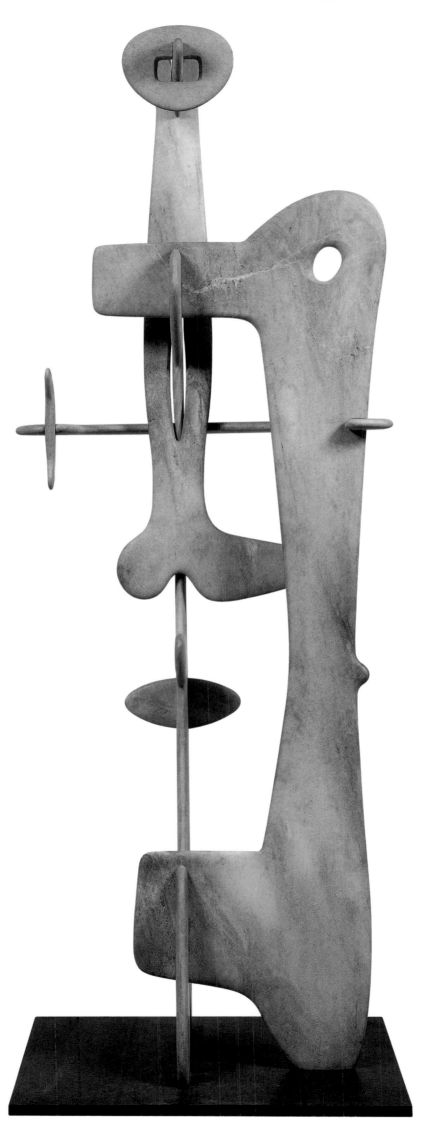

Kouros, 1946. Pink Georgia marble on gray slate base (9 elements); 108 x 34 x 42 in. (274.3 x 86.3 x 106.6 cm). The Metropolitan Museum of Art, New York; Fletcher Fund.

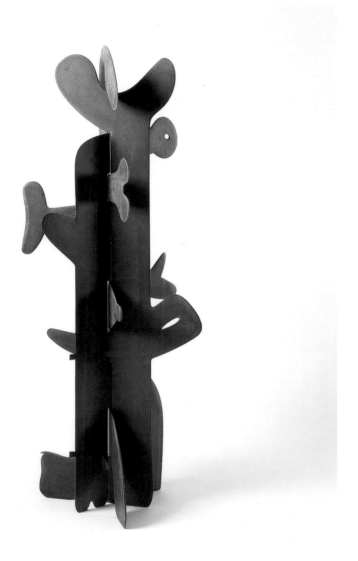

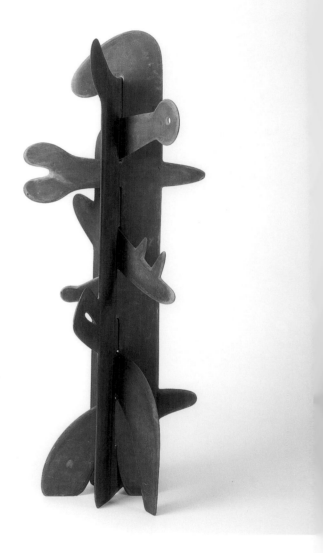

OPPOSITE AND ABOVE
Three views of *Trinity*, 1945.
Black slate (3 elements);
55 x 22 x 20 in. (139.7 x 55.8 x 50.8 cm).
The Noguchi Museum, New York.
Photo by Kevin Noble.

ISAMU NOGUCHI : MASTER SCULPTOR

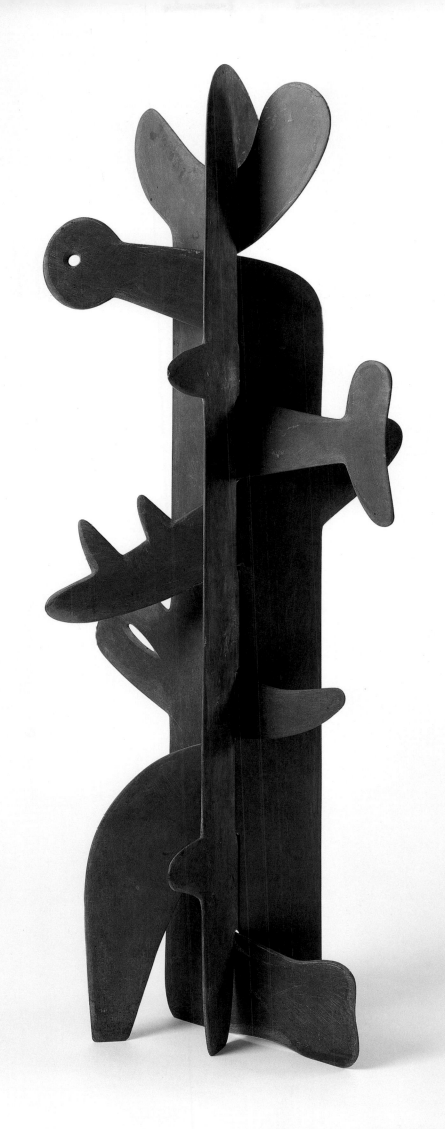

The appeal of primitivist totemic figures proliferated among New York artists, as evidenced by Pollock's *Guardians of the Secret* from 1943, David Smith's *Classic Figure* from 1944, and *Agricola I* from 1951, Seymour Lipton's *He Is Not a Man* from 1951, and Henry Moore's *Upright Motif* from 1956.

The hieratic and iconic qualities are particularly evident in Noguchi's *Kouros* (see page 105) from 1946. Measuring nine feet tall, it dwarfs most viewers. Photographs cannot convey the sculpture's impact: the combination of large scale with slender forms and precarious balance, the elegance of the contours and warmth of the rosy-gray marble coexisting with the aloof strangeness of the figure, the weightiness of stone offset by the hovering appearance of the upper figure. Like *Man, Kouros* has a clearly defined front, with its small head facing forward and all the elements at right angles to each other. This frontality echoes the Greek stone sculptures of young men in the Archaic period (seventh to fifth century BCE); *Kouros* is the Greek word for man. In this work Noguchi affirmed that his art descends to some degree from the classical art of Europe, as well as from American and Asian sources.

Kouros, like all of Noguchi's interlocking sculptures, challenges viewers to figure out how it is put together and, in so doing, to discover that no element can be removed without causing total collapse. Regardless of the specific allusions in some titles, the fundamental message is that we are all connected and interdependent. Noguchi was quite insistent about this; these sculptures are not permanently put together—there are no screws, bolts, or adhesives. As he put it, "you have to consider...the forces that conspire to hold up the figure...only the stones holding themselves together"—just as individual persons integrate diverse aspects within themselves and as societies can only survive when disparate elements support each other.

The white marble *Metamorphosis* offers an exceptionally ordered structure with organic forms neatly placed at right angles in a rectangular frame. The forms variously curl, extend, and arch in multiple directions comparable to biological activities of growth and mutation. The enclosure may represent a scaffolding on which the forms thrive, like plants in a greenhouse. Conversely, the forms may be imprisoned and struggle to break free from restraints—an apt analogy for Noguchi himself during the war years. Both interpretations exist simultaneously; Noguchi was becoming more comfortable with multivalence rather than singular meanings. As viewers contemplate *Metamorphosis* from multiple points of view, each perspective reveals a different composition. This complex spatiality was in itself a remarkable achievement, especially as the artist limited himself to thin slabs of material.

The title of *Trinity* emphasizes that this sculpture has three distinct sides and invites viewers to circumambulate. From one side a small one-eyed head appears to stretch outward, as if trying to see farther or to escape. From another angle, a scissorslike shape pierces the body, as if violently attacked by an unseen assailant. On one side a tumescent penis appears; a thorny weapon pokes out the verso. All these conflicting elements and interpretations are locked together in enforced coexistence or integration. *Trinity* is a three-in-one entity; no single side dominates. The surprise of discovering three quite different images might prompt a viewer to consider how subjective is every individual's perspective, not merely in the physical domain but also in the realm of ideas and beliefs. For example, from the perspective of American lawmakers, citizens of Japanese ancestry posed a threat to national security; from the Nisei's point of view they were being unjustly discriminated against (Americans of German and Italian descent were not imprisoned). The title of *Trinity* also evokes the religious concept of three-in-one; such paradoxical unity is fundamental to the Christian Trinity of Father, Son, Holy Spirit and to the Hindu triad of Brahma, Vishnu,

OPPOSITE
Metamorphosis, 1946.
White Italian marble (10 elements);
69 x 17 x 15 in. (175 x 43 x 38 cm). Yale
University Art Gallery, New Haven,
Connecticut; Henry John Heinz II, B.A.
1931, Fund.

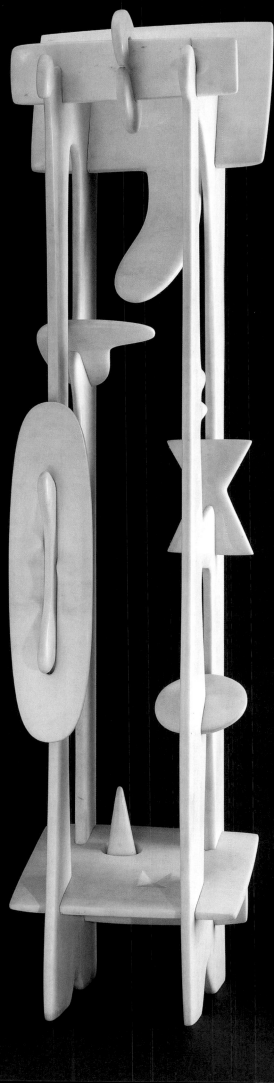

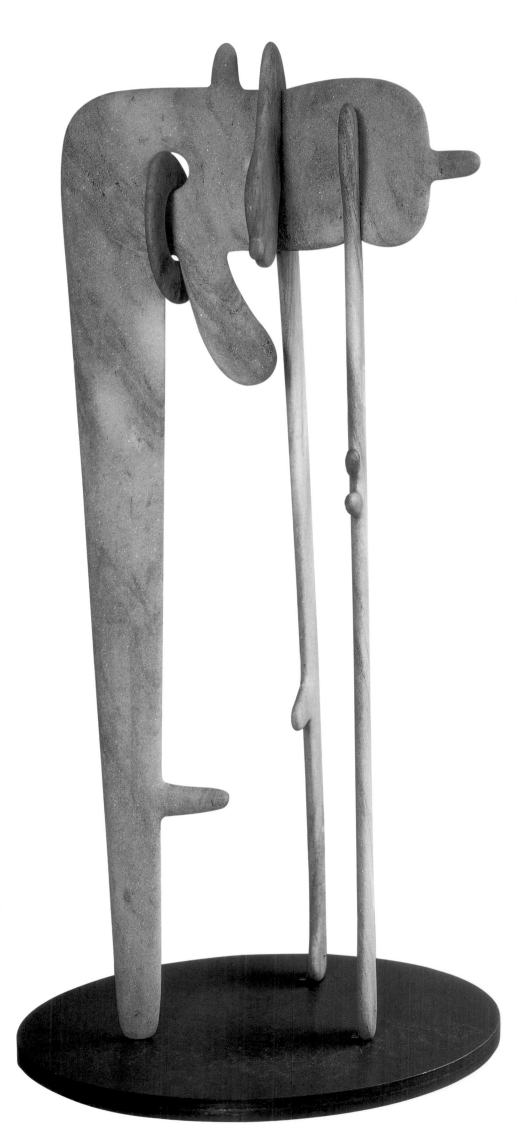

Avatar, 1947. Georgia pink marble
(4 elements); 78 x 33 x 24 in.
(198 x 83.8 x 60.9 cm). Kröller-Müller
Museum, Otterlo, Netherlands.
Bronze, lent by Milly and Arne
Glimcher, New York.

Shiva. Devotees may honor one more than the others but all are fundamentally linked into an indivisible whole.

From late 1945 through 1947 Noguchi's relationship with Tar Pandit, a young woman from India, prompted him to learn more about the culture of her country. He already knew a great deal about various Eastern religions and arts from his readings and travels in 1928 and 1930–31. Although they were together only rarely (she was away finishing college and thereafter traveled to Mexico and California), her letters document their emotional connection. Perhaps one of the greatest attractions of Hinduism for Noguchi was its diversity and lack of centralized authority. For more than two millennia Hindu theology has adapted to changing situations; Buddha, for example, was accepted as a manifestation of a Hindu deity. Noguchi titled one of his largest interlocking sculptures *Avatar*, a Sanskrit word referring to the physical manifestation of a god on earth. The sculpture's triadic composition (three vertical components propping each other up in balance) may refer to the Hindu trinity of Brahma, Vishnu, and Shiva, who symbolize the cycle of creation, preservation, and destruction that defines the universe. Vishnu, the eternal protector, periodically descends to earth in a variety of forms, called *avatars*, in order to banish evil and save humanity. Through past eons Vishnu assumed nine avatars; the tenth and final is yet to come. Noguchi's sculpture may thus be interpreted as a plea for divine intercession to end the horrors of World War II and prevent nuclear holocaust. Such a plea was not an expression of belief in Hinduism *per se*; Noguchi never adhered to any religion, and the sculpture itself does not resemble any of the specific forms associated with Vishnu. Rather, Noguchi probably created the composition without a subject in mind, and titled it afterward. Broadly defined, the term *avatar* means the continuity and renewal of existence through many ages and many changes—an optimistic concept.

Noguchi used a Sanskrit work for the title of another sculpture, *The Gunas*. In Hindu culture the *gunas* are three fundamental modes of reality or consciousness that exist within each person. The uppermost is a metaphysical state of spiritual wisdom, while the lowest is ignorant and materialistic. The middle state consists of energy. Through thoughts and actions a person can rise to the upper level or descend to the lower. The process may be repeated innumerable times in one life and in various reincarnations, aided by Ayurvedic medicine and practices. Noguchi's sculpture abstractly represents the balance and interconnection of the three modes of consciousness. Like *Avatar*, the concept of *The Gunas* was ultimately hopeful: through deliberate efforts a person may rise to enlightenment. The composition of *The Gunas* suggests this through the directional flow of the horizontal element linking the three vertical elements. That Noguchi's interest in these ideas was philosophical rather than religious is indicated in a letter from Pandit in January 1947. After visiting the Vedanta Society in California and just missing Jidda Krishnamurti,[50] she mockingly reassures Noguchi that she had "not got religion, don't worry; the light has not yet dawned on me nor am I one with the Divine."[51] She understood the artist's interest in the tenets of many religions while maintaining an independent stance. Although the artist never spoke of it, his wartime fascination with compositions and concepts of three may reflect his evolving definition of self as being more than bicultural. Certainly by 1948 Noguchi was actively pursuing a path of global aesthetic fusion.

Drawing after "The Gunas,"
**1947. Ink on paper;
8 1/2 x 3 in. (21.5 x 7.6 cm).
The Noguchi Museum,
New York.**
Photo by Kevin Noble.

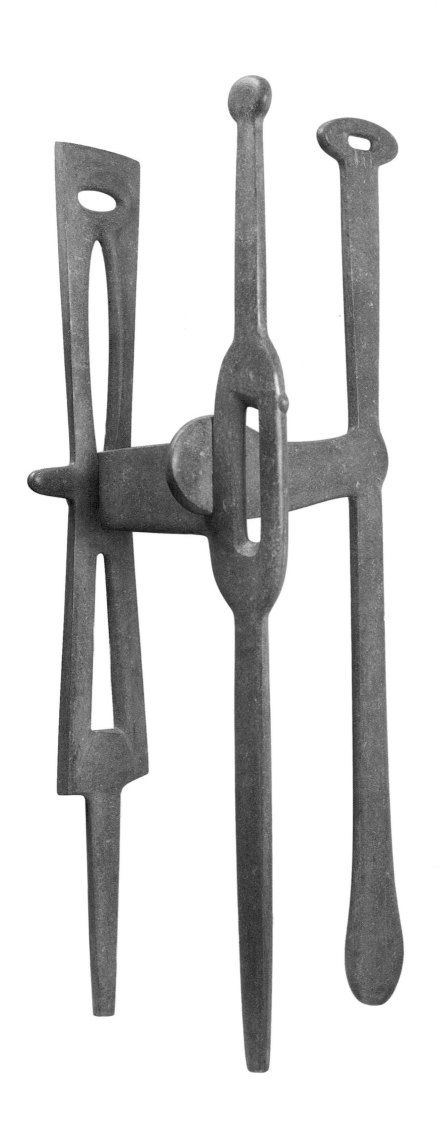

The Gunas, 1946. Brown marble
(5 elements); 73 ¹/₄ x 26 ¹/₄ x 25 ¹/₂ in.
(186.1 x 66.7 x 64.8 cm).
**Whitney Museum of American Art,
New York; purchase with funds
from the Howard and Jean Lipman
Foundation, Inc.**
Photo by Geoffrey Clements.

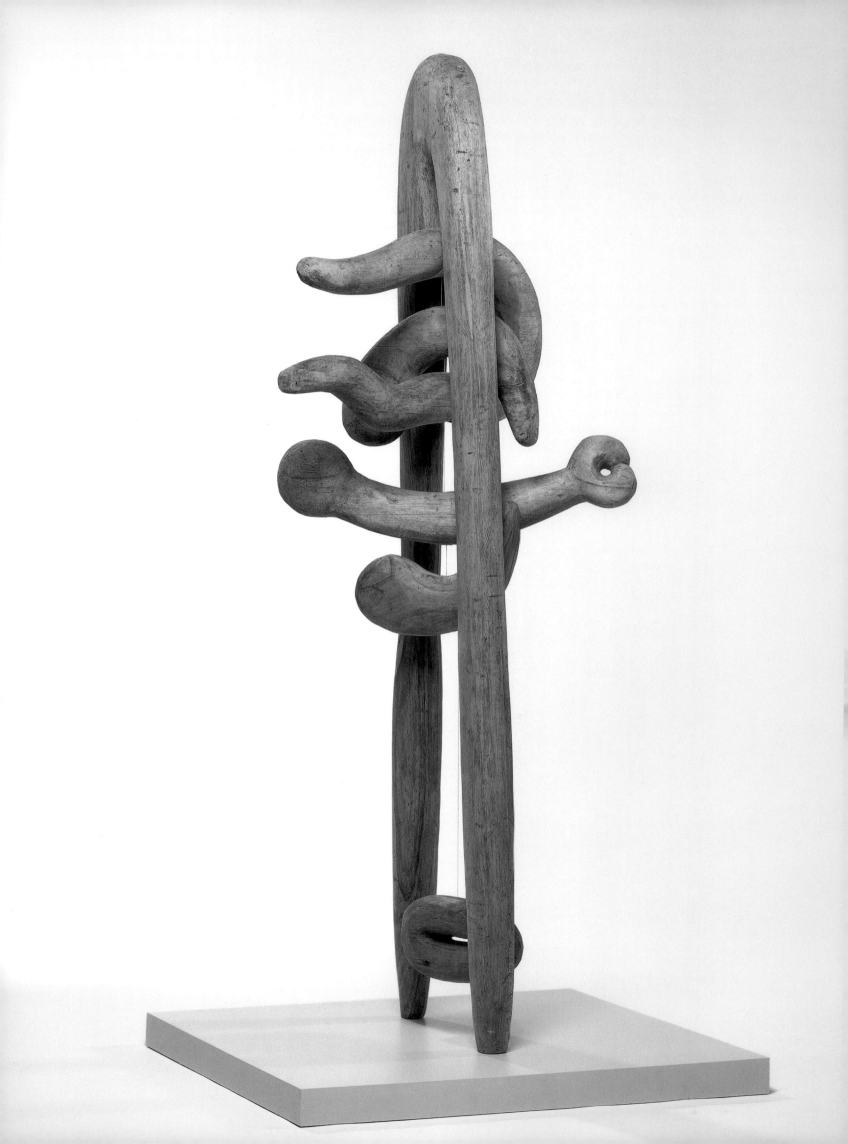

Sculptures and Environments with a Global Perspective

After five years of intense creativity, exploring his own psyche in the privacy of his studio, Noguchi found it difficult to emerge and grapple with the emotional and societal aftermath of the war. The atomic destruction of Nagasaki and Hiroshima, in particular, weighed upon his heart. At first the American reaction to the nuclear blasts had been relief that the war had ended. But as the devastation and suffering of the survivors were documented in newsreels and photographs, many people reacted with horrified guilt, which tempered their initial elation. When the Soviets soon thereafter acquired nuclear capability, initiating the international tensions of the Cold War, Noguchi sank almost to despair: "My depression was increased by the ever-present menace of atomic annihilation." In July 1948 he was profoundly shocked and saddened by Gorky's suicide.

Several sculptures from the postwar years express his melancholia and pessimism. *Hanging Man* (see page 120), although abstract, alludes to ignominious death. The sculpture hangs from a single thin wire, perhaps an allusion to the precarious state of humanity. By using aluminum—a material essential for airplanes and therefore not available to civilians during the war—the artist may have insinuated that the utopian hopes of the prewar Constructivists have been strung up uselessly on a wall. Unlike *Death (Lynched)* from 1934, *Hanging Man* makes no specific social or political reference; it may indicate just or unjust punishment or even self-destruction.

For the most part Noguchi's art did not undergo a radical change. He continued to make indoor metaphoric landscape sculptures, notably two that seem to indicate the extremes of his hopes and disillusionments. *The Field* (see page 121) consists of a panel of rough redwood into which four slits have been cut. Through this plowed earth, phallic-shaped seedlings of white marble push up—a fairly obvious symbol of fertility and future abundance. (Originally this work stood horizontally; for exhibition a wire was added to hang it vertically on a wall.) Noguchi once remarked that *Night Land* (see pages 116, 117) alludes to a couple in bed, but that idea became entirely transformed into something else that he vaguely described as people in a landscape. The flat rectangular surface features six abstract forms in high relief and two recessed areas, principally a circle in the center. Perhaps as a response to Giacometti's *No More Play* and *Palace at 4 a.m.*, *Night Land* suggests the realm of dreams and magic. The forms may be the "people" Noguchi mentioned, placed around the kiva-like circle. (A kiva is a circular subterranean space used for ceremonies by the Pueblo and Hopi people in the southwestern United States.) Unlike his previous landscape sculptures, *Night Land* is neither horizontal nor vertical. The underside of the sculpture lacks support in each corner, forcing *Night Land* to rest on a downward tilt. When first exhibited in 1949, Noguchi placed the sculpture directly on the floor, where the viewer literally looks down on it, like a ruin. Altogether the sculpture serves as a metaphor for a world blown off-kilter and cast into darkness.

In a similarly unhappy vein, *Cronos* refers to the Greek myth of the Titan who killed his children rather than share power with them. Only his son Zeus survived, and replaced his father as the primary deity. Noguchi later acknowledged that his *Cronos* sculpture arose in part from autobiography, alluding to his distant father's hostility and his own desire to surpass his father's renown. More generally, the sculpture is about death, loss, and regret. Inside its tall narrow arch are suspended several biomorphic and bone-shaped forms that the artist later described as "falling tears, or the limbs, of his sons devoured by the Titan."

Noguchi's despondency was only slightly offset by the success of his recent sculptures. In the critically acclaimed exhibition *Fourteen Americans*

OPPOSITE
Cronos, 1947 (cast 1962).
Balsa wood with string;
86 1/4 x 22 x 31 in. (219 x 55.8 x 78.7 cm).
Walker Art Center, Minneapolis;
gift of the artist.

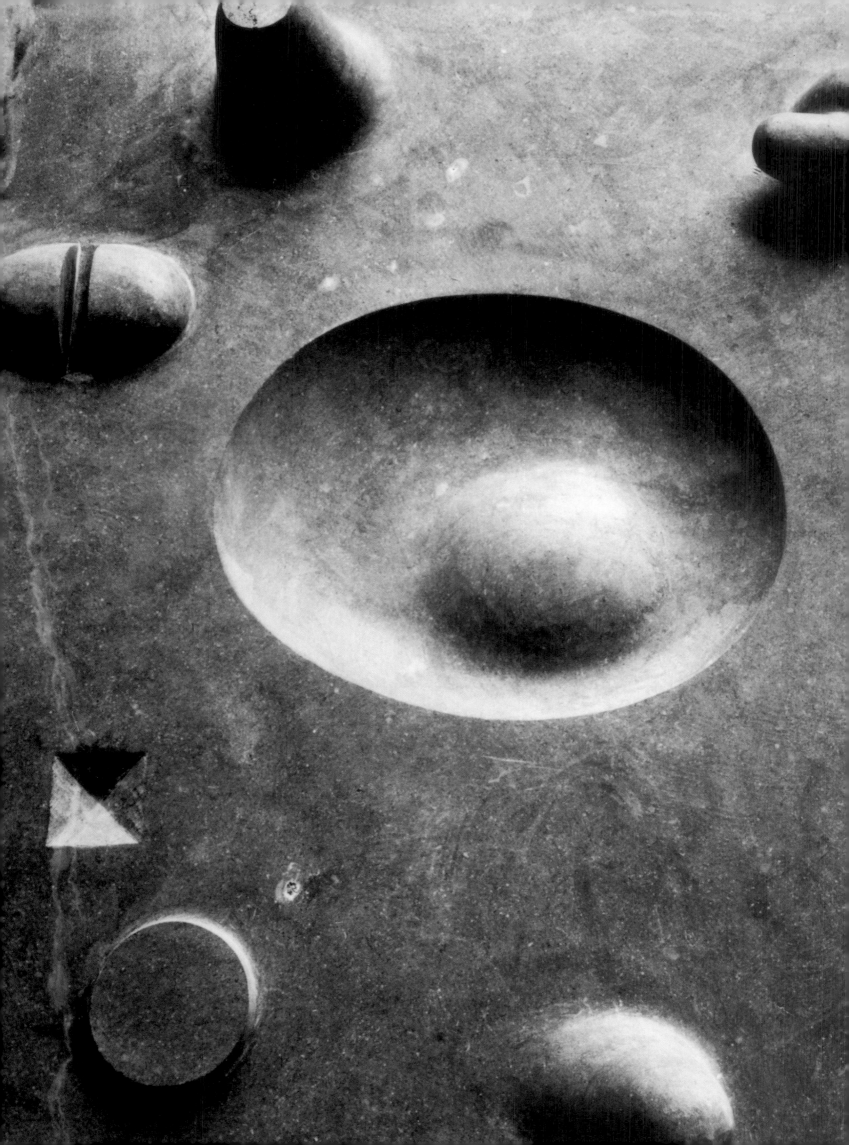

OPPOSITE AND BELOW
**Two views of *Night Land
(Night Voyage)*, 1947. York fossil
marble; 22 x 47 x 37 ¹/₂ in.
(55.8 x 119.3 x 95.2 cm).
The Hall Family Foundation
Collection, Nelson-Atkins
Museum of Art, Kansas City.**
Photo by Bill Jacobson Studio,
courtesy PaceWildenstein.

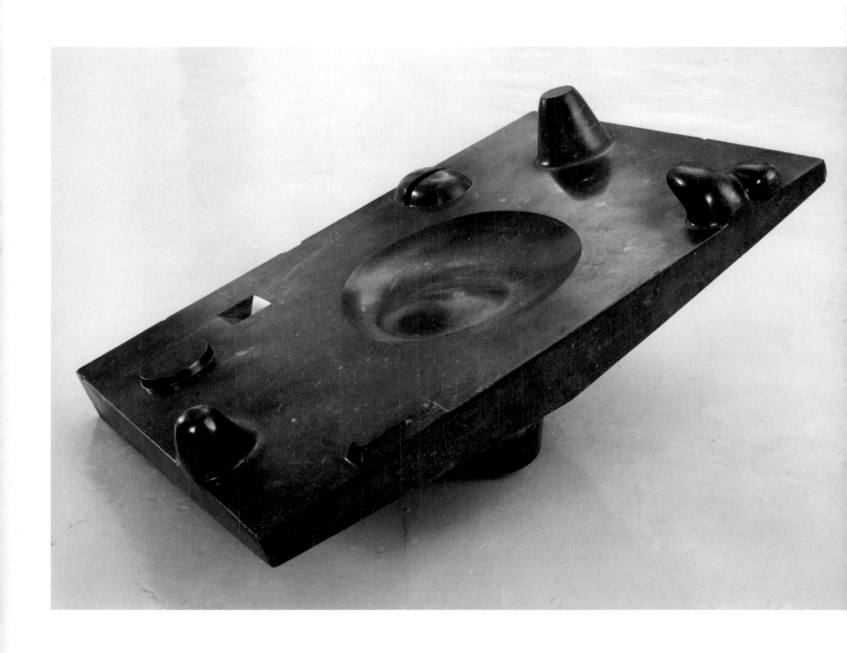

at The Museum of Modern Art in 1946, the range of works—including *My Pacific*, *Monument to Heroes*, *Katchina*, *Kouros*, and *Gregory*—made clear his multicultural sources of inspiration. His interlocking sculptures and metaphoric landscapes demonstrated the viability of biomorphism at the very moment when the Surrealist movement itself was fading away. Noguchi's statement in the catalogue makes no mention of his remarkable recent works. Instead he addressed the future, asserting that art can be a powerful means of rebirth and growth. Acknowledging that "awareness is the ever changing adjustment of the human psyche to chaos," he wrote that the postwar era required a "constant transfusion of human meaning into the encroaching void."[52] This statement suggests that Noguchi was familiar with Jean-Paul Sartre's existentialist philosophy, which had first been presented in his massive tome *L'être et le néant* (*Being and Nothingness*) in 1943.

Sartre's ideas became internationally famous in early 1946 through his succinct and compelling essay "Existentialism Is a Humanism" and through his lecture tour in the United States. Sartre spoke eloquently about concepts such as the void, nothingness, freedom, alienation, and self-determination. He defined the term *le vide* (the void) not merely as emptiness, but as the lack of any inherent meaning in life. He asserted that even though everyone may not be conscious of it, the fundamental purposelessness of life gives rise to a primal state of angst. Many intellectuals, writers, artists, and filmmakers accepted this premise, portraying life as dark and pointless.[53] Seeking a way out of his own emotional abyss, Noguchi found inspiration in Sartre's philosophy, as indicated by the sculptor's statement: "Our existence is precarious, we do not believe in the permanence of things. The whole man has been replaced by the fragmented self; our anguish is that of Buchenwald and impending cataclysms." This phraseology echoed rather explicitly Sartre's essay in the exhibition catalogue for Giacometti's sculptures at the Pierre Matisse Gallery in early 1948. Sartre likened Giacometti's skeletal figures to survivors of concentration camps and acclaimed them as testaments to existentialist angst and determination. Noguchi was deeply moved by Giacometti's postwar sculptures, even adapting the *Hand* for the centerpiece for his own proposed memorial to Gandhi in 1948–49.

Drawing after "This Tortured Earth," **1947. Ink on paper; 2¹/₂ x 2¹/₈ in. (6.35 x 5.3 cm). The Noguchi Museum, New York.** Photo by Kevin Noble.

Sartre emphasized what can emerge from the absence of predetermined meaning in life: every person is free to define his or her own goals. As the result of countless decisions, we become who we choose to be: "Man is nothing else but that which he makes of himself."[54] Sartre exhorted his audiences to take action toward improving oneself and the world. Noguchi published two essays in 1949: "Towards a Reintegration of the Arts" and "Meanings in Modern Sculpture,"[55] in which he asserted that art can help shape society in positive ways:

> When the very meaning of life becomes obscure and chaotic, how necessary is the order with which the practice of the arts leads to harmony and without which there is only brutality. I think of sculpture especially as the art of order—the harmonizer and humanizer of spaces.

Art can bring "a sense of belonging out of our loneliness" and can "give meaning when there was none." As Fuller had long advocated, Noguchi wanted to use the subliminal power of physical objects and environments to affect people's states of mind in positive ways. He synthesized the Constructivists' desire to improve society with the Surrealists' goal of transforming and expanding personal consciousness. And Noguchi now brought into the open his long-simmering idea that aesthetic experience at its best offers more than mere visual pleasure:

> When artists seek a reality beyond actuality, how many depths and how many truths separate the aesthetic and the religious emotions? If religion dies as dogma, it is reborn as a direct personal expression in the arts. I...refer...to the almost religious quality of ecstasy and anguish to be found [in] abstract art. Using the ever more perceptive truths of nature's structure, the invocation is still to God. I see no conflict between spirituality and modern art...; rather it opens another channel to our non-anthropomorphic deity.

Drawing after "Night Land," 1947. Ink on paper; 3 1/4 x 5 3/8 in. (8.2 x 13.7 cm). The Noguchi Museum, New York. Photo by Kevin Noble.

Noguchi was certainly not proposing that art become a new religion, only that art could offset the increasingly commercialized and depersonalized lives of modern people: "An anti-materialist revolution is necessary, but...we need [not] retire into yogihood." Instead, artists should step up to the challenge of offering meaningful aesthetic experiences to the public: "For the artist there is the special duty...to seek profoundly through the imagination the truth and send its light into the darkness of men's hearts."

The emotions expressed in *Night Land*, *Hanging Man*, and *Cronos* contradict the valiant goals proclaimed in the artist's essays. In fact, he was not sure how to proceed. His earlier commitment to European utopian ideas and to Social Realist imagery were no longer viable options. Those modes had become dangerous in the postwar years, especially while the House Committee on Un-American Activities and Senator Joseph McCarthy were

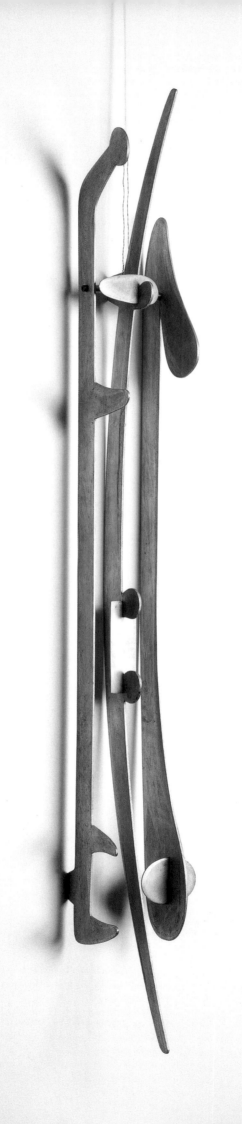

The Field, 1948. Redwood
and marble; 6 x 10 $^1/_2$ x 11 in.
(15.2 x 26.6 x 27.9 cm).
Private collection.
Photo courtesy PaceWildenstein.

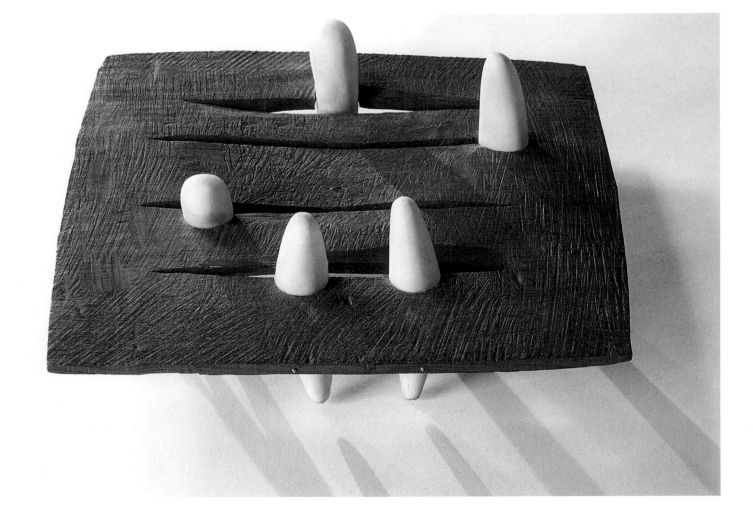

maliciously hunting for leftist writers and filmmakers. Most artists and critics sought refuge in abstract art that avoided any reference to reality and current events. Determined to find ways to create sculptures beneficial to the common man, Noguchi sought inspiration abroad (as he had in 1927–28 and 1930–31). In May 1949 he received a research grant from the Bollingen Foundation, which was dedicated to furthering intercultural activities. Noguchi left the United States to study monuments of social and religious significance in diverse locations: the ancient pyramids in Egypt, the prehistoric Druidic dolmens at Stonehenge in England, the medieval Buddhist temples of Borobudur in Java (Indonesia) and Angkor Wat in Cambodia, the Hindu cave temples at Ellora (India), the Mughal Taj Mahal at Agra, and Zen monasteries and temples in Japan. These travels, completed in stages between 1949 and 1953, confirmed Noguchi's belief that art could benefit the masses. In ways analogous to the places he had visited—but in terms suited to modern audiences—his sculpture would strive to attain that sense of connection. If he could experience the meditative sanctuary of temples without espousing those religions, if he could feel at one with nature in the artificially contrived gardens of Zen monasteries, then surely somehow he could create an echo of those experiences in his sculptures.

Ruins of the Museum of Science and Technology in Hiroshima, July 3, 1947.
Photo © Bettmann/Corbis.

Noguchi was profoundly affected by his visit to Japan—his first since 1931. Seeking to understand his heritage more fully, and concerned that the American occupation was destroying precious aspects of Japanese culture, he made an intense study of the traditional arts in Kyoto. This inspired the artist to look for ways to build "a fence against the dark."[56] His prewar interests in public monuments and commercial design reemerged strongly in two projects in 1952, which he approached as complementary opposites: one concerned with death and darkness, the other with light and transcendence. For Hiroshima he proposed a *Memorial to the Dead*. It was to consist of an austere parabolic arch rising 26 feet above a square platform and extending below into a subterranean chamber. The massive proportions of the black granite arch demand sobriety and respect, quite unlike the celebratory effect of the nineteenth-century Arc de Triomphe in Paris or Eero Saarinen's soaring Gateway Arch in Saint Louis in the mid-1960s (see page 222). In Noguchi's plan, the mausoleum below ground would contain a black-granite casket with a list of the names of Hiroshima residents who had died from the atomic blast and its aftermath. Suspended in the center (like the falling tears in *Cronos*) was a panel with the calligraphic ideogram for the word "courage." Although rejected by the authorities, Noguchi's proposal had a conceptual simplicity and symbolic power that anticipates what Maya Lin would later accomplish with the "wall of the dead" of the Vietnam Veterans Memorial in Washington DC.

Simultaneously, Noguchi began to design *akari* (paper lamps) for mass production. While making *Lunars* in 1943–44, he had devised a

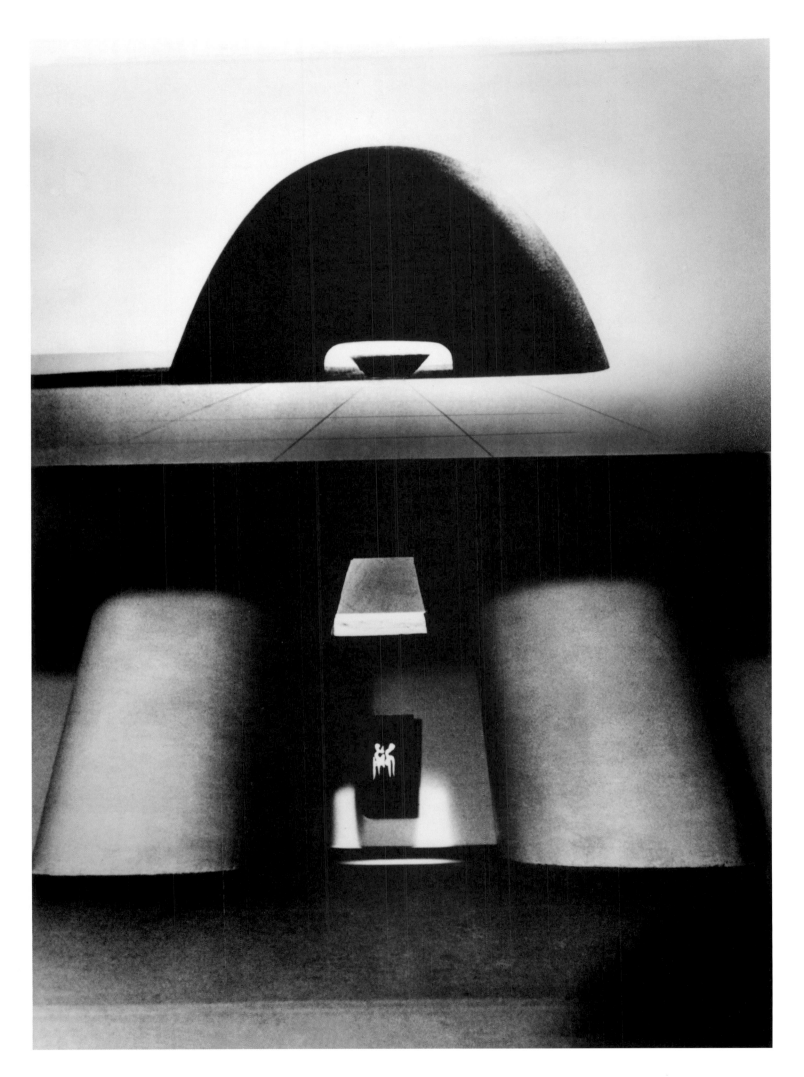

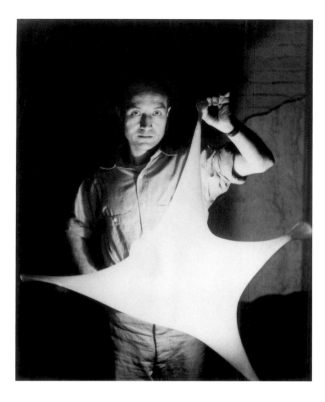

light sculpture made from stretchable cloth. In Japan eight years later, using the traditional rice paper and bamboo, Noguchi devised many shapes and sizes of *akari* to be sold at modest prices. Gradually he developed larger variants as sculptures that were featured in an exhibition as "shapes of light."[57] When viewed in a darkened gallery, these sculptures manifest two kinds of light: the luminous paper surfaces themselves and the ephemeral glow that extends outward into the surrounding space. Noguchi enhanced this incorporeal experience by hanging them from the ceiling so that they appear to hover weightlessly in midair, creating an environment for the experience of light—not light for practical purposes, but light as an intangible state, beautiful in itself and capable of distancing viewers from mundane reality. In the 1960s other sculptors began creating sculptures of light, notably Robert Irwin, who blurred the distinction between light emanations and translucent plastic disks.

Noguchi with "Light Sculpture," c. 1944. Cloth and electric light; dimensions unrecorded. No longer extant.
Photo by Rudolph Burckhardt, courtesy The Noguchi Museum.

During the early 1950s Noguchi increasingly identified himself with his Japanese heritage. Married to the film star Yoshiko (Shirley) Yamaguchi, he insisted on living in a traditional thatched house and began to wear kimonos at a time when most Japanese were abandoning them. The artist learned to speak and write Japanese, and he used the old-fashioned technologies of ceramics and iron casting for his sculptures. Among his iron works, the somber *Atomic Head* consists of a masklike face that is roughly textured and has only one eye. In contrast, *Okame* (see page 195) is lighthearted: the title refers to a good-natured, fat, and licentious female character in Japanese folklore who invites others to enjoy the pleasures of life. Several clay pieces refer to the long tresses of a character from a Chinese opera based on a folktale about a seductive woman who morphs into a serpent; Noguchi's wife played the lead in a movie adaptation of the tale. Some of his clay works challenged contemporary Japanese ceramists

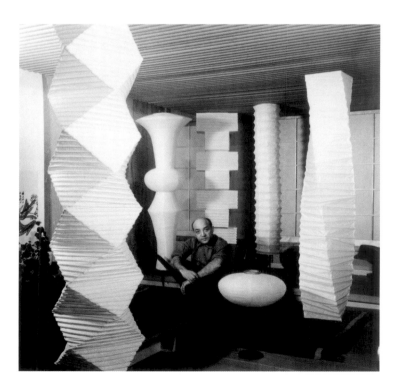

Noguchi with akari light sculptures in New York studio, 1960s.
Photo courtesy The Noguchi Museum.

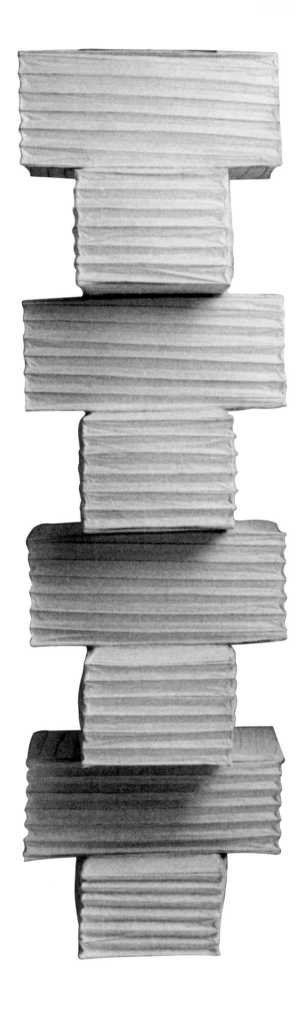

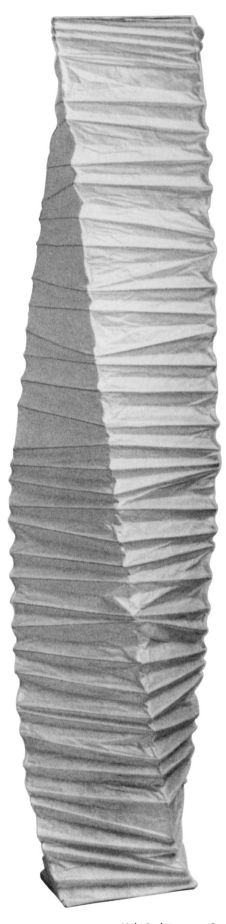

Light Sculptures, 1956–57.
Rice paper, bamboo, wire and
electric lights; H. approximately
8 ft. each (2.4 m).
The Noguchi Museum, New York.
Photo by Michio Ito.

War (Helmet), 1952.
Terracotta; 28 $^1/_8$ x 13 x 12 $^3/_8$ in.
(71.3 x 33 x 31.4 cm).
Sogetsu Art Museum, Tokyo.
Photo by Lab Station.

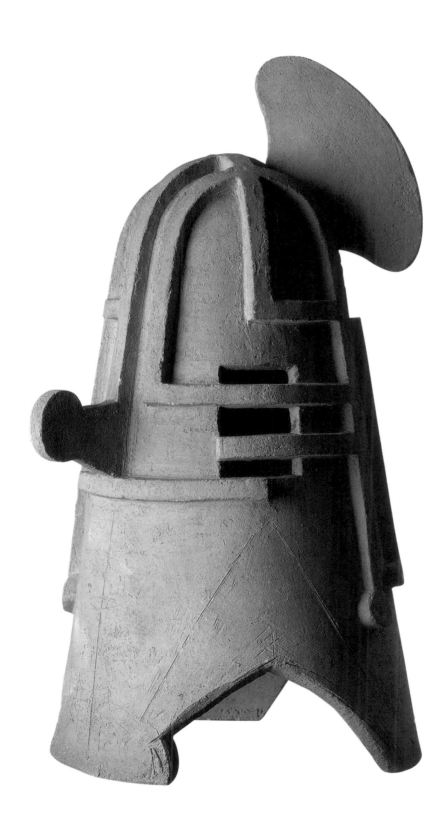

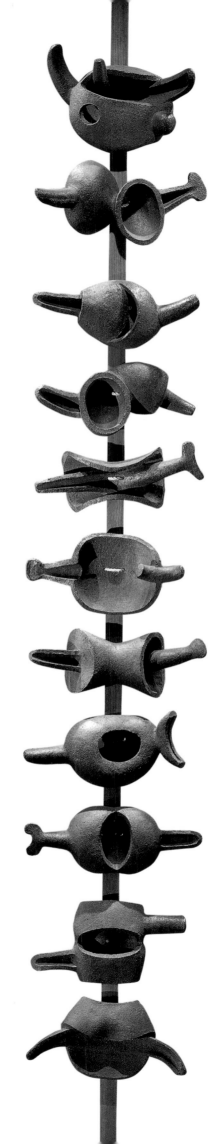

Even the Centipede. 1952. Red
stoneware and hemp cord on
wood pole (pole replaced 2003);
165 1/2 x 18 in. (420.6 x 46 cm).
**The Museum of Modern Art, New
York; A. Conger Goodyear Fund.**
Photo by John Tsantes, courtesy Arthur M. Sackler
Museum, Smithsonian Institution.

to blur or erase the distinction between craft and sculpture—a goal that Peter Voulkos was also pursuing in his clay compositions in California.

Even the Centipede, his largest clay sculpture, consists of 11 modeled forms attached to a two-by-four inch wood pole. Noguchi recalled that he created this composition after seeing how a centipede, if cut in two, can walk away as two separate ones—a lowly but effective metaphor for surviving trauma and continuing life.[58] Noguchi also indicated that this sculpture was intended to present a whole comprising separate and equal elements—a synthesis of independence and cohesion, rather like the definition of an ideal society consisting of individuals. The organically shaped forms of *Even the Centipede* have protrusions on each side,

OPPOSITE
Endless Coupling, 1957. Iron (edition of 3 or 4); 58 1/2 x 14 1/2 x 14 in. (148.6 x 36.8 x 35.3 cm). Hirshhorn Museum and Sculpture Garden, Smithsonian Institution, Washington DC; gift of Joseph H. Hirshhorn.
Photo by Lee Stalsworth.

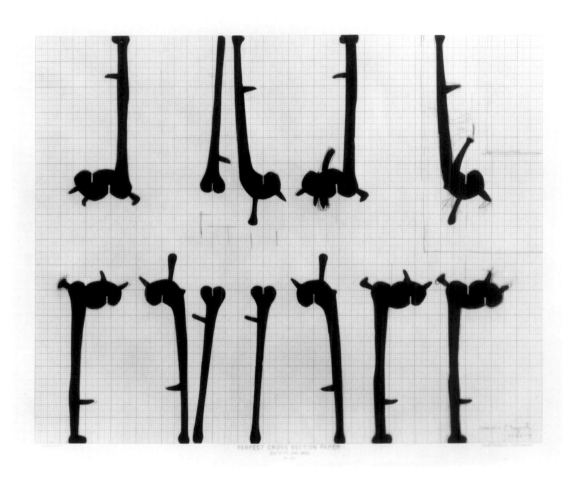

Worksheet for Sculpture, 1945–47. Black craft paper and pencil on graph paper; 18 x 23 in. (45.7 x 58.4 cm). The Noguchi Museum, New York.
Photo by Kevin Noble.

curving in slightly different directions to convey a wriggling effect akin to the vitality of scurrying insects. Some of the phallic- or finger-shaped extensions point outward, a few penetrate their own vaguely abdominal forms, and one "open wrench" form grasps at empty space. Noguchi's ability to convey a sense of movement and vitality in a static object fulfills an ancient Chinese criterion for art: to capture *chi* (*qi*)—the fundamental energy of the universe manifested in every aspect of nature. Yet in equal measure Noguchi's forms may be likened to Arp's and Calder's perky and fantastic Surrealist creatures. The shape of *War (Helmet)* (see page 126) refers to the elaborate helmets formerly worn by samurai, yet this work also has affinities with Henry Moore's *Helmet Head* sculptures made about the same time in England. What is Japanese and what is European had become indistinguishable in Noguchi's global aesthetics.

After the military occupation of Japan many Americans became interested in Japanese culture, including ceramics, Zen Buddhism, cinema, martial arts, and calligraphy. The painter Mark Tobey, the composer John Cage, and some of the Beat Generation writers in San Francisco incorporated aspects of Zen into their aesthetics.[59] The Museum of Modern Art built a

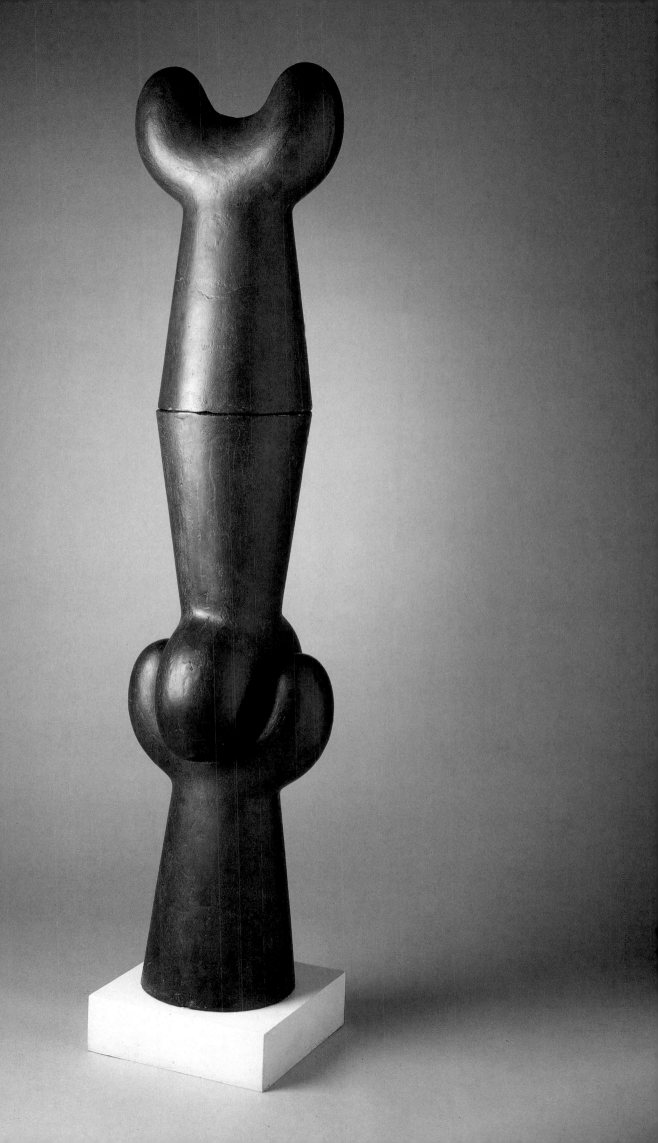

traditional Zen temple in mid-Manhattan in 1954 (see page 219) and four years later presented an exhibition of calligraphy. Although visitors could not understand what the ideograms meant, most could appreciate them as gestural abstractions having the verve of contemporary paintings by Jackson Pollock, Franz Kline, and Willem de Kooning. Noguchi's sculpture *Calligraphics* alludes to the expressive ink strokes essential to Chinese and Japanese art and literature, while the vertical arrangement of components has the totemic quality of sculptures being made by contemporary American sculptors such as David Smith and Richard Stankiewicz.

After the period of concentrating on Japanese culture for inspiration, Noguchi sought to bring aspects of it to the world, initially in the form of enclosed outdoor garden environments. From the mid-1950s onward he received increasing numbers of commissions for sculptures and gardens. His first major garden was made for the new headquarters of UNESCO, in Paris, which solicited works from various artists for indoor and outdoor locations. In contrast to Moore's characteristic stone carving of a biomorphic reclining figure, Noguchi proposed a Japanese-style garden in the rectangular area separating the main building from an adjacent one. At the entrance to the garden he placed a vertical stone slab from Japan, which he altered only by incising a few abstract motifs such as an asterisk and a

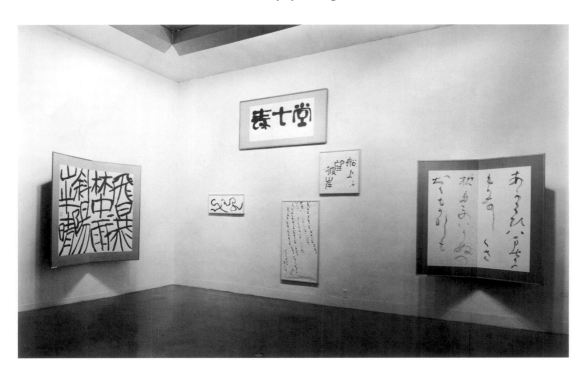

Installation view of the exhibition "Japanese Calligraphy" at The Museum of Modern Art, New York, June 22 through September 19, 1959.
Digital image © 2003 The Museum of Modern Art, New York.

serpentine form. The visitor then walks down an incline and into several self-sufficient areas, including a small island of plants and gently flowing water. Despite the surrounding buildings this space exists apart—a place for experiencing peace—something that diplomats from many nations needed to remember as their goal at UNESCO. From the entrance the entire garden cannot be seen all at once; visitors must walk into it, leaving the world behind. Noguchi, of course, learned this lesson from his study of Japanese gardens (see pages 189, 197), especially the "pleasure gardens" (designed as a succession of defined spaces, each offering a different aspect of nature) and the meditation gardens for Zen monks (gardens designed to be viewed from one side, not entered). Although traditional Japanese garden designers never mixed together categories, Noguchi was concerned only with creating an oasis apart from the materialist world. His composition also takes into account an aerial perspective. Only from above can viewers appreciate the elegant design of the garden as a whole, as a *yin/yang* melding of organic shapes. The UNESCO garden brought together

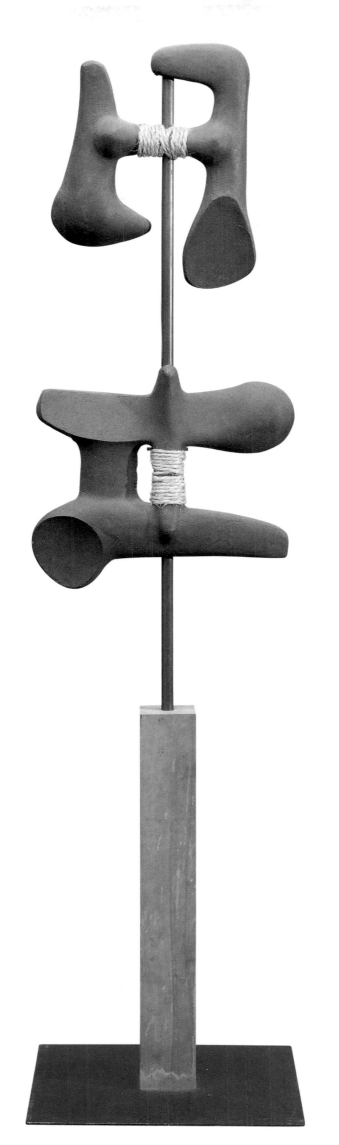

Calligraphics, 1957. Iron, rope, and wood on steel base plate (edition of 6); 70 5/8 x 18 x 3 5/8 in. (179.3 x 45.7 x 9 cm). **Memorial Art Gallery of the University of Rochester, New York; R.T. Miller Bequest.** Photo by James Via.

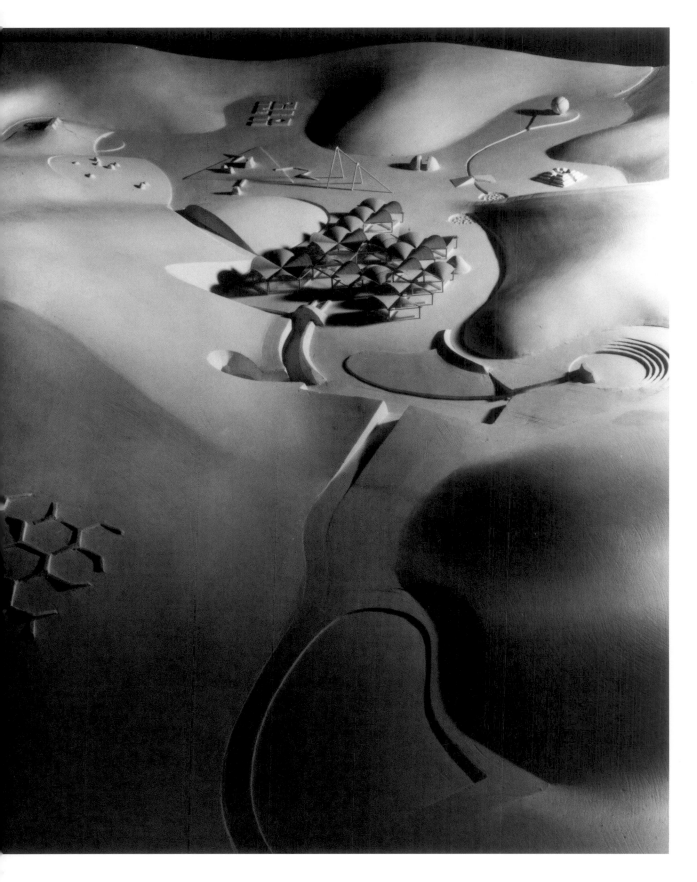

Noguchi and Yoshio Otani.
Site Model for "Kodomo No Kuni"
Playground, Tokyo, 1965–66. Plaster,
22 x 33 ⁷⁄₈ in. (56 x 86 cm).
Private collection, Japan.
Photo courtesy The Noguchi Museum.

OPPOSITE
Japanese Garden at UNESCO,
1956–58. Earth, stone
(80 tons), water, concrete, grass,
trees, lotuses, and bamboo;
18,300 sq. ft. (1,700 sq. m).
UNESCO, Paris.
Photo by Isamu Noguchi,
courtesy The Noguchi Museum.

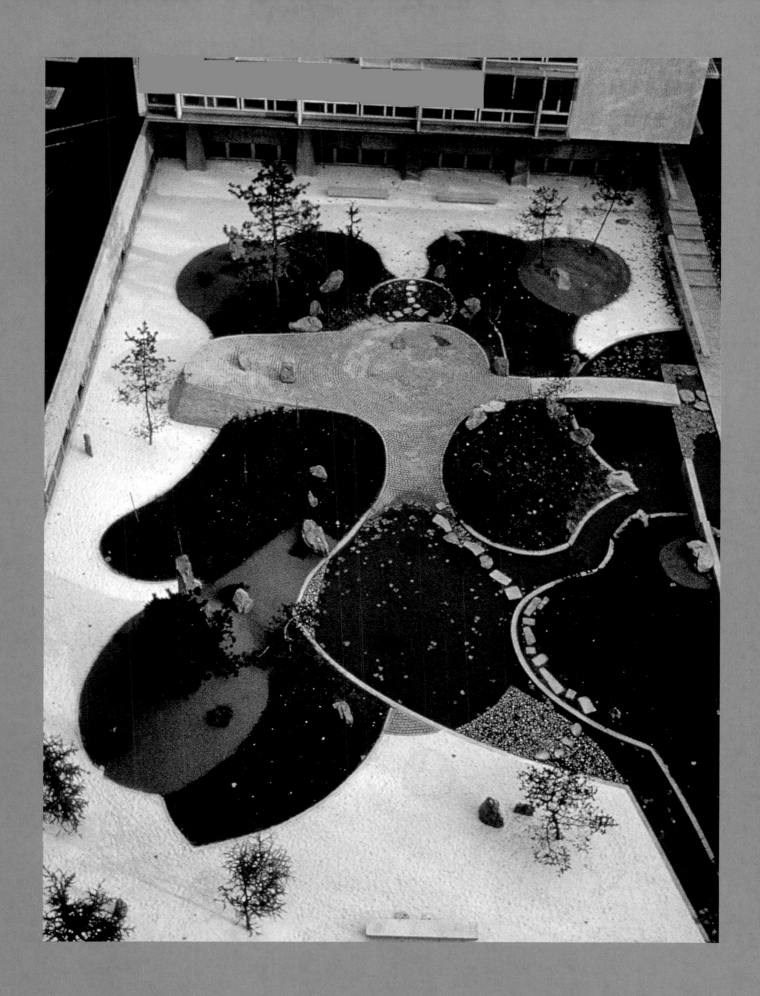

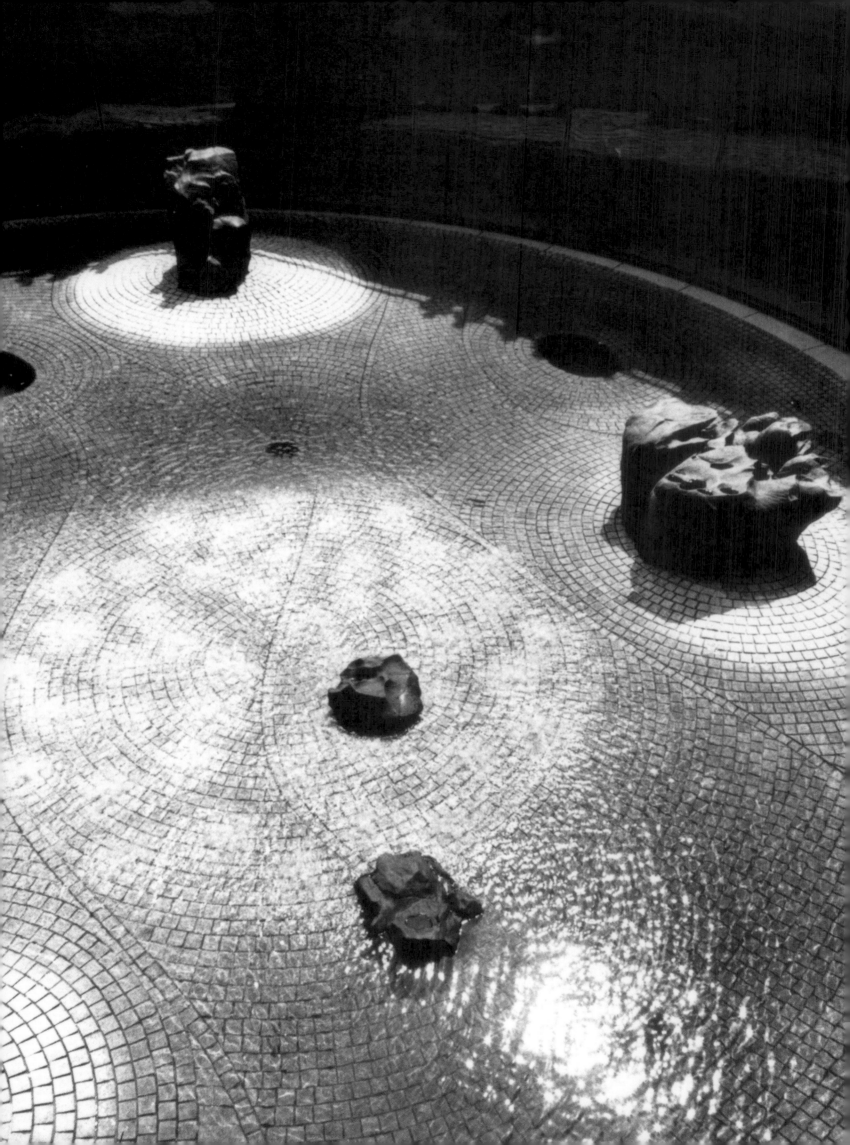

the meditative peace of traditional Japanese gardens with the Surrealist escapist yearning of the *Lunar Landscape* from 1943–44.

Noguchi's need to explore complementary opposites is apparent in two major garden designs in the early 1960s. For the Chase Manhattan Bank Plaza in the financial district of the world's busiest city, he provided a self-contained environment intended as a visual respite from the hustle and bustle of life. The sunken garden presents a pristine microcosmic landscape of mountains in a sea—Noguchi's idiosyncratic version of a Zen meditation garden. The circular shape alludes to Earth itself as well as to the sun above and planets beyond. The bottom of the garden was paved with stones arranged in circular and crescent-shaped whorls comparable to the patterns of sand raked daily by Zen monks in their meditation gardens (see pages 196 and 202). When the pavers are seen through clear water, they suggest the ebb and flow of tides or currents. Noguchi searched throughout rural Japan for the magnificent rocks that here represent mountains. He wanted a purely natural environment, so the rocks were sculpted by eons of wind and water, not by man. The asymmetrical placement of the "mountains" in the "sea" offers endlessly changing vistas, as viewers walk around the periphery. No single perspective dominates, either from the plaza above or the offices below. The quiet sound of water lapping against stones can soothe those who stop to listen. Sunlight creates lively ephemeral sparkles on the water's surface, much the same as those that soothe vacationers at a beach or on a ship. As workers and customers hasten to take care of business in New York, Noguchi's garden invites them to stop and replenish themselves, to rediscover the slower pace and rhythms of nature. Noguchi offered thousands, eventually millions, of ordinary people "the magic of discovering the world."

OPPOSITE AND BELOW
Water Garden, 1961–64. Stone, water, and cement; Diam. 6o ft. (18.2 m). Chase Manhattan Bank, New York.
Photo by Arthur Levine, courtesy The Noguchi Museum.

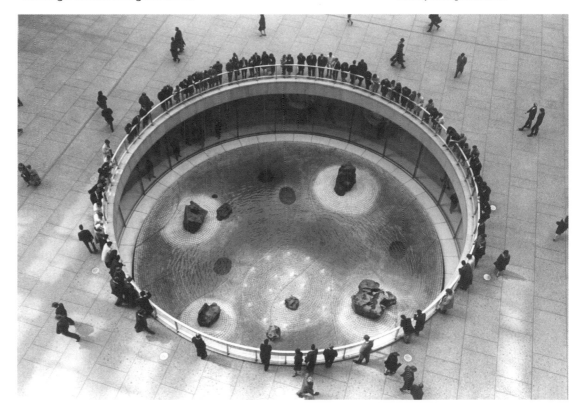

For the enclosed courtyard of the Beinecke Library at Yale University Noguchi created the antithesis of the Chase Manhattan design. Instead of taking nature as his paradigm, he produced an intellectually rigorous, entirely man-made environment. Because the Beinecke Library houses only rare books and manuscripts, visitors consist mostly of scholars and advanced students who presumably have the education needed to analyze and interpret this challenging meditation garden. Noguchi

used this opportunity to pay homage to a site he had visited in India, the eighteenth-century astronomical observatory in Jaipur. Astrologers used these geometric structures to study the movement of stars and other cosmic bodies in order to measure time and develop accurate horoscopes for Hindu children. As Noguchi noted in 1950, these now-disused structures impress modern viewers as abstract sculptures while conveying an intimation of their original purpose:

> Whether or not they were intended to do so, [these] works have turned out to be an expression of wanting to be one with the universe. They contain an appreciation of measured time and the shortness of life and the vastness of the universe.[60]

The Beinecke courtyard invites an erudite audience to contemplate the language of pure abstraction and to experience a sense of connection with the amazing order of the universe. The floor of Noguchi's garden is marked by square shapes and curving lines that may suggest global longitude and latitude as well as planetary orbits and the trajectories of comets. He conceived the three main forms to indicate certain concepts. As in *Monument to the Plough*, the gently sloping pyramid symbolizes Earth and its stability; its apex points to infinity. The donut-shaped form represents the sun, which the sculptor likened to "a ring of energy."[61] The cube balanced atop one corner suggests the precarious balance of modern civilization. Here Noguchi invited trained intellects to intuit their place in the cosmic scheme. As he once said, "[T]here is a kind of relationship which has nothing to do with a message but has to do with people's place in the world, their sense of belonging. I think that kind of thing can be suggested by art."

The austere geometry and whiteness of the Beinecke composition seems to anticipate the emergence of Minimalism, which was launched in the *Primary Structures* exhibition of 1966 in New York. The young Minimalists, including Donald Judd, Sol LeWitt, and Frank Stella, were devoted to abstract art. However, they used pristine geometric forms for their own sake, while Noguchi insisted on the validity of the universal language of abstraction as devised and defined by European utopians in the 1910s and 1920s. The Beinecke's sculpted courtyard is a realm not only of intellect but also of sociological aspirations.

After the dualist extremes of the Chase Manhattan and Beinecke projects, Noguchi reintegrated organic with geometric forms. In the courtyard garden for IBM, 1964, the white marble abstract components are balanced by a pool of water and a willow tree—an elegant solution that would inspire other landscape architects, notably Gordon Bunshaft's design for the Hirshhorn Museum's sculpture garden. Noguchi also developed the components of the Beinecke garden as individual sculptures. On Broadway in Manhattan his monumental *Red Cube* of 1968 balances its enormous mass on one

Two views of *The Astronomical Observatory of Jai Singh II, Jaipur, India,* 1727. Marble; 90 x 144 x 89 ft. (27.4 x 44 x 27 m).
Photos by Isamu Noguchi, courtesy The Noguchi Museum.

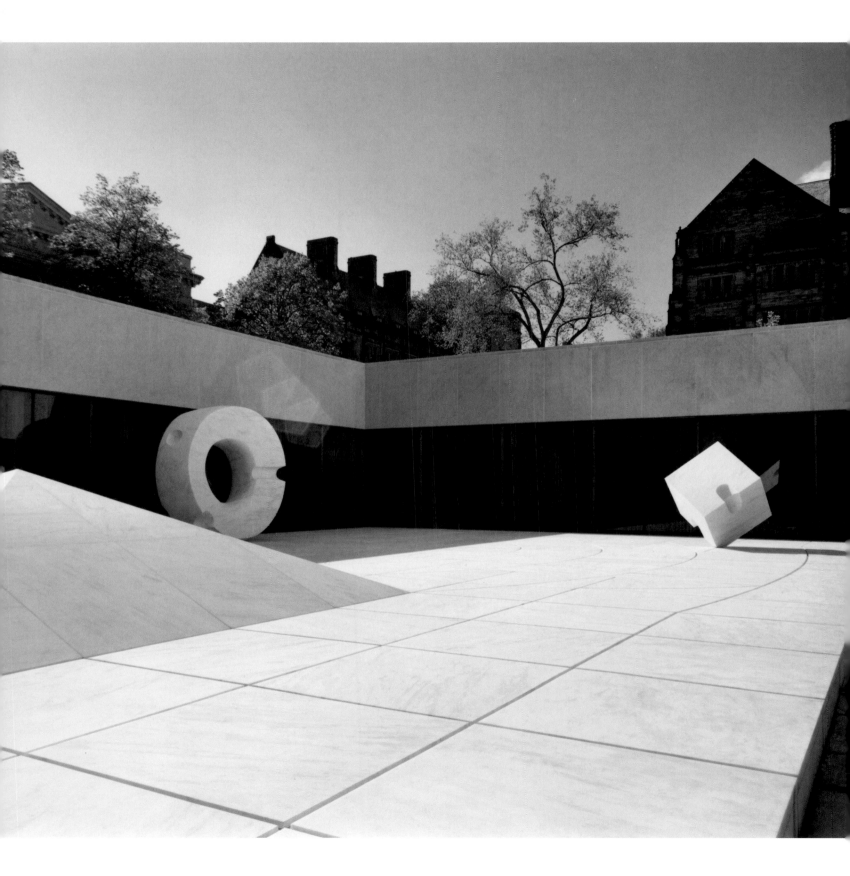

Courtyard Garden for Beinecke Library, 1960–64. White marble; 40 x 60 ft. (12.2 x 18.3 m). Yale University, New Haven.
Photo by Ezra Stoller, courtesy Esto.

corner, reminding people of the precariousness of life. In 1969 he hollowed out a cube and cut openings into each side to create *Skyviewing Sculpture*, intended to invite passers-by to step inside to contemplate the sky through the sculpture which sets them apart from the activity outside. This man-made frame for nature, which turns the clouds and sky into a moving tableau, anticipated in smaller scale James Turrell's first *Skyspace* of 1970.

During the 1960s Noguchi continued to explore complementary opposites in various ways. He led a truly a peripatetic life, living and working part of each year in New York and Japan, with regular sojourns in Italy and visits to other countries. He ascribed geographic relevance to certain materials. He determined that carving stone was appropriate for Italy and Japan, but not the United States: "It seemed absurd to me to work with rocks and stones in New York, where walls of glass and steel are our horizon, and our landscape is that of boxes piled high in the air." Metal constructions dominated American sculpture, ranging from David Smith's elegant formalist compositions to the weighty austerity of Richard Serra's steel structures. Noguchi approved of these metal constructions as eminently suitable for American art:

> The field of sculpture is being inundated with new materials and tools—many of them quite wonderful—made possible by our technology....This has stimulated our search for the expression of reality through the direct use of materials—as by direct carving, sawing, melting, flowing, welding, gluing, braising, grinding, etc....This rediscovery of the sculptor as a direct worker...indicates the promise of sculpture's growing reintegration with society.[62]

Noguchi valued this definition of the sculptor as manual laborer; as in his youth, he believed that an artist could not make art for the masses if his own life exists in a separate domain. Yet Noguchi was also an erudite intellectual; some of his works have allusions understood only by an educated elite—a paradox of intent that he never fully resolved.

Few of Noguchi's constructed metal sculptures of the 1950s and 1960s attain the subtlety or presence of his works in other media. In terms of temperament welding did not really suit him: "I don't like working in a sort of dark place with this flashing light looking through a glass hood." For a while he cut and folded thin sheets of aluminum, using the traditional Japanese techniques of paper folding (*origami*). He achieved better results in stainless steel after 1958, when he began using a professional welder and a high-speed burnishing tool. At that time Smith and George Rickey were just starting to develop their stainless-steel constructions; Smith encouraged Noguchi. *Solar* consists of a flat disk nestled between slender obelisk-like supports; near the top small semicircles protrude. Noguchi's title invites the viewer to perceive the disk as the sun, set perhaps amid mountain peaks. The sun is doubly present: the circle as indicator and the silvery surface reflecting actual light. The burnishing tool imbeds in the metal surface a barely perceptible curvilinear pattern that can catch and amplify external light. When placed outdoors, the changing angle and intensity of sunlight renders visible different patterns. Through the course of the days and seasons the sculpture can literally "show" the passage of time—a theme that would engage Noguchi's attention as he aged. When *Solar* is installed indoors, electric lighting can be dramatically staged; a single spotlight aimed at the disk, for example, can emphasize the orb's symbolic role as the source of all terrestrial life.

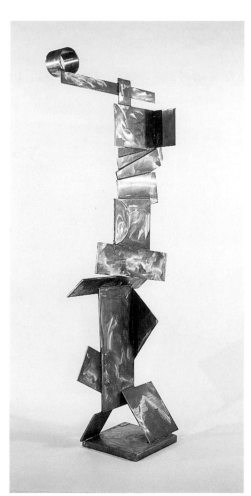

David Smith. *Lectern Sentinel*, 1961. Stainless steel, 101 3/4 x 33 x 20 1/2 in. (258.4 x 83.8 x 52.1 cm). Whitney Museum of American Art, New York; purchase with funds from the Friends of the Whitney Museum of American Art.
Photo by Jerry L. Thompson. Art © Estate of David Smith/Licensed by VAGA, New York.

OPPOSITE
Solar, 1958. Stainless steel, 97 x 35 x 9 in. (246.3 x 88.9 x 22.8 cm). Susan Lloyd.
Photo courtesy Christie's Images.

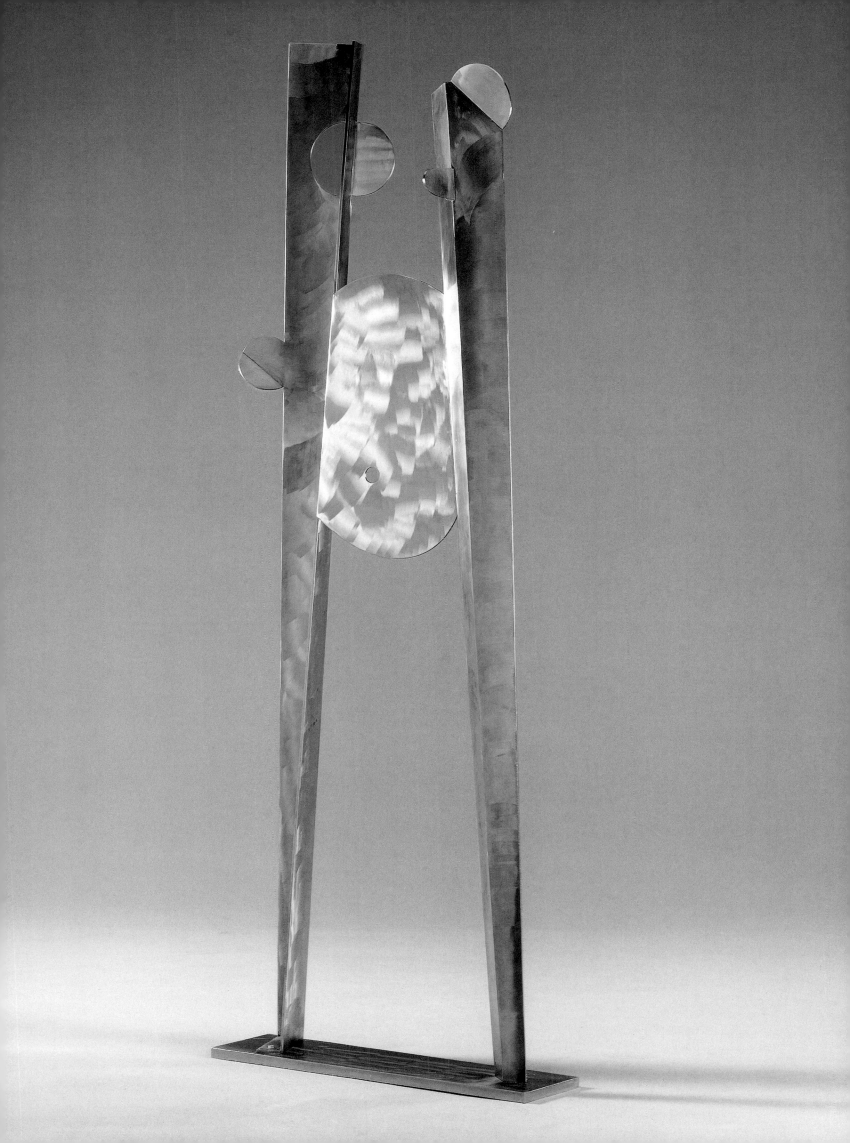

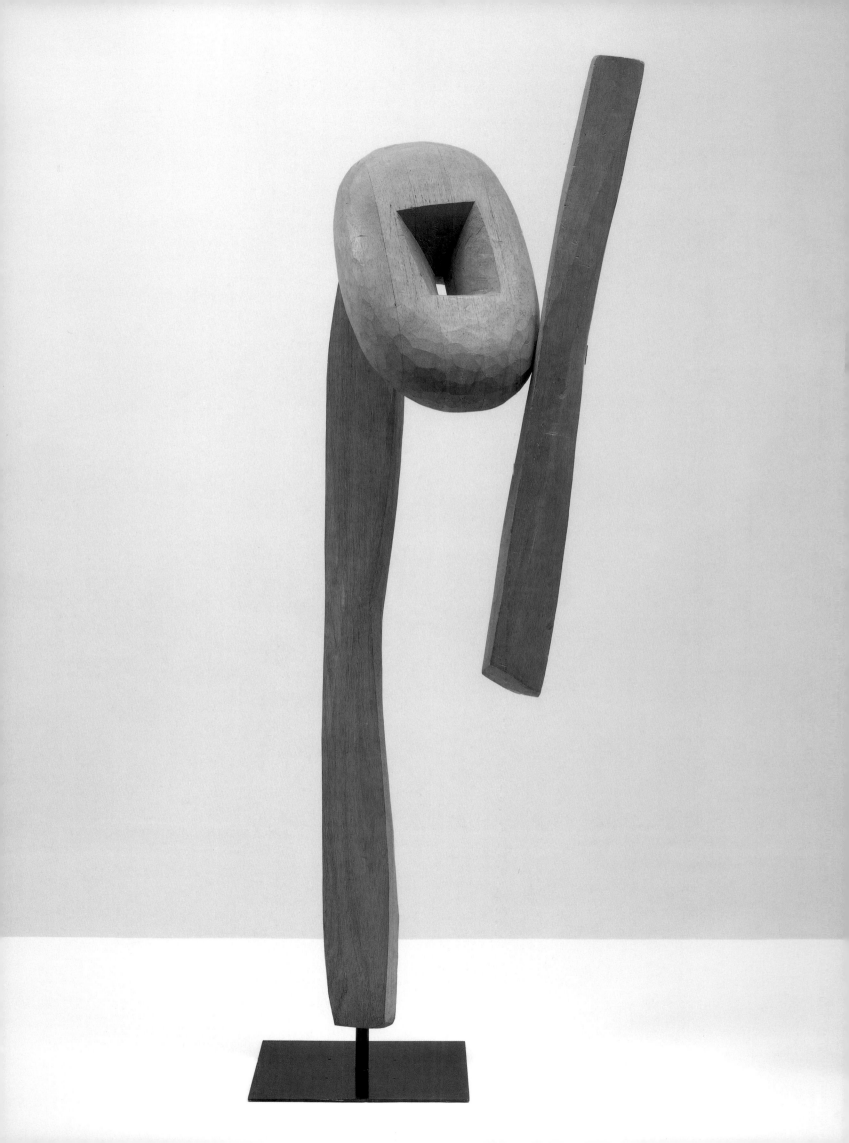

Noguchi integrated geometric form with effects of solar light in several monumental fountain-sculptures in the 1970s, especially the ones in Osaka in 1970 and in downtown Detroit. The Horace E. Dodge Fountain consists of a tripodlike stainless-steel structure that defines its own internal space, a space activated by water propelled upward and falling to earth. The open circle at the top of the tripod diffuses water into a halo of airborne droplets so fine and ephemeral that it catches sunlight in elusive rainbows. This synthesis of industrial and natural components was far more effective than some smaller indoor sculptures in which a piece of stone is mounted on a metal shaft. Although the contrast of materials can be visually pleasing, their analogies seem a bit forced: nature pierced by industrial civilization, technology supporting the spirit, and so on.

From 1959 to 1962 Noguchi created a series of sculptures expressing melancholic themes—notably *Solitude*, *The Cry*, *Victim*, and *Mortality* (see page 204). Noguchi addressed these heavy subjects by using ultra-light balsa wood, which allowed him to attach and suspend forms in ways that convey emotions. The thrusting diagonal in *Victim* suggests aggression, while the oblique element perched tangentially on *The Cry* visually emulates a voice projecting from the open mouth. The slender vertical elements of *Mortality* and *Solitude*, suspended originally by twine from the topmost piece, convey limpness and inertia. Balsa is an exceptionally soft wood, easily dented, frayed and broken—the material itself offers a metaphor for the fragility of life. For an exhibition in 1963 Noguchi had these compositions cast in bronze, a material that he normally disliked. In this case he justified it as a means of adding symbolic and literal weight,[63] but the bronze diminishes the impression of vulnerability and helplessness so effectively achieved in the balsa wood originals.

Horace E. Dodge Fountain in the Philip A. Hart Plaza, Detroit, 1972–79, stainless steel, water, electric lights, and computerized system; H. 24 ft. (7.3 m).
Photo by Balthazar Korab, courtesy The Noguchi Museum.

By the mid-1960s Noguchi recognized his preference for stone above all other materials:

> I love the use of stone, because it is the most...meaning-impregnated material. The whole world is made of stone.... Stone is the direct link to the heart of matter—a molecular link. When I tap it, I get an echo of that which we are. Then, the whole universe has resonance.

He wanted to experience the reality of each stone, to merge his consciousness with it: "I try to look in a rock and find...the spirit of a rock." This approach was partly derived from his deeper understanding of Zen, yet his desire to *know* stone in every way possible, to always discover something new in it, was also the methodology of phenomenology. Sartre and especially Maurice Merleau-Ponty had defined knowledge as the cumulative results of long-term empirical study, analysis, and intuition. At any one time the entirety of an Other (object, person, idea, emotion, etc.) cannot be fully perceived, only an aspect of it. Each observation or insight adds to the observer's knowledge; the process is endless because each Other has innumerable aspects. In some instances a person may experience an intense sense of direct connection. Thus the process itself provides purpose and awareness. Although Noguchi did not describe his persistent exploration of stone in phenomenological terms, his approach was remarkably similar.

OPPOSITE
The Cry, 1959. Balsa wood on artist's steel base; 86 1/4 x 30 x 20 in. (219 x 76.2 x 50.8 cm).
The Solomon R. Guggenheim Museum, New York.
Photo by David Heald.

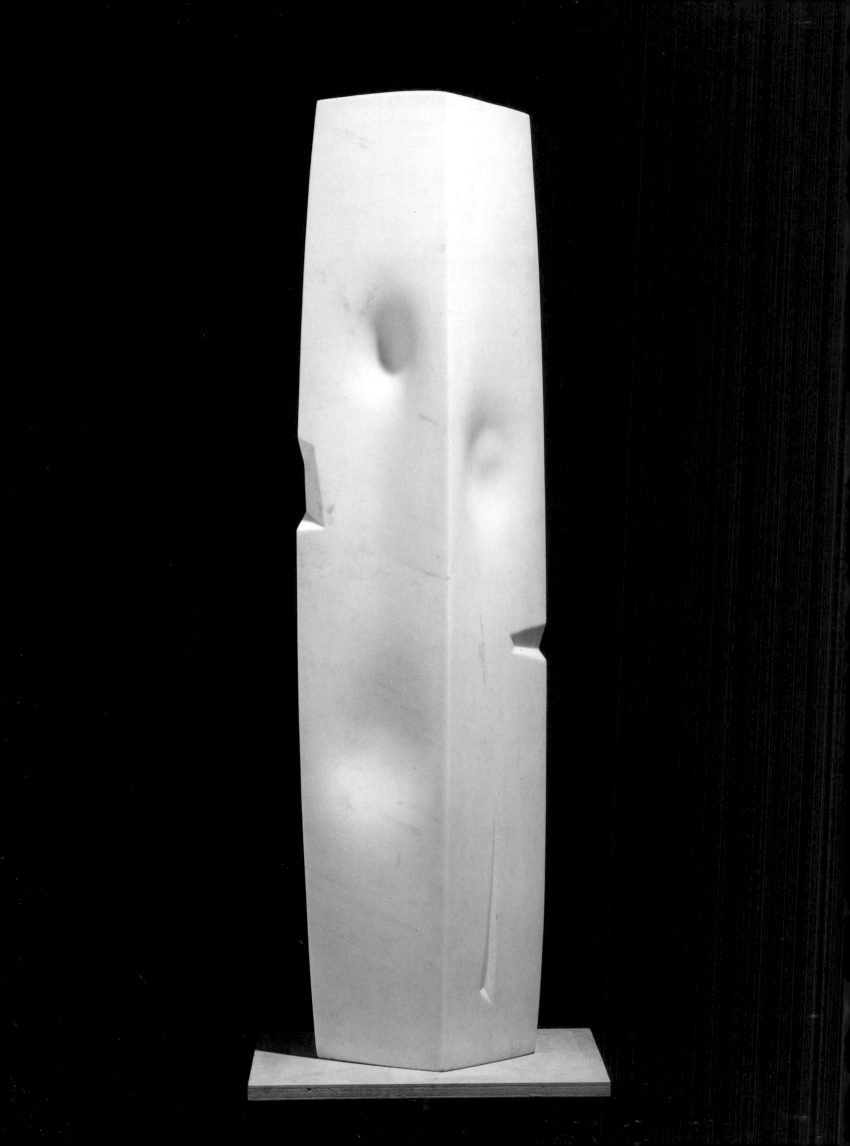

Noguchi favored certain types of stone for their appearance, texture, and potential meaning(s). As he once noted, "when I work in heavy granite, I become heavy in thought and emotion."[64] During the 1960s he especially favored various types of granite and marble. A metamorphic stone created by heat and pressure over long periods of time, marble has a crystalline structure that differs depending on its source. It often incorporates flecks of quartz and mica that catch light in various ways, lending a subtle luminosity to stones with the largest and most numerous crystals. Colors range from pure white and black to gray, pink, yellow, and green. Some marbles incorporate two hues, such as white with a salmon-pink grain or dark gray with green. Noguchi usually selected marble from quarries in Greece and especially in Italy. At the Henraux quarry near Lucca, Noguchi had access to experienced stonecutters and their latest technology, specifically a diamond rotary saw that measured a meter (about three feet) in diameter. The new tool allowed larger pieces of marble to be cut along precise lines; this challenged him to experiment and work on a larger scale. A rectangular block of pure white marble, for example, could inspire Noguchi to respect the stone for itself. In *Integral* he modified the straight edges into elegantly tensioned curves and small notches. A stone of exceptional purity standing solid and upright offers a quiet tribute to any uncorrupted person or thing. Conversely, Noguchi made *To Darkness* from deep black marble; after carv-

To Darkness, 1965–66.
**Black marble; 17 x 70 x 17 in.
(43 x 177.8 x 43 cm)
on artist's granite base.
The Noguchi Museum,
New York.**
Photo by John Berens.

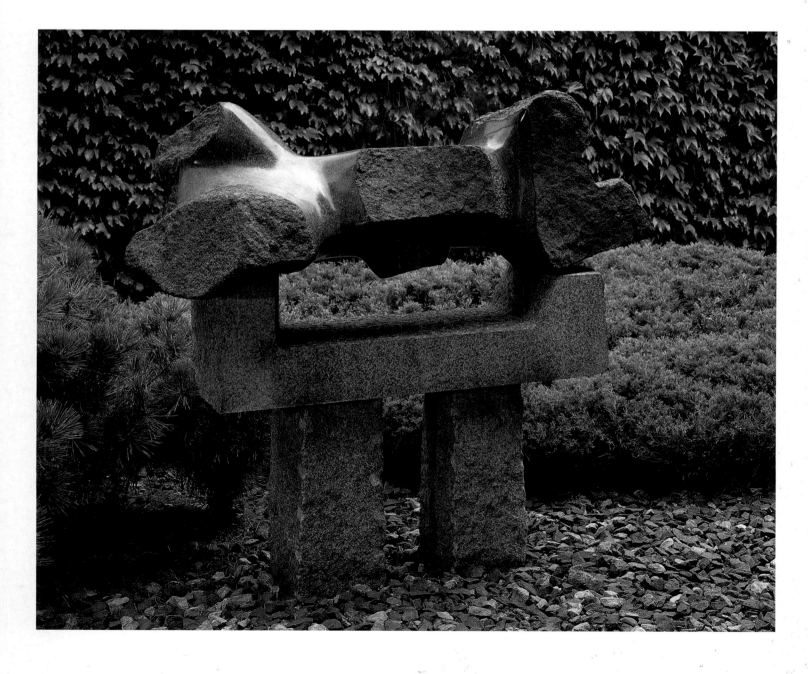

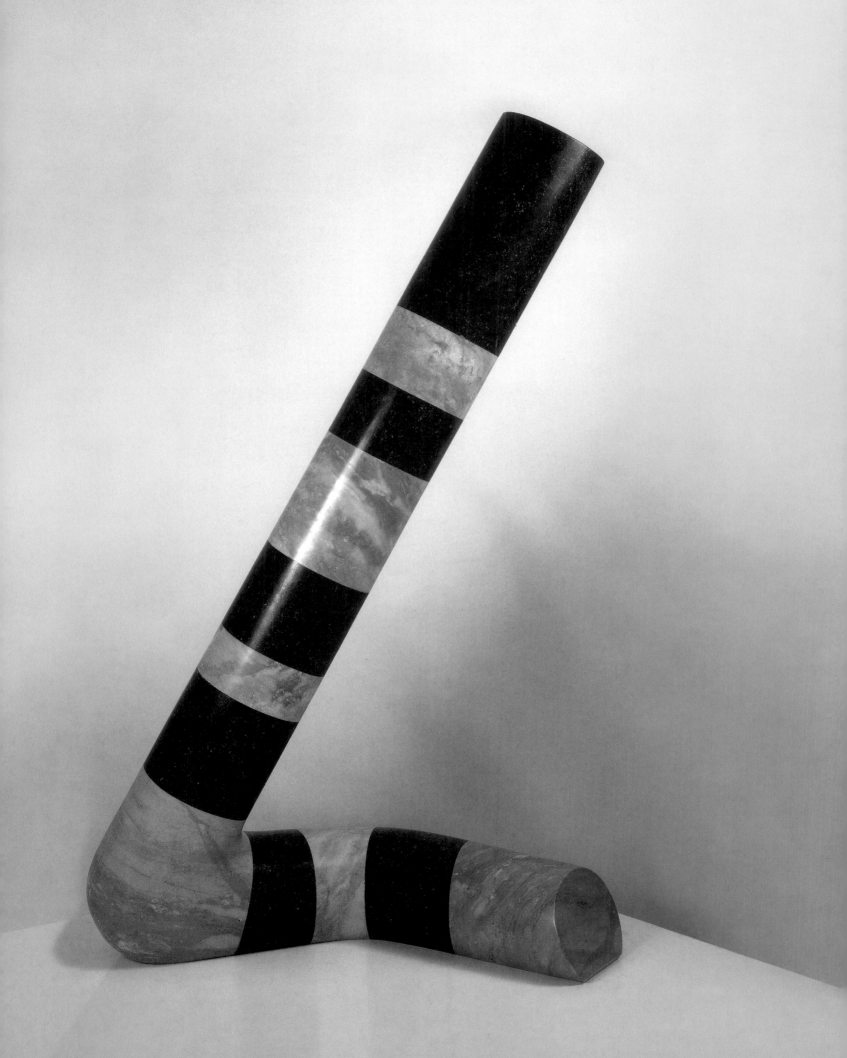

ing and polishing it, he broke off the ends. The contrast between smooth and jagged conveys a sense of something fine having been abused and damaged—perhaps an analogy for the effects of life's tribulations on the human spirit.

In a series of sculptures constructed from segments of differently colored marble Noguchi played with the sheer beauty of the materials. The pattern of alternating segments pays homage to the striated facades of medieval churches in Tuscany—places of refuge and contemplation. Noguchi's method, however, was more akin to structural engineering. He strung the heavy marble segments together on an internal steel wire, like beads on a necklace, but torqued into dynamic linear shapes. *The Bow*, for example, might allude to the movement of a respectful Asian greeting, or a performer's acknowledgment of applause, or the tension of an archer's weapon (which traditionally in Japan is pulled taut while the arrow is pointed at the ground), or an exceptionally large and assertive checkmark. Above all, *The Bow* is an elegant abstract sculpture exuding a directional energy. The strict alternation of elements in perfect alignment invites comparison with the contemporaneous wall-mounted "stacks" by Judd. Like Noguchi, Judd emphasized the contrast of materials (such as wood and lead, or brass and plastic), but he did so purely for their visual effects, not as indicators of any attitude toward society or technology. In *The Sun at Noon* Noguchi used alternating marble segments as an allusion to the movement of the sun itself and to clocks that measure its passage in time.

The sun became one of Noguchi's preferred motifs, both for the purity of its shape and the innumerable connotations associated with it. As the source of life on earth, the sun symbolizes creation and renewal; in some religions

Noguchi at the Henraux quarry, Pietrasanta, Italy, 1970.
Photo by Arnold Eagle,
courtesy The Noguchi Museum.

it is equated with divinity. Noguchi's sun sculptures are not solid circles; generally he preferred a disk. This emphasis on contour avoided association with the rising sun of the Japanese flag, and allowed the artist to play with the relationship of mass to void. The granite *Black Sun* has deeply carved, energetic forms on the front and back surfaces. Using black stone contradicts the sun's inherent brightness, thereby integrating and balancing the *yin/yang* of light/dark. In contrast to *Black Sun* and the Beinecke's white one, *Sun at Noon* has more opening than stone. According to Noguchi, the empty center represents "the zero of nothingness from which we come and to which we return"—an allusion to the Hindu and Buddhist concepts of existence as cyclical, emerging from the universal void and returning to it. Noguchi created a series of sculptures on this theme, including *The Void*, *Walking Void*, and *Energy Void* (see pages 208, 209). The word itself has a negative connotation, as in the phrase "his/her death left a void in my life." Yet the term has a powerful positive meaning: the goal of meditation in several Asian religions is to vacate the mind and to attain a consciousness transcending all thought. Thus the *Void* sculptures encompass in one entity the opposing concepts of utter emptiness and mystical union with the universe. *The Void* in rose-grained marble has a large rectangular opening intended to be seen from a frontal viewpoint. *Walking Void* is best seen in profile so that the two vertical elements appear to be striding forward. In contrast, the sinuous contour of *Energy Void* invites viewers to walk around it, discovering with every step a new relationship of solid to solid, and solid

OPPOSITE
The Bow, 1970. Yellow Siena marble and black Petit granite;
54 x 17 1/4 x 31 in. (137 x 43.8 x 78.7 cm).
Neuberger Museum of Art,
State University of New York;
gift of the artist.
Photo by Eric Pollitzer.

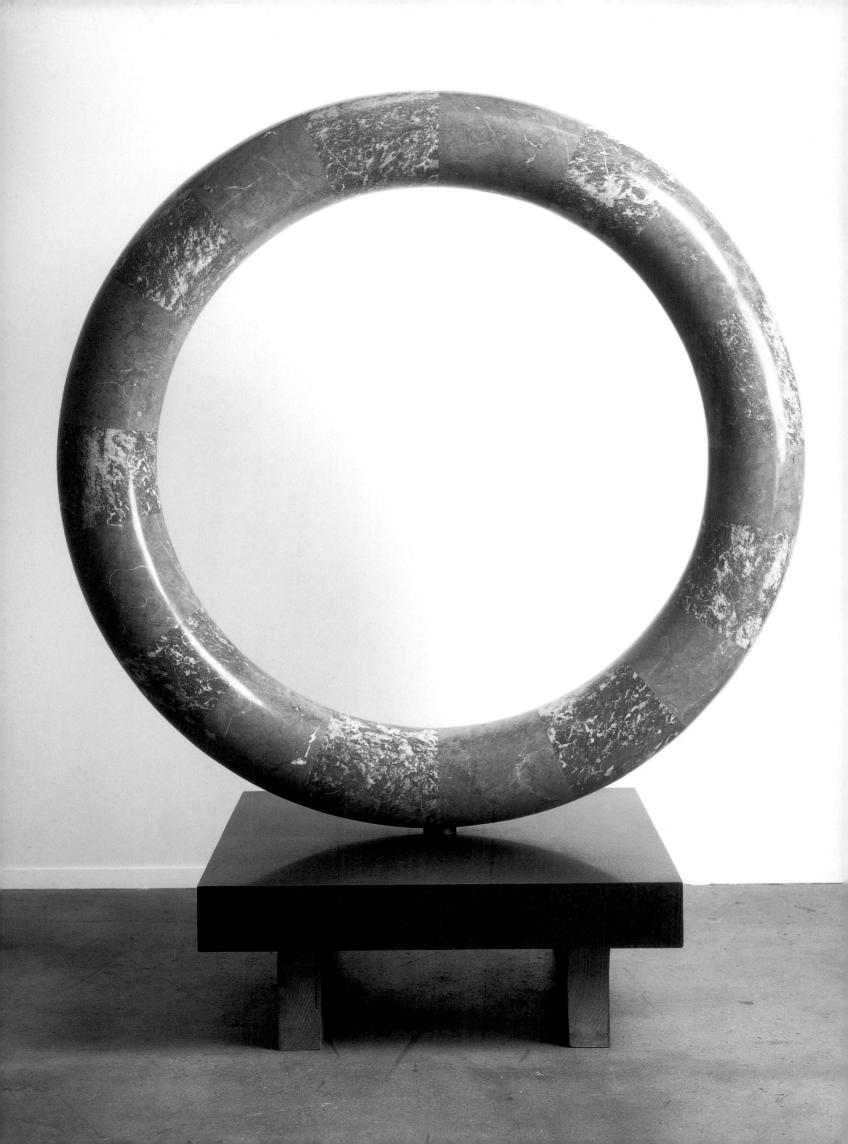

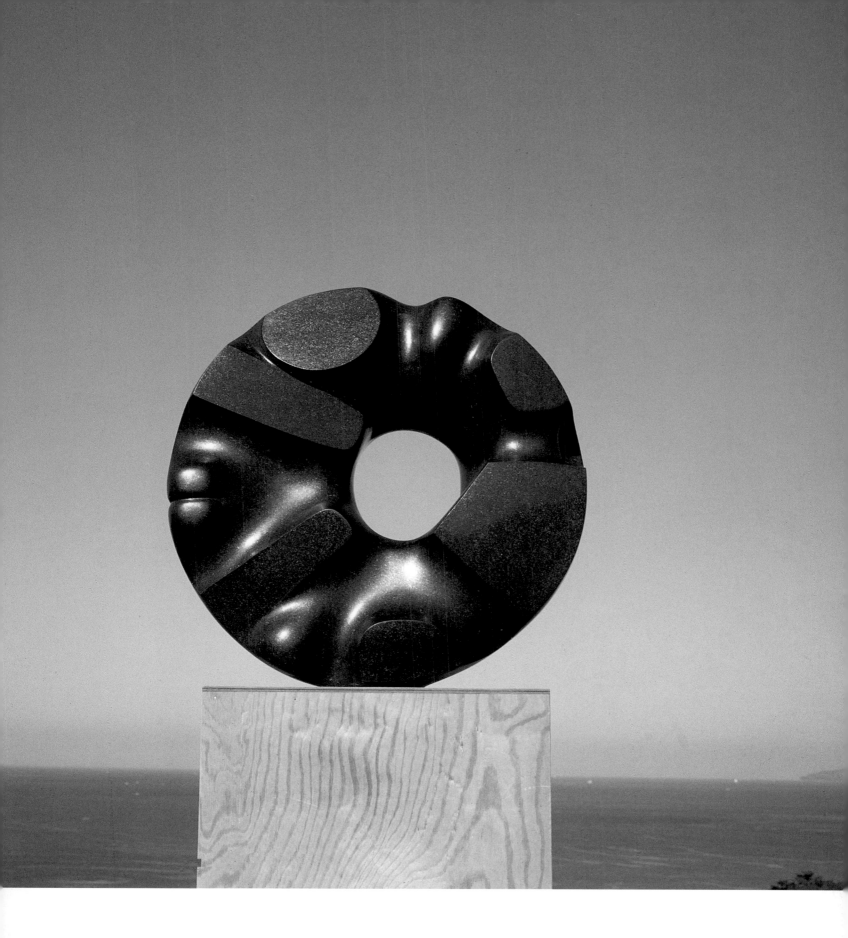

OPPOSITE
The Sun at Noon, 1969. French red and Spanish Alicante marble; Diam. 61 x 8 in. (Diam. 154.9 x 20.3 cm) on artist's stone base with wood supports.
The Noguchi Museum, New York.
Photo by Kevin Noble.

Black Sun, 1960. Swedish black granite; Diam. 30 in. (76.2 cm).
National Trust, Rockefeller Estate, Kykuit, Westchester, New York.
Photo by Michio Ito, courtesy Rockefeller Archive Center.

to void. *Energy Void* offers so many changing realities that viewers tend to walk around it several times slowly. The process has a ritual quality, not unlike the walking meditation practiced by Himalayan Buddhists and akin as well to modern tourists walking around an ancient ritual site like Stonehenge. The succession of changing compositions in one sculpture is an achievement usually ascribed to the works of Tony Smith, but Noguchi also accomplished it in his own understated way.

In his individual sculptures Noguchi continued to develop vertical and horizontal formats in tandem. The landscape-as-metaphor approach resulted in several massive outdoor sculptures, all carved in Japan. Works

OPPOSITE
The Uncertain Sea, 1968.
Black granite; 8³/₄ x 42 x 29 in.
(22.2 x 106.7 x 73.6 cm)
on artist's wood supports,
H. 8 in. (20.3 cm).
Frederick R. Weisman Art
Foundation, Los Angeles.

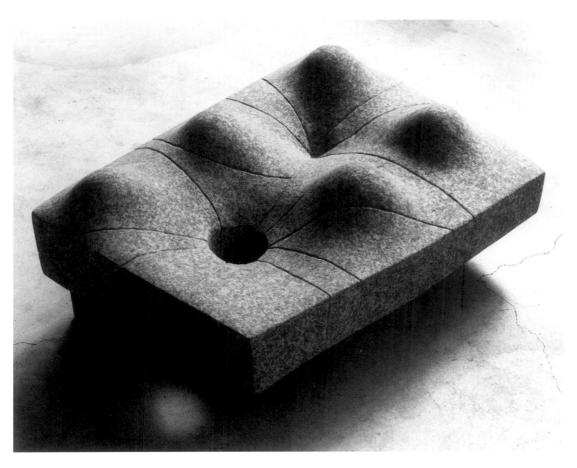

Lunar, 1961–65. Granite;
13¹/₄ x 32¹/₄ x 24¹/₂ in.
(33.6 x 81.9 x 62.2 cm).
The Noguchi Museum,
New York.
Photo by Rudolph Burckhardt.

such as *Unmei (Destiny)* (see page 153) became sculptural landscapes within the larger natural landscape. Relatively small landscape carvings such as *Lunar* and *The Uncertain Sea* from 1968 and *Galaxy Calligraphy* from 1983–84 (see page 175) remind viewers indoors of the vast world beyond the confines of buildings. The surging forms like ocean swells in *The Uncertain Sea* rise menacingly in an otherwise peaceful seascape. Perhaps Noguchi intended an indirect political allusion; 1968 was an extremely turbulent year with violent public protests in the United States and abroad. *Water Table* (see page 151) invites viewers to contemplate themselves in the blackness of the water in the two very shallow recessed areas. Noguchi chose the black granite to enhance the dark mirrorlike surface of the water, anticipating by several years Wolfgang Laib's first *Milkstone*. *Galaxy Calligraphy* invokes an infinite cosmos with distant constellations that intrigue, yet elude us. The effect of these horizontal indoor landscapes depends to a great extent on their installation and lighting. In his centuries-old house near his studio in Mure on Shikoku Island, Noguchi placed a small landscape in the dark foyer illuminated by a single overhead light. The impression of having suddenly stepped completely out of normal time and familiar place was wonderfully magical.

During the 1970s, sculptures like *Magic Ring* and *Shodo Shima (Magic Island)* (see page 152) evoke the ruins of ancient ceremonial spaces. These

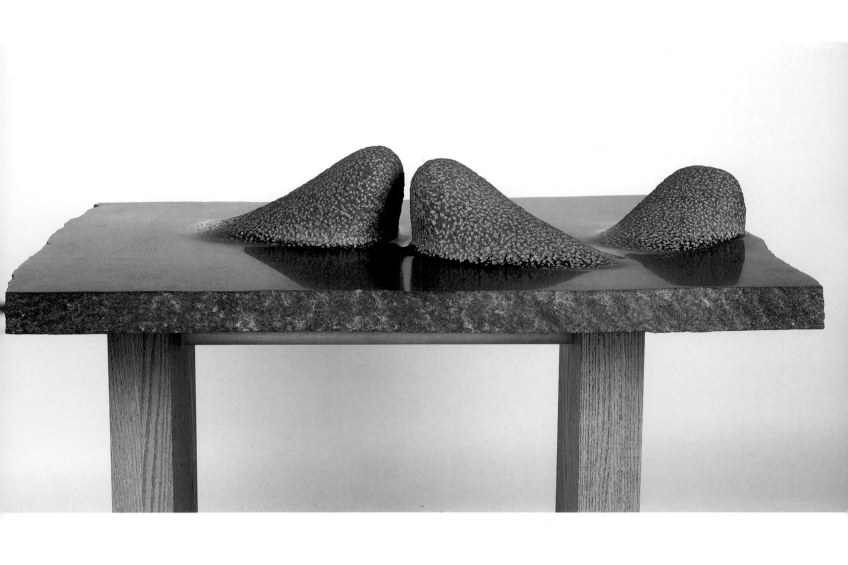

works repose directly on the earth or floor, to be regarded from above. Neither minilandscapes nor whole environments, these sculptures invite viewers to consider various allusions. *Shodo Shima* consists of two massive L-shaped stones enclosing a half-dozen stone "eggs." A child might see this sculpture as a dinosaur nest; adults may recognize the "eggs" as symbols of birth, growth, unknown potential—things that need to be protected if they are to survive and mature.

In his later years Noguchi increasingly worked at his studio in Mure, where he developed the style for which he is most famous. With local Japanese stoneworkers as assistants, he searched for large boulders with distinctive characteristics. He was particularly fascinated by basalt, which is essentially solidified lava. Basalt may incorporate other stones and mineral particles such as feldspar, iron, and copper, which add ocher, brown, yellow, and greenish hues to the basic dark gray. Through millions of years some basalt boulders have developed an encapsulating granular crust that is extraordinarily beautiful. For sculptures such as *The Inner Stone* (see page 155), *To Bring to Life* (see page 157), and *Unmei (Destiny)*, the artist made only a few decisive cuts into the stone, revealing the dark gray core. The contrast between the delicate, pale, irregularly textured exterior and the durable, dark, smooth interior is stunningly beautiful, and the metaphoric possibilities (inner/outer, old/young, etc) are almost limitless.

OPPOSITE
Water Table, 1968.
**Black Swedish granite and water;
L. 51 in. (129.5 cm).
The Noguchi Museum, New York.**
Photo by Kevin Noble.

**Wolfgang Laib. *Milkstone,*
1975, this version 1987–89.
White marble and milk;
$3/4$ x 48 x 51 in.
(1.9 x 121.9 x 129.5 cm).
Private collection.**

Noguchi likened basalt to geodes, encapsulating its own history inside. He preferred massive sculptures, each carved from a single stone and intentionally retaining an ancient appearance. Monoliths such as *To Bring to Life* evoke the mysterious dolmens of Stonehenge and the lingams of Shiva in India (though this latter reference did not become deliberate until he saw an exhibition on Indian art devoted to Shiva in 1981).[65] The title of *To Bring to Life* suggests a kind of magic, with the artist in the role of magician (or god). The phrase may also refer to terms used by Japanese stoneworkers who perpetuated the Shinto tradition of revering ancient rocks. Those carvers described chiseling as "killing" a stone and polishing as "bringing the stone to life." Noguchi's interest in traditional Shinto

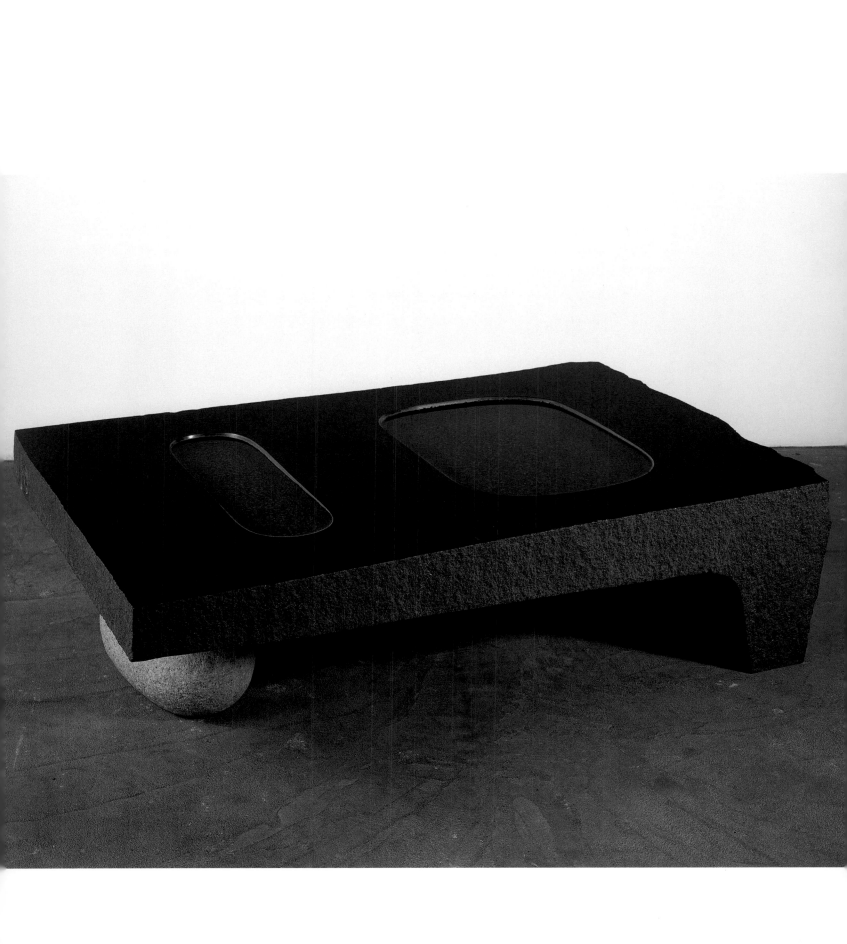

Shodo Shima (Magic Island), 1978.
Granite (8 elements); 12 x 66 x 69 in.
(30.4 x 167.6 x 175.2 cm)
Walker Art Center, Minneapolis;
gift of the artist.

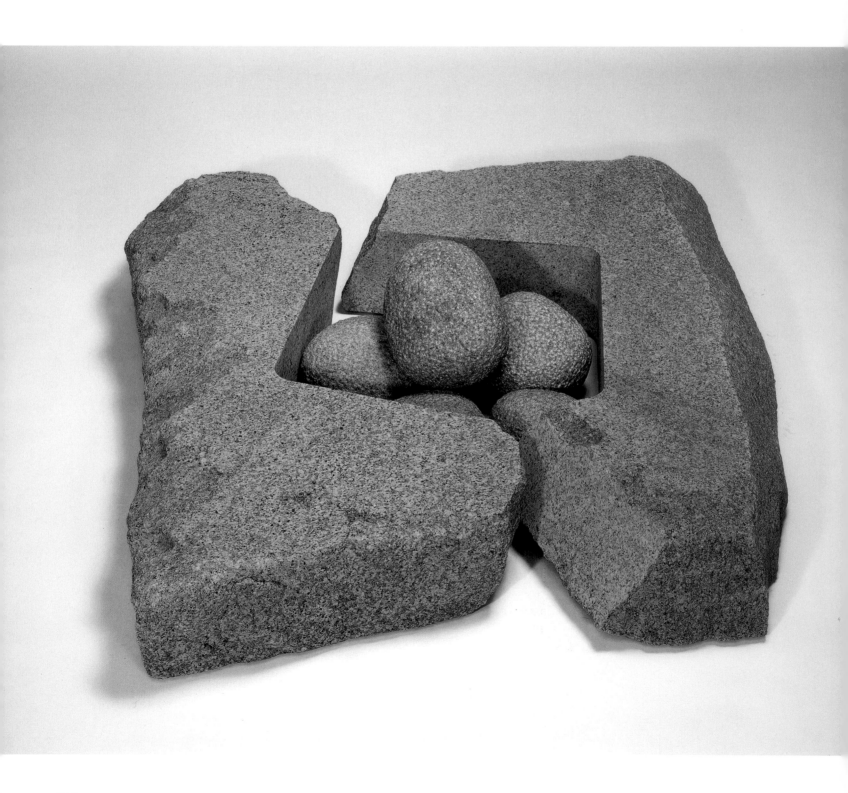

reverence for stones may have been sparked in part by the ideas of Masayuki Nagare in the late 1950s and early 1960s. Working in parallel ways to Noguchi, Nagare had made and exhibited iron, ceramic, and wood sculptures in Tokyo in 1953–55. He then devoted himself to carving stone by hand, relying on modernized adaptations of Shinto animist beliefs, *yin/yang* harmony, and traditional Japanese methods of handcarving.[56] Nagare's stone sculptures were first exhibited in Tokyo in 1957. Although Noguchi attended that show, he seemed to learn more later from the traditional stonecutters who assisted him at his studio in Mure, where he lived and worked for several months every year.

The small forms cut into *To Bring to Life* suggest islands or lakes and streams, as if the stone were a vast vista seen from a great distance. Yet the sculpture also has an awesome totemic presence that goes well beyond the primitivist totems he had created in the 1950s for *The Family* (see page 155). In his best works of the 1970s, Noguchi achieved a unique synthesis of figure and landscape.

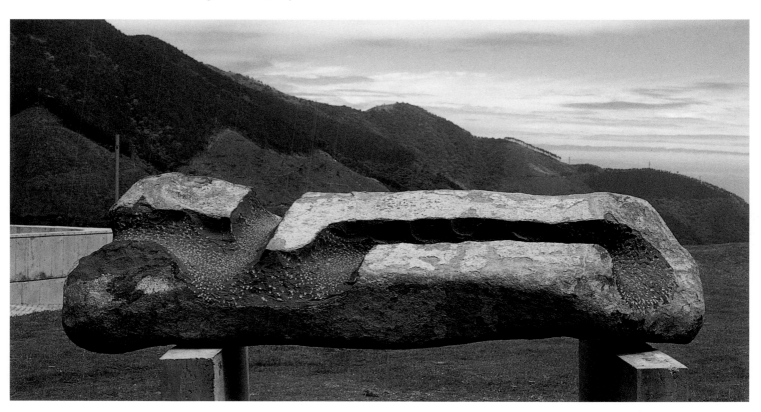

When placed outdoors, as many of Noguchi's basalt sculptures are, they are inevitably affected by weather. The crust sheds small and large flakes; this has led some owners (especially museums) to bring the sculptures indoors. Although the desire to preserve the original appearance is understandable, Noguchi considered these changes to be valid indicators of the passage of time—a theme very important to him as he passed his seventieth birthday. The title and placement of *Landscape of Time*, 1975, in a plaza in Seattle indicates his desire to stimulate busy urbanites to reconsider how they spend their time. Ancient rocks surrounded by recent buildings may remind viewers of their miniscule role in the vast sweep of eons, while the eroding surfaces of the stones indicate the inexorable march of time in their own lives. Noguchi carved *Age* in 1981 to reveal areas of contrasting colors so that the work almost seems to consist of several different kinds of stone—a visual analogy for multiplicity in one. Even without such explicit titles Noguchi intended the actual process of carving to document the passage of time in his own life. Using manual tools he marked very hard stones with hundreds of individual chisel strokes. Like the skeins of paint in Jackson Pollock's paintings or On Kawara's obsession with

Unmei (Destiny), 1970. Basalt; L. 138 in. (350.5 cm). The Noguchi Museum, New York. Photo by Isamu Noguchi.

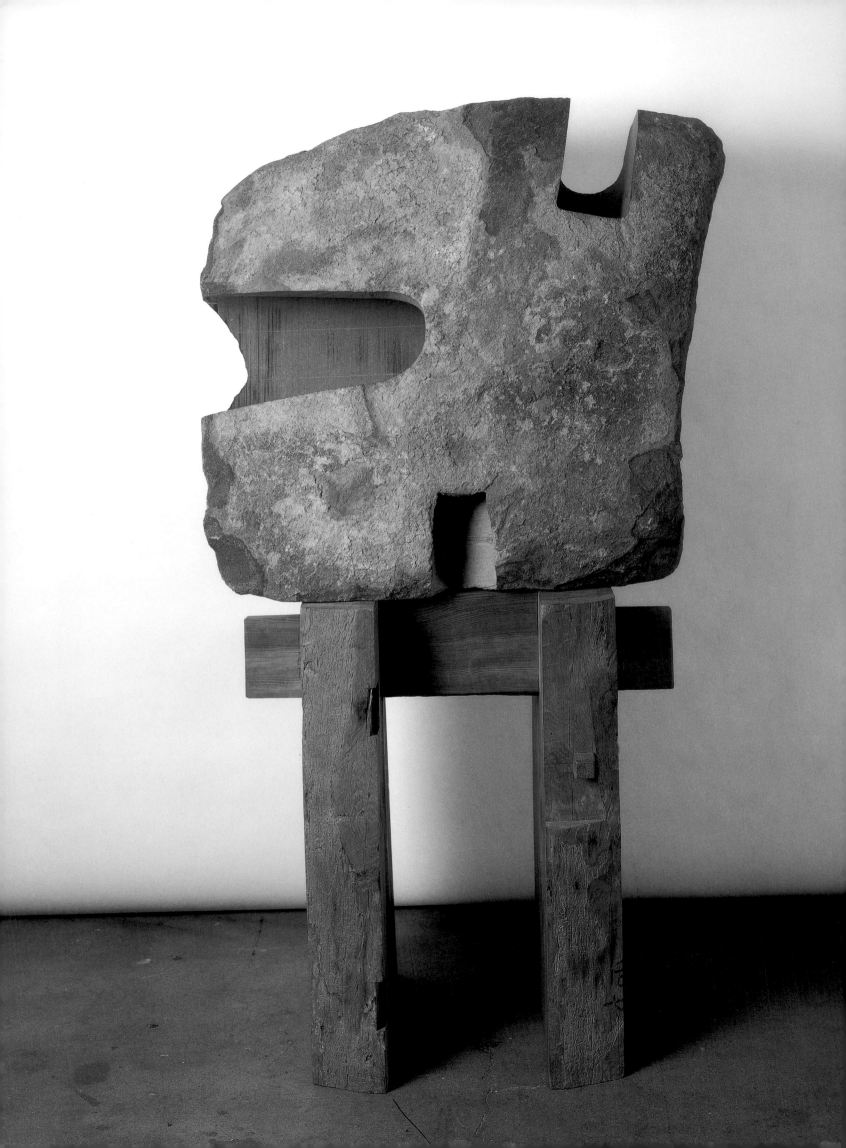

numerical sequences, Noguchi's visible marks in stone document both the physical action and his awareness of time passing. Although he hoped that viewers would intuit these ideas, ultimately he acknowledged that "work is something like having a conversation with yourself—a personal soliloquy in which through argument and trial you try to nail something down, express the inexplicable. [After the sculpture is finished] then you recognize that the sculpture is really yourself."

During the last 15 years of his life every aspect of the process of carving became conceptually significant.[71] Finding the right stone in the Japanese countryside became a pilgrimage or quest. Breaking away a stone from its site in nature became a kind of birthing ritual. In many cases he preferred the older manual method: assistants would insert wood wedges and hammer them in until the stone broke loose. Sometimes a boulder would cleave completely under a single blow by a sledgehammer, or a boulder might shatter into several pieces. Noguchi considered these occasional accidents as acts of fate, determining how he should form certain sculptures. For example, seen from the front, *The Great Rock of Inner Seeking* (see page 160) presents the granular surface characteristic of basalt, with the gray core revealed through carving as a sinuous flowing form like a waterfall or stream. The back of this massive sculpture, however, is completely different. When the boulder was separated from the earth, it broke apart and Noguchi decided to keep the cylindrical drill cavities as a pattern of its own. In this one work he incorporated untouched nature and the artifice of tools, forever united by an act of fate.

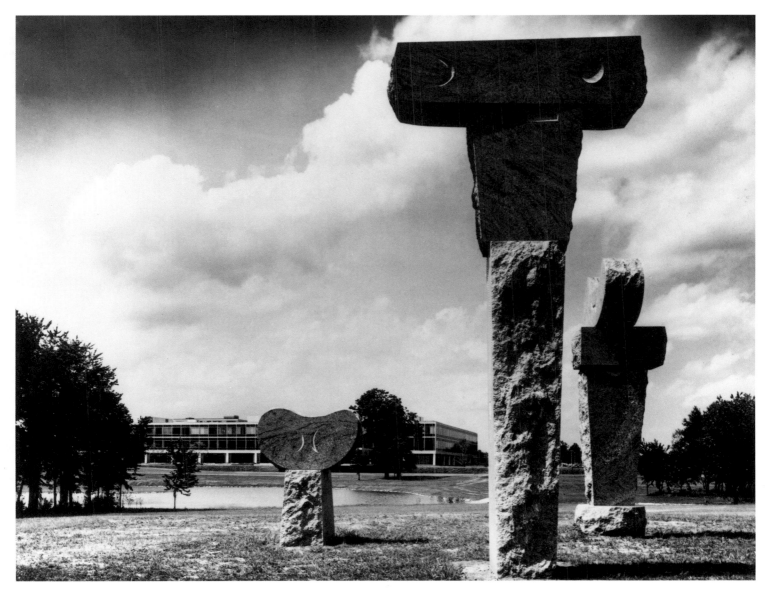

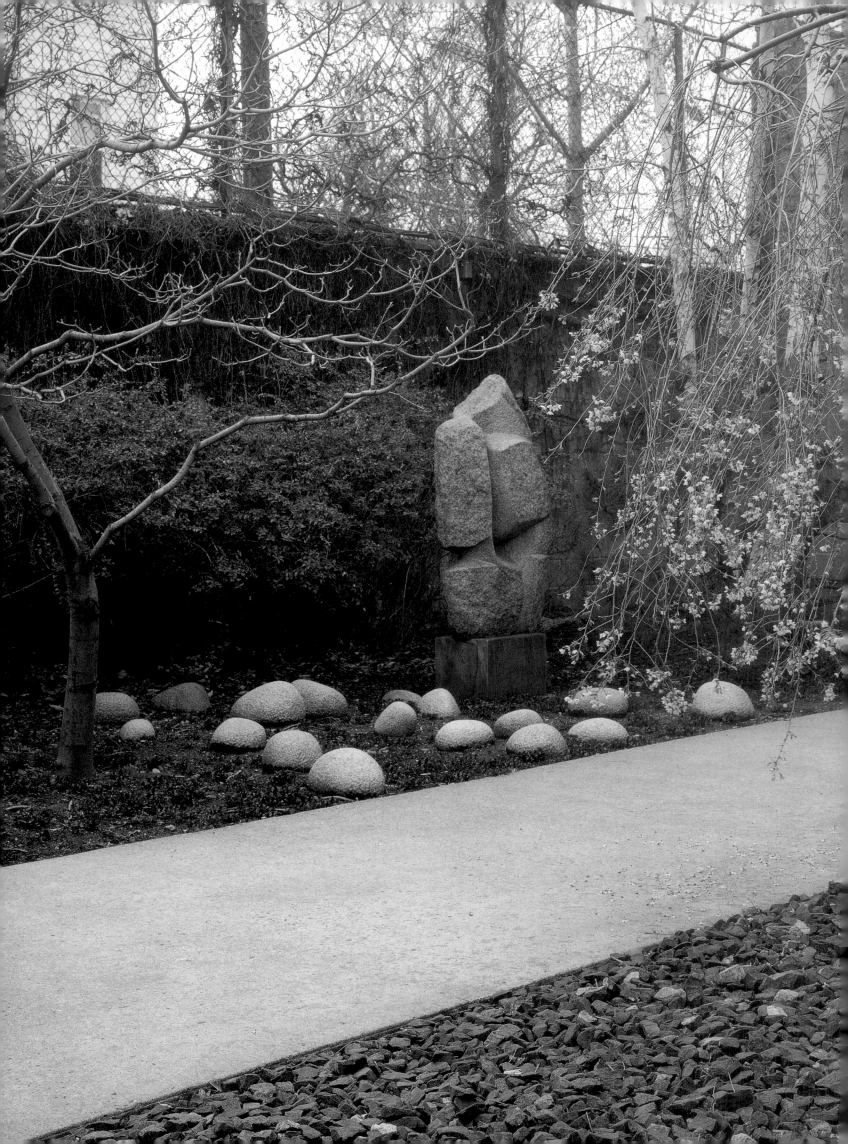

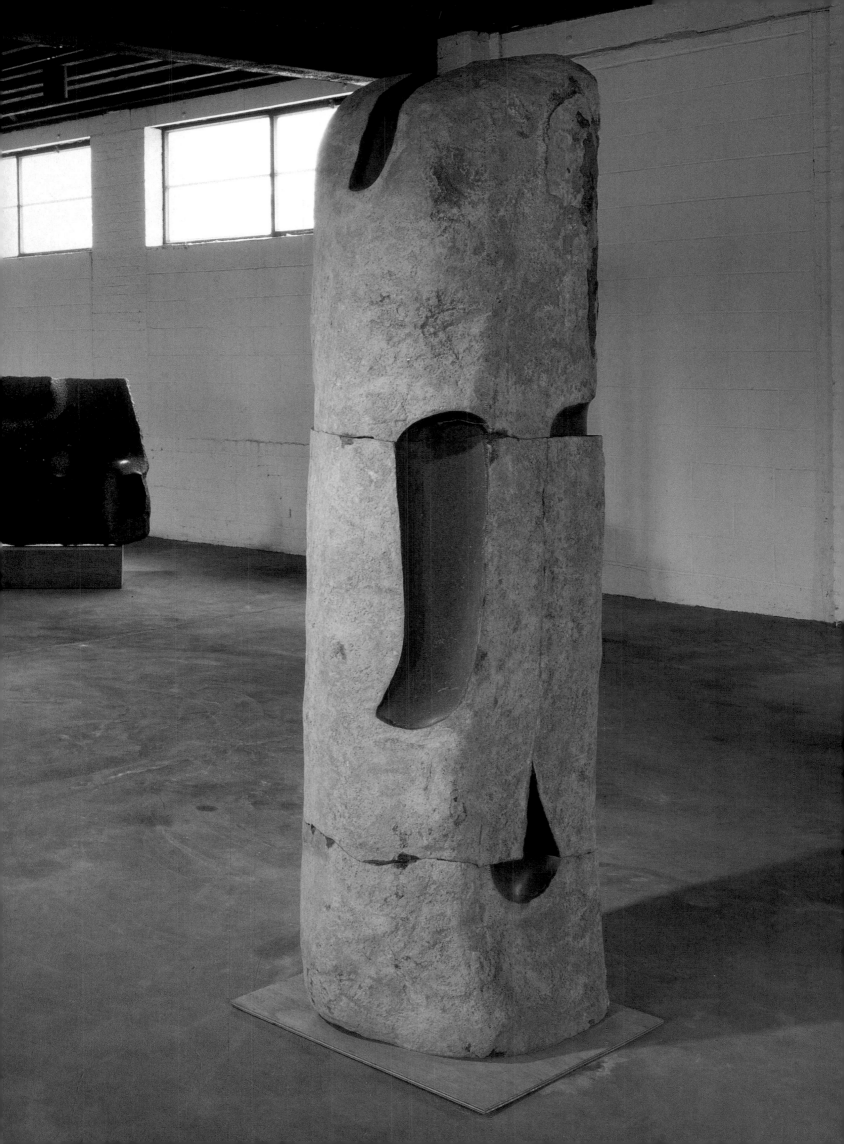

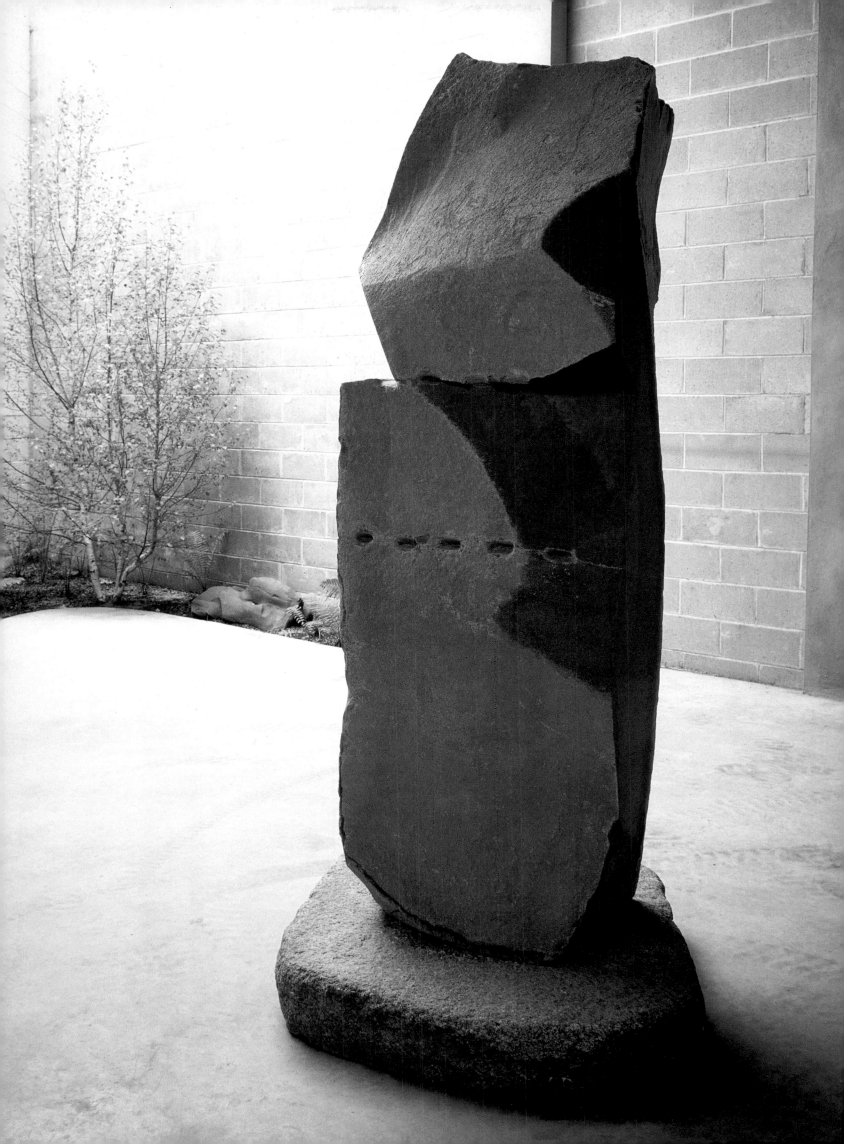

For some late sculptures, such as *Brilliance* (see pages 158, 159), Noguchi selected a boulder that visibly retained a sense of being part of the earth, with several strata of iron ore meandering through it like streams in a desert. Small recesses suggest the tiny clefts in a massive cliff. He then deliberately broke up the monolithic boulder and reassembled it in a different configuration. The three component parts are askew, creating new spatial and textual relationships such as the razor-sharp edge of the top element overhanging the recessed plane below. Noguchi carefully aligned a crack bisecting the gray plane of the top element with the juncture of rough and smooth surfaces below. He even devised a stylized monogram that suits the natural textures of the stone. The sense of being broken and put together recalls the theme of Humpty Dumpty and the idea of damage as an integral part of life: "By breaking a thing...it usually works out that what you plan to do is not what you end up with at all, because the breakage has given it another character." While this may be interpreted as a Zen attitude, chance and destruction are also essential to European Dada and Surrealism, to certain Hindu beliefs, and to the Chinese *I Ching*—all of which Noguchi knew well.

In his late carvings and garden environments Noguchi achieved subtle and sophisticated syntheses of nature with the man-made, fusing organic and geometric, balancing intuition with intellect. *California Scenario* seamlessly integrates them. Although it is an enclosed space adjacent to an office building, *California Scenario* appears open and spacious; the proportional relationship of the asymmetric pyramid to the smaller rocks and plants creates a sense of vastness and scale beyond the actual dimensions of the garden. Local desert stones unify this environment in color and texture. The channel of water running through the center contrasts with, and enhances, the viewer's awareness of the surrounding dryness. The pronounced individuality of elements of the Beinecke courtyard has here matured into a cohesive whole; sculpture and environment are one.

Noguchi's innovations in site-specific environments, as well as his ideas about art as process and time as a component, link his aesthetics with some aspects of Conceptual art, particularly Minimalism and Earthworks. But his devotion to carving stone and his belief in the nonverbal communicative power of forms and materials became increasingly out of step with

Front and back views of
The Great Rock of Inner Seeking, **1974.**
Basalt; 128 x 62 3/8 x 35 in.
(325 x 158.4 x 89 cm) on artist's
granite base 21 x 59 x 38 3/4 in.
(53.97 x 149.86 x 98.43 cm.).
National Gallery of Art, Washington
DC; gift of Arthur M. Sackler M.D. and
Mortimer D. Sackler M.D.
Photo by Lyle Peterzell.

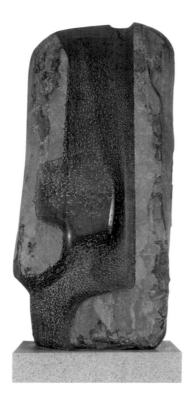
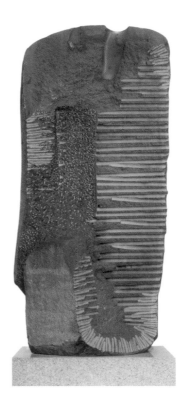

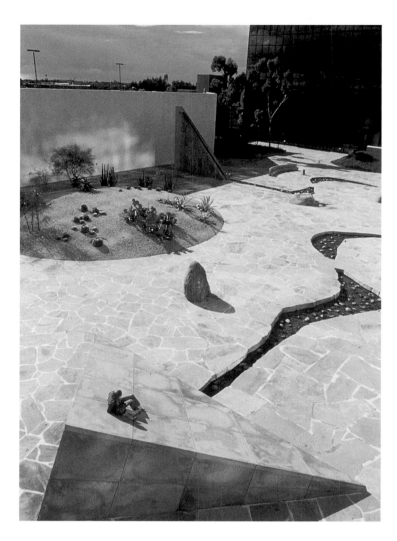

Noguchi and Shoji Sadao.
California Scenario, Costa Mesa,
1980–82. Stone, water, earth,
plants; 1.6 acres.
Photo by Gary McKinnis,
courtesy The Noguchi Museum.

vanguard art from the mid-1960s through the early 1980s. While Andy Warhol, Claes Oldenburg, and others appropriated commercial imagery from advertising and other aspects of mundane life, Noguchi maintained that art could convey more profound experiences. During the last years of his life he knew quite well that his utopian goals and visual language were causing younger artists and critics to marginalize his works. More recently the emotional sterility of some Conceptual art and the cynicism of some postmodernists have prompted a new generation of artists to use natural materials again and to incorporate allusions to diverse cultures. Anish Kapoor, for example, has turned to carving stones, including sturdy granite and the fragile semitranslucent alabaster of Italy. Today, as the rhythms of daily life accelerate to almost overwhelming speeds and as the political world becomes increasingly uncertain and divisive, Noguchi's beliefs—that art can enrich the lives of ordinary people and can transcend national, religious, and ethnic barriers—have gained new relevance.

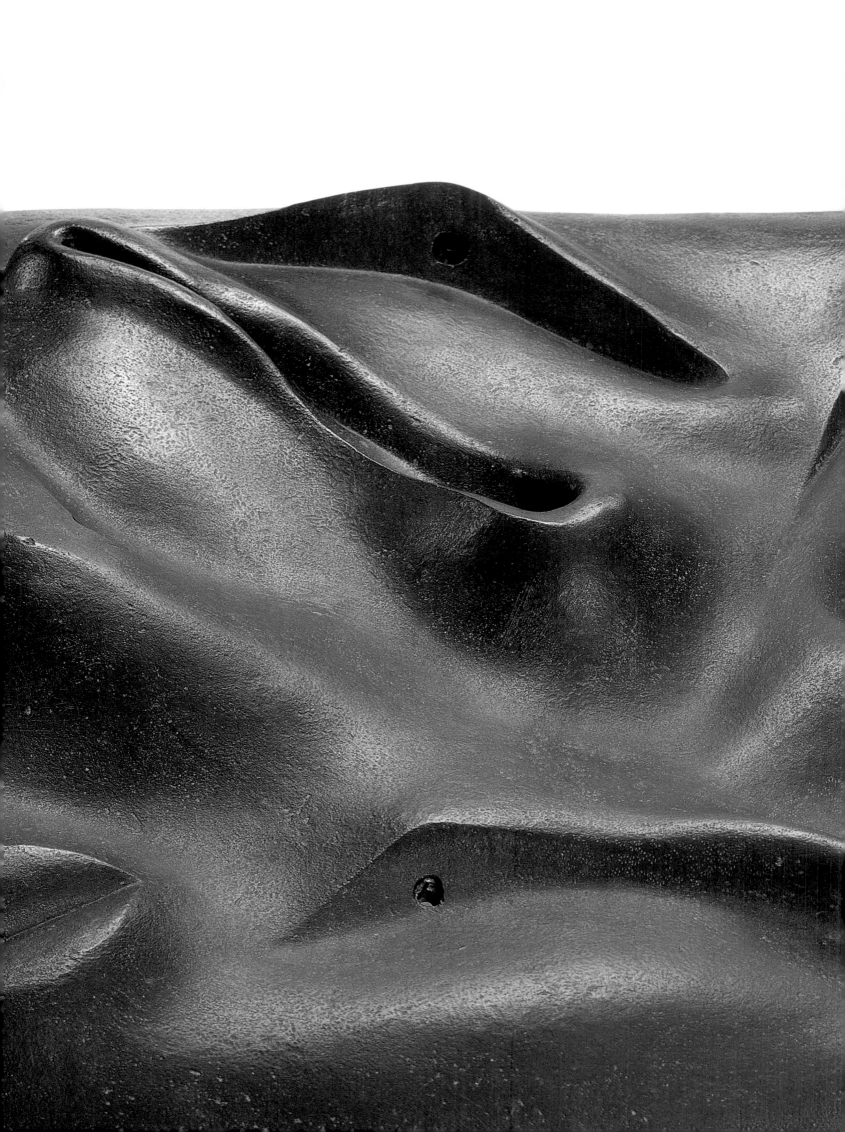

Breaking Ground
The Environmental Works of Isamu Noguchi

Dana Miller

In the winter of 1933–34 Isamu Noguchi had a vision. "I saw the earth as sculpture," he wrote. "I got the feeling that the sculpture of the future might be on the earth."[2] Soon after, Noguchi conceived of *Monument to the Plough* (see pages 52 and 168), a plan for a gently sloping pyramid of earth measuring 1,200 feet on each side.[3] The first of a series of large-scale proposals, the work marked a dramatic shift in his conceptual and aesthetic framework for sculpture. While he would continue to create discrete sculptural objects throughout his career, Noguchi began to trace a corollary track in his work, one in which the landscape became the setting, scale, and medium. His expanded awareness of sculptural space, which he described as an "awakening to the geography and to the spaces of the land," initiated a commitment to shaping the environment that would extend across six decades and lead to some of Noguchi's most significant contributions to twentieth-century sculpture.[4] This "awakening" also anticipated the Earthworks of the 1960s by more than a generation. Viewed through the prism of Earthworks, we can identify several specific ways in which Noguchi's early environmental proposals prefigure those later developments. And yet by the time the first Earthworks were being conceived in the late 1960s, Noguchi had long since moved on, pointing his own landscape projects in a divergent direction.

Noguchi first saw the possibilities for the earth as malleable material and the landscape as sculptural space in 1931, when he returned to Japan for the first time since his childhood. He spent months studying traditional ceramics in Kyoto, an experience he described as "a seeking after identity with some primal matter beyond personalities and possessions."[5] He visited the city's gardens, including the famous Zen garden at Ryoanji and the Silver Pavilion at Ginkakuji with its unique sand formations. The gardens, particularly the "stroll gardens," taught Noguchi that sculpture need not be placed on a pedestal but could extend all around—to be walked on and through. They offered a model of a mutually reactive space in which the viewer could become a participant in the work as it presented ever-changing spatial and temporal relationships. Noguchi was also deeply affected by the grave mounds of Japan. Their earthen medium, simple geometry, and ritual purpose offered Noguchi a prototype for integrating man, nature, and sculpture. This combination of elements would continue to resonate with the artist after World War II, particularly following his visits to the prehistoric mounds of North America, such as the Great Serpent Mound and the mound city near Chillicothe, both in Ohio.

When he returned to New York in late 1931 Noguchi supported himself by making sculpted portrait busts, but the possibility of working with the landscape had captured his imagination. His engagement with the earth became highly symbolic; it had grown to represent for him the deepest essence of nature, a belief perhaps derived from the animism embedded in many Eastern religions and philosophies. "I think the creation of art is an intimate involvement between matter and man. He emerges out of the mud, and he finds his way."[6]

In 1933 Noguchi devised *Monument to the Plough*, one side of which would be planted with wheat, the second tilled in furrows radiating from the bottom corner, and the third side only half plowed, with the furrows radiating from the top. The apex of the man-made mountain was to be capped with

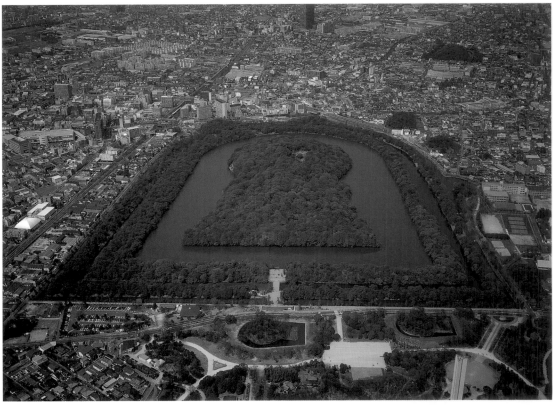

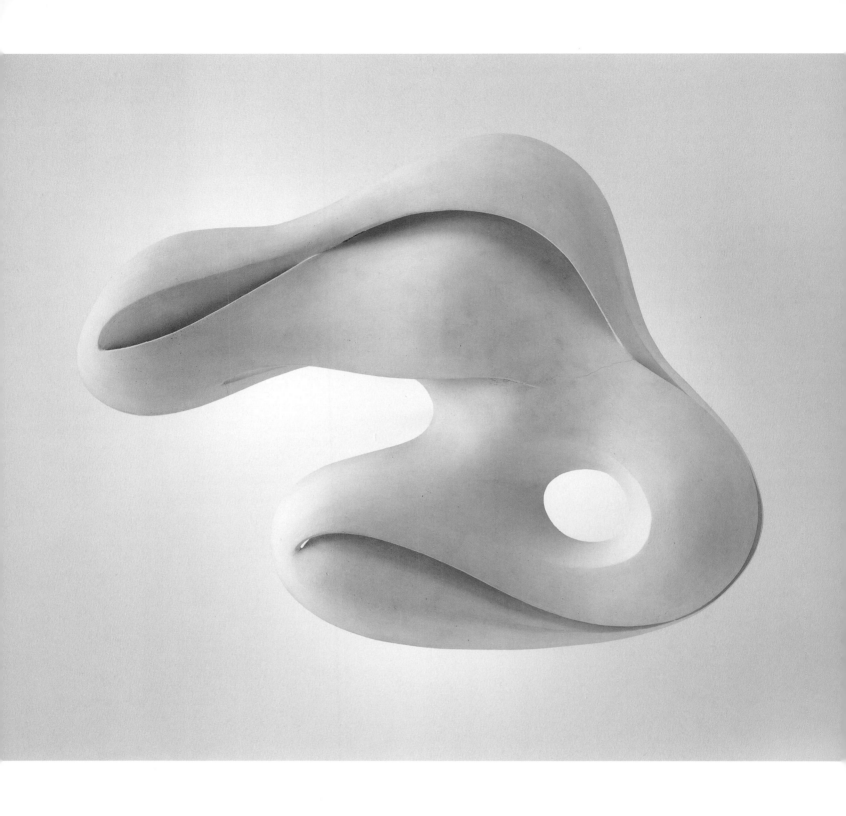

Floating Lunar, 1944–45.
**Magnesite cement, electric light,
and plastic; 32 $\frac{1}{2}$ x 23 $\frac{1}{2}$ x 10 in.
(82.5 x 59.7 x 25.4 cm).
Private collection.**
Photo by Kevin Noble,
courtesy The Noguchi Museum.

concrete, upon which a stainless-steel sculpture of a plow would rest, fusing the pyramidal form of ancient monuments with a material and tool of modern industry. Noguchi's proposal reflected what he perceived as a particularly American relationship to the land and celebrated the technological innovations that had made America's westward expansion possible. His work was also an homage to America's Founding Fathers. It was:

> A monument to Benjamin Franklin and Jefferson, who invented the American plow—a plow which digs the earth, a plow with which they were able to 'break the plains,' as they say...It was to be a monument to the American beginning.[7]

Noguchi wrote variously that he intended the work to be created in Idaho or Oklahoma, but regardless of its exact site, he envisioned the work rising from America's heartland in the metaphorical sense, if not from its literal center. Less than two years after his trip to Japan, *Monument to the Plough* rooted the artist's own identity in the American Midwest, where he had spent much of his adolescence. "My model indicated my wish to belong to America, to its vast horizons of earth."[8] Noguchi's monument would be of such a massive scale that it would perfectly convey both a sense of a specific place and the sublime nature of the entire American landscape.

Monument to the Plough also grew out of the socially and politically charged artistic climate of the Great Depression years. The drawing for the work specified that it was to be erected on land affected by the Wheat Crop Curtailment Program. A controversial policy encouraged by the Federal Farm Board in the 1930s, wheat crop curtailment sought to reduce the amount of acreage sown, thereby decreasing supply and increasing the price farmers could charge for their wheat. *Monument to the Plough* therefore is as much a memorial to the bygone pioneer era as it is a celebration of American ingenuity and progress. Noguchi had created a reclamation work in proposing alternate uses for land that would otherwise go fallow. He also proposed a new use for the plows that would lie idle—that of sculptural tool.

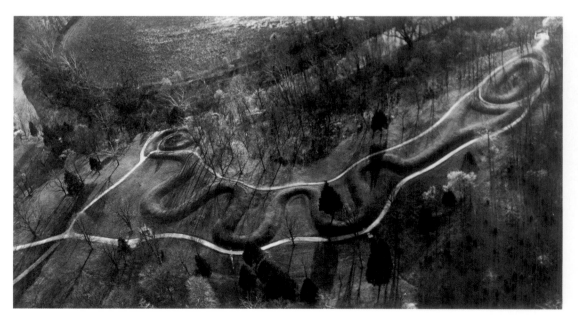

This Tortured Earth, 1943.
Bronze (edition of 3);
28 x 28 x 4 in. (71 x 71 x 10 cm).
The Noguchi Museum.
Photo by William Taylor,
courtesy The Noguchi Museum.

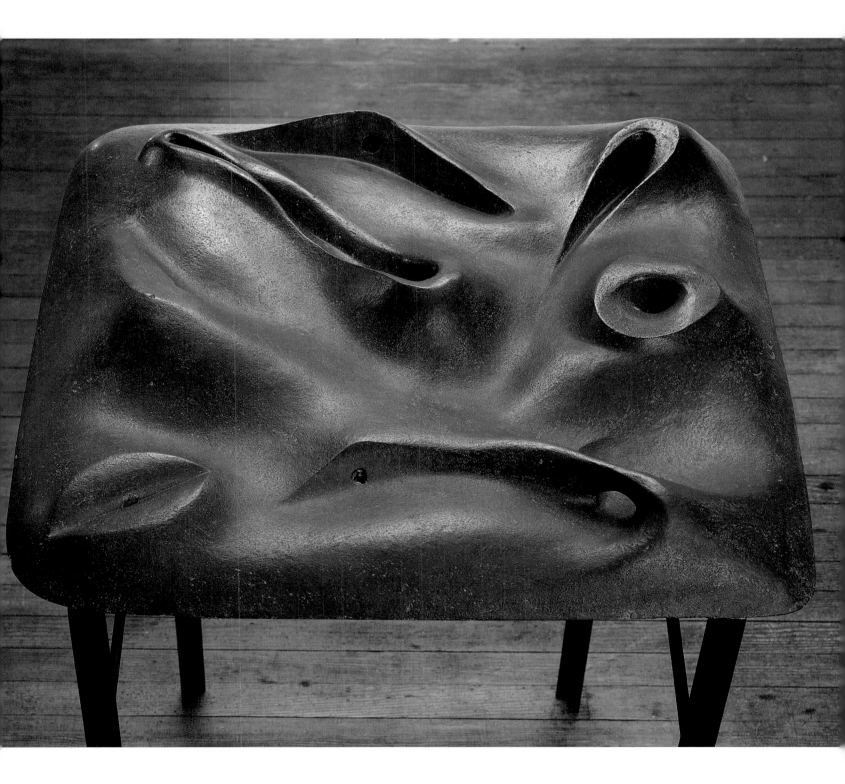

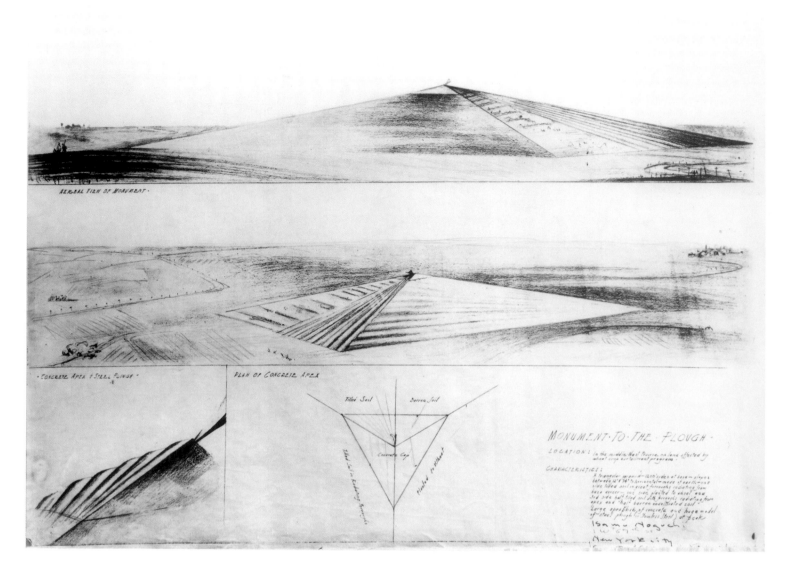

Labels within drawing:
AERIAL VIEW OF MONUMENT ·
· CONCRETE APEX & STEEL PLOUGH ·
PLAN OF CONCRETE APEX
Tilled Soil Barren Soil
MONUMENT · TO · THE · PLOUGH ·

Drawing for "Monument to the Plough," **1933. Photostat; dimensions unknown. No longer extant.**
Photo courtesy The Noguchi Museum.

Noguchi proposed *Monument to the Plough* to the Public Works of Art Project, a government-sponsored program that employed many artists during the early years of the Great Depression. A letter between the New York and Washington offices of the PWAP stated, "Noguchi's designs have just arrived, and the Technical Committee in the central office turned their thumbs down on them so hard they almost broke their thumb nails."[9] He was suspended from the program shortly thereafter for neglecting to produce any "purely sculptural work."[10]

Noguchi's next landscape design and first urban proposal was *Play Mountain*, a 100-square-foot playground for New York City's Central Park, dominated by a large mound, one side of which would be carved into a triangular set of steps resembling the furrows of *Monument to the Plough*. In many ways Noguchi's notion of sculptural space found its ideal expression in playgrounds.[11] The child could activate his playgrounds as ritualistic, atavistic spaces in the same way that dancers moved about his stage sets, or adults moved through the "stroll gardens" of Japan. Noguchi's playground designs can be read as utopian metaphors in which city children reclaim a more intimate relationship to nature, one akin to that of early man. For Noguchi, playgrounds symbolized the sculptor's interaction with primordial matter, a primal experience that recalled his cherished childhood in Japan. Playgrounds also allowed Noguchi to achieve the proper scale that was so essential to him, specifically the proportion of the terrain to children. "Playgrounds are a way of creating the world....It's a way of creating an ideal land—on a smaller scale," he explained. Noguchi's playgrounds were microcosms; creating a similarly proportioned space for adults would

have required more space than was feasible in the city and ultimately may not have appealed to him.

> It's a topology I'm interested in—a land in which one can run around, three feet high. I've been more attentive to that than, say, creating a park in which grown-ups might run around. The very restrictions make room for the more intense experience of childhood—where the world is newer, fresher, and where you have a kind of geometric confrontation with the world.[12]

The plan was presented in 1934 to New York Park Commissioner Robert Moses, whose hostile response would set the tone for Noguchi's relationship with the city's park administrators in the years to come.

The following year Noguchi suggested an even more provocative project to the recently formed Works Progress Administration. As he later recalled:

> I said, "Now, look, why don't you let me do you a sculpture in front of the Newark Airport?" There was a triangle there. "I'd like to make a sculpture just to be seen from the air so that when you come to a landing you will see the sculpture there." You wouldn't see it otherwise. Well, they laughed their heads off at the whole idea.[13]

Noguchi never produced any drawings or models for this project, but its aerial vantage point affirmed his interest in topography and signaled new possibilities for the conception and perception of sculpture.

Noguchi proposed another playground for New York City in 1941. *Contoured Playground* was to be composed entirely from surface modulation, thereby avoiding the potentially injurious elements of traditional playground equipment (see page 70). Its undulating mounds, grooves, terraces, and pools would provide endless possibilities for safe and imaginative play. But World War II brought more pressing concerns to New York's city officials, and *Contoured Playground* never got past the

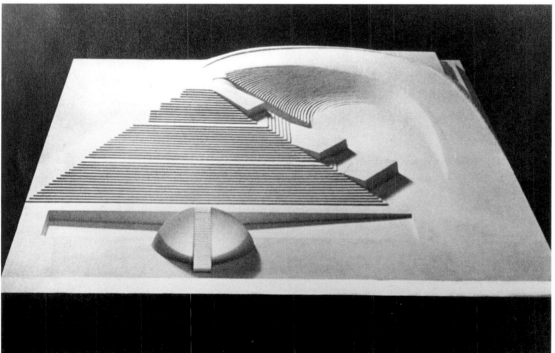

model stage. When the model was exhibited at the San Francisco Museum of Modern Art in 1942 it was juxtaposed with architectural plans for the Poston internment camp, which Noguchi had voluntarily entered that same year. An internal memo prepared for the show read:

> Noguchi's conception of sculpture takes in more and more territory. The reason he gives is that the whole earth is sculpture and that until the mass has been attended to the details have no meaning....He fancies himself as one of the early "earth sculptors."[14]

Noguchi's interest in the landscape only intensified during his internment. After returning to New York from Poston in late 1942, Noguchi made a series of small landscape reliefs in 1943, among them *My Arizona*, *Yellow Landscape* (see page 73), and *This Tortured Earth*. Initially titled *War Tortured Earth*, Noguchi apparently was inspired to make *This Tortured Earth* after seeing aerial photographs of the bomb-riddled African desert.[15] A planar expanse with slashes and holes perforating its surface, the work was conceived like many of his earlier proposals as a memorial, this time to the tragedy of war (see page 84). Noguchi's fascination with machinery as a means of sculpting the earth's crust, first evident in *Monument to the Plough*, had been extended, somewhat caustically, to military equipment. "There is injury to the earth itself. The war machine, I thought, would be excellent equipment for sculpture to bomb it into existence."[16] Noguchi considered *This Tortured Earth* a model for a larger environmental work, though at the

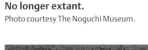

Model for "Sculpture to be Seen from Mars," 1947. Sand; dimensions unknown. Unrealized. No longer extant.
Photo courtesy The Noguchi Museum.

time he hung the relief on the wall. Soon after, he made a bronze, tabletop version of the work (see page 167).

After the war Noguchi created a small number of proposals in which he repurposed the elemental convex and concave forms of his early playground designs for other urban uses. His 1945 submission for the Jefferson National Memorial Competition in Saint Louis included a variegated surface and a snaking stream and echoed the Great Serpent Mound, which he visited that year. Noguchi collaborated with the architect Edward Durell Stone to integrate architectural spaces within the planned mounds.

Then, in 1947, Noguchi created perhaps his most fantastic, and also his most pessimistic, large-scale proposal. *Sculpture to be Seen from Mars* was to be a grouping of geometrical earth mounds that formed the generalized features of a human face. Noguchi intended to construct the work "in some desert, some unwanted area" on such a massive scale—the nose itself would stretch one mile in its longest direction—that it would be visible from other planets (in this way it is an inverse of his earlier *Lunar Landscape*, page 79). Conceived of just two years after the United States dropped atomic bombs on Hiroshima and Nagasaki, and originally entitled *Memorial to Man*, the work was an effigy of a vanished human race. In the same way that the plow represented a bygone era of American expansion, the face symbolized the whole of humanity after its self-annihilation.[17] By creating *Sculpture to be Seen from Mars* as a vast, earthen sculpture that could only be properly viewed from above, Noguchi aligned himself with the ancient makers of the enormous Nazca lines in Peru, about whom he later speculated:

> They probably had some means of letting their imaginations travel to outer space.... I don't think it's necessary to be corporeally or visually in outer space.... Our imagination does travel. I mean, who hasn't been on Mars and seen it? To the artist, going to the moon was nothing new. I've been up there all the time.[18]

Noguchi's reference to the Nazca lines underscores his lifelong fascination with prehistoric sites and ancient monuments. Between 1949 and 1956 he traveled intermittently on a grant from the Bollingen Foundation to study places of "leisure," which he defined as "all the places that people used to believe in as the congealments or cruxes of meaning within each culture."[19]

The Ring, 1945–48.
Gray granite, 12 x Diam. 22 in.
(30.5 x Diam. 55.9 cm).
Whitney Museum of American Art,
New York; gift of the artist.
Photo by Jerry L. Thompson.

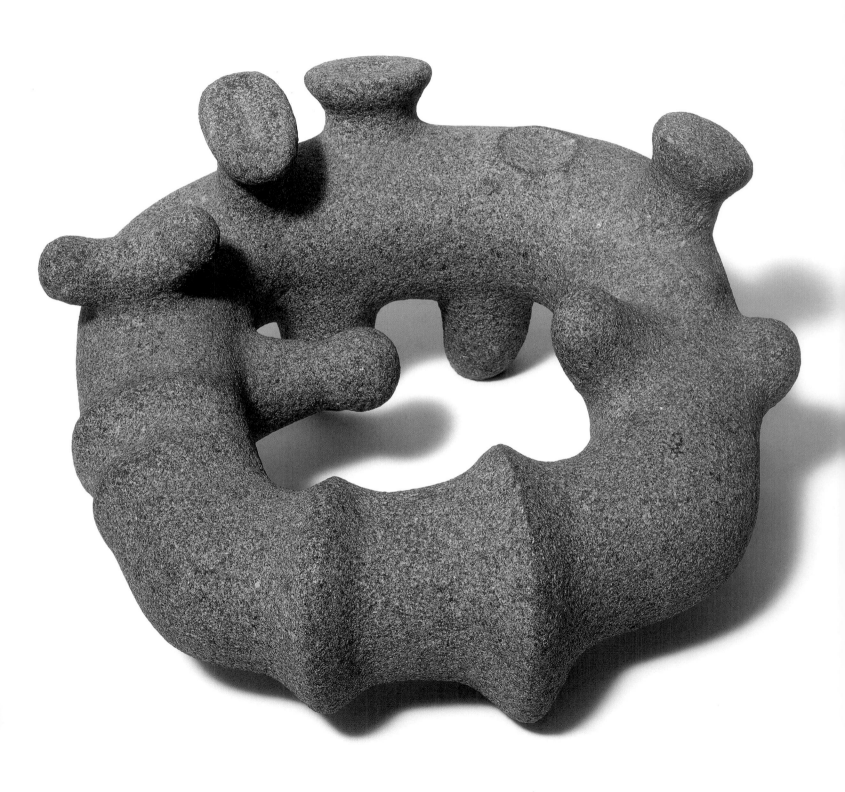

He visited Stonehenge, the menhirs and dolmens of France, the Great Pyramids of Egypt, the Maharajah Jai Singh's observatory in Jaipur, and many other sites.

Upon returning from his initial Bollingen trip in 1951, the communal and functional character of his environmental works took on a greater urgency. That same year Noguchi received his first commission for an environmental project—a garden for Antonin Raymond's Reader's Digest Building in Tokyo. For the first time, he was able to realize his visions in real, topological space. Collaborating with Japanese gardeners for portions of this project, as well as on subsequent projects, Noguchi deepened his knowledge of Japanese garden design principles during this decade. Other commissions soon followed: the courtyard garden and ground floor of the Lever House office building in New York, 1952 (unrealized), the interior courtyards and garden for Connecticut General Life Insurance Company, 1956–57, and the UNESCO gardens in Paris, 1956–58 (see page 133). By the end of the 1950s, Noguchi was widely recognized as one of the foremost innovators of public sculpture, and he regularly received commissions of an architectural scale.

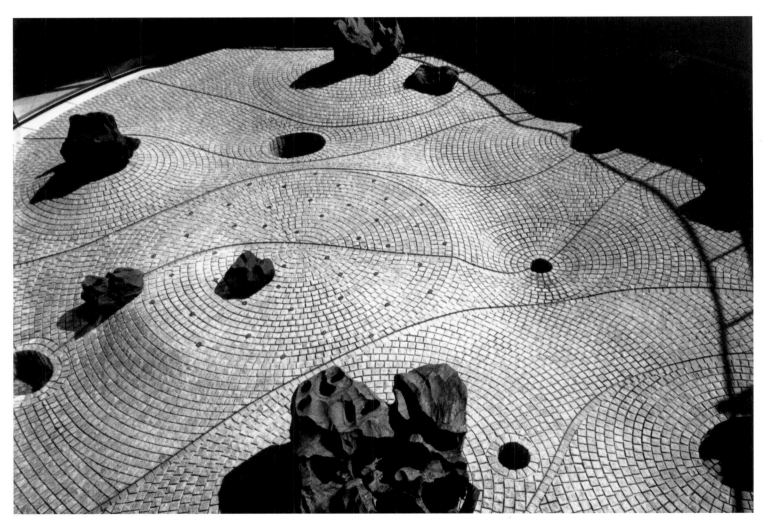

Noguchi's sunken gardens at The Beinecke Rare Book and Manuscript Library at Yale University, (see pages 137 and 176), and Chase Manhattan Bank Plaza (see pages 134 and 135), are in keeping with the meditative type of Japanese garden, rather than the more participatory nature of the "stroll gardens." The gardens cannot be entered, only viewed from the sides and above. Noguchi took great care in shaping the floor planes of both gardens, emphasizing the geometric divisions of the flat surface. He arranged the paving of the Chase garden in concentric patterns, evoking the movement of water and reinforcing the actual presence of water in summer. In the

Detail of *Water Garden*, 1961–64.
Stone, water, and cement;
Diam. 60 ft. (18.2 m).
Chase Manhattan Bank, New York.
Photo by Andrew Popper.

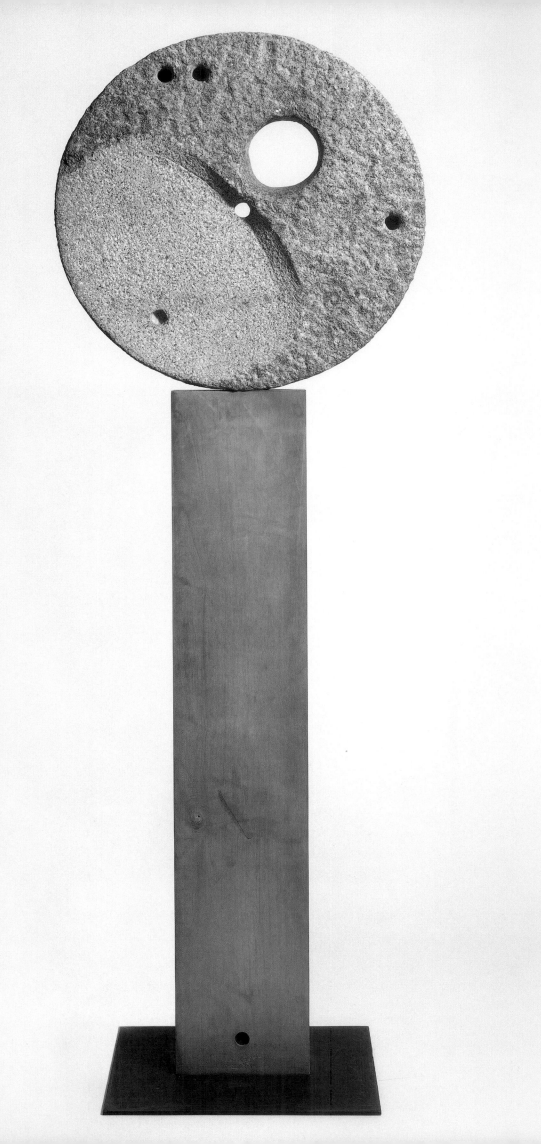

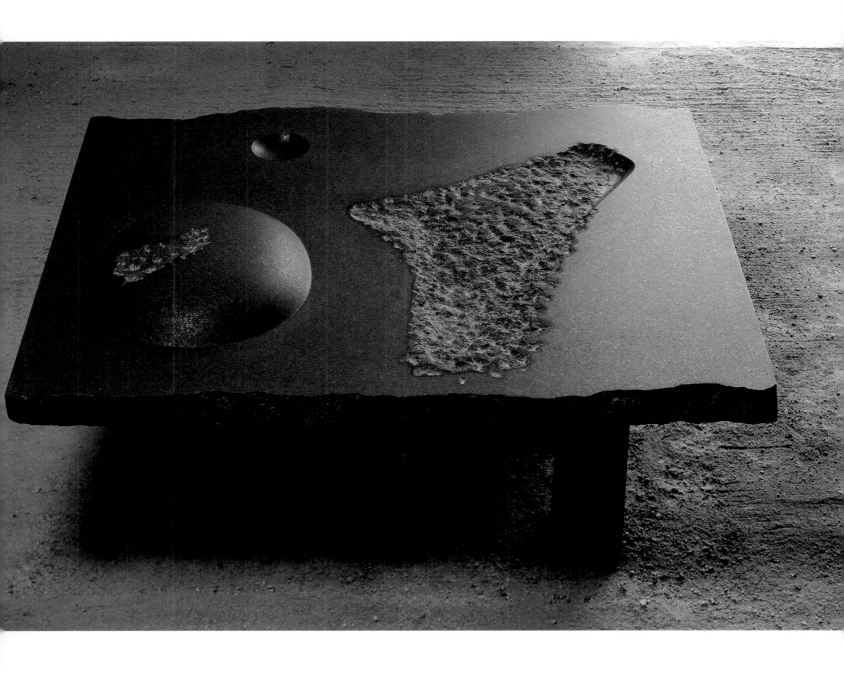

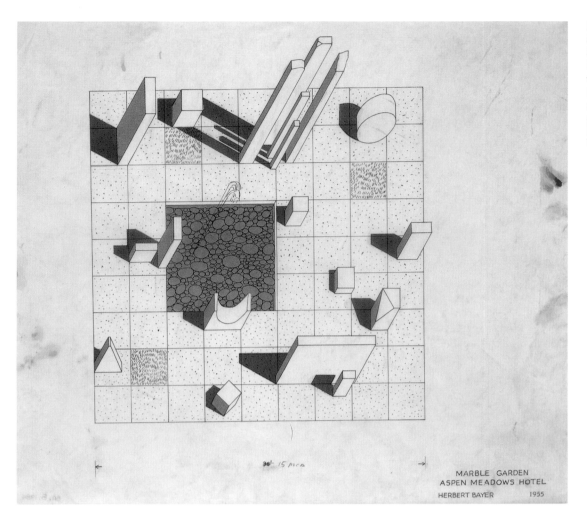

Herbert Bayer. *marble garden, isometric drawing, for The Aspen Institute, Aspen Meadows*, 1955. Ink and printed film on paper; 13 5/8 x 15 1/2 in. (34.6 x 39.4 cm). Herbert Bayer Collection and Archive, Denver Art Museum; gift of Joella Bayer.
Photo © 2003 Artists Rights Society (ARS)/ VG Bild-Kunst.

MARBLE GARDEN
ASPEN MEADOWS HOTEL
HERBERT BAYER 1955

winter the garden is dry, which prompted Noguchi to refer to it as "my version of Ryoanji," the famed dry garden in Kyoto.[20]

Noguchi was not the only artist working to create sculptural environments in earth and stone after World War II. The Austrian-born Herbert Bayer (1900–1985) was creating works in the mid-1950s that were remarkably similar to Noguchi's works in both conceptual and formal terms. Bayer had taught at the Bauhaus before emigrating to New York in 1938 and, like Noguchi, advocated for the social application of art. In 1955, nine years after he had settled in Aspen, Colorado, Bayer created *earth mound* (also called *grass mound*) and *marble garden* for the newly built Aspen Institute for Humanistic Studies (now The Aspen Institute). A tumuli-like ring of earth, *earth mound* is approximately 40 feet in diameter and encircles a granite boulder, a small hill, and a depression in the ground. Bayer composed *marble garden* from stone remnants he found in the area,

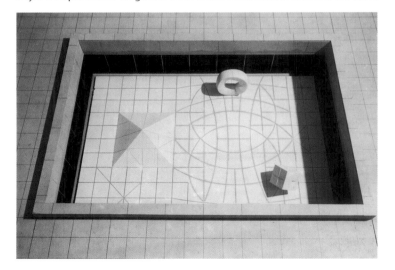

Model for "Courtyard Garden of the Beinecke Library," 1960–64. Wood, painted wood and plaster; 6 x 23 1/2 x 36 1/2 in. (15.2 x 59.7 x 92.7 cm). The Noguchi Museum.
Photo by Charles Uht.

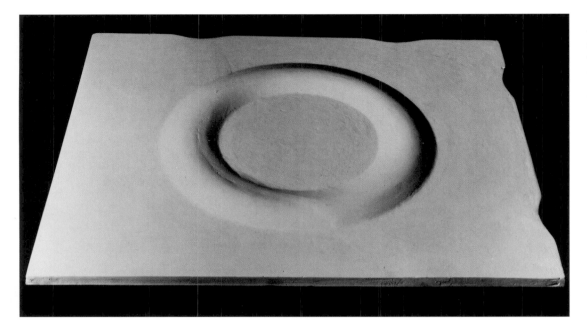

which he then placed on a grid enclosing a square pool of water. The work bears a significant likeness to Noguchi's Beinecke garden. It is quite possible that R. Buckminster Fuller, a friend of both artists who was also involved in designing the Aspen Institute site, may have been a conduit for the ideas shared by these two artists.

Perhaps Noguchi's most ambitious project of the 1960s was the Billy Rose Sculpture Garden for the Israel Museum in Jerusalem, 1960–65. He contoured the enormous hillside, moving ton after ton of earth with heavy equipment to create "an undulating and walkable landscape, something memorable born out of the adversity of the terrain."[21] The garden was terraced into several elevations that were defined by enormous curved retaining walls. The walls, some almost 30 feet high, were made from stone rubble found in the area, and serve as a primary sculptural statement. Although the site was intended to display other sculptures, Noguchi considered the empty garden a work in itself.

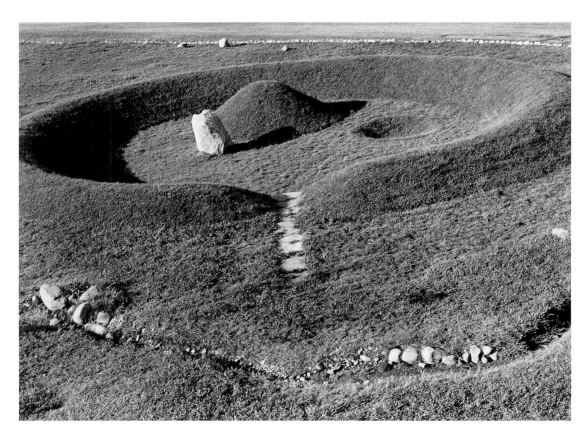

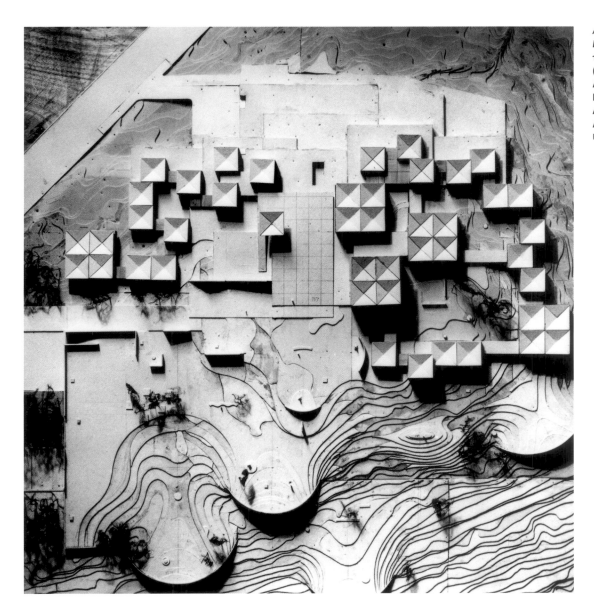

Aerial view of "Model for the Billy Rose Sculpture Garden," 1960–65. Model: 7 x 69 x 40 in. (17.8 x 175.1 x 101.5 cm). Actual garden: 5 acres. Israel Museum, Jerusalem. Architects: Dora Gad and Alfred Mansfeld.
Photo courtesy The Noguchi Museum.

Here you have a sculpture fifty meters high, twenty dumas (five acres) wide, weighing a million tons. No, it is a piece of the earth itself, extending all the way to China. This is what I have sculptured, and one may walk upon it and feel its solidity under foot and know that it belongs to all of us without limit and equally.[22]

As Noguchi was finishing the Billy Rose Sculpture Garden, a new generation of American artists was testing the limits of accepted sculptural practice. Noguchi's 1927 call for "an unlimited field for abstract sculptural expression" foreshadowed the convictions of many of the artists who came of age in the 1960s. By the middle of that decade a spate of museum and gallery exhibitions had highlighted the increasing primacy of three-dimensional form, along with its escalating scale and ambitions.[23]

It was in this context that American artists such as Carl Andre, Michael Heizer, Nancy Holt, Walter De Maria, Robert Morris, Dennis Oppenheim, and Robert Smithson repositioned their works onto and into the landscape. Like Noguchi, Smithson early in his career proposed a plan for a large-scale public sculpture to be situated near an airport. In 1966 Smithson was hired as an artist-consultant to the architecture firm Tippetts-Abbett- McCarthy-Stratton (T.A.M.S.) for the new airport between Dallas and Fort Worth, Texas. Smithson enlisted Andre, LeWitt, and Morris to participate. Each of the four artists proposed a separate "low-level ground system" for the "clear zones" on the perimeters of the airport—works that could be seen in full only from the air, much as Noguchi had intended for his Newark project.

Morris's proposal for the airport, which he described as "Project to be Made of Earth," consisted of a circular mound of compacted sod surrounded by a trench. Intended for placement between the runways, the work could have variable dimensions; Morris gave the example of a 100-foot radius.[24] Andre proposed "a crater formed by a one-ton bomb dropped from 10,000 feet," or, alternatively, "an acre of bluebonnets (state flowers of Texas)."[25] The crater (and possibly the idea of the flowers as well) was conceived in part as an antiwar statement as the Vietnam conflict escalated, echoing Noguchi's proposal for *This Tortured Earth*. LeWitt's project would place a smaller wood cube with "something" inside it within a larger cement cube and then bury it three feet beneath the ground. Smithson's project for the airport went through a succession of changes, many recorded in extant sketches. His published version described "a progression of triangular concrete pavements that would result in a spiral effect. This could be built as large as the site would allow, and could be seen from approaching and departing aircraft."[26] He included an overhead photograph of a model in the article, as well as an aerial survey of the airport indicating the placement of all four sculptural projects (see page 181).

Although none were realized, the airport proposals established a precedent for many subsequent Earthworks—the use of raw materials, simple geometry, and large-scale, low-lying, or concave forms. They also indicated a new emphasis on the aerial perspective. As Smithson wrote in his 1969 essay "Aerial Art," "Just how we should look at art is a question that is rarely considered. Simply looking at art at eye-level is no solution."[27] "Aerial Art" was among a number of widely read articles by Smithson in which he articulated his new conception and perception of sculpture.[28] The airport project also precipitated discussions between Smithson

Robert Smithson. *Wandering Earth Mounds and Gravel Paths*, 1967. Blueprint with collage and pencil; 11 x 14 in. (27.9 x 35.6 cm). Estate of Robert Smithson.
Photo courtesy James Cohan Gallery, New York, © Estate of Robert Smithson / Licensed by VAGA.

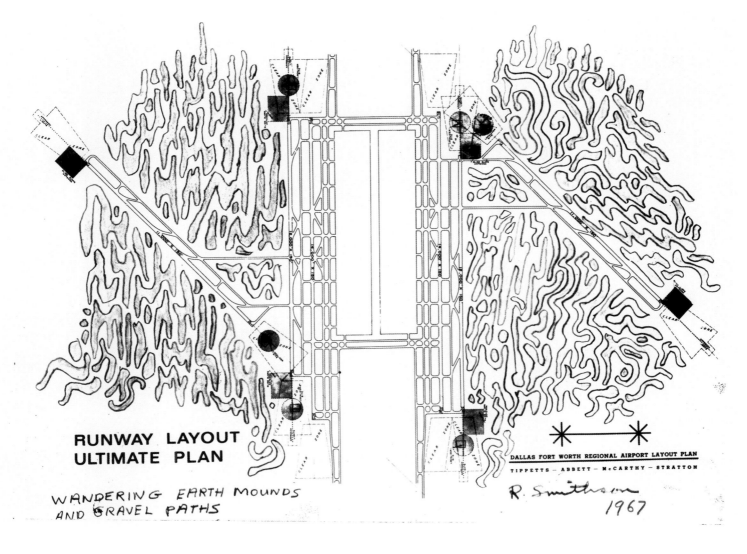

RUNWAY LAYOUT
ULTIMATE PLAN

DALLAS FORT WORTH REGIONAL AIRPORT LAYOUT PLAN
TIPPETTS — ABBETT — McCARTHY — STRATTON

WANDERING EARTH MOUNDS
AND GRAVEL PATHS

R. Smithson
1967

and dealer Virginia Dwan, which culminated in the seminal *Earthworks* exhibition in October of 1968 at the Dwan Gallery in New York. The show included, among others, Andre, De Maria, LeWitt, Heizer, Oppenheim, and Smithson, as well as photographs of Bayer's *earth mound*. Bayer's inclusion in the Dwan exhibition acknowledged his precedence and influence on the younger artists. Both Morris and Andre had seen Bayer's Aspen works in the year and a half leading up to the show. One cannot help but wonder whether Noguchi's early landscape designs would have been included in the Dwan exhibition had he been able to realize any of them, since many of the artists included were working with similar ideas about the earth as sculpture.

The *Earthworks* exhibition offered one of the first opportunities for artists to share with their peers and critics their far-flung experimentation with the land, although most of the works were represented only by photographs or models. Heizer's inclusion consisted of a photograph of his series *Nine Nevada Depressions*, 1968, which he called "negative objects." Each was a large cut or excavation in the cracked mud of the Nevada desert. Oppenheim exhibited *Mount Cotopaxi Transplant*, 1968, a model for the replication of the topographical contour lines of Ecuador's Cotopaxi volcano in the flat fields of Kansas. The contour lines, to be created by a crop harvester in a preexisting wheat field, would be centered on Smith Center, Kansas, the point of origin for all federal maps of North America. In many ways the proposal calls to mind *Monument to the Plough*.

Many of the best-known of the Earthworks were created shortly after the exhibition, among them Heizer's *Double Negative* (see page 184). Two enormous, facing cuts in the surface of an isolated mesa in the Nevada desert, *Double Negative* reached a depth of 50 feet and measured 1,500 feet long by 42 feet wide overall. Heizer's *Displaced-Replaced Mass*, 1969, involved moving three boulders weighing a total of 147 tons from the Sierra Nevada Mountains in California to the bottom of trenches dug in the Nevada desert. Like *Sculpture to be Seen from Mars*, Heizer claimed that the work could withstand a nuclear apocalypse.

One of the most frequently illustrated Earthworks, Smithson's *Spiral Jetty* (see page 183), from 1970, is a jetty of earth and rocks that juts out into the Great Salt Lake, in Utah. Broadening the spiral form he employed in the airport project, the work snakes in on itself in an area of the lake where the microbacteria had turned the water red. The rising water level meant that layers of salt would accumulate on the work, which would eventually be swallowed up by the lake, a process that complemented (whether he intended it or not) Smithson's fascination with crystalline structures and entropic forces.

Despite the diverse nature of the 1960s Earthworks, connections can be drawn between them and Noguchi's landscape works on both formal and methodological levels. At the heart of both sets of artistic projects was the manipulation of the earth, with all of its attendant symbolism. Like Noguchi, many of the Earthwork artists sought a link with more archaic or ritualistic modes of art through the raw materiality of the earth. "I think earth is the material with the most potential because it is the original source material," Heizer said.[29] And, like Noguchi, a number of the later generation (many of whom originated from western states) considered the landscape an apposite location for a particularly *American* work. In describing his impetus to work in the Nevada desert, Heizer remarked, "I wanted to make an American art which was transnational....It was a question of an American sensibility, things were being done that felt uniquely American—a lot of them had to do with size—size and measurement."[30] Similarly, Smithson said of his own maturation as an artist in the mid-1960s: "I was interested in this kind of archetypal gut situation that was based on primordial needs and the unconscious depths....Out of the defunct, I think, class culture of

Europe, I developed something that was intrinsically my own and rooted to my own experience in America."[31]

The super-sized scale of the Earthworks meant that they could only be seen in full from above, recalling the aerial vantage point of Noguchi's *Sculpture to be Seen from Mars*, *This Tortured Earth*, and his unrealized Newark airport proposal. The aerial view flattens volumes and privileges surface differentiation, favoring the low-lying, lateral spread that characterized many of Noguchi's early proposals. Experiencing the works on the ground entails using the imagination, which completes what the viewer knows to be there but cannot apprehend at once. Spatial and temporal levels are intertwined as the viewer passes over or through them. Oppenheim explained, "The sense of physically spanning land, activating a surface by walking on it, began to interest me. When you compare a piece of sculpture, an object on a pedestal, to walking outdoors for ten minutes and still being on top of your work, you find an incredible difference in the degree of physicality and sensory immersion."[32]

The ritualistic journey required to view the isolated Earthworks recalls both the ceremonial aspects of ancient antecedents and the remote location of Noguchi's own proposals for *Monument to the Plough*, *This Tortured Earth*, and *Sculpture to be Seen from Mars*. But Noguchi abandoned this aspect of his proposals after World War II, when he no longer felt the need or desire to identify with the American landscape or to assert the particularly American character of his works. Following the more participatory example of his playgrounds and dance sets, rather than the less accessible proposals for monuments or effigies, his postwar works were intended for direct physical interaction, not distant reverence. In 1952 he wrote, "Freeing itself from the museum-conscious pedestal and its false horizons, sculpture must reenter the world proportionate to man—not monumentality, a man's foot is the measure."[33] Perhaps more importantly, Noguchi's environmental works of the postwar era were created with utopian aspirations, primarily to restore a connection between city dwellers and nature.

Robert Smithson. *Aerial Map: Proposal for Dallas Fort-Worth Regional Airport*, 1967.
Mirrors; 52 1/2 x 48 1/2 x 1/4 in. (133.4 x 123.2 x 0.6 cm).
Estate of Robert Smithson.
Photo courtesy James Cohan Gallery, New York, © Estate of Robert Smithson / Licensed by VAGA.

His gardens, playgrounds, and plazas incorporate water, plants, rocks, and contoured earth but were meant to be integrated into daily life and were usually adjacent to, or enclosed by, buildings.

> I think my madness in wanting to make gardens and so forth lies in this usefulness; it's a kind of humanizing of space, and humanizing of sculpture. It's not merely sculpture for aesthetic purposes, nor a question of ego or something else; it's not even images of archaeology or some fantasy in the desert. Rather, it is something that is actually very useful, and very much a part of peoples' lives.[34]

The Earthwork artists also acknowledged mankind's increasing alienation from nature, but unlike Noguchi, they made no attempt to reclaim nature for the city dweller. In 1968 Smithson wrote, "The city gives the illusion that earth does not exist. Heizer calls his earth projects 'The alternative to the absolute city system.'"[35] Although Smithson began to conceptualize his Earthworks in connection to an architectural project, he would soon seek locations in which the city, with all of its limitations and architectonic references, did not exist. The desert West offered these artists a blank slate on which to carve and build, and the freedom of scale not available in the city. "The desert is less 'nature' than a concept, a place that swallows up boundaries," Smithson wrote. "When the artist goes to the desert he enriches his absence and burns off the water (paint) on his brain. The slush of the city evaporates from the artist's mind as he installs his art."[36]

By 1973 Noguchi was describing the projects of his younger colleagues as escapist works that failed to meet one of his primary goal for sculpture—integrating art into society.

> There are people now who have more or less come around to my point of view who go out in the desert and dig a trench and say, "Look, we've found the earth." But that, again to me is a kind of fragmentary thing. First of all, it's an artificial situation, the desert let's say, far away from anybody like doing something on the moon. You don't have to go all the way to the moon to do something. You

can do it right here. When you give yourself special situations like that, again to me, it's a denial or an avoidance of the real problem, the real situation.[37]

The conflict between integration and separation runs parallel to allusions to the sublime in nature. Christopher Hussey's (1899–1970) book *The Picturesque*, 1927, offers an interpretation of Edmund Burke's notion of the Sublime. Hussey ascribes these attributes to the Sublime: obscurity, power, privations (vacuity, darkness, solitude, and silence), vastness, infinity, succession, and uniformity.[38] Several of Noguchi's early proposals, with their overwhelming dimensions and isolated locations, share these qualities. As Noguchi's works shifted to more populated spaces, however, notions of the Sublime were abandoned. Vastness, obscurity, privations, infinity, and uniformity were sacrificed as the works became more intimate, more human in scale. They were also more accessible, situated amid all of the sensory distractions of the city. The spaces differed in form, and required synthesizing disparate elements to create a total environment. In short, Noguchi's works tended toward the beautiful, which Hussey described in terms of smallness, smoothness, gradual variation, and delicacy of form and color. Noguchi was providing oases of controlled nature in the midst of urban life.

In contrast, the Earthworks in remote areas of the West invited allusions to the Sublime. The heroic scale of the works announced their willingness to compete with the vastness of the American landscape

Robert Smithson. *Spiral Jetty in the Great Salt Lake, Utah*, 1970. Rock, salt crystals, earth, and water with algae; 500 ft. x approximately 15 ft. (152.4 x 4.6 m). Collection Dia Art Foundation, New York.

Art © Estate of Robert Smithson / Licensed by VAGA. Photo © Gianfranco Gorgoni.

and the geological forces that shape the earth's surface. Heizer relocated 240,000 tons of earth for *Double Negative*. *Displaced-Replaced Mass* fast-forwarded the geologic cycle of mountains eroding, a process that typically takes tens of thousands of years. Oppenheim's Mount Cotopaxi work was to have a diameter of ten miles. As he explained, "Things like the Grand Canyon have always frightened artists. They've always seemed like forms impossible to duplicate or rival. Now artists have been willing to meet these objects in their own ball park."[39] Earthworks rarely included vegetation (Oppenheim's Earthworks being an obvious exception), and their consistency of material and stark geometry, often raw cuts in the earth, reveal the influence of Minimalism. The isolation of these works facilitated an encounter closer to premodern modalities of experience and enhanced their awe-inspiring impact. Without the sensory distractions of the city, the viewer could perceive the works in the limitlessness of nature in almost total silence and solitude, all among Hussey's preconditions for experiencing the Sublime.

Michael Heizer. *Double Negative*, **1969–70. Displacement of 240,000 tons of rhyolite and sandstone; 1,500 x 50 x 30 ft. (457.2 x 15.3 x 9.2 m). The Museum of Contemporary Art, Los Angeles; gift of Virginia Dwan.** Photo courtesy Triple Aught Foundation.

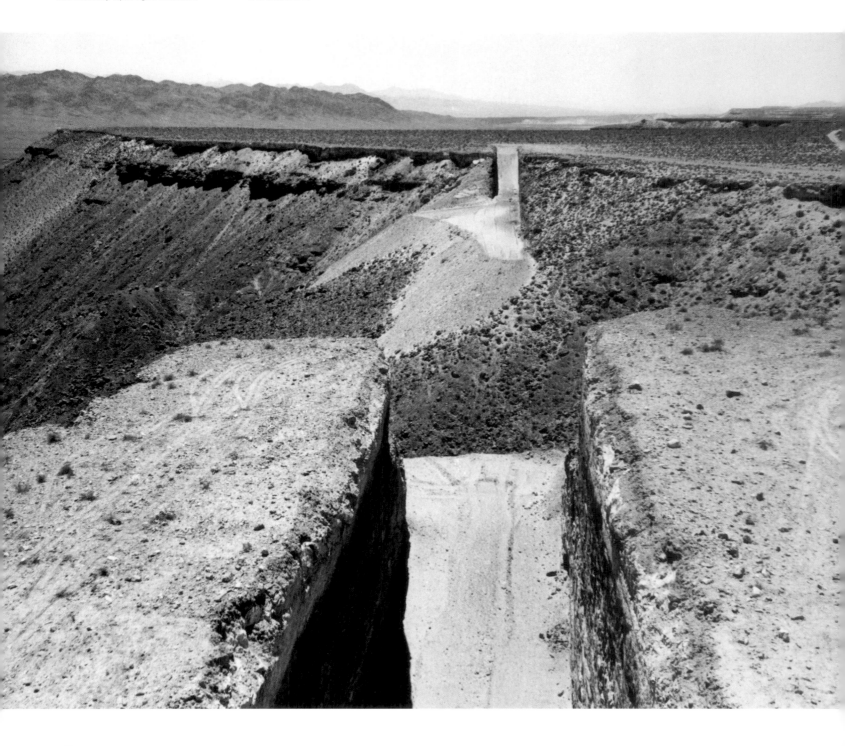

Many of the later artists were interested in the process of making Earthworks—the geological disruptions and perforations of the earth's strata—as much as the finished sculpture. "These processes of heavy construction have a devastating kind of primordial grandeur, and are in many ways more astonishing than the finished project—be it a road or a building," Smithson wrote.[40] These concerns were in keeping with the development of Conceptualism and Process art in the late 1960s. Although Noguchi expressed little interest in the aesthetics of the interim stages of his environments, his radical idea of using farming equipment or bomber planes to sculpt the landscape presaged the deployment of dynamite and construction equipment for Earthworks. The bulldozer was the twentieth century's equivalent of the plow, sweeping American progress forward and asserting man's dominance over nature.

Despite the fundamental shift in Noguchi's landscape proposals in the 1950s, one wonders if his objection to Earthworks was not tinged with some resentment or envy. After all, these younger artists were carrying out ideas similar to those he imagined four decades before, in proposals that the art world of the 1930s was not ready to support. Or perhaps Noguchi's opinion was colored by a sense of failure in not realizing any of his own early earth projects. In 1968, at the height of the Earthworks movement, he reflected on a solicitation he turned down in 1959 to repurpose 60 million cubic yards of excavated earth for the city of Detroit. "There are few moments of courage when we do not compromise for the more easily possible."[41]

Noguchi's 1933 *Monument to the Plough* celebrated America's pioneer spirit and "the plow that broke the plains." In proposing the work Noguchi was himself opening a new frontier for sculptural possibilities. He merged the fields of architecture, landscaping, and industrial design long before the era of postmodernism when cross-disciplinary work would become commonplace. Younger artists of the 1960s and 1970s also regarded the vast spaces of the American West as a kind of manifest destiny for their sculptural ambitions, though few of them were aware of Noguchi's earliest proposals for sculpting the earth. Interestingly, social application and reclamation became an increasingly important consideration for these younger artists, and many would adapt their own landscape work during the 1970s along very similar lines to Noguchi's midcentury approach. Today Noguchi is mentioned only briefly in the literature on Earthworks and Land art.[42] Even without being fully acknowledged, however, Noguchi's early endeavors broadened the definition of public sculpture and lay the groundwork for succeeding generations to sculpt the landscape.

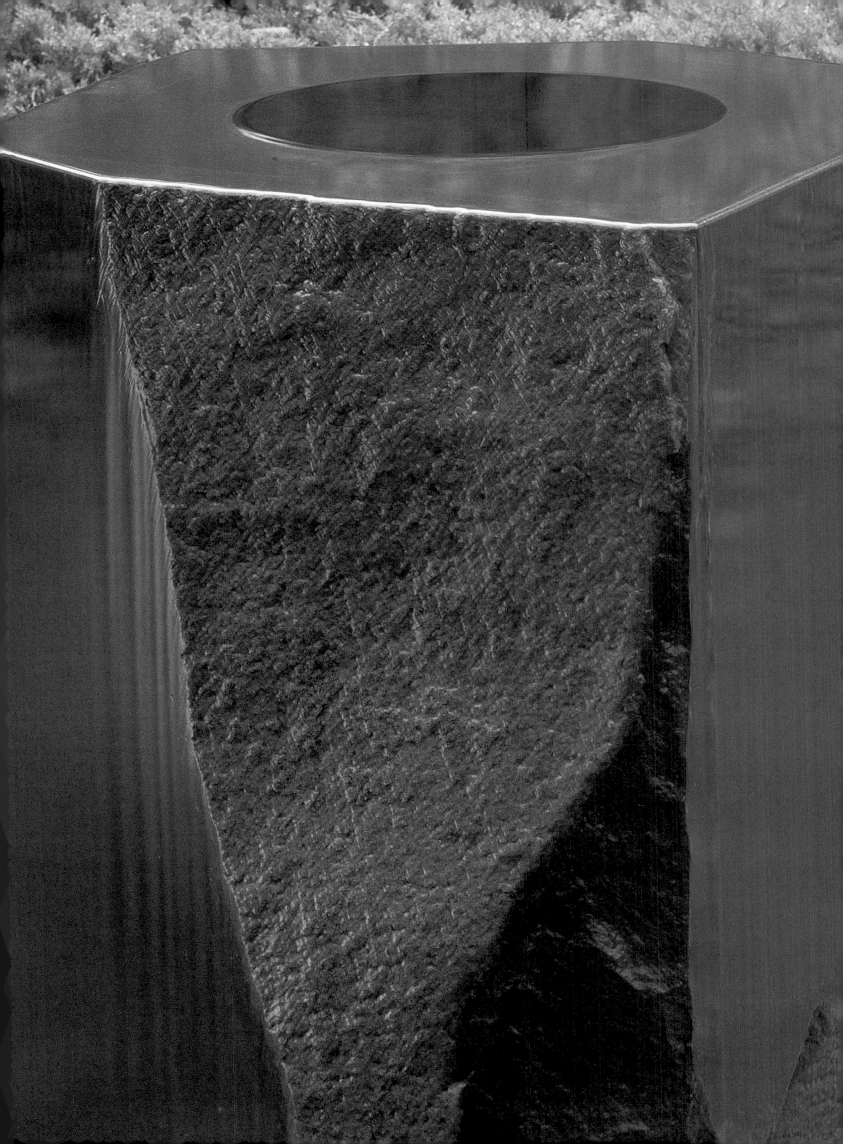

Sitting Quietly
Isamu Noguchi and the Zen Aesthetic

Bonnie Rychlak

OPPOSITE
The Well, 1970. Basalt;
H. 26 3/4 in. (60.3 cm).
The Noguchi Museum, New York.
Photo by Kevin Noble.

Noguchi's late stone works, more often than not, are interpreted as metaphors for a kind of Zen awareness. Critics have suggested that the artist adapted much of his mature sculptures—which drew from architecture, calligraphy, and garden design—to various tenets of the Zen aesthetic.[1]

The offspring of a Japanese father and an American mother, Noguchi was physically striking. With blue eyes and a wry, ironic smile, he did not possess the identifiable countenance of either Asian or Western ancestry. Always making the most of his identity as the "other," or the "outsider," Noguchi cultivated a public image as an ascetic, a solitary artist, and an outsider, but in so doing he unwittingly limited the critical understanding of his work, at times even marginalizing it. Recognizing that his dual racial and cultural heritage defined him as an "exotic" participant in American modernism, Noguchi aimed to straddle both Western and Eastern cultures, crossing from one to the other when strategically valuable. The following discussion aims to explore the intricate and ambiguous relationship between the artist—both his self-image and his work—and various facets of Zen Buddhism, and to relate them to some of the social and artistic environments that may have influenced Noguchi's spiritual inquiries and discoveries.

Although Noguchi never undertook any formal Eastern religious practice, he projected a Zen Buddhist aesthetic, particularly in his later years when he spent more time in Japan. Noguchi actually embraced no one religion, but expressed an intellectual interest in many. The natural materials and refined minimal forms of his work, as well as their titles, persistently linked the artist and his image to Zen Buddhism. Possibly what interested Noguchi most about Zen was the fact that to him it was a way of life rather than a religion in the traditional sense (although it did evolve from an esoteric sect of Buddhism) and he could participate in it without committing to it.

Living in Japan with his mother until he was 13 years old, Noguchi inevitably assimilated many Japanese traditions and observed non-Western social and cultural customs. Apprenticed to a Japanese carpenter, he learned some traditional Zen Buddhist precepts that are common in Japanese culture, such as a reverence for the meticulousness of craft, the awesome sacredness of nature, and the sanctity of everyday life. In his autobiography Noguchi noted that his mother regularly read William Blake to him and that the memory of hearing the poetry of Blake early on was etched in his psyche.[2] Perhaps Blake expressed Noguchi's own intense reverence for what the artist held to be the sacredness of nature and a devoted awareness of nature's continuum. In America, as an adolescent, his philosophical development continued while living in the care of a family of Swedenborgians[3] who espoused a theory of the unity of the universe that opposed determinist thinking, one that was more akin to an Eastern tradition of nondualistic relativism. Swedenborgian teachings would prove to be formative for a young boy growing up in the vast expanse of middle America, although likely not all that alien to him after his early years in a Buddhist country.

Noguchi as a young man, 1932.
Photo by Berenice Abbott, courtesy Estate of Berenice Abbott.

Noguchi was by no means the first American to become interested in Eastern religions. From literary circles in the mid-nineteenth century—when little was known of Eastern thought—Orientalism[4] and musings on the "exotic" East were becoming popular in America and Europe. The writings of the Transcendentalists, principally Ralph Waldo Emerson, transmitted some basic Buddhist ideas, and Henry David Thoreau's *Walden* discussed Indian philosophy, particularly the *Bhagavad Gita*. In 1844 Elizabeth Palmer Peabody's translation from the French of the *Lotus Sutra* was published in Thoreau's Transcendentalist magazine, *The Dial*.[5] In his autobiography Noguchi noted his admiration for the writings of Max Müller, a mid-nineteenth-century scholar of comparative mythology, whose commentary addressed sculpture and the Orient.[6]

Noguchi was probably first introduced to Buddhism when he read Tenshin Okakura's book *The Ideals of the East*. Okakura (1862–1913) was a Japanese scholar of Orientalism and a curator for the Museum of Fine Arts, Boston. His writings on the traditions of Japanese culture awakened Noguchi's own secular fascination with Eastern traditions. As Noguchi later reflected, Okakura's book had shaped the course of his inquiry into the meaning of the East.[7] In 1927 Noguchi spent one month in London specifically to study Oriental texts at the British Library. He studied Hinduism, Taoism, and Buddhism, learning some of the basic features of Buddhist beliefs, including detachment from the material

world, deference to nature, spontaneity, chance, and the abandonment of rational thought.[8] Noguchi wrote several times that he aspired to "see nature through nature's eyes," and noted in his autobiography that, during this time in London, he became particularly interested in the work of Ananda Coomaraswamy, an Indian Indologist, art historian, and eminent Orientalist, who wrote extensively on themes related to the universal traditions in all religions. Like other artists of the time, Noguchi was fascinated by some of the principles and terms in Eastern texts, where such concepts as spontaneity, emptiness, the void, and transience, helped him understand his own reservations about the well-delineated hierarchy in Western art.

Years earlier, Noguchi's father, Yonejiro Noguchi, had benefited from his Oriental exoticism in Europe and America, establishing himself as an Imagist poet among such contemporaries as W. B. Yeats and Ezra Pound,

Rock garden in Myokenji Temple, Kyoto, Japan, 1398.
Photo © Michael S. Yamashita/Corbis.

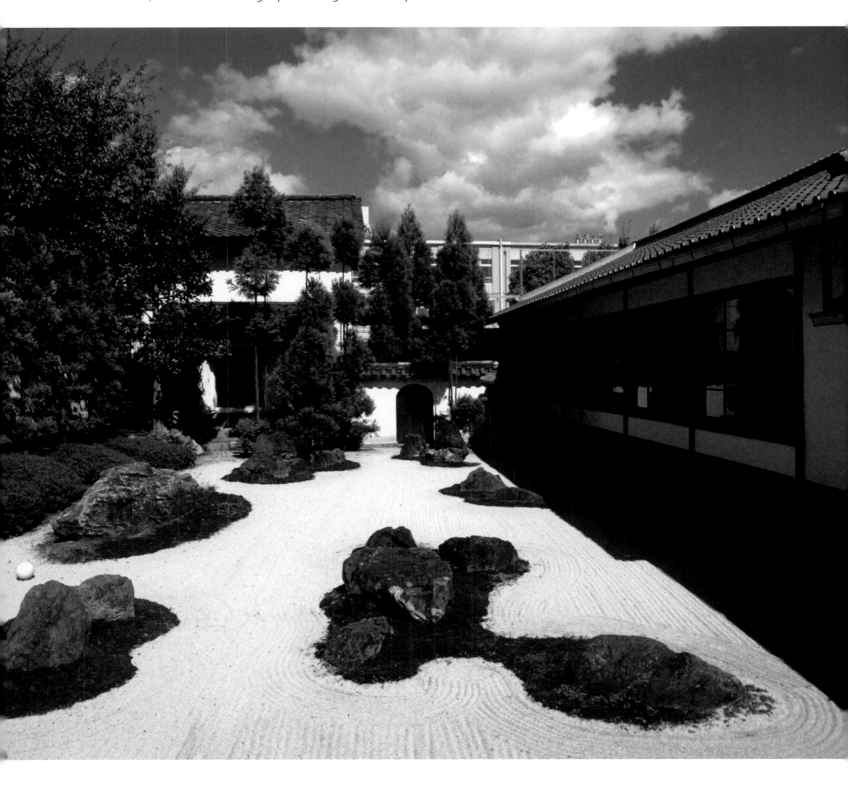

having a pivotal role in relating Japanese poetics to intentions of Western modernism. Although Isamu was estranged from his father his entire life, he admired his father's aesthetic influence on two distinct societies. He was also well aware that the Noguchi name garnered substantial respect in literary and artistic circles. Accordingly, in 1923 the fledgling artist changed his surname from his mother's to his father's, from Gilmour to Noguchi, announcing that Gilmour was not a fitting name for a sculptor.[9]

Traveling to Europe for the first time in 1926, on a Guggenheim Fellowship, the young sculptor found that the esteemed Noguchi name opened important doors for him. In America, however, his bicultural heritage was sometimes a liability as when, in 1934, he exhibited his socially progressive models for memorials and monuments for the working classes. The criticism was harshly racist, rebuffing Noguchi as a "wily...semi-oriental sculptor" and disparaging his sculpture as "just a little Japanese mistake."[10] But, by refusing to commit to a single cultural standard, Noguchi was not constrained by any one convention. In turn, the lack of constraint afforded him the freedom to participate in any style, discipline, or aesthetic theory he chose.[11]

Noguchi's first direct encounter as an adult with Zen was in 1931 in Kyoto, where the artist spent four months, working in the pottery studio of the renowned ceramist Jinmatsu Uno and visiting museums and Zen gardens. It was in Kyoto that Noguchi observed his way of life becoming contemplative, as he learned to perceive art as beyond art objects.[12] Guided by a young sculptor named Sasamura, Noguchi visited the famous temple gardens of Kyoto, including the most well known of Zen temple gardens, Ryoanji. He also met the important scholar of Oriental art Langdon Warner (1881–1955), who took him to visit Horyuji Temple in nearby Nara. Kyoto and its environs provided Noguchi with a lasting store of impressions and images as well as techniques that would inform and become integrated into his mature sculpture.[13]

Many years would pass before Noguchi visited Japan again. In the interim he explored a variety of aesthetic directions, seemingly far removed from spiritual pursuits. From the 1930s onward, he had involvements with Surrealism, The New York School, and Minimalism. Noguchi also pursued his aspirations for art that could improve the daily life of humanity. His efforts encompassed industrial and furniture designs, as well as landscape, garden, and playground projects.

Within these various movements Noguchi had the opportunity to associate with many artists on the American scene in the 1940s that shared his fascination with Eastern thought and ideas of myth and the unconscious, including the painters Barnett Newman, Mark Rothko, Franz Kline, and Mark Tobey. In 1949 the Zen scholar Daisetz T. Suzuki (1870–1966) published *Introduction to Zen Buddhism* in English, and his subsequent lectures at Columbia University were attended by artists Philip Guston, Ibram Lassaw, and Ad Reinhardt. During the 1950s Suzuki was immensely influential on the painters William Baziotes, Jackson Pollock, and Theodoros Stamos, as well as the sculptors Richard Lippold and Seymour Lipton.[14] In San Francisco, members of the Beat culture actively embraced Zen philosophy, including the poet-playwright Michael McClure (a friend of Noguchi's), writer Jack Kerouac, painter Gordon Onslow-Ford, and especially the poet Allen Ginsberg.[15] Many of these artists would spearhead the 1960s counterculture, and books such as *Zen in the Art of Archery* by Eugen Herrigel and *The Way of Zen* by Alan Watts were standard reading for the incipient New Age ideology when words like "nothingness" were entering the American vernacular.

As early as the 1950s, meditation centers opened in America and Buddhist texts were translated into English. Zen ideas were taking hold intellectually and creatively in many disciplines from coast to coast, no-

tably in dance with Merce Cunningham and music with John Cage; both emphasized chance, accident, and process (approaches to making art that also had roots in Automatic Surrealism). Noguchi collaborated with these two "gurus" of Zen on the dance production of *The Seasons* in 1947. The continued collaboration of Cage and Cunningham would inspire the next generation of artists, such as Robert Rauschenberg and Jasper Johns.

Unlike John Cage, however, Noguchi did not make Zen Buddhist rhetoric explicit or direct in his work. Cage held to principles of the avoidance of hierarchy and a refusal to make distinctions between art and ordinary objects, music and ordinary sounds, dance and ordinary movements.[16] These principles were not necessarily part of Noguchi's visual vocabulary, although Noguchi did share Cage's belief in the importance of the role accident and chance played in the creation of art. According to Michael McClure, "Noguchi believed that preconception is the death of art. He... spoke with pleasure of the recognition of myriad accidents in the world. Accident is a result of clear and evident causes. It is fine to be appreciator and instigator of the accident; it makes a brighter world."[17] Referring to

Sky Mirror, 1970. Basalt; H. 26 3/4 in. (60.3 cm). **The Noguchi Museum, New York.** Photo by Kevin Noble.

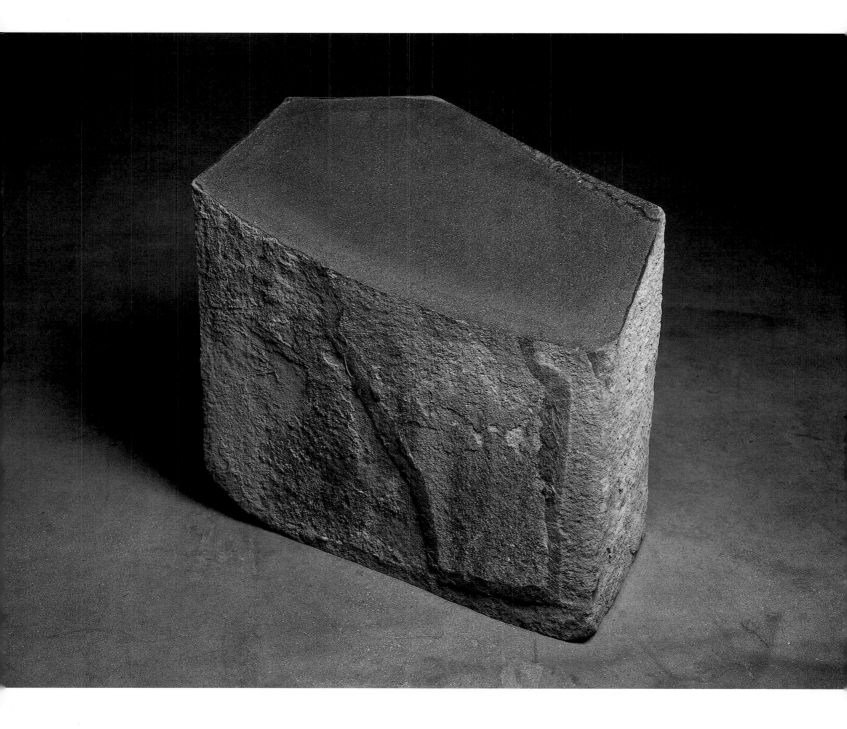

his minimally carved block of basalt, *Sky Mirror*, 1970, Noguchi wrote that "each sculpture is a miracle of chance. The shape, the size, the color, the blemish, its correction. And time, which completes all things, brings the sun into its alignment, when stone becomes mirror."[18] Noguchi managed the process of chance, fostered the "mistake" and cultivated the accident, believing that the process could be revelatory about the work itself. In this regard, Cage and Noguchi anticipated the Minimalist emphasis on randomness, repetition, and redundancy, particularly in music, with such artists as La Monte Young, Steve Reich, and Philip Glass.

In 1949 Noguchi applied for and received a grant from the Bollingen Foundation,[19] to study what he described as the "environments of leisure," its meaning, use and relationship to society. His interest in this subject centered on questions of what leisure time and space, whether contemplative or participatory, might be in different cultures and what relationship it might have to religion and "play." This grant enabled him to travel exten-

Floor Frame, 1962. Bronze
(2 elements); L. 42 in. (106.7 cm).
The Noguchi Museum, New York.
Photo by Kevin Noble.

ISAMU NOGUCHI : MASTER SCULPTOR

Head of a Japanese Girl, 1931.
**White ceramic; 9 3/8 x 7 1/2 in.
(23.8 x 19 cm). Location unknown.**
Photo by Berenice Abbott,
courtesy The Noguchi Museum.

sively during the next six years, including an extended visit to Japan. There
he met Hasegawa Saburo (1906–1957), an English-speaking intellectual
and European-style painter (Noguchi described him as painting more or
less like Paul Klee) who had already discerned that modernist tendencies
such as abstraction and Surrealism could be found in traditional Japanese
culture. He was hired by the *Mainichi* newspaper to guide Noguchi through
old Japan and facilitate Noguchi's first authentic contact with Zen. Before
they set out in late spring 1950, Noguchi reread Suzuki's *Zen and Its Influence
on Japanese Culture* [*Zen and Japanese Culture*].[20] Hasegawa described in let-
ters and memoirs their long discussions of Zen poets, literature, architec-
ture, calligraphy, and tea. Noguchi would later reminisce that "Hasegawa
helped me travel and reexperience the beauty of ancient temples and
gardens, and to imbibe the tranquility of Zen."[21] The two complemented
each other: Hasegawa's sophisticated understanding of Western egocen-
trism stimulated Noguchi's childlike, impatient enthusiasm, and Hasegawa
was intrigued by Noguchi's Western materialism juxtaposed with his
spiritual insights into old Japan.

 Key aspects of Zen that Noguchi observed during this time in Japan
helped shape his sculptural vision. One concept, *wabi,* represents the
concept of "less is more." In Zen painting the style is best illustrated by a
very spare use of brushstrokes. Noguchi incorporated this idea into certain
sculptures that he placed directly on the floor, such as *Floor Frame*, from
1962, which approaches Minimalism in its simplicity and economy of form.
In Japanese dictionaries *wabi* is also defined as "poverty," especially self-
induced poverty where one is content with quietly contemplating nature.
In other words, *wabi* is a longing for a primitive simplicity. In art, *wabi* calls
for disregarding too much detail and an "aloofness from conventional
rules…where one normally expects a line or a mass or a balancing element,
it is missed but yet the imperfection is in itself perfection—to embody
beauty in a form of imperfection or even ugliness."[22]

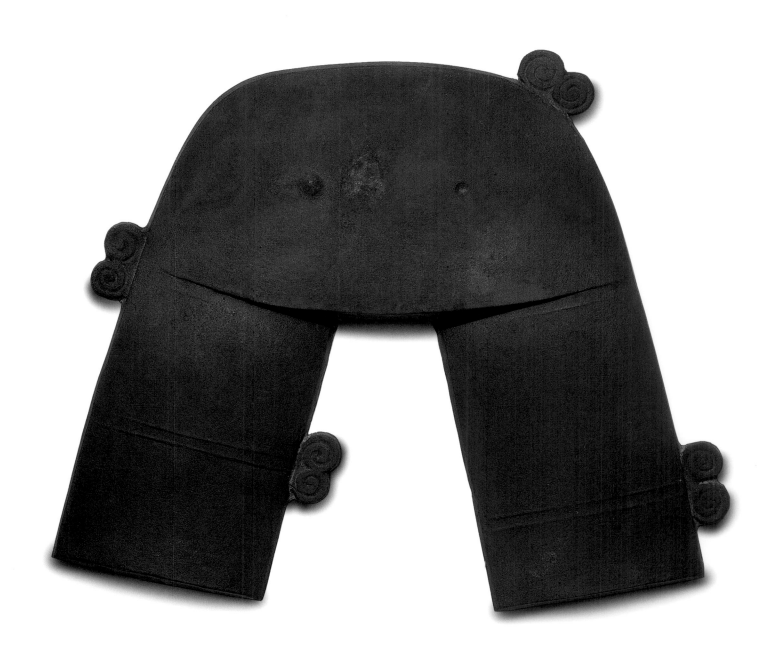

Celebration, c. 1952.
Bronze; 17⁷/₈ x 20 x 1¹/₂ in.
(45.2 x 50.8 x 3.8 cm).
Whitney Museum of American
Art, New York; gift of Howard
and Jean Lipman.
Photo by Robert E. Mates.

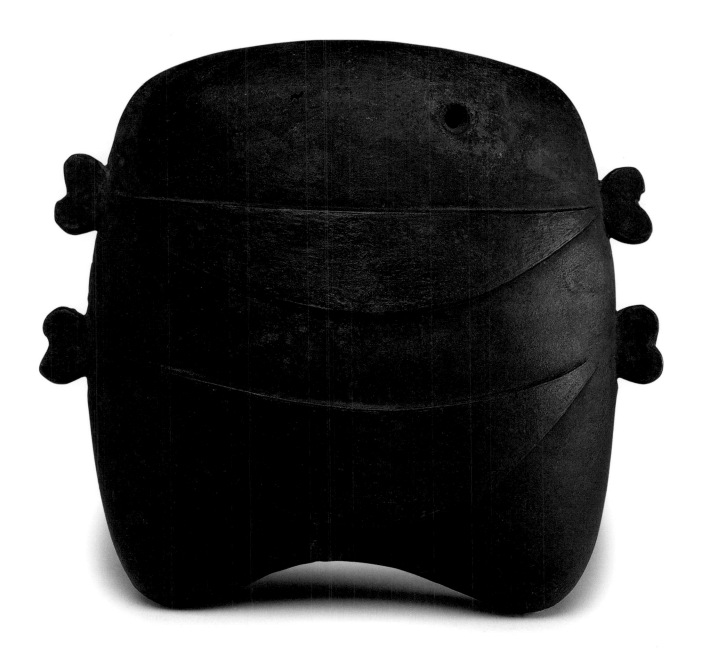

Okame, 1956. Iron
(edition of 4); 9 $\frac{1}{2}$ x 10 $\frac{1}{4}$ x 3 $\frac{5}{8}$ in.
(24 x 26 x 9 cm).
Hirshhorn Museum and Sculpture
Garden, Smithsonian Institution,
Washington DC; gift of Joseph H.
Hirshhorn.
Photo by Lee Stalsworth.

Artworks by Noguchi of a *wabi*-inspired nature were produced on his earlier 1931 trip to Japan when he worked on terracottas. Two portrait heads made then can be seen as unfettered examples of his prescient Zen aesthetic: *Uncle Takagi* (see pages 40 and 41) and *Tsuneko-san*. Noguchi's Uncle Takagi was a Zen monk. Clearly crafted in the tradition of priestly Zen Buddhist portraiture, this portrait of his uncle was based on the principles of *wabi*. The subtle wrinkling of the subject's brow is executed with economical bravura as in *Tsuneko-san,* a portrait of Noguchi's maid in 1931. This head is also austere, with two faintly incised lines indicating her hairline. With nearly closed eyes that impart a sense of meditative calm and worldly detachment,[23] these portrait heads can be seen as prototypes of sculptures imbued with transcendental metaphors.

Wabi principles underlay many of Noguchi's subsequent sculptures, including *This Earth, This Passage*. Not elevated either metaphorically or literally, this sculpture was formed in clay with the artist's feet before it was cast in bronze. Its basic doughnut shape presents the direct evidence of the process of its making—feet pressed into clay.

Detail of gravel and moss-covered mounds in rock garden, Tofukuji Temple, Kyoto, Japan, 1236.
Photo © Michael S. Yamashita/Corbis.

ISAMU NOGUCHI : MASTER SCULPTOR

The second key concept of the Japanese Zen aesthetic is *sabi*, which Suzuki defined as "imperfection accompanied by antiquity or primitive uncouthness. If an object of art suggests even superficially the feeling of a historical period, there is *sabi* in it. The artistic element that goes into the constitution of *sabi* literally and poetically means 'loneliness' or 'solitude.' Aloneness indeed appeals to contemplation and does not lend itself to spectacular demonstration."[24] This aspect of *sabi* appealed to Noguchi's sense of alienation, which he claimed was a result of his not feeling at home in any one country, a state of mind that continually troubled him but one that he also guarded.

Visiting the Horyuji Temple in Nara, Hasegawa and Noguchi discovered that the Golden Hall had been destroyed by a fire. Hasegawa recalled that he "could hardly bear to look at it....Noguchi, however, remarked, 'Isn't it more beautiful now?' This, Hasegawa thought, showed Noguchi using quite naturally the principle of *sabi* '...a smile of recognition of a commonality of belief came across Noguchi's face.' Hasegawa said to Noguchi, 'Isamu, [if] you could see beauty in the charred remains of Horyuji [then

This Earth, This Passage, 1962.
**Bronze; 8 x Diam. 42 in.
(20 x Diam. 107 cm).
The Noguchi Museum, New York.**
Photo by Kevin Noble.

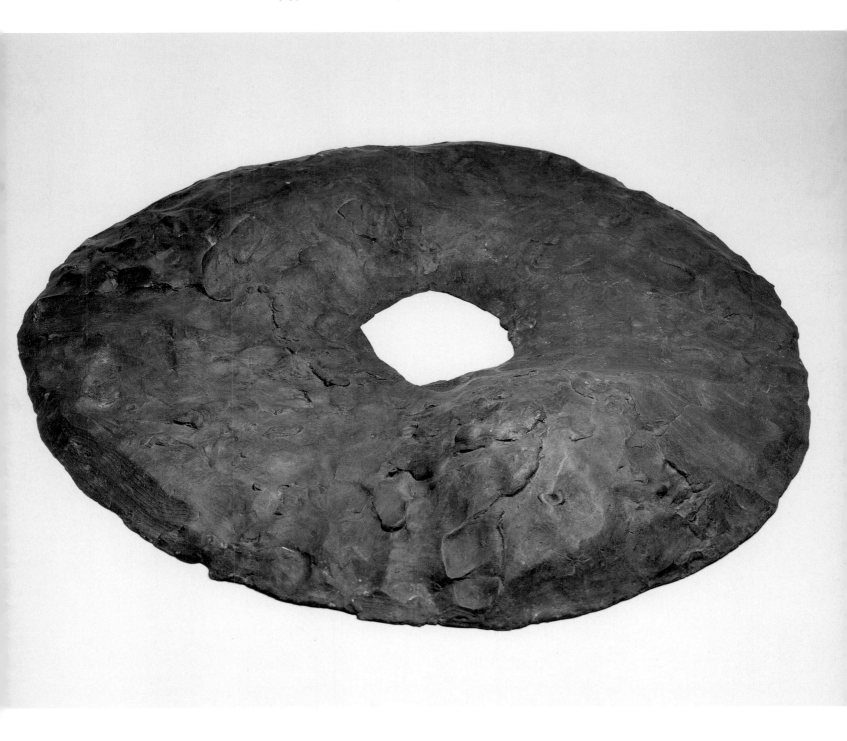

Charred structure of Horyuji Temple,
Nara, Japan, **mid-1950s.**
Photo by Isamu Noguchi,
courtesy The Noguchi Museum.

you] are probably closer to the Japanese love of *sabi* than I am.' Noguchi sat quietly for a moment, looking a bit embarrassed (feeling perhaps his irony was not appreciated), and then replied: 'Arp is just as Japanese as anyone in feeling.'"[25]

A third very important characteristic of the Zen aesthetic, most visibly observed in Japanese landscape design and architecture, is asymmetry. According to Suzuki, "symmetry inspires a notion of grace, solemnity, and impressiveness, which is again the case with logical formalism or the piling up of abstract ideas. Western thought has symmetry intrinsically connected to the intellect and the intellectual primarily aspires to balance while the Japanese are apt to ignore it and incline strongly towards imbalance,"[26] a principle that touched Noguchi on an intuitive level.

Shodo Flowing is part of a series of balsa woods that Noguchi carved, then cast in bronze. In this body of work he considered the bronze as the primary object, not the balsa wood. This was unusual for Noguchi, who generally disliked the casting process and did not believe in the inherent aesthetic qualities of bronze. In this unique body of work the heaviness of bronze appears weightless, transformed from the balsa wood, which inherently is very light. The balsa woods were expressionistically sliced with a knife and akin to gestures of calligraphy, as slicing remains as residue on the bronze. (*Shodo* is the Japanese word for calligraphy). The sculpture's elements hang together; counterbalancing each other in an understated demonstration of delicacy and precision. As in many of Noguchi's sculptures, the aesthetic principles of Zen—imbalance, asymmetry, the "one-corner," poverty (*wabi*) or aloneness (*sabi*), and cognate ideas—were physically or metaphorically explored.[27]

Additionally relying on his learned sense of balance and symmetry from the West as well as basic principles of physics, Noguchi engineered iconic Zen-inspired shapes and forms. An example of such an engineering feat is *The Sun at Noon*, 1969, one of many sculptures consisting of a frontal circle or an opened-centered stone. Here blocks of alternating marble are held together by rods and epoxy, then carved to a smooth perfect circle. The sculpture holds firm under its own mass, transcending the weight of marble. In both Western and Eastern cosmology, the form of the circle is the eternal center. In Zen, the circle represents emptiness and alludes to "great-perfect-mirror-wisdom which articulates that the mind must be kept entirely free from selfish affects and intellectual calculations so that original intuition is ready to work at its best."[28] In other words, it represents the effort to create a state of "no-mindness" or mind empty of content.

Intellectually Zen appealed to Noguchi as it provided a spiritual profile without his having to conform to a specific religious dogma. Regarded by adherents as indefinable, incommunicable, and an individual experience that transforms consciousness, it also fit with his approach to sculpture and

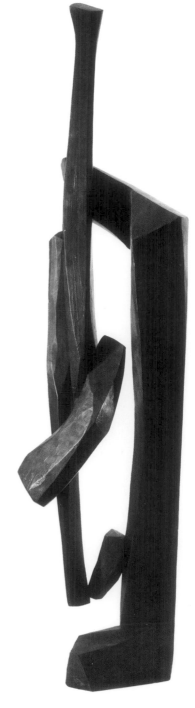

Shodō Flowing, **1969. Bronze;**
76 x 16 in. (193 x 40.6 cm).
The Noguchi Museum, New York.
Photo by Joubert,
courtesy Galerie Claude Bernard.

Life of a Cube No. 5, 1962. Black
granite; 12 5/8 x 12 3/8 x 12 5/8 in.
(32.1 x 31.4 x 32.1 cm)
on artist's wood base.
The Noguchi Museum, New York.
Photo by Kevin Noble.

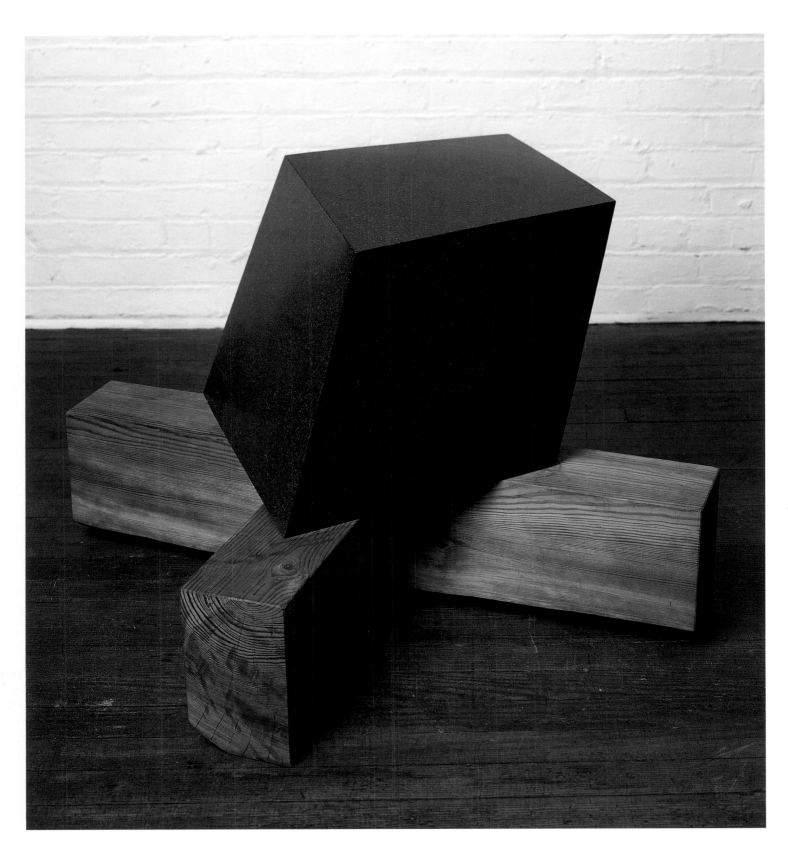

method of working. Noguchi explained, "[W]ith Zen there is a more direct linkage to art than through other mystical forms. It is the appreciation of the thing itself. It is like a reverse linkage: you can't say whether art comes from the spiritual or vice versa."[29]

Introduced to Japan from China in the twelfth century as a sect of Buddhism, Zen can actually be traced much further back, to the fifth century, when the Indian priest Daruma introduced his version of Buddhism to China. Daruma taught that through the practice of meditation one could attain enlightenment by eliminating the rational thoughts that assume the world can be understood through observation, believing instead that the world and the self are illusions. Daruma preached that by dint of hard meditation, one can become enlightened. The basic practice of Zen revolves around long sessions of *zazen* (sitting in meditation), which is intended to empty the mind of illusion, leading to *satori*, or enlightenment. Various methods were devised to jolt the student of Zen out of his rational wits. These included shouts, loud noises, and peculiar exchanges of questions and answers, called

Illusion of the Fifth Stone, 1970.
**Aji granite (5 elements);
47 x 54 x 48 in.
(119.4 x 137.2 x 122 cm).
The Noguchi Museum, New York.**
Photo by Shigeo Anzai.

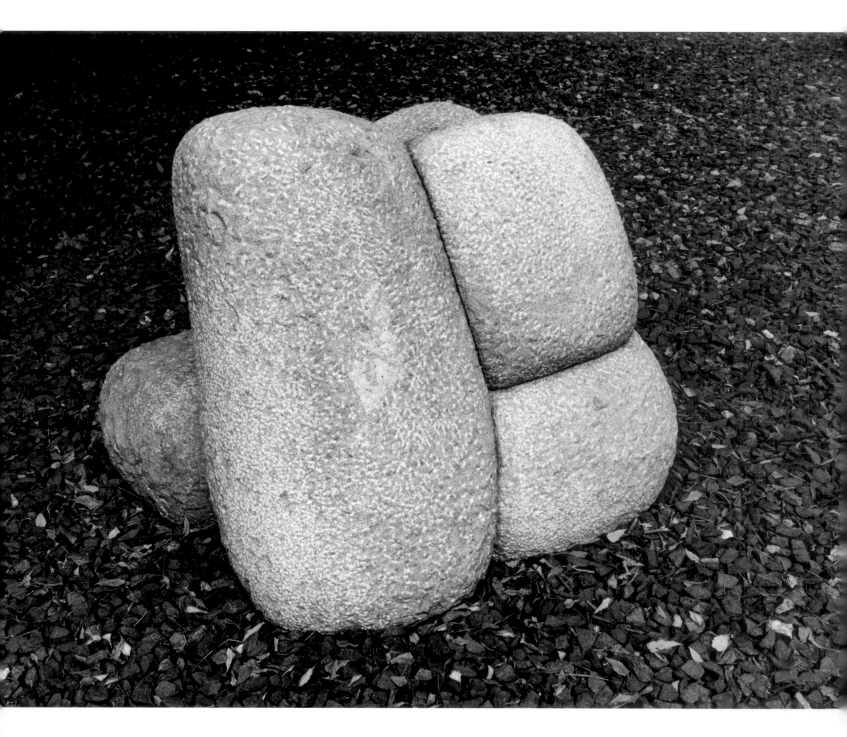

mondo, between master and pupil. The most notable of these techniques is the *sat*, which involves a large stick called a *kyosaku* used to strike anyone who dozes off. Tea drinking (and the eventual rituals of the Zen tea ceremony) was introduced as a remedy for staying awake during long periods of meditation.

Two schools of Zen eventually took hold in Japan: the Soto School, which emphasizes *zazen* and gradual enlightenment, and the Rinzai School, which places more stress on *koans* and a sudden, sometimes violent enlightenment. Disciples of Zen found themselves persisting in rational thought, so *koans*—mind twisters with no rational answers (a well-known example is "what is the sound of one hand clapping?")—were invented. A Zen student is obliged to continually keep a *koan* in mind, which eventually exhausts rational thought, allowing one to revert to the roots of consciousness. Noguchi incorporated *koans*, puzzles, and visual brainteasers into many of his stone sculptures, such as *Illusion of the Fifth Stone* and *Life of a Cube No. 5* (see page 199). As for the cube form, Noguchi made many studies and versions of this configuration, fascinated

Noguchi with "Another Land" sculpture in studio yard, Mure, Shikoku, Japan, late 1970s.
Photo courtesy The Noguchi Museum.

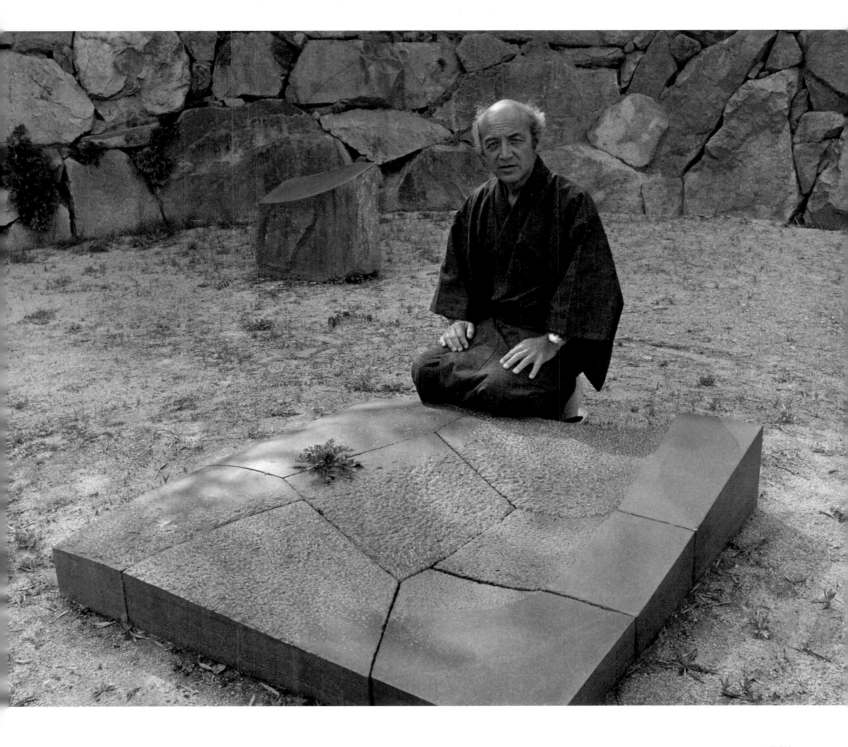

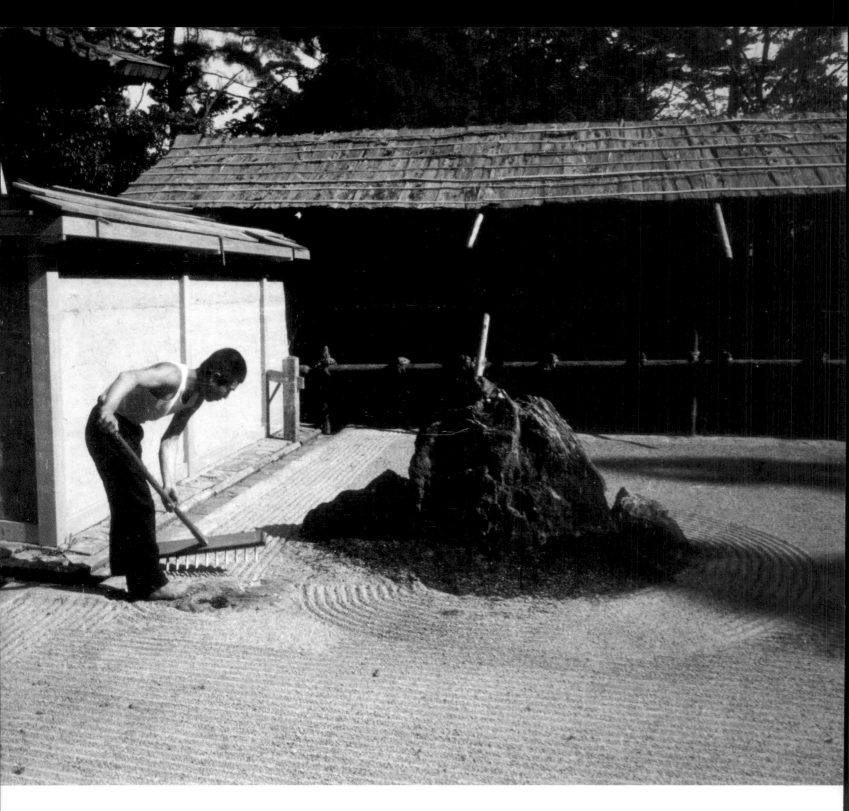

Man raking sand in rock garden, Japan, mid-1950s.
Photo by Isamu Noguchi, courtesy The Noguchi Museum.

with asymmetrical shapes that appear symmetrical and vice versa. He considered the simple form of a cube to be highly complex. *This Place* and *Another Land* (both 1968) present a composition as a puzzle: a carved slab of stone cut into pieces that have then been put back together, or perhaps the pieces were cut first and then assembled. Noguchi referred to these sculptures as "a landscape within a landscape" or "as water flows and nature's passage." [30] Noguchi would later enigmatically summarize:

> I would say from my own experience that the motivation for art doesn't come from religious formulation or anything of that kind. These formulations are, in a sense refractions of the main flow, which comes from something else. It always comes from something else, indirectly, in a flow. With some people, it comes with less obstruction. Breaking away from barriers like habit and convenience and fear, and accommodation—barriers which affect everybody, not just artists. But the artist tries to overcome such barriers, especially barriers of the self and what one thinks about art, for

instance. Everything becomes in time a barrier. Everything becomes in time an opportunity. I don't try to speak in riddles, but that's the way it is.[31]

Noguchi's visits with Hasegawa to the temple garden of Ryoanji profoundly affected his thinking and conceptual designs for art. Representing—in nearly abstract terms—a contemplative landscape, raked gravel simulates water and rocks stand for islands or mountains. An important aspect of the layout of the stones is the concept of the harmony of odd numbers. The combination of 7-5-3 is used not only in the composition of rock gardens but also in the Zen aesthetic notion of asymmetry. This concept—fundamental to Japanese aesthetics—is based on the idea that leaving something incomplete inherently creates interest, whereas uniformity allows no room for growth. Ryoanji is a quietly authoritative composition of 15 small, dark rocks arranged in five groupings embedded in raked white gravel and framed by a rectangular earthen wall. (Partially buried rocks are a critical aspect in Zen gardens and contrast with many of Noguchi's sculptural designs, which are either level to the ground or only give the illusion of being buried.) Each group alternates between an upward and a horizontal thrust; complex linear relations exist between stones in each grouping. Noguchi's imagination was captured:

> In viewing this garden [Ryoanji] one has the sense of being transported into a vast void, into another dimension of reality—time ceases, and one is lost in reverie, gazing at the rocks that rise, ever in the same but different spot, out of the white mist of gravel.... One feels that the rocks were not just placed there, that they grow out of the earth (the major portion buried), their weight is connected with the earth—and yet perhaps for this very reason they seem to

Lessons of Musokokushi, **1962. Bronze (5 elements); dimensions variable. The Noguchi Museum, New York.**
Photo courtesy The Noguchi Museum.

Mortality. 1961, cast 1962.
Bronze (edition of 8);
H. 75 in. (190.5 cm).
The Noguchi Museum, New York.
Photo by Kevin Noble.

float like the peaks of mountains. Here is an immaculate universe swept clean....[32]

Unlike English parks, which tend to be copies of nature, or French gardens that superimpose a rationalized, hierarchical design on the natural forms of the landscape, the Zen garden represents an artistic arrangement of nature, a perfection of it. Zen priests designed many gardens in Japan for the main purpose of contemplation and meditation. There are no bright colors or masses of beautiful flowers, only rocks, sand, water, trees, and green shrubs. Often sand is substituted for water and woodlands are replaced by dwarfed trees. Stepping-stones are spaced irregularly apart to keep one constantly aware of the surroundings. It was the Zen priest Muso Kokushi who introduced Zen garden design to Japan in the fourteenth century, giving visual expression to the ideal realm of Zen. He was always careful not to overcrowd his designs in an attempt to make them more interesting. Noguchi made a memorial of sorts to this famous Zen priest and garden designer. A sculpture he referred to as "my own Ryoanji," *Lessons of Musokokushi* (see page 203), is created out of clay or plaster and then cast in bronze. Noguchi shaped five mountainlike forms with his feet and by doing so, established a human dimension to the sculpture, avoiding the dwarfed Zen scale. The residue of the process is clearly imprinted on the surface of each element, and unlike the stones in traditional Zen gardens, *Lessons of Musokokushi* is not relationally precise and has no transcendental affectations.

Garden Elements, 1962.
Bronze (3 elements);
L. 33 in. (83.8 cm).
The Noguchi Museum, New York.
Photo by Kevin Noble,
courtesy The Noguchi Museum.

Origin, 1968.
Black granite; 23 x 30 x 32 in.
(58.4 x 76.2 x 81.3 cm).
The Noguchi Museum, New York.
Photo by Erick Johnson,
courtesy The Noguchi Museum.

In *Garden Elements*, Noguchi followed some of the cardinal principles of Japanese garden design. His three-element, odd number of islands or mountain forms are a free-form composition that can be configured in any arrangement. The dominant or "master rock" is consistently surrounded by the "attendant" stones or smaller islands. The mountain form, fundamental to Zen garden design, is meant to be perceived with awe and reverence, as a sacred element rising from the earth. When he was in his seventies, Noguchi explained his thoughts of "emergence out of the earth."[33] *Origin*, a black granite sculpture from 1968, looks like some primordial mountain form rising out of the earth, when in fact it rests directly on the ground and is hollowed out, only appearing to be solid and massive. Here Noguchi succinctly demonstrated his understanding of the dichotomy of Zen metaphors as he used and misappropriated them in his sculptures, leaving any notions of the sacred behind, creating sculptures such as *Origin* for exhibition purposes rather than for gardens.

Mu, 1950, carved 1951.
Sandstone; H. 7 ft. (2.1 m).
Keio University, Tokyo.
Photo courtesy The Noguchi Museum.

Equally as significant as the gardens to Noguchi was the architecture of the Zen temple complex of Ryoanji—which also incorporated the odd-number concept of Zen. Zen temple designs usually place the main hall at the center of an organic chaos of sub-temples. The buildings are usually built into or on a mountain, expressing closeness with nature and harmony with the landscape. The materials are natural—unpainted wood, bark, straw rushes, reed, stones, and rice paper. The tonality is monochrome and blends all the elements together, with the intent of enhancing a sensibility of unpretentiousness. These materials and their tonalities became those preferred by Noguchi. Rarely did he paint or embellish his sculpture. Since Zen priests regard worldly possessions as antithetical to their practice, austerity was an essential part of their discipline and reflected in the bare, unadorned design of the interiors. This concept was of particular importance to Noguchi, who believed sculpture should aspire to more than mere decoration or adornment for architecture.

Zazen, 1983–84.
Sheet bronze; 31 x 30 1/4 x 10 in.
(78.7 x 76.8 x 25.4 cm).
The Noguchi Museum, New York.
Photo by Kevin Noble.

The Zen concept of nothingness (*mu* in Japanese) was another important principle for Noguchi. Directing the reading of many of his sculptures through their titles, he named one, *Mu,* a work in plaster from 1950, which prompts the viewer to see through its open form. The opening is seen as the circumference of an encircling form that is empty. *Mu* is not a continuous circle, but a broken one. According to the art historian Bert Winther-Tamaki:

> If the word with which the Hindu refers to Zen is 'om', this is 'mu' (emptiness or nothingness….That Noguchi applied this word *mu* to a sculpture that would hold the rays of the setting sun, suggests a remembrance of the charmed moment which Noguchi shared with Hasegawa in 1950 when they visited the garden of the Katsura Detached Palace. The use of the word *mu* as a title can only encourage the viewer to examine his sculpture in connection with the wealth of literature surrounding the Buddhist metaphysics of *mu* or *sunyata* in Sanskrit. In the 1950s, this concept was not simply an esoteric archaism extracted from ancient texts, it was one of the single most important concerns of twentieth century Japanese philosophy.[34]

My Mu, 1950. Shigaraki ceramic;
13 x 9 x 6 5/8 in. (33 x 22.8 x 16.8 cm).
The Noguchi Museum, New York.
Photo by Kevin Noble.

The so-called table sculptures, such as *Whetstone* (see page 210), and *Galaxy Calligraphy* (see page 175), appear to be manifestations of a Zen sensibility with minimal mounds or waves rising from flat stone, suggesting miniature, contained landscapes, imbued with aspects of *wabi* and *sabi* style. However, their scale and definitions alluding to tables push the objects into a curious utilitarian domain-portable landscape. Noguchi evidently liked to "fool around" with Eastern and Western sensibilities even as he disregarded conventions from both.

The Void, 1970. Pink marble;
H. 75 in. (190.5 cm).
The Noguchi Museum, New York.
Photo by John Berens.

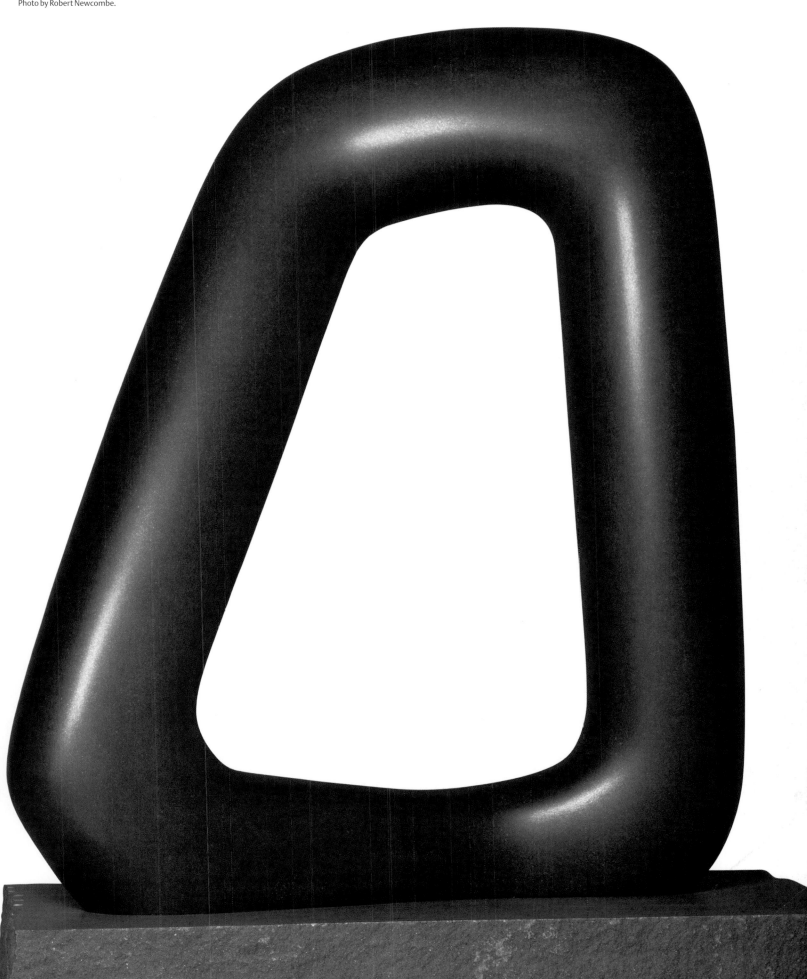

Energy Void (Six-Foot Version), 1971,
carved 1985. Swedish black granite;
72 x 62 x 22 1/2 in. (182.8 x 157.4 x 57 cm)
on artist's granite base with
wood supports.
The Hall Family Foundation Collection,
Nelson-Atkins Museum, Kansas City.
Photo by Robert Newcombe.

With Noguchi the titles for many sculptures (such as *Myo* from 1957–66, *Zazen* from 1983–84, and *The Great Rock of Inner Seeking* from 1974) point to how the artist wanted certain sculptures to be viewed. The Zen aesthetic propagates the absence of selfhood and the merging of subject and object into one absolute emptiness. However, for Noguchi, his sculptures with distinguished Zen titles may suggest a Zen awareness, but all the while they retain a worldly, material objective. Ultimately his artwork is made to be presented in a Western art context for commercial purposes. Noguchi stated that:

> the ideas of Zen Buddhism seem to offer to some at least the possibilities of contact with further depths of inner experience from which to draw substance for further development. However, in this, Zen may be misunderstood in that it is no means to ends other than its own.[35]

During the last 20 years of his life Noguchi traveled often to Japan. There he was considered with respect, yet without the bothers of American-style celebrity. In Japan he could work quietly and be treated with the veneration

Whetstone, 1970.
**Granite, L. 42 in. (106.7 cm)
on artist's wood support.
The Noguchi Museum, New York.**
Photo by Shigeo Anzai.

Myo, 1957–66.
**Kurama granite, 65 x 35 x 15 in.
(165.1 x 88.9 x 38.1 cm).**
Photo courtesy The Noguchi Museum.

accorded to the elderly. Noguchi made most of his sculptures in Japan in the 1970s and 1980s, working with artisans trained in traditional methods of carving stone. He promulgated the image of a Zen artist, going so far as to reconstruct an old samurai house for himself, where he maintained an austere, unadorned lifestyle without modern conveniences. In New York, even though he liked to rest on tatami, he lived a cosmopolitan, modern life and was the consummate promoter of his projects, skillfully administering the business aspects of his career.

Whether or not his ideas were based literally in the Zen aesthetic, Noguchi strove to articulate a vision for his art that aspired to something beyond the concrete:

> I don't think that art comes from art....I think it comes from the awakening person. Awakening is what you might call the spiritual. It is a linkage to something flowing very rapidly through the air. I can put my finger on it and plug in, so to speak. Do artists need a spiritual way or do they need art? You can say that one is the same as the other. Everything tends toward awakening, and I would rather use the word awakening than a word derived from some system.[36]

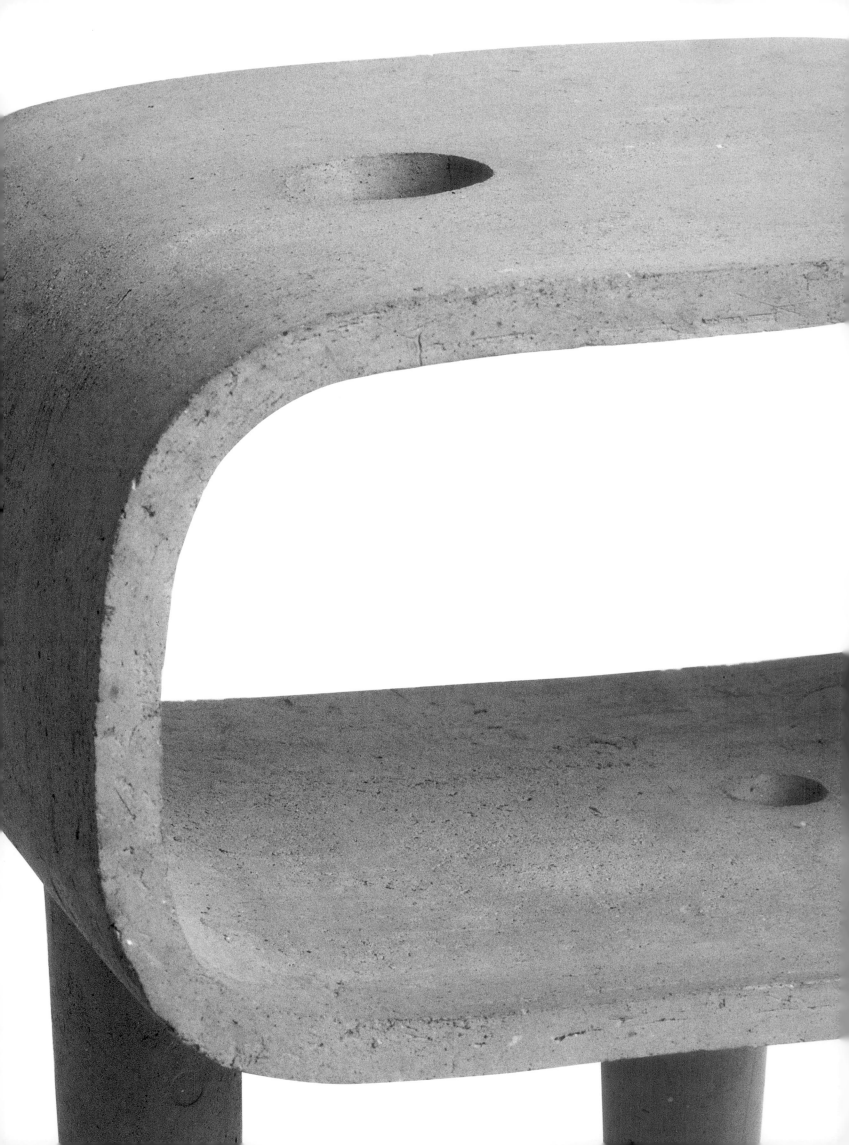

Contextual Chronology

1904

Born in Los Angeles on November 17 to Japanese poet Yonejiro (Yone) Noguchi and American writer Leonie Gilmour. Isamu's father returns to Tokyo before his son's birth.

1906

Isamu and his mother travel to Japan, where they remain, living apart from his father.

- In London, Tenshin Okakura publishes *The Book of Tea*, one of several books written in English that assert the supremacy of Asian art over Western culture.

1909–11

- In Paris, Filippo Marinetti publishes his "Futurist Manifesto" calling for revolutionary new art that rejects past cultural traditions and embraces the modern technological world. Pablo Picasso and Georges Braque exhibit Cubist paintings that inspire other artists to develop related styles.
- Wassily Kandinsky writes "Concerning the Spiritual in Art" (published in Munich, Germany, 1912).
- Sigmund Freud publishes "The Origin and Development of Psychoanalysis" in the *American Journal of Psychology* in 1910.

1912–15

Attends Japanese school in seaside town of Chigasaki. Yonejiro Noguchi marries a Japanese woman and starts a family in Tokyo.

- After two decades of massive immigration, 14.7% of the American population is foreign-born.
- California's Alien Land Act of 1913 prohibits aliens who are ineligible for citizenship— including all Asian immigrants—from owning land.
- The *International Exhibition of Modern Art* (*The Armory Show*) introduces European modern art to audiences in New York, prompting young artists to experiment with new forms and techniques.
- In Europe, World War I begins in mid-1914, soon entangling Germany, France, and Great Britain.

TOP
Yonejiro Noguchi (father of Isamu), n.d.
Photo courtesy The Noguchi Museum.
ABOVE
Leonie Gilmour Noguchi (mother of Isamu), c. 1912.
Photo courtesy The Noguchi Museum.

- In Paris, Picasso uses found objects to create collages, paintings, and sculptures.
- In St. Petersburg, Russia, Kazimir Malevich launches Suprematism, a radical art movement emphasizing the purity of geometric forms, particularly the square.
- In Prague, Franz Kafka publishes *The Metamorphosis* (1915; first English translation 1937).
- In Zurich, Switzerland, Carl Jung publishes *Psychology of the Unconscious* (English translation 1916).
- D. W. Griffith premieres his film *The Birth of a Nation* (1915).

1916–17

Attends St. Joseph's College, a French Jesuit school in Yokohama, Japan, for two years.

- Bolshevist/Communist Revolution occurs in Russia in 1917, creating new Union of Soviet Socialist Republics the following year.
- The U.S. enters World War I.
- In Zurich, the Dada movement rejects artistic and social conventions in favor of shocking audiences with antirational, and often offensive, techniques. Dada spreads to Paris, Berlin, and New York, where Marcel Duchamp exhibits his "readymades"—everyday objects (such as a bottle rack, a urinal, and a bicycle wheel)—as art.
- Dutch painters Piet Mondrian and Theo Van Doesburg publish the first issue of *De Stijl*, promoting their vision of a utopian modern art predicated on primary colors and straight lines.
- Russian Constructivist artists, including Vladimir Tatlin and Aleksandr Rodchenko, support the revolution by advocating abstract forms and industrial materials as means to facilitate a new society.

OPPOSITE
Detail of *My Mu*, 1950.
Shigaraki ceramic; 13 x 9 x 6 5/8 in.
(33 x 22.8 x 16.8 cm).
The Noguchi Museum, New York.
Photo by Kevin Noble.

1918–21
Gilmour sends her son to attend high school in Rolling Prairie, Illinois, where he is mentored by progressive teacher Dr. Edward Rumely. Gilmour remains in Japan until 1923.

- World War I ends.
- In the U.S., new quotas restrict immigration to 3% of each nationality's population in the 1890 census, effectively reducing the number of Asian immigrants.
- In India, Mohandas Gandhi organizes nonviolent protests against British rule.
- In New York, the Société Anonyme is founded to promote international avant-garde art; they present the first American exhibitions of works by Kandinsky (1923) and Alexander Archipenko (1921).
- In Germany, Walter Gropius founds the Bauhaus school for art, architecture, and design, with the goal of bridging the gap between fine and applied arts.
- In Bern, Switzerland, Hermann Rorschach develops the "inkblot" test.

1922–23
Graduates from La Porte High School in Illinois. Briefly apprentices with sculptor Gutzon Borglum, then enrolls in two years of premedical studies at Columbia University in New York.

- U.S. Supreme Court rules that Japanese immigrants are ineligible for American citizenship.
- In Italy, Benito Mussolini forms his Fascist government.
- In Leningrad, Vsevolod Meyerhold's *The Magnanimous Cuckold* features the first Constructivist stage sets, designed by Lyubov' Popova.
- The Brooklyn Museum of Art presents *Contemporary Russian Paintings and Sculpture*.
- In Germany, Adolf Hitler writes *Mein Kampf* (published in 1925).

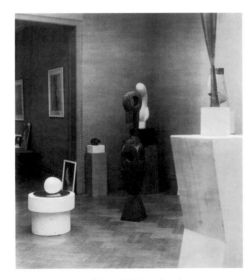

Installation view of the exhibition of sculptures by Constantin Brancusi at the Brummer Gallery, New York, 1927.
Photo by Yasuo Kunioshi, courtesy Musée Nationale D'Art Moderne, Centre Georges Pompidou, Bibliothèque Kandinsky.

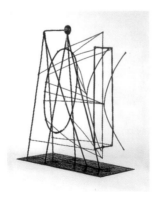

Pablo Picasso. *Maquette for "Monument to Guillaume Apollinaire,"* 1928. Iron wire; 19 7/8 x 7 1/4 x 16 in. (50.5 x 18.5 x 40.8 cm). Musée Picasso, Paris.

1924
Enrolls in evening sculpture classes at Leonardo da Vinci Art School on the Lower East Side of Manhattan. Completes many drawings in an academic style, including portraits and nudes. Leaves Columbia and rents a studio where he creates clay and plaster figurative works in a similarly academic style. Begins to use Noguchi as his surname rather than Gilmour.

- Native Americans granted citizenship. New U.S. law halts Japanese immigration.
- In Paris, André Breton publishes *Manifeste du Surréalisme*, which advocates exploring the unconscious, relying in part on dreams and the Freudian technique of free association.

1925–26
Exhibits academic work at the National Academy of Design in New York and the Pennsylvania Academy of the Fine Arts in Philadelphia. Elected to the National Sculpture Society. Sees vanguard art at Alfred Stieglitz's Intimate Gallery and JB Neumann's New Art Circle. Exhibition of Constantin Brancusi's sculpture at the Brummer Gallery inspires him to apply for a fellowship to study in Europe and the Far East.

- In Paris, *La Peinture Surréaliste* exhibition takes place at Galerie Pierre. The large *Exposition Internationale des Arts Décoratifs et Industriels Modernes* features the geometric style of Art Deco and radical architectural proposals such as Le Corbusier's *Pavilion de L'Esprit Nouveau*, Rodchenko's *Workers' Club*, and a reconstruction of Tatlin's *Monument to the Third International*.
- Alexander Calder arrives in Paris and creates his first wire portrait-sculptures.
- The Société Anonyme organizes the large *International Exhibition of Modern Art* at the Brooklyn Museum of Art, including European and Russian avant-garde artists.
- Alain Locke publishes *The New Negro: An Interpretation* (1925), encouraging African Americans to develop new modes of artistic expression based upon their African heritages.

1927–28

In March, the artist travels to Paris and becomes Brancusi's studio assistant for several months. Studies at the conservative Académie de la Grande Chaumière but creates abstract drawings and sculptures in wood, stone, and brass in his own studio. Immerses himself in the international artistic community, meeting many artists, including Calder and Stuart Davis. Spends a month at the British Library reading about Asian culture.

- New York University opens the Gallery of Living Art, the first American museum of modern art, including works by Picasso, Fernand Léger, El Lissitzky, Joan Miró, and Mondrian.
- In Paris, Galerie Pierre and Galerie Surréaliste present group exhibitions of Surrealist art, as well as solo shows of paintings by Yves Tanguy and Miró. Galerie Georges Bernheim exhibits Max Ernst's *frottages* and *grattages*. The exhibition *Le Surréalisme existe-t-il?* at Galerie au Sacre du Printemps includes works by Jean Arp, Giorgio de Chirico, Ernst, André Masson, Miró, Francis Picabia, and Tanguy. Breton publishes *Le Surréalisme et la Peinture.* Salvador Dalí produces *Un Chien Andalou.*
- In Paris, Picasso, working with Julio González, creates his first welded metal sculpture constructions.
- In Berlin, Bertolt Brecht produces The *Threepenny Opera* (1928) with Kurt Weill.
- In Freiburg, Germany, Martin Heidegger publishes *Being and Time,* the philosophical treatise laying the groundwork for modern phenomenology (1927; English translation, 1962).
- In London, Dr. Daisetsu T. Suzuki publishes *Essays in Zen Buddhism* (1927), followed by three volumes of *Studies in Zen Buddhism* in Kyoto (completed 1934).
- Charles Lindbergh completes first transatlantic flight.

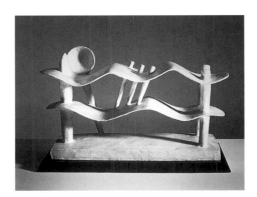

Alberto Giacometti. *Reclining Woman Who Dreams,* 1929, cast 1959. Painted bronze; 9 1/4 x 16 7/8 x 5 3/4 in. (23.5 x 42.6 x 14.5 cm). Hirshhorn Museum and Sculpture Garden, Smithsonian Institution, Washington DC; gift of Joseph H. Hirshhorn.

R. Buckminster Fuller. *Model for "Ten-Deck Building,"* c. 1929–32. Photo by F. S. Wilson, courtesy the Buckminster Fuller Estate.

1929

Returns to New York in early spring. Exhibits works from Paris at little-known Eugene Schoen Gallery. Supports himself with portraits of such notables as George Gershwin, Berenice Abbott, and his new friends Julien Levy, Buckminster Fuller, and Martha Graham.

- The stock market crashes in the U.S., triggering the Great Depression.
- The Museum of Modern Art opens in New York.
- In Paris, Arp, Van Doesburg, and others organize groups to promote geometric abstraction, including Cercle et Carré (1929), Art Concret (1930), and Abstraction-Création (1931).
- In Paris, Jean Cocteau publishes his novel *Les Enfants Terribles.*

1930

Travels with Fuller to Chicago and Cambridge, Massachusetts. Successful exhibition of 15 portrait sculptures at Marie Sterner Gallery in New York enables him to return to Paris in April. Travels on to Moscow and then Beijing, where he studies traditional ink brush painting for seven months.

- In Paris, Calder produces his first mobiles after visiting Mondrian's studio. Alberto Giacometti creates his first Surrealist sculptures in radical new formats.
- In New York, Miró has first American exhibition at the Valentine Gallery.
- Freud publishes *Civilization and Its Discontents.*

1931

Leaves Beijing for Tokyo, his first visit to Japan since 1917. Is rebuffed by his father but welcomed by his uncle Totoro Takagi. Travels to Kyoto, where he studies ceramics with Jinmatsu Uno, admires *haniwa* funerary sculptures and Zen temples, and meets Asian art scholar Langdon Warner. Exhibits ceramics in Tokyo. Returns to New York in October. The Whitney Museum of American Art acquires his portrait bust *Ruth Parks* (1929).

- The global economic depression worsens.
- Japan invades Manchuria, setting off an undeclared war with China.
- In Hartford, Connecticut, the Wadsworth Atheneum organizes *New Super Realism,* the first exhibition of Surrealist art at an American museum. In New York, Julien Levy opens his gallery, which promotes Surrealism and exhibits Calder's mechanized mobiles.

1932

Exhibits brush drawings at Demotte Gallery and ceramics at John Becker Gallery in New York. *Angna* **acquired by The Metropolitan Museum of Art.**

- Japan bombs Shanghai, China, and resigns from the League of Nations.
- In New York, the Julien Levy Gallery hosts the first exhibition of Joseph Cornell's boxes and the first American show of Ernst's work.
- Aldous Huxley publishes *Brave New World.*

1933

Travels to London to exhibit his brush drawings. Designs his first playground project, *Play Mountain,* **and makes models for** *Monument to the Plough* **(both unrealized) and** *Monument to Ben Franklin* **(realized 1985). Levy publishes essay on Noguchi in** *Creative Art.* **Leonie Gilmour dies in New York.**

- In Germany, Hitler and the National Socialist German Workers' (Nazi) party win elections. Gestapo pressure causes the Bauhaus to close, prompting several teachers to emigrate to the U.S., including Josef Albers and Gropius.
- As part of the New Deal, President Franklin D. Roosevelt establishes the Public Works of Art Project (later the Works Progress Administration) to commission artists to create works for public buildings and projects; more than 5,000 artists are employed during the next ten years.
- Dalí has his first American exhibition at the Julien Levy Gallery. Calder moves back to the U.S.
- In London, after seeing Surrealist works in Paris, Henry Moore and Barbara Hepworth adopt a biomorphic style.

1934

Dropped from the government's public art project because of his unconventional proposals. Continues to make and exhibit portrait sculptures.

- In New York, Diego Rivera's mural at Rockefeller Center is destroyed after he includes a portrait of Russian Communist leader Vladimir Lenin.

Constantin Brancusi. *Endless Column,* 1937.
Iron and alloys; H. 96 ft. 3 in. (29.3 m).
Tirgu Jiu, Romania.
© 2003 Artists Rights Society (ARS)/ADAGP.
Photo © Adam Woolfit Photography.

Celebration at the opening of the World's Fair, New York, 1939.
Photo © Bettmann/Corbis.

Eric Schaal. *Salvador Dalí's "Dream of Venus" pavilion at the New York World's Fair,* 1939.
© Estate of Eric Schaal/Artists Rights Society (ARS), and © Salvador Dalí, Gala-Salvador Dalí Foundation/ Artists Rights Society (ARS).

- In New York, the Julien Levy Gallery shows Giacometti's Surrealist sculptures in marble, wood, and plaster; Miró exhibits at the new Pierre Matisse Gallery.
- American artist Mark Tobey spends a month studying calligraphy and painting at a Zen monastery near Kyoto.
- *Time* magazine features painter Thomas Hart Benton, supporting the Regionalist artists who advocated American subjects and styles not derived from European sources.

1935

Exhibits public project proposals and 15 sculptures in plaster, wood, and chrome-nickel at Marie Harriman Gallery, his last solo show in New York until 1949. Submits sculpture proposal for Newark Airport (unrealized). Designs stage set for *Frontier,* **the first of 21 designs for Graham's dance performances. Makes his first trip to California. Travels to Mexico City in the fall to participate in its public art program.**

- The Nazis repudiate the Treaty of Versailles and institute the Nuremberg Laws, which revoke Jewish citizenship in Germany and forbid intermarriage.
- Frank Lloyd Wright designs Fallingwater in Bear Run, Pennsylvania.

1936–37

In early 1936, sculpts *History of Mexico,* **a large relief depicting the class warfare of laborers against capitalists, then returns to New York. Designs the** *Radio Nurse* **intercom, his first mass-manufactured object.**

- In Spain, civil war erupts and continues until 1939. Picasso's painting *Guernica,* a protest against the atrocities of the Spanish civil war, is exhibited at the 1937 World's Fair in Paris.
- In Munich, the Nazis organize the *Degenerate Art* exhibition, blacklisting many modern artists.
- Japan launches full-scale invasion of China.
- In New York, the American Artists' Congress is organized to oppose fascism and publish the periodical *Art Front.* The American Abstract Artists group is organized to promote abstract art.

- Surrealist art exhibitions open in Copenhagen, London, Zurich, and Paris. The Museum of Modern Art in New York presents the exhibition *Fantastic Art, Dada, Surrealism*.
- Composer John Cage hears a lecture on Dada and Zen by Nancy Wilson Ross at the Cornish School in Seattle.
- Charlie Chaplin stars in *Modern Times* (1936).

1938–39
Submits three proposals for the 1939 World's Fair; makes *Chassis Fountain*, his first fountain, for Ford Motor Company's pavilion. Troubled by escalating war in Europe. Period of close friendship with Arshile Gorky. Visits Hawaii; proposes playground equipment for a park in Honolulu (unrealized). Designs his first table for manufacture. Wins commission for *News*, a large relief for the entrance to the Associated Press Building at Rockefeller Center.

- Germany annexes Austria, invades Czechoslovakia, and launches harsh attacks on Jewish property and civil rights. When Germany invades Poland, France and Great Britain, in turn, declare war on Germany. Francisco Franco gains full power in Spain.
- In Paris, *Exposition Internationale du Surréalisme* at the Galerie des Beaux Arts features radical installation of 1,200 coal sacks suspended from the ceiling by Duchamp, and bizarrely altered mannequins by Arp, Dalí, Giacometti, Miró, and others.
- In New York, David Smith exhibits welded iron sculptures and drawings in his first solo show at Marian Willard's East River Gallery.
- In New York, the Museum of Non-Objective Painting (later renamed the Solomon R. Guggenheim Museum) opens with exhibition of abstract works, including more than 100 works by Kandinsky. The Museum of Modern Art presents *Picasso: Forty Years of His Art*.
- In New York, the World's Fair presents technology in many forms as the promise of, and the means to, a better future, despite war and economic woes.
- In Kyoto, Suzuki publishes *Zen Buddhism and Its Influence on Japanese Culture*; (English translation as *Zen and Japanese Culture* in New York in 1959.)
- John Steinbeck publishes *The Grapes of Wrath*.

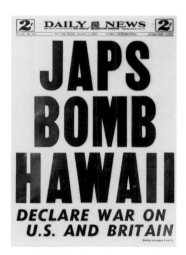

Daily News headline, December 7, 1941.
Photo © Bettmann/Corbis.

The Hirano Family at Colorado River Relocation Center, Poston, Arizona, c. 1943–45.
Photo © Corbis.

1940
Designs stage sets for Graham's *El Penitente*. Has solo exhibition at The Honolulu Academy of Arts.

- U.S. Nationality Act specifies that American citizens of foreign parents can lose their citizenship if they reside abroad for more than six months, work for a foreign government, or vote in a foreign election.
- Paris and most of France fall to the Germans. Japan occupies French Indochina and joins the Axis Powers.
- Germany invades Denmark, Norway, Holland, Belgium, Luxembourg, and France, causing many artists, including Roberto Matta and Tanguy, to flee Europe.

1941
Constructs model for *Contoured Playground for Central Park* (unrealized). Drives to San Francisco with Gorky that summer and then lives in Los Angeles.

- Germany invades the U.S.S.R., Yugoslavia, and Greece.
- Japan attacks the American naval base at Pearl Harbor; U. S. enters World War II. Within two days the government arrests more than 1,000 citizens of Japanese descent as potential security risks, and declares the West Coast a military zone.
- More European artists arrive in the U.S., including Breton, Dalí, Duchamp, Ernst, Man Ray, Mondrian, and Wifredo Lam.

1942

The San Francisco Museum of Modern Art presents an exhibition of his work in May. Enters the Colorado River Relocation Camp in Poston, Arizona. After seven months, returns to New York and rents studio at 33 MacDougal Alley.

- The War Relocation Authority forcibly moves more than 77,000 Japanese-American residents to ten internment camps in Arizona, Arkansas, California, Idaho, Utah, and Wyoming. In May, "volunteers" from California arrive at the Colorado River Relocation Center in Poston, Arizona. In November, an attack on an internee triggers a ten-day mass strike at Poston. In December, internees at Manzanar Camp in California protest living conditions. The subsequent crackdown results in two deaths. By the end of the war, more than 120,000 Japanese Americans have been incarcerated in these camps.
- In New York, Breton and Duchamp organize the *First Papers of Surrealism* exhibition.

1943

Creates his first "lunar" illuminated sculptures. Designs three-legged lamp for mass-production by Knoll.

- Germany retreats from Russia after failed siege of Stalingrad.
- In New York, exhibition of Calder's sculptures and Tanguy's paintings at Pierre Matisse Gallery. Retrospective of Calder's works at The Museum of Modern Art opens in December and extends into early 1944.
- In Paris, Jean-Paul Sartre publishes *Being and Nothingness* (English translation, 1956.)

1944

Designs sets for Graham's *Herodiade*. Designs chess set for exhibition at the Julien Levy Gallery, and a coffee table for manufacture by Herman Miller. Begins making interlocking biomorphic sculptures in stone and slate.

- Allies invade Normandy in June. Paris is liberated three months later.

Mushroom cloud over Nagasaki, August 9, 1945.
Photo © Bettmann/Corbis.

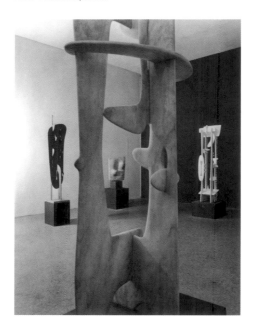

Installation of Noguchi sculptures in the exhibition "Fourteen Americans" at The Museum of Modern Art, New York, September 10–December 8, 1946.
Digital image © 2003 The Museum of Modern Art, New York.

1945

Proposes project for Jefferson Memorial Park in St. Louis, Missouri (unrealized). Visits Great Serpent Mound in Ohio.

- Germany surrenders. War in Europe ends; 55 million people have died.
- After firebombing Tokyo, the U.S. drops an atomic bomb on Hiroshima. Three days later, another bomb is dropped on Nagasaki, killing approximately 150,000 people and prompting Japan to surrender.
- Japanese Exclusion Act is repealed, allowing West Coast resettlement.
- In New York, Gorky has solo exhibition at the Julien Levy Gallery with catalogue preface by Breton.
- Sartre begins lecture tour through the U.S.

1946

Exhibits 12 sculptures in *Fourteen Americans* exhibition at The Museum of Modern Art. Thomas Hess publishes "An Art Contemporary Contour: Isamu Noguchi" in *ARTnews*.

- U.S. detonates the first of 23 atomic explosions on Bikini Atoll in the South Pacific.
- In Nuremberg, the trial of Nazi war criminals ends with 14 convictions.
- The U.S. State Department organizes *Advancing American Art,* an exhibition of mid-century American art that travels to Europe, Latin America, and Asia.
- In Boston, Ruth Benedict publishes *The Chrysanthemum and the Sword: Patterns of Japanese Culture*, an effort to redress the West's postwar image of Japanese culture.

1947

Creates model for *Sculpture to be Seen from Mars* (unrealized). Designs ceilings for the Time-Life Building in New York and the American Stove Company in St. Louis. Designs sets for John Cage and Merce Cunningham's *The Four Seasons*. Contributes two works to *Exposition Internationale du Surréalisme*. Yonejiro Noguchi dies.

- Japan signs the "MacArthur Peace" treaty with an American-drafted constitution and elections.
- In Paris, the last major Surrealist group exhibition, *Exposition Internationale du Surréalisme,* takes place at the Galerie Maeght.

1948

Creates lunar stairwell for SS *Argentina*. Designs sets and costumes for George Balanchine's ballet *Orpheus*. After Gandhi is assassinated, designs a memorial park for New Delhi, India (unrealized).

- The United Nations is established.
- U.S. Congress approves the Marshall Plan for the reconstruction of Europe.
- The U.S. airlifts supplies to Berlin during blockade by the Soviets. The Cold War begins.
- At Betty Parsons Gallery in New York, Jackson Pollock shows his drip paintings for the first time; he becomes famous the next year when *Life* magazine publishes "Jackson Pollock: Is He the Greatest Living Painter in the United States?"
- Gorky commits suicide shortly after Noguchi and Lam leave his home in Connecticut.
- Alfred Kinsey publishes *Sexual Behavior in the Human Male*.

1949

Exhibits recent sculptures at the Charles Egan Gallery, New York. Wins a fellowship to travel throughout Europe and Asia during the next several years.

- Mao Zedong seizes power and establishes the Communist People's Republic of China.
- In New York, the Julien Levy Gallery closes. Louise Bourgeois exhibits her wood sculptures at Peridot Gallery. Franz Kline, Willem de Kooning, Robert Motherwell, and Ad Reinhardt found The Artists' Club, where discussions disseminate aesthetic and philosophic ideas, including those from the Chinese *I-Ching* and Japanese Zen Buddhism.
- In London, Suzuki publishes English translation of *Introduction to Zen Buddhism* (originally written as essays in Kyoto from 1914 to 1934), with preface by Jung.
- In London, George Orwell publishes *1984*.
- In Paris, Simone de Beauvoir publishes *The Second Sex* (English translation 1953).

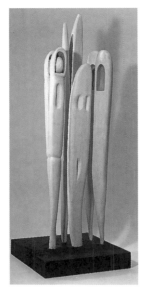

Louise Bourgeois. *Quarantania*, 1947. Painted pine wood (7 elements); 84 ³/₄ x 31 ¹/₄ x 29 ¹/₄ in. (215.3 x 79.4 x 74.3 cm). Whitney Museum of American Art, New York; gift of an anonymous donor.
Photo by Jerry L. Thompson.
Art © Louise Bourgeois/Licensed by VAGA.

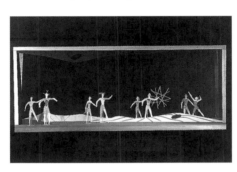

The Seasons, 1947. Painted wood, acrylic, mat board, gouache, metallic paper; 22 x 36 x 8 ¹/₄ in. (55.9 x 91.4 x 30 cm). New York Public Library.
Photo courtesy The Noguchi Museum.

Noguchi sculpting in his studio at Kita Kamakura, Japan, 1952.
Photo courtesy The Noguchi Museum.

1950

Travels to Japan for the first time in nearly 20 years. In Tokyo, cultivates relationships with artists and architects, designs a room and garden room for his father at Keio University, and exhibits his ceramics and proposal for a Hiroshima Bell Tower (unrealized) at Mitsukoshi Department Store. Reads Suzuki's *Zen and Its Influence on Japanese Culture*.

- In Washington, the House Committee on Un-American Activities (HUAC) increases persecution of filmmakers, writers, artists, and others with leftist political views. Congress passes the McCarran Internal Security Act, which requires "subversives" to register with the government.
- North Korea invades South Korea; the U.S. sends troops to defend the South.
- David Smith makes larger welded metal sculpture constructions, continuing through the next two decades.

1951

Commissioned to create two bridge railings for Peace Park, Hiroshima. Designs his first *akari* lamps in Gifu and a garden for the Reader's Digest Building in Tokyo. Shows a marble sculpture in the first São Paulo Bienal in Brazil.

- In New York, Leo Castelli's *Ninth Street Show* brings together the Abstract Expressionist painters with younger artists such as Jasper Johns and Robert Rauschenberg.
- In Japan, the Bokujin-kai (Ink Human Society) is founded to transform traditional calligraphy into modern Expressionist painting. The cover of its first periodical features a painting by Franz Kline.
- J. D. Salinger publishes *The Catcher in the Rye*.

1952

Proposes design for *Memorial to the Dead* at Hiroshima (unrealized). Collaborates with architect Gordon Bunshaft of Skidmore, Owings, and Merrill to design the courtyard garden at Lever House (unrealized). Marries the actress Yoshiko (Shirley) Yamaguchi. Living in a small house near ceramicist Kitaji Rosanjin in Kita Kamakura, he makes clay sculptures. The Museum of Modern Art in Kamakura exhibits his *akaris* and ceramics.

- The Allied occupation of Japan ends.
- U.S. Immigration and Nationality Act eliminates race as a bar to naturalization and immigration, but it institutes a quota system that permits only 185 Japanese immigrants a year. California's Supreme Court rules the Alien Land Act of 1913 unconstitutional; four years later, all alien land laws are repealed.
- U.S. tests the first hydrogen bomb on Enewetak Atoll in the Pacific. The following year, the Soviet Union detonates its own hydrogen bomb.
- Harold Rosenberg coins the term "Action Painting" to describe the gestural painting methods of Kline, Pollock, and de Kooning.
- At Black Mountain College in North Carolina, Rauschenberg and Merce Cunningham collaborate on Cage's *Untitled Event*, which he composed using the *I-Ching*. Cage also premieres *4′ 33″*, a Zen-influenced piece requiring a performer to sit silently before a piano for 4 minutes and 33 seconds.
- At Columbia University in New York, Dr. Suzuki begins his influential series of lectures on Zen philosophy and culture; attendees include Cage, Reinhardt, and Philip Guston. The lectures continue into 1957.
- Samuel Beckett publishes *Waiting for Godot* (English translation 1954).
- Ralph Ellison publishes *The Invisible Man*.

1953

Spends much of the year in France, Greece, and Hong Kong because the U.S. refuses to issue a visa to Yamaguchi.

- Two years after being convicted for treason, Julius and Ethel Rosenberg are executed.
- Korean War armistice is signed.
- In New York, The Betty Parsons Gallery presents the first of many exhibitions of Japanese artists, notably the painters Kenzo Okada and Minoru Kawabata, as well as calligrapher Toko Shinoda.
- In New York, Eugen Herrigel publishes *Zen in the Art of Archery,* with preface by Suzuki.

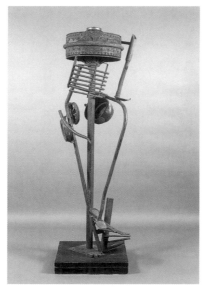

Richard Stankiewicz. *Kabuki Dancer*, 1954.
Iron and steel; 84 x 24 x 26 1/4 in.
(213.4 x 61 x 66.7 cm).
Whitney Museum of American Art, New York; purchase with funds from the
Friends of the Whitney Museum of American Art.
Photo by Geoffrey Clements; Estate of Richard Stankiewicz, courtesy Zabriskie Gallery, New York.

Aerial view of the "Japanese Exhibition House" in the garden of The Museum of Modern Art, New York, June 16, 1954–October 16, 1955.
Digital image © 2003 The Museum of Modern Art, New York.

Saburo Murakami. *Six Holes*, 1955.
Photo © Makiko Murakami, courtesy Ashiya City Museum of Art and History.

1954

Exhibits 12 ceramic sculptures at the Stable Gallery in New York. Designs table and stool for manufacture by Knoll.

- U.S. Supreme Court rules that "separate but equal" public school segregation is unconstitutional.
- In New York, The Museum of Modern Art organizes a series of exhibitions devoted to Japanese culture, including *Japanese House* (1954–55), ceramics by Rosanjin (1955), and *Abstract Japanese Calligraphy* (1958).
- Painter Ad Reinhardt publishes series of articles on Asian art in *ARTnews*.
- In Los Angeles, Peter Voulkos produces innovative clay sculptures inspired by Picasso's sculpture and Japanese ceramics.

1955

Exhibits *akaris* at Bonniers department store in New York. Designs sets for the Royal Shakespeare Company's *King Lear*. Casts iron sculptures in Gifu, Japan.

- The civil rights movement begins in Montgomery, Alabama, when Rosa Parks refuses to give her seat on a bus to a white passenger.
- In Tokyo, the First Gutai Art Exhibition introduces Japanese Process and performance art.
- In San Francisco, Allen Ginsberg performs the poetry reading *Howl*, launching the Beat counterculture movement of artists, writers, and musicians—notably William Burroughs and Jack Kerouac—who rebel against middle-class values.
- In London, Suzuki publishes *Studies in Zen*.
- Herbert Marcuse publishes *Eros and Civilization*.

1956–57

Commissioned to design gardens for UNESCO in Paris, the headquarters of Connecticut General Life Insurance Company in Bloomfield, and a lobby for 666 Fifth Avenue in New York; each completed by 1958. Divorces Yamaguchi, but continues to work part of every year in Japan for the next three decades. Visits the island of Shikoku, searching for stones for the UNESCO project. Submits proposal for a memorial in New Delhi in honor of the Buddha's 2,500th birthday (unrealized).

- In London, the term "Pop" is first used to describe works exhibited at the Institute of Contemporary Art because they borrow imagery directly from contemporary advertising and popular culture.
- In New York, The Museum of Modern Art presents a retrospective of David Smith's sculptures. Donald Judd has first solo exhibition at Panoras Gallery.
- American painters Sam Francis, Reinhardt, and Tobey travel to Japan. In New York, Martha Jackson Gallery hosts a Gutai show, and Dr. Suzuki is interviewed in print and on television.
- In New York, Alan Watts publishes *The Way of Zen* (1957).
- Jack Kerouac publishes *On the Road* (1957).
- In Paris, Roland Barthes publishes *Mythologies* (1957, English translation 1972).

1958–59

Produces sheet metal sculptures at a lighting factory in Long Island City, New York. Begins a series of balsa wood sculptures that continues through 1962. Exhibits marble, granite, and iron sculptures at the Stable Gallery. Exhibits three marble and iron sculptures in *Documenta 2* in Kassel, West Germany.

- Communist Fidel Castro overthrows the regime of Fulgencio Batista in Cuba.
- Debate between Richard Nixon and Nikita Khrushchev is broadcast live from Moscow.
- In New York, the new Leo Castelli Gallery exhibits Johns's *Targets* and Rauschenberg's "combine" paintings. Louise Nevelson expands her found-wood objects and assemblages into large-scale reliefs and environments.

Mark Tobey. *Battle of the Lights*, 1956. Gouache and tempera on paper mounted on board; 43 15/16 x 35 3/8 in. (111.6 x 89.9 cm). Whitney Museum of American Art, New York; gift of Lydia Winston Malbin in honor of Walter Fillin.
Photo by Geoffrey Clements.

David Smith. *Raven IV*, 1957. Steel; 28 x 32 3/8 x 13 1/4 in. (71.3 x 82.2 x 33.5 cm). Hirshhorn Museum and Sculpture Garden, Smithsonian Institution, Washington DC; gift of Joseph H. Hirshhorn.
Photo by Lee Stalsworth.

Claes Oldenburg. *7-Up*, 1961. Enamel paint on plaster-soaked cloth on wire; 55 3/8 x 39 1/4 x 5 1/2 in. (140.7 x 99.7 x 14 cm). Hirshhorn Museum and Sculpture Garden, Smithsonian Institution, Washington DC; Joseph H. Hirshhorn Purchase Fund and Joseph H. Hirshhorn Bequest Fund.

- At the Reuben Gallery in New York, Allan Kaprow presents *18 Happenings in Six Parts*, a series of non-narrative, multimedia performances based on everyday life.
- In Paris Christo makes his first wrapped sculptures. Yves Klein has his first exhibition.
- Claude Lévi-Strauss publishes *Structural Anthropology* (1958).

1960

Begins projects for the Beinecke Library at Yale University in New Haven, Connecticut; the First City National Bank Building plaza in Fort Worth, Texas; and the Billy Rose Sculpture Garden at the Israel Museum in Jerusalem. Begins carving stone sculptures inspired by the sun.

- In New York, John Chamberlain shows sculptures made from crushed car parts at Martha Jackson Gallery. Mark di Suvero begins his monumental steel constructions. Jean Tinguely's self-destructing, scrap-metal sculpture *Homage to New York* implodes in The Museum of Modern Art's garden. Carl Andre begins making sculptures composed of repeated identical wood units, later uses metal.

1961

Establishes studio in warehouse district of Long Island City, New York. Exhibits stainless steel sculptures at Cordier and Warren Gallery. Commissioned to create Chase Manhattan Bank Plaza garden. Collaborates with architect Louis Kahn for *Riverside Drive Playground* (unrealized).

- The Berlin Wall is erected, increasing Cold War tensions.
- In New York, The Museum of Modern Art presents *Art of Assemblage* exhibition. Claes Oldenburg exhibits his painted plaster sculptures of everyday objects at The Store on the Lower East Side, which also serves as the venue for a number of Happenings and performances. Dan Flavin makes his first sculptures from fluorescent and incandescent lights. George Segal starts making figurative sculptures cast in plaster gauze from live models.
- In Dusseldorf, Germany, Joseph Beuys starts teaching at the Staatliche Kunstakademie.

1962–63
Artist-in-residence at the American Academy in Rome, where he has balsa wood and clay sculptures cast in bronze. Begins to work at the Henraux marble quarries near Pietrasanta, Italy, where he will return each year for the next decade.

- Martin Luther King Jr. delivers his "I Have a Dream" speech at a massive march for civil rights on the Mall in Washington DC.
- U.S. President John F. Kennedy assassinated.
- Pop art gains momentum, appearing on the covers of *Time, Life,* and *Newsweek* magazines. Andy Warhol has his first solo exhibition in New York and opens The Factory; exhibits *Campbell's Soup Can* silkscreens in Los Angeles and then makes first *Brillo Box* sculptures. Roy Lichtenstein exhibits his cartoon paintings at Leo Castelli Gallery. James Rosenquist and George Segal each have their first exhibitions in New York, and Oldenburg shows his first soft sculptures at the Green Gallery. Sidney Janis Gallery organizes *The New Realists*.
- Fluxus founders George Maciunas, Nam June Paik, and Wolf Vostell perform Neo-Dada multidisciplinary work, *Zen for Head,* in Wiesbaden, Germany, and subsequently organize Fluxus Festivals throughout Europe and America. Paik exhibits his television sculptures at the Galerie Parnass in Wuppertal, Germany.
- Edward Kienholz starts creating his assemblage tableaux. Tony Smith makes his first large-scale geometric sculpture.
- Carolee Schneemann performs *Eye Body: 36 Transformative Actions for Camera,* a feminist work anticipating Body art.
- General Services Administration institutes the Art in Architecture Program, mandating that new federal buildings must include art (inactive from 1966–72).
- Betty Friedan publishes *The Feminine Mystique* (1963).
- Alfred Hitchcock releases his film *The Birds* (1963).

Eero Saarinen and Associates.
The Gateway Arch, 1962-68. Saint Louis, Missouri. Stainless steel; H. 630 ft (192 m.).
Photo © Corbis.

Andy Warhol. *Brillo Box*, 1964. Paint and ink on wood; 13 x 16 x 11 1/2 in. (33 x 40.6 x 29.2 cm). Whitney Museum of American Art, New York; gift of the American Contemporary Art Foundation Inc., Leonard A. Lauder President.
© 2004 Andy Warhol Foundation for the Visual Arts/Artists Rights Society (ARS). Photo courtesy PaceWildenstein.

Yayoi Kusama. *Installation view of "Narcissus Garden" at the 33rd Venice Biennale*, 1966. 1,500 plastic mirror balls; each Diam. 7 7/8 in. (20 cm).
Photo courtesy Yayoi Kusama Studio.

1964
Designs gardens for IBM Headquarters in Armonk, New York.

- U.S. involvement in the Vietnam War escalates into large-scale, direct military intervention.
- In the U.S., the Civil Rights Act prohibits discrimination based on color, race, religion, or national origin.
- Rauschenberg, Oldenburg, and Johns represent the U.S. at the Venice Biennale.
- In New York, Yoko Ono performs *Cut Piece* at Carnegie Hall. Shigeko Kubota performs *Vagina Painting* at the Perpetual Fluxus Festival the following year.
- After exhibiting painted wood sculptures at the Green Gallery in New York, Donald Judd gives instructions to an industrial fabricator to produce galvanized metal wall sculptures ("stacks"). The following year he publishes his influential essay "Specific Objects," presenting ideas later termed Minimalist.
- Sol LeWitt produces his first serial open-cube sculptures.

1965–66
Exhibits carved stone sculptures at Cordier and Ekstrom Gallery in New York. Collaborates with architect Yosho Otani on playground at Kodomo No Kuni, near Tokyo. Designs sets for *Cortege of Eagles*, his last collaboration with Graham. In Shikoku, carves monumental *Black Sun* for the Seattle Art Museum, assisted by Masatoshi Izumi.

- Malcolm X assassinated in Harlem, one year after publishing his autobiography. Race riots break out in the Watts section of Los Angeles; riots in major cities across America soon follow.
- Mao Zedong launches the Cultural Revolution in China (1966–69).
- National Organization for Women founded in New York, and the Black Panthers organize in Oakland, California.
- In New York, The Museum of Modern Art's exhibition *The Responsive Eye* features Op artworks by Bridget Riley, Victor Vasarely, and others. Oldenburg proposes his first imaginary colossal monuments of everyday objects.

- First major exhibitions of Minimalist art in New York: *Primary Structures: Younger American and British Sculptors* at the Jewish Museum and *Systemic Painting* at the Guggenheim.
- *Eccentric Abstraction* at Fischbach Gallery in New York features Post-Minimalist sculptures by Bourgeois, Lee Bontecou, Yayoi Kusama, Richard Artschwager, and Lucas Samaras.
- Robert Smithson receives commission for Dallas–Fort Worth Airport project.
- Marcel Breuer designs building for the Whitney Museum of American Art in New York. Bunshaft designs building and sculpture garden for the Hirshhorn Museum in Washington DC.
- Michel Foucault publishes *Les mots et les choses (The Order of Things)* (1966; English translation 1970).

1967
Exhibits combination metal-and-stone sculptures at the Cordier and Ekstrom Gallery.

- *Artforum* magazine publishes LeWitt's essay "Paragraphs on Conceptual Art," proposing that ideas are more important than actual works. Michael Fried's critique of Minimalism, "Art and Objecthood," and Robert Morris's Post-Minimalist "Notes on Sculpture" are also published in the same issue.
- In Genoa, Italy, Germano Celant's *Arte Povera* exhibition at Galleria La Bertesca introduces a group of Italian artists who sculpt with everyday materials and unconventional techniques, partly in a critique of American Minimalism. Three years later in Turin, Italy, Celant organizes pivotal exhibition *Conceptual Art, Arte Povera, Land Art.*
- Barnett Newman's sculpture *Broken Obelisk* is installed at the Seagram Building, New York.
- Duane Hanson creates his first life-size, hyper-realistic, resin and fiberglass sculptures depicting ordinary people.
- Marshall McLuhan publishes *The Medium Is the Message.*

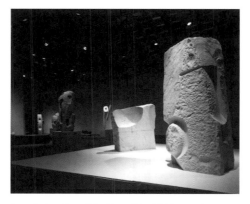

Installation view of the Noguchi exhibition at the Whitney Museum of American Art, New York, 1968.
Photo by Michio Noguchi, courtesy Whitney Museum of American Art, New York.

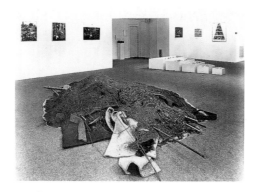

Installation view of the "Earthworks" exhibition at the Dwan Gallery, New York, October 1968.
Photo by Walter Russell, courtesy the Dwan Gallery Archive.

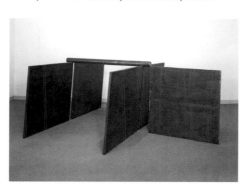

Richard Serra. *2-2-1: To Dickie and Tina,* 1969, fabricated 1986. Steel; 51 3/8 x 120 x 99 3/8 in. (130.5 x 305 x 252.4 cm).
Hirshhorn Museum and Sculpture Garden, Smithsonian Institution, Washington DC; Joseph H. Hirshhorn Purchase Fund.

1968
Installs *Red Cube* at 140 Broadway in New York. Proposes fountains for the U.S. Pavilion at Expo 70, Osaka, Japan. Begins series of segmented marble sculptures in Italy. Publishes autobiography, *A Sculptor's World.* Whitney Museum of American Art, New York presents retrospective. Solo show of recent sculptures at the Gimpel and Hanover Gallery in London and Zurich.

- Social unrest results in mass student and worker protests in Europe and the U.S.
- Martin Luther King Jr. and Robert Kennedy assassinated.
- Tony Smith shows his first steel sculptures in Bryant Park, New York.
- Christo wraps his first building, the Kunsthalle in Bern.
- In New York, the *Earthworks* show at the Dwan Gallery features land-based projects by Michael Heizer, LeWitt, Walter De Maria, Robert Morris, Dennis Oppenheim, and Smithson.
- Tom Wolfe publishes *The Electric Kool-Aid Acid Test.*

1969
Establishes studio at Mure, outside Takamatsu on Shikoku Island, Japan, and henceforth creates most of his granite and basalt sculptures there, assisted by Izumi. *Black Sun* is installed in Seattle. Exhibits *akari* as sculptures of light at Cordier and Ekstrom Gallery in New York.

- In New York, *0 Objects, 0 Painters, 0 Sculptors,* one of the first major Conceptual art exhibitions, is organized by Seth Siegelaub.
- Whitney Museum of American Art organizes *Anti-Illusion: Procedures/Materials* exhibition of Post-Minimalist, process-oriented art, including works by Eva Hesse, Bruce Nauman, Keith Sonnier, Richard Tuttle, Robert Morris, Smithson, and others. Marina Abramovic, Vito Acconci, Chris Burden, Gilbert and George, Rebecca Horn, and Bruce Nauman produce Body art. Howard Wise Gallery presents *TV as a Creative Medium,* a pioneering exhibition of video art.
- In Bern, Harold Szeemann's *When Attitudes Become Form* also showcases international Process art.
- In the Nevada desert, Heizer begins *Double Negative* Earthwork, completed in 1970.
- First human being walks on the moon.

1970

Begins *Void* sculptures. Exhibits striated marble sculptures at Cordier and Ekstrom Gallery in New York.

- In New York, several exhibitions feature radically new approaches to art, especially *Conceptual Art and Conceptual Aspects* at the New York Cultural Center and *Information* at The Museum of Modern Art. The Jewish Museum presents *Software Information Technology: Its New Meaning for Art*. Sound art is presented in the Museum of Contemporary Crafts's exhibition *Sound* and the Museum of Conceptual Art's *Sound Sculpture as Art*.
- Smithson creates *Spiral Jetty* in Great Salt Lake, Utah.

1971–73

Designs Hart Plaza and Dodge Fountain for Detroit. Exhibits 16 recent sculptures at Minami Gallery in Tokyo.

- Massive protests against the Vietnam War in Washington DC until U.S. troops withdraw in 1973.
- U.S. returns Okinawa to Japan, prompting a restoration of diplomatic relations.
- Linda Nochlin publishes "Why Are There No Great Women Artists?" in *ARTnews*. Judy Chicago and Miriam Schapiro found the Feminist Art Program at the California Institute of the Arts.
- Richard Serra starts producing monumental steel sculptures.
- In *Artforum*, Leo Steinberg coins the term "post-Modernist" to describe Rauschenberg's use of cultural images and to advocate a pluralistic approach to art criticism, refuting Clement Greenberg's formalist aesthetics.
- Picasso dies.

1974

Collaborates with architect Shoji Sadao on *Intetra* fountain for Palm Beach. Begins work on aluminum sculptures for Shinto Bank of Tokyo Building. Monumental *Energy Void* sculpture is installed in Pepsico Garden, Poughkeepsie, New York.

- President Nixon resigns.
- Beuys performs *Coyote: I Like America and America Likes Me*, a weeklong event with a live coyote at Rene Block Gallery, New York.
- Gordon Matta-Clark makes *Four Corners: Splitting* by carving a vertical slice through a house in Englewood, New Jersey.

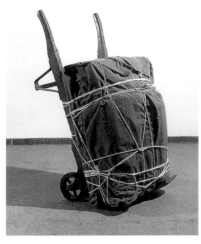

Christo. *Package on a Hand Truck*, 1973. Metal, tarpaulin, wood, and rope; 52 x 24 1/4 x 29 in. (131.9 x 61.6 x 73.7 cm). Whitney Museum of American Art, New York; gift of Mr. and Mrs. Albrecht Saalfield.
Photo by Geoffrey Clements. Art © Christo 1973.

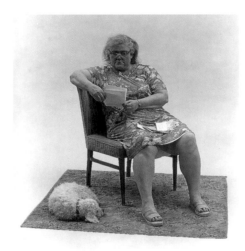

Duane Hanson. *Woman with Dog*, 1977. Painted polyvinyl with cloth and hair; 46 x 48 x 51 1/2 in. (116.8 x 121.9 x 130.8 cm). Whitney Museum of American Art, New York; purchase with funds from Frances and Sydney Lewis.
Art © Estate of Duane Hanson/Licensed by VAGA.
Photo by Jerry L. Thompson.

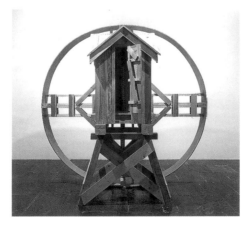

Alice Aycock. *Untitled (Shanty)*, 1978. Wood; 54 x 30 x 30 in. (137.2 x 76.2 x 76.2 cm). Whitney Museum of American Art, New York; gift of Raymond J. Learsy.
Photo by Geoffrey Clements.

1975–76

Exhibits steel sculptures at Pace Gallery in New York. Designs *Landscape of Time* for Jackson Federal Building plaza in Seattle, and *Playscapes Playground* for Piedmont Park in Atlanta. Designs two monumental industrial pipe sculptures: *Portal* in Cleveland and *Sky Gate* in Honolulu.

- Khmer Rouge takes power in Cambodia, uprooting millions of people to rural areas and killing the professional classes, especially teachers. They rule until 1979.
- Mao Zedong dies.
- Museum of Contemporary Art in Chicago organizes *Bodyworks* exhibition.
- United Graffiti Artists has its first exhibition at Artists Space in New York. Anthony Caro's elegant geometric sculptures exhibited at The Museum of Modern Art.
- Christo installs *Running Fence* in Sonoma and Marin counties, California.
- Robert Wilson and Philip Glass debut *Einstein on the Beach* at Festival d'Avignon, France.

1977–78

Designs interior court *Tengoku (O, Heaven)* for Sogetsu School of Japanese Flower Arrangement. The Museum of Modern Art in New York exhibits his commercial designs. With Sadao, designs sculpture garden for The Museum of Fine Arts, Houston. Walker Art Center organizes *Noguchi's Imaginary Landscapes* retrospective exhibition, which travels to five other cities. Sam Hunter publishes the first book-length monograph on Noguchi.

- 15 countries, led by the U.S. and Soviet Union, sign nuclear nonproliferation pact.
- In New York, *Pictures*, an exhibition at Artists Space, introduces young artists using photographic methods, including Barbara Kruger, Sherrie Levine, and Cindy Sherman.
- De Maria creates *The Lightning Field* in New Mexico, and the *New York Earth Room* and *Broken Kilometer* in New York.
- In New York, the *Bad Painting* exhibition at the New Museum of Contemporary Art features artists who reject the detachment of Minimalism and Conceptualism in favor of deliberately crude figurative works infused with personal meaning. *New Image Painting* at the Whitney Museum of American Art features Neo-Expressionist figurative painting by Susan Rothenberg, Jennifer Bartlett, Robert Moskowitz, Neil Jenney, and Elizabeth Murray.

1979–80

Designs outdoor sculptural environments for Bayfront Park in Miami and, with Sadao, the Japanese American Cultural Center in Los Angeles and *California Scenario* for South Coast Plaza in Costa Mesa, California. Carves basalt *Passage of Seasons* for The Cleveland Museum of Art and *Unidentified Object* for The Metropolitan Museum of Art. Designs *Constellation (For Louis Kahn)* at the Kimball Art Museum, Forth Worth.

- American hostages seized from embassy in Iran. Ronald Reagan elected president. Iran–Iraq war begins.
- Judy Chicago exhibits collaborative feminist art project *The Dinner Party* at the San Francisco Museum of Modern Art.
- In New York, Julian Schnabel has first solo show at Mary Boone Gallery, and Keith Haring begins graffiti drawings in subway stations. Collaborative Artists' *Times Square Show* in a massage parlor presents works by punk and street culture–based artists, including Kenny Scharf, Jean-Michel Basquiat, Nan Goldin, David Hammons, and Jenny Holzer.
- Francis Ford Coppola's film *Apocalypse Now* (1979) savagely critiques the Vietnam War.

1981–82

Designs museum on the land adjacent to his Long Island City studio. Redesigns *Monument to Benjamin Franklin* for installation in Philadelphia.

- Serra's monumental *Tilted Arc* is installed in Federal Plaza in New York.
- Maya Ying Lin's *Vietnam Veterans Memorial* is dedicated in Washington DC.
- Sherrie Levine, David Salle, and others "appropriate" other people's artworks into their own works. Holzer's first LED work is displayed in Times Square.
- In New York, Basquiat has first exhibition at Fun Gallery. The East Village art scene peaks with more than 70 commercial art galleries.
- In London, *A New Spirit in Painting* at the Royal Academy introduces recent works by Gerhard Richter, Anselm Kiefer, Sandro Chia, and others.
- Pace of modern life accelerates as new technologies emerge, including personal computers, word processors, fax machines, microwave ovens, and satellite and cordless phones.

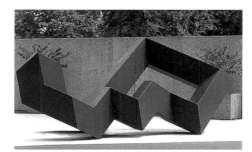

Tony Smith. *Throwback*, 1976–79.
Painted aluminum; 81 x 156 x 95 $^5/_8$ in.
(206.2 x 396 x 141.6 cm).
Hirshhorn Museum and Sculpture Garden, Smithsonian Institution, Washington DC; museum purchase.

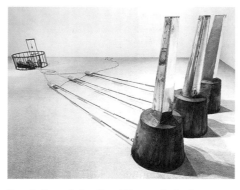

Dennis Oppenheim. *Caged Vacuum Projectiles*, 1979.
Copper smoke stacks, rubber straps, vacuum cleaners, steel cage, and wood suction cups; 14 x 20 x 50 ft. (4.3 x 6.1 x 15.2 m).
Photo by J. Ball, courtesy Richard Hines Gallery.

Mary Miss. *Battery Park City (Esplanade)*, 1985–88.
Wood, water, earth, cement, trees; 2.5 acres.
Photo courtesy the artist.

1983–84

Designs water garden for Domon Ken Museum in Sakata, Japan. Izumi begins to take on a more active collaborative role in carving stone sculptures at Mure studio.

- In New York, the New Museum of Contemporary Art presents *Art and Ideology* and *Difference: On Representation and Sexuality.*

1985–87

Represents the U.S. at the Venice Biennale. Isamu Noguchi Museum and Garden opens to the public in Long Island City.

- In U.S.S.R., Mikhail Gorbachev begins policy of détente. Chernobyl nuclear plant explodes.
- Guerrilla Girls launch their activist campaign to be the "conscience of culture."
- Nan Goldin's *Ballad of Sexual Dependency* photographs are exhibited and published.
- Centre Georges Pompidou in Paris presents *Les Immatériaux*, an exhibition of work exemplifying Jean-François Lyotard's "postmodern condition."

1988

Designs plan for 400-acre park near Sapporo, Japan. Dies December 30 in New York.

Notes

Isamu Noguchi: Master Sculptor
Valerie J. Fletcher
pages 14–161

1 Exhibitions addressing the artist's achievements in design and landscape include Martin Friedman, *Isamu Noguchi: Visionary Landscapes* (Minneapolis: Walker Art Center, 1978). The most recent is *Isamu Noguchi: Sculptural Design* organized by the Vitra Design Museum in 2002 and circulated internationally, with excellent essays in the accompanying catalogue. Comprehensive books include Sam Hunter, *Isamu Noguchi* (New York: Abbeville Press, 1978), Bruce Altshuler, *Noguchi* (New York and London, Abbeville Press, 1994), and Dore Ashton, *Noguchi, East and West* (New York: Alfred A. Knopf, 1992). This essay is deeply indebted to these studies.

2 Paul Cummings, "Interview with Isamu Noguchi," November–December 1973, original typescript (Washington DC: Archives of American Art, Smithsonian Institution). Artist's quotations used in this essay are taken from Cummings, "Interview with Isamu Noguchi," the artist's autobiography *A Sculptor's World* (New York: Harper and Row, 1968), and his comments in *The Isamu Noguchi Sculpture Garden* (New York: Harry N. Abrams, 1987). Other sources are cited individually; many have been reprinted in Bruce Altshuler and Diane Apostolos-Cappadona (eds.), *Isamu Noguchi: Essays and Conversations* (New York: Harry N. Abrams, 1994).

3 Bonnie Rychlak, curator of The Noguchi Museum, has organized installations of Noguchi's photographs, *akari*, architectural models, and stage-set designs. The exhibition by Louise Cort and Bert Winther-Tamaki, *Noguchi's Ceramics* (Washington DC: Arthur M. Sackler Gallery, Smithsonian Institution, 2003) places those works in the context of contemporaneous Japanese ceramists.

4 Noguchi, "My Sculpture," *Isamu Noguchi* (Tokyo: Minami Gallery and Bijutsu Shuppan Design Center, 1973), nonpaginated.

5 The last major museum exhibition of the sculptures was organized by John Gordon at the Whitney Museum in 1968. The first scholarly examination was Nancy Grove, *Isamu Noguchi: A Study of the Sculptures* (thesis, City University of New York, 1983). The first catalogue raisonné by Nancy Grove and Diane Botnick, *The Sculptures of Isamu Noguchi, 1924–1979* (New York and London: Garland Publishing, 1980), documented 800 sculptures. The updated version being compiled at The Noguchi Museum has assigned numbers to more than 1,100 sculptures.

6 Marshall McLuhan, *The Medium Is the Message* (New York: Randon House, 1967).

7 See Bert Winther-Tamaki, *Isamu Noguchi: Conflicts of Japanese Culture in the Early Postwar Years* (Diss., New York University, 1992), and *Art in the Encounter of Japanese Culture in the Early Postwar Years* (Honolulu: University of Hawaii Press, 2001).

8 Yone settled in San Francisco for seven years. During a visit to New York in 1901, he hired Leonie Gilmour, a recent graduate of Bryn Mawr College and the Sorbonne, to help him translate his *American Diary of a Japanese Girl* into English. By 1903 they were married or living together, but Yone left for London shortly before Isamu was born, and thence to Japan. Gilmour lived in Japan from 1906 to 1920.

9 The Church of the New Jerusalem, officially founded in London in 1787, was based upon the writings of the Swedish visionary Emanuel Swedenborg (1688–1772). His *Arcana Coelestia* (*Heavenly Secrets*) of 1747–56 reinterprets the Bible as a means of spiritual development; *Earths in the Universe* of 1758 recounts his conversations with spirits from other worlds; *Divine Providence* of 1764 addresses questions of good and evil, explaining how humans can become angels. Swedenborg believed that the spiritual and material domains are not separate.

10 See Valerie J. Fletcher et al., *Four Latin American Pioneers of Modernism: Diego Rivera, Joaquín Torres-García, Wifredo Lam, and Matta* (Washington DC and London: Thames and Hudson/Hirshhorn Museum and Sculpture Garden, Smithsonian Institution, 1992).

11 Press release for Noguchi's exhibition at the San Francisco Museum of Art, July 1942 (Noguchi Museum archive).

12 Noguchi, "Art and the People," lecture in Osaka (June 13, 1950), published in *Mainichi* newspaper (June 16, 1950), 4.

13 Although Brancusi called his works bronze, metal analyses of several (including the Hirshhorn Museum's *Prometheus*) have confirmed that he used brass (my thanks to Lynda Zycherman and Angela Chang at The Museum of Modern Art, New York, for this information). Both alloys consist primarily of copper, but bronze was for "high art" while brass was for lamps and other mundane items. In the early 1910s several sculptors, including Elie Nadelman and Alexander Archipenko, also realized that brass was more readily polished to a high golden sheen.

14 F. T. Marinetti, "The Futurist Sensibility" (1913), reprinted in Umbro Apollonio, *Futurist Manifestos* (New York: Viking Press, 1970), 96.

15 El Lissitzky, "New Russian Art" (1922), reprinted in Sophie Lissitzky-Küppers, *El Lissitzky: Life, Letters, Texts* (New York Graphic Society, 1968), 333.

16 László Moholy-Nagy, *Abstract of an Artist* (New York: Wittenborn Press, 1947), 76.

17 For information on utopian abstract art in the early twentieth century, see: Steven Mansbach, *Visions of Totality: László Moholy-Nagy, Theo van Doesburg, and El Lissitzky* (Ann Arbor: UMI Press, 1980); Valerie J. Fletcher, *Dreams and Nightmares: Utopian Visions in Modern Art* (Washington DC: Smithsonian Institution Press, 1983); and the bibliographies therein.

18 For further discussion of Noguchi's early works from the 1920s through the 1930s, see Deborah Goldberg, *Isamu Noguchi: The Artist as Engineer and Visionary Designer* (Diss., New York University, 1990), as well as Anna C. Chave, "Brancusi and Noguchi," and Ingrid Schaffner and Donna Gelerter, "Mr. Expanding Universe" in *Isamu Noguchi: Sculptural Design*, 26–105.

19 Noguchi may have been prompted to hang this sculpture in midair after visiting the studio of Alexander Calder, who had arrived in Paris in 1926. Calder made lightweight wire constructions of faces and figures, some of which he suspended on walls and from the ceiling. The two sculptors became friends, often partying together and later keeping in touch. Noguchi once acknowledged Calder as "one of my early influences [in Paris], in that his things were anti-gravity," but Noguchi's *Abstraction in Almost Discontinuous Tension* predated Calder's first sheet-metal mobiles by several years.

20 Noguchi would later modify these sculptures in ways that diminished their precarious and experimental aspects. He removed the wires from *Positional Shape* and mounted it in one immovable position. The metal element for *Red Seed* was lost at some time; Noguchi replicated it in 1983. For a photograph showing its original appearance, see *The Isamu Noguchi Garden Museum*, 232. The sculptor electroplated his early sheet-brass sculptures with gold so that they no longer needed regular polishing to maintain their high sheen. By that time Noguchi had enough experience to differentiate the maintenance of metal sculptures from "truth to materials."

21 Piet Mondrian, "From the Natural to the Abstract, or from the Indefinite to the Definite" (1918) and "Neoplasticism in Painting" (1917), cited in Hans Jaffé, *De Stijl* (New York: Harry N. Abrams, 1971), 38 and 75.

22 On several occasions Noguchi stated unequivocally that he made portraits because "I needed money badly" and "there was nothing to do but make heads. It was a matter of eating, and this was the only way I knew of making money" (cited in Schaffner and Gelerter, 71, note 3). For a sympathetic and scholarly treatment of the portraits, see Nancy Grove, *Isamu Noguchi: Portrait Sculpture* (Washington DC: Smithsonian Institution Press, 1989).

23 According to Noguchi, *The Queen* consists of two elements originally made and exhibited as two separate works, and it was his friend Gorky who combined them and invented the title in 1945 (questionnaire, August 3, 1970, in the Whitney Museum's object records). Although numbered 1/3 this sculpture is unique.

24 See Robert Marks, *Dymaxion World* (Garden City, NY: Anchor Books, 1960, reprinted 1973) and Lloyd S. Sieden, *Buckminster Fuller's Universe* (New York: Plenum Press, 1989).

25 Stainless steel had been invented in 1913, when a British metallurgist—trying to improve rifle barrels—accidentally discovered that adding chromium to low-carbon steel reduces corrosion. The *Portrait of Immo Gulden* is rarely seen and so has not been analyzed to confirm its material. When exhibited in 1935, it was listed as chromium-nickel plate, but Grove, *Isamu Noguchi: Portrait Sculpture*, 84, confirms that it was his first stainless-steel sculpture.

26 Hans Oersted, a Danish chemist, was the first to produce tiny amounts of aluminum in 1825. By 1845 the German chemist Friedrich Wöhler had developed a way to produce larger amounts. His method was improved in 1854 by the French chemist Henri-Etienne Deville; his process allowed for the first commercial production of aluminum. In 1886 in the United States, Charles Hall invented the most successful technique and founded what would become the Aluminum Company of America (ALCOA).

27 Photograph by F. S. Lincoln, published in *Time* magazine (October 10, 1932), 19, and reproduced in Goldberg, plate 49. For a photograph of Page posing in the costume designed by Noguchi, see Robert Tracy, *Spaces of the Mind: Isamu Noguchi's Dance Designs* (Proscenium Publishers, New York, 2000), 23.

28 The name Monel refers to the president of the International Nickel Company, which introduced this corrosion-resistant alloy of 67% nickel, 28% copper, with trace amounts of other metals. In the 1920s Monel Metal was used only for industrial applications, such as automatic milking-machines for cows. After World War II, Seymour Lipton and other American sculptors would use it for sculpture, usually opting to weld and solder its surface expressively, in contrast to Noguchi's highly polished Machine Age surfaces.

29 J. W. L., "Current Exhibitions," *Parnassus* (March 1935), 22.

30 Noguchi included *Death*, along with his proposals for public monuments, in his exhibition at the Marie Harriman Gallery in 1935. According to the artist (*Isamu Noguchi Garden Museum*, 236), he intended to show *Death* with *Birth*, a white marble sculpture depicting actual childbirth. When Harriman deleted *Birth* from the exhibition, she defeated his intention of presenting a strong contrast of opposites. It was in this exhibition that Noguchi finally presented himself as a sculptor of utopian public monuments and art with a social purpose, rather than as a European constructivist or Chinese painter or a Japanese ceramist.

31 Press release for Noguchi exhibition, San Francisco Museum of Modern Art, July 1942 (Noguchi Museum archive).

32 Comte de Lautréamont, *Les Chants de Maldoror* (Paris, 1869).

33 Noguchi, "What's the Matter with Sculpture?" *Art Front* 16 (September–October 1936), 13–14.

34 Works that, in retrospect, seem particularly relevant to Noguchi's later development include Arp's painted wood reliefs *Shirt Front and Fork* (1922), *Dancer* (1923–24), *Torso with Navel* (1925), and his freestanding plasters *Head with Annoying Objects* (1930), *Torso* (1930–31), and *Human Concretion* (1935), as well as Picasso's *Bather* and *Seated Bather* paintings from 1927–30.

35 See Helen A. Harrison, *Dawn of a New Day: The New York World's Fair 1939–40* (New York University Press and Queens Museum, 1980).

36 Magnesite cement, a compound of magnesium, carbon, and oxygen, can also be yellowish-white or tinted to any hue desired. Noguchi favored its somewhat ghostly appearance as a surface for direct and indirect lighting effects. He also made a table from magnesite cement in 1939.

37 Noguchi, "What's the Matter with Sculpture?"

38 For more on Calder during the 1930s and 1940s, see Joan Marter, *Alexander Calder* (Cambridge University Press, 1991), especially the installation photograph on page 188. See also Alexander S. C. Rower's chronology in Marla Prather et al., *Alexander Calder* (Washington DC: National Gallery of Art, 1998). The Miró exhibition at MoMA took place from November 1940 to January 1941. See also William Griswold et al., *Pierre Matisse and His Artists* (New York: J. Pierpont Morgan Library, 2002).

39 Letter from Baziotes' brother, 1940; he added that the artist "doesn't know what they mean." See the excellent history by Martica Sawin, *Surrealism in Exile* (Cambridge, MA: MIT Press, 1995), 86.

40 Cited in Julien Levy, *Surrealism* (New York, 1936), dedication page.

41 Noguchi to Friedman, *Noguchi's Imaginary Landscapes*.

42 Noguchi, "My Sculpture."

43 Noguchi, letter to Hirshhorn Museum and Sculpture Garden, August 1972. Noguchi's approach to the *Lunars* is more ambivalent than Fuller's words in "No More Second-hand God" (1940): "A sufficient light within a seemingly opaque black object / may suddenly convert that object into a brilliant varicolored lantern."

44 See Tracy, *Spaces of the Mind*, 37–43, for information and excellent photographs.

45 Throughout his long life Noguchi was often generous in acknowledging inspiration from Brancusi, Fuller, Calder, and Gorky, but he vehemently denied that Surrealist art—especially Tanguy's—affected his own new works. This denial stemmed from the bitter humiliation he experienced in 1946, when James Johnson Sweeney refused to acquire *Kouros*—one of Noguchi's greatest sculptures—for The Museum of Modern Art's collection, because the eminent curator considered it derivative of Tanguy's paintings. See Hunter, *Noguchi*, 83, and Ashton, *Noguchi East and West*, 71–73.

46 Katherine Kuh, "An Interview with Isamu Noguchi," *Horizon* 11 (March 1960), 101–112, reprinted in Kuh, *The Artist's Voice* (New York: Harper and Row, 1962), 171–187.

47 Ibid.

48 See Amy Lyford, "Noguchi, Sculptural Abstraction, and the Politics of Japanese American Internment," *Art Bulletin* 85, no. 1 (March 2003), 136–51.

49 Kuh, "An Interview with Isamu Noguchi."

50 During the 1920s the India-born Jidda Krishnamurti was acclaimed by Theosophists as their teacher and guru, but he parted from their Society in 1929 to assert his independence. For the next half century (he died in 1986) he traveled the world speaking about spiritual matters, but without advocating any one religion. His ideas were informed by the concepts of modern psychology; he encouraged listeners to free themselves from their innermost burdens of anger, fear, aggression, and so on. His global perspective and independent credo that "truth is a pathless land" would have appealed to Noguchi. Krishnamurti's earliest books include *Freedom from the Known* (New York, 1928).

51 Pandit's letters to Noguchi in 1946–47 (Noguchi Museum archive) reveal the delight, affection, and humor they shared during her senior year at Wellesley and during her travels to California, Mexico, and finally to India.

52 Noguchi, "On Sculpture," in Dorothy Miller, *Fourteen Americans* (New York: The Museum of Modern Art, 1946), 39.

53 Jean-Paul Sartre, "L'Existentialisme est un Humanism," October 1945, translated as "Existentialism and Humanism" in March 1946. Sartre's lecture tour in the United States lasted from mid-December 1945 to mid-March 1946; his ideas, often misunderstood, became an international vogue.

54 Sartre, "L'Existentialisme est un Humanism," October 1945, translated in Walter Kaufmann, *Existentialism from Dostoevsky to Sartre* (New York: New American Library, 1957), 347.

55 All quotations in this paragraph are taken from Noguchi's two essays: "Towards a Reintegration of the Arts," *College Art Journal* 9 (Autumn 1949), 59–60, and "Meanings in Modern Sculpture," *Art News* 48 (March 1949), 12–15, 55–56; reprinted in *Essays and Conversations*, 1994, 26–36.

56 Noguchi, unpublished typescript, August–September 1952 (Noguchi Museum archive), quoted in Altshuler, 63.

57 The exhibition took place at the Cordier and Ekstrom Gallery, New York, in late 1968.

58 Kuh, "An Interview with Isamu Noguchi."

59 See Helen Westgeest, *Zen in the Fifties* (Zwolle, The Netherlands: Cobra Museum, 1996).

60 Noguchi, "Astronomical City," *Portfolio* (1951).

61 Noguchi, "New Stone Gardens," *Art in America* 52 (June 1964), 84–89.

62 Noguchi, "Meanings in Modern Sculpture" (1949).

63 In his autobiography Noguchi ruefully noted that "Accepting a medium that I had so long avoided had its rewards. It is shippable, durable and eminently classifiable as art (saleable).... I must reconcile myself to the realities of the art world: whether or not bronze is a reproduction is secondary to its effectiveness as art.... I could tolerate bronze only by ascribing to it some new quality such as weight...."

64 Kuh, "An Interview with Isamu Noguchi."

65 Anne d'Harnoncourt recounted Noguchi's stunned response to the many lingams (phallic symbols of Shiva's power) in an exhibition they visited together. He was so moved that he rushed back to his studio to work.

66 See Masayuke Nagare, *The Life of a Samurai Artist* (New York: Weatherhill, 1994).

Breaking Ground:
The Environmental Works of Isamu Noguchi
Dana Miller
pages 162–85

1 Isamu Noguchi, "Proposal to the Guggenheim Foundation," 1927, reprinted in eds., Diane Apostolos-Cappadona and Bruce Altshuler, *Isamu Noguchi: Essays and Conversations* (New York: Harry N. Abrams, in association with the Isamu Noguchi Foundation, 1994), 16.

2 Noguchi, "The Road I Have Walked," in *Play Mountain: Isamu Noguchi and Louis Kahn* (Tokyo: Watari-um and The Isamu Noguchi Foundation, 1996), 100.

3 The project is known to us now only through photographs of the model and the rendering by an architect identified as R. Blas, who is mentioned in an April 12, 1934, letter from Noguchi to the PWAP. Records of the PWAP, Record Group 121, Correspondence of Region 2 Office (New York Area) with artists, 1933–34. Archives of American Art, New York, Smithsonian Institution, microfilm DC 114, (0095). A memo dated April 13, 1934, states that Noguchi referred to this work as "*American Plow*." Records of the PWAP, Archives of American Art/Smithsonian Institution, (0099).

4 Noguchi, "The Road I Have Walked," 100.

5 Noguchi, *A Sculptor's World* (New York: Harper and Row, 1968), 21.

6 John Gruen, "The Artist Speaks," *Art in America* 56 (March–April 1968), 31.

7 Noguchi, "The Road I Have Walked," 100. The plow was the subject of a number of works during the Depression, including the 1936 film *The Plow that Broke the Plains*, produced by the Resettlement Administration and directed and written by Pare Lorentz with music by Virgil Thomson. Noguchi's first set design was for Martha Graham's 1935 *Frontier*, the subject of which was the opening of America's western frontier.

8 Noguchi, *A Sculptor's World*, 22. See also Bert Winther-Tamaki, "Isamu Noguchi: Places of Affiliation and Disaffiliation," in *Art in the Encounter of Nation: Japanese and American Artists in the Early Postwar Years* (Honolulu: University of Hawai'i Press, 2001). Dr. Rumeley, founder of the Interlaken high school that Noguchi was sent to attend in Indiana, developed a tractor for his family's farm equipment business, the Advance-Rumeley Company in La Port.

9 Letter dated February 29, 1934. Records of the PWAP, Archives of American Art/Smithsonian Institution, (0083).

10 Letter from Lloyd Goodrich to Noguchi dated February 23, 1934, states that his last day is February 26, 1934. Records of the PWAP, Archives of American Art/Smithsonian Institution, (0082). Further correspondence indicates that he began receiving payment from the PWAP again on March 15 and was finally dismissed on April 14, 1934. Records of the PWAP, Archives of American Art/Smithsonian Institution, (0096).

11 For a discussion of the importance of play to Zen see Dore Ashton, *Noguchi, East and West* (New York: Alfred A. Knopf, 1992), 52.

12 Gruen, 31.

13 Cummings, "Interview with Isamu Noguchi," 88.

14 Memorandum to San Francisco Museum of Art [c. 1942], "Sculpture by Isamu Noguchi, June 30–August 2, 1942," Exhibitions As Hung files, San Francisco Museum of Modern Art, Research Library. I thank Neil Printz for initially bringing this memo to my attention.

15 Thomas Hess, "Isamu Noguchi," *Art News* 45 (September 1946), 50.

16 Noguchi, *The Isamu Noguchi Garden Museum*, 152. The work is captioned as *Model for This Tortured Earth*, and included in a list of "concepts for space and sculpture, space as sculpture (realized), and sculpture in a given site" in the catalogue.

17 The only existing photograph of the work in the collection of the Isamu Noguchi Foundation, Inc., is inscribed on the verso in the artist's hand: "Monument to Man, model for enormous pyramid construction to be seen from airplanes." This undated inscription connects it more directly to his Newark Airport proposal. Sam Hunter's 1978 book also indicates that the work was to be placed near an airport. Sam Hunter, *Isamu Noguchi* (New York: Abbeville Press, 1978), 59–60.

18 Martin Friedman, *Noguchi's Imaginary Landscapes* (Minneapolis: Walker Art Center, 1978), 46. This catalogue marked the first instance in which Noguchi's works were discussed using the term "Earth art," and sets an important precedent for my essay.

19 Ibid., 7.

20 Noguchi, "The Road I Have Walked," 102.

21 Noguchi, *A Sculptor's World*, 173.

22 Ibid., 174.

23 Among the exhibitions were *Primary Structures* at The Jewish Museum in 1966, *Eccentric Abstraction* at Fischbach Gallery in 1966, and *Sculpture in the Environment*, a show of outdoor works organized in 1967 by Sam Green for the City of New York. Noguchi was among the first artists approached by Green, but his proposal for a playground in Central Park exceeded the project's budget and in the end he did not participate in the show. Suzaan Boettger, *Earthworks: Art and the Landscape of the Sixties* (Berkeley: University of California Press, 2002), 6.

24 Boettger, *Earthworks: Art and the Landscape of the Sixties*, 95.

25 Jack Flam, ed., *Robert Smithson: Collected Writings* (Berkeley: University of California Press, 1996), 117. Andre's proposal was omitted in the version of Smithson's essay published as "Aerial Art," *Studio International* 177 (April 1969), 180–81.

26 Smithson, "Aerial Art," 180.

27 Ibid., 180.

28 Robert Smithson, "Towards the Development of an Air Terminal Site," *Artforum* 5 (June 1967), 36–40, and Smithson, "A Sedimentation of the Mind: Earth Proposals," *Artforum* 7 (September 1968), 44–50.

29 Julia Brown, "Interview," in Brown, ed., *Michael Heizer: Sculpture in Reverse* (Los Angeles: Museum of Contemporary Art, 1984), 14.

30 Ibid., 10.

31 Paul Cummings, "Interview with Robert Smithson for the Archives of American Art," in Flam, ed., *Robert Smithson: Collected Writings*, 283–84.

32 Willoughby Sharp, "Dennis Oppenheim Interviewed by Willoughby Sharp," *Studio International* 182 (November 1971), 186.

33 Isamu Noguchi, "Essay for Museum of Modern Art, Kamakura," 1952, reprinted in *Essays and Conversations*, 39.

34 Noguchi, "The Road I Have Walked," 103.

35 Smithson, "A Sedimentation of the Mind: Earth Proposals," 45.

36 Nancy Holt, ed., *The Writings of Robert Smithson* (New York: New York University Press, 1979), 89.

37 Cummings, "Interview with Isamu Noguchi," 86.

38 Christopher Hussey, *The Picturesque: Studies in a Point of View* (reprint: Frank Cass and Company Limited: London, 1983), 58–60. John Beardsley references Hussey in *Earthworks and Beyond: Contemporary Art in the Landscape* (New York: Abbeville Press, 1998), 62.

39 Roy Bongartz, "It's Called Earth Art—And Boulderdash," *New York Times Magazine*, February 1, 1970, 27.

40 Smithson, "A Sedimentation of the Mind: Earth Proposals," 45.

41 Noguchi, *A Sculptor's World*, 160. Interestingly, many of Noguchi's comments about his earliest landscape projects, particularly the Newark Airport proposal, seem to date from or after 1968.

42 One important exception is John Beardsley's *Earthworks and Beyond: Contemporary Art in the Landscape*.

Sitting Quietly:
Isamu Noguchi and the Zen Aesthetic
Bonnie Rychlak
pages 186–211

1 Writers and critics, artists and collaborators have often referred to Noguchi as working in a Zen tradition. Sam Hunter, noted art historian, cited Noguchi's formal sculptural relationship to Zen in his monograph on Noguchi published by Abbeville in 1978. Dore Ashton, a dedicated writer on Noguchi, often discussed Noguchi's use of Zen references in his titles for his sculptures. Martha Graham, the modern dancer with whom Noguchi collaborated with for more than 30 years, when interviewed for a *New York Times* article said, "I realized that he had the stringency, that everything was stripped to essentials rather than being decorative. Everything he does means something. It is not abstract except if you think of orange juice as the abstraction of an orange. Whatever he did in those sets he did [for me] as a Zen garden does it, back to a fundamental of rite and ritual.." Noguchi scholar, Bert Winther-Tamaki as well as Noguchi himself have affirmed these philosophical assumptions.

2 Isamu Noguchi, *A Sculptor's World* (New York: Harper and Row, 1968), 19.

3 Emanuel Swedenborg (1688–1772), born in Sweden, gained a reputation as a clairvoyant, and in some circles as a mad visionary. His religious teachings offered a new vision of God, with radical insights into the nature of the relationship between the spiritual and natural worlds. He claimed to be able to literally see into the spiritual world and professed his ability to describe that world. Swedenborg's work was intended to provide a universal and rational ethical guide for people seeking a useful and meaningful life. Swedenborg's influence extended to many philosophers, artists, and writers over the centuries—including William Blake, Ralph Waldo Emerson, W. B.Yeats, Benjamin Franklin, Carl Jung, and the famous Zen Buddhist scholar Daisetz T. Suzuki-- who in turn, had a profound impact on Noguchi's thinking and art.

4 Edward Said, *Orientalism*, [New York: Pantheon, 1978] describes notions of the Orient as being separate, eccentric, backward, silently different, sensual, and passive, conquerable, and inferior. Orientalism, as a concept of Western thinking and judged by Western values, displays feminine penetrability and supine malleability, and tends toward despotism and away from progress. The West has always considered the Orient as the Other.

5 Carole Tonkinson, ed., introduction to *Big Sky Mind: Buddhism and The Beat Generation* (New York: The Berkeley] Publishing Group, 1995), 3.

6 Noguchi, *A Sculptor's World*, 13.

7 Dore Ashton, *Noguchi, East and West* (Berkeley: University of California Press, 1992), 36.

8 Bert Winther-Tamaki, "Isamu Noguchi: Conflicts of Japanese Culture in the Early Postwar Years" (PhD diss., University of Michigan, 1992), 26.

9 Yoshinobu Hakutani, ed., *Selected English Writings of Yone Noguchi*, vol. 1 (Cranbury, N.J.: Associated University Presses, Inc., 1992), 42.

10 Noguchi, *A Sculptor's World*, 22-23.

11 Anna Chave, "Brancusi and Noguchi: Towards a Larger Definition of Sculpture," in *Isamu Noguchi Sculptural Design*, eds. Jochen Eisenbrand, Katarina V. Posch, and Alexander von Vegesack (Weil am Rhein, Germany: Vitra Design Museum, 2001), 37.

12 Noguchi, *A Sculptor's World*, 42.

13 Ashton, *Noguchi, East and West*, 44.

14 Winther, "Isamu Noguchi: Conflicts," 25–26.

15 Noguchi and Ginsberg met several times in the early 1950s at the Zen temple Enkaku-ji in Kamakura, Japan, to discuss Suzuki's writings. Unpublished interview preserved in the archives of The Noguchi Museum.

16 Edward Strickland, *Minimalism: Origins* (Bloomington and Indianapolis: Indiana University Press, 1993), 30.

17 Michael McClure, *Isamu Noguchi at Gemini 1982–1983* (Los Angeles: Gemini, G.E.L, 1983), 7.

18 Isamu Noguchi, *The Isamu Noguchi Garden Museum* (New York: Harry N. Abrams, 1987), 62.

19 Named for the small village in Switzerland where Carl Gustav Jung had his personal retreat, the Bollingen Foundation provided financial assistance to a number of scholars and intellectuals, many of whom would have an impact on late twentieth-century New Age thinking, such as Joseph Campbell (the scholar of comparative religions and mythology and a close friend of Noguchi's later in life) and Alan Watts (who received a Bollingen grant to write *The Way of Zen*), as well as Gary Snyder for Zen-inspired poetry.

20 Ashton, *Noguchi, East and West*, 96.

21 Noguchi, *A Sculptor's World*, 31. Hasegawa years later would move to San Francisco, teach Zen painting, and become a master to many other artists, including Franz Kline.

22 Ibid, 24.

23 Ashton, *Noguchi, East and West*, 34.

24 Ibid, 25.

25 Ashton, *Noguchi, East and West*, 102–103.

26 Suzuki, *Zen and Japanese Culture*, 27–28.

27 Ibid, 27.

28 Ibid, 121.

29 Lipsey, *An Art of Our Own*, 355.

30 Noguchi, The Isamu Noguchi Garden Museum, 60.

31 Lipsey, *An Art of Our Own*, 356.

32 Ashton, *Noguchi, East and West*, 111.

33 Noguchi, quoted in Ashton, *Noguchi, East and West*, 171

34 Winther, "Isamu Noguchi: Conflicts," 183–184.

35 Isamu Noguchi, "The Complete Artist," in *Isamu Noguchi: Essays and Conversations*, eds. Diane Apostolos-Cappadona and Bruce Altshuler (New York: Harry N. Abrams, in association with the Isamu Noguchi Foundation, 1994), 47–48.

36 Lipsey, *An Art of Our Own*, 355.

Exhibition Checklist

Paris Abstraction, 1927–28.
Gouache on paper; 25³/₄ x 19³/₄ in. (65.4 x 50.2 cm).
The Noguchi Museum, New York.

Paris Abstraction, 1927–28.
Gouache on paper; 25³/₄ x 19³/₄ in. (65.4 x 50.2 cm).
Whitney Museum of American Art, New York;
gift of The Isamu Noguchi Foundation, Inc.

Paris Abstraction, 1927–28.
Gouache on paper; 25³/₄ x 19³/₄ in. (65.4 x 50.2 cm).
Whitney Museum of American Art, New York;
gift of The Isamu Noguchi Foundation, Inc.

Paris Abstraction, 1927–28.
Gouache on paper; 25³/₄ x 19³/₄ in. (65.4 x 50.2 cm).
Whitney Museum of American Art, New York;
gift of The Isamu Noguchi Foundation, Inc.

Paris Abstraction, 1927–28.
Gouache on paper; 25³/₄ x 19³/₄ in. (65.4 x 50.2 cm).
The Noguchi Museum, New York.

Paris Abstraction, 1927–28.
Gouache on paper; 25³/₄ x 19³/₄ in. (65.4 x 50.2 cm).
The Noguchi Museum, New York.

Paris Abstraction, 1927–28.
Gouache on paper; 25³/₄ x 19³/₄ in. (65.4 x 50.2 cm).
The Noguchi Museum, New York.

Paris Abstraction, 1927–28.
Gouache on paper; 25³/₄ x 19³/₄ in. (65.4 x 50.2 cm).
The Noguchi Museum, New York.

Paris Abstraction, 1927–28.
Gouache on paper; 25³/₄ x 19³/₄ in. (65.4 x 50.2 cm).
The Noguchi Museum, New York.

Paris Abstraction, 1927–28.
Gouache on paper; 25³/₄ x 19³/₄ in. (65.4 x 50.2 cm).
The Noguchi Museum, New York.

Abstraction (*Leda*), 1928.
Brass (later gilded; ring element refabricated);
23³/₈ x 14¹/₄ x 11 in. (59.4 x 36.2 x 27.9 cm),
on artist's marble base 1¹/₂ x Diam. 15 in.
(3.8 x Diam. 38 cm).
The Noguchi Museum, New York.

Positional Shape, 1928.
Brass (later gilded);
23 x 21 x 8³/₄ in. (58.4 x 53.3 x 22.2 cm).
The Noguchi Museum, New York.

Red Seed, 1928.
Teak wood, metal rod (rod refabricated 1985), and
marble; 17¹/₂ x 13¹/₂ x 10³/₄ in. (44.4 x 34.3 x 27.3 cm).
The Noguchi Museum, New York.

Portrait of R. Buckminster Fuller, 1929.
Chrome-plated bronze (edition of 2);
13 x 7 x 9¹/₂ in. (33 x 17.8 x 24.1 cm).
Private collection, Portland,
courtesy of the Buckminster Fuller Estate.

Beijing Scroll: Reclining Female Nude Holding Head, 1930.
Ink on rice-paper scroll;
90¹/₄ x 43³/₄ in. (229.2 x 111 cm).
The Noguchi Museum, New York.

Beijing Scroll: Slouching Monk, 1930.
Ink on rice-paper scroll;
87 x 38¹/₈ in. (221 x 96.8 cm).
The Noguchi Museum, New York.

Portrait of Uncle Tagaki, 1931.
Terracotta with plaster (edition of 4);
12¹/₄ x 7³/₄ x 8 in. (31 x 19.7 x 20.3 cm).
The Noguchi Museum, New York.

The Queen, 1931.
Terracotta (two elements);
45¹/₂ x 16 x 16 in. (115.6 x 40.6 x 40.6 cm).
Whitney Museum of American Art, New York;
gift of the artist.

Miss Expanding Universe, 1931, cast 1932.
Aluminum (edition of 2);
40⁷/₈ x 34⁷/₈ in. (103.8 x 88.6 cm).
Toledo Museum of Art; museum purchase.

*Bolt of Lightning: Model for "Monument to Benjamin
Franklin,"* 1933, revised 1981–83, realized 1985.
Stainless steel and painted brass;
51 x 17¹/₂ x 17¹/₂ in. (129.5 x 44 x 44 cm).
The Noguchi Museum, New York.

Portrait of Immo Gulden, 1934.
Stainless steel; H. 12 in. (30.5 cm).
Mr. and Mrs. Paul Immo Gulden, Jr., Rumson,
New Jersey.

Death (*Lynched Figure*), 1934.
Monel Metal with rope; figure 39 x 29⁵/₈ x 21 in.
(99 x 75.2 x 53 cm) with artist's later wood and
painted steel mount, H. 89 in. (226 cm).
The Noguchi Museum, New York.

Sculpture with Driftwood, 1940–41.
Wood, painted wood, and metal rods;
56 x 12 x 12¹/₂ in. (142.2 x 30.4 x 31.7 cm).
Mr. and Mrs. Charles Diker, New York.

Monument to Heroes, 1943.
Cardboard, paint, wood, bone, and string;
28¹/₄ x 15¹/₂ x 14 in. (71.7 x 39.3 x 35.5 cm).
The Noguchi Museum, New York.

Untitled, 1943.
Colored plastic on posthumous metal base;
21 x 14 x 16¹/₄ in. (53.3 x 35.6 x 41.3 cm).
The Noguchi Museum, New York.

Yellow Landscape, 1943 (partially reconstructed 1995).
Hydrocal plaster, wood, and string;
29 x 27 x 3¹/₂ in. (73.7 x 68.6 x 8.9 cm).
The Noguchi Museum, New York.

Time Lock, 1943.
Languedoc marble; 25³/₄ x 20 x 17 in. (65.4 x 50.8 x 43.1
cm) on artist's later wood and painted steel base.
The Noguchi Museum, New York.

This Tortured Earth, 1943, cast later.
Bronze (edition of 3); 28 x 28 x 4 in. (71 x 71 x 10 cm).
The Noguchi Museum, New York.

Lunar, 1943.
Magnesite cement, electric light, colored plastic,
wood, string; 4³/₄ x 15⁵/₈ x 21 in. (12 x 39.6 x 53.3 cm).
Virginia and Herbert Lust, New York.

Lunar Landscape, 1943–44.
Magnesite cement, electric lights, acetate, cork,
and string; 34¹/₂ x 24³/₄ x 7⁷/₈ in. (87.6 x 62.8 x 20 cm).
Hirshhorn Museum and Sculpture Garden,
Smithsonian Institution, Washington DC;
gift of Joseph H. Hirshhorn.

Lunar Fist, 1943–44.
Magnesite cement, plastic resin, and electric light;
8 x 9 x 7 in. (20.3 x 22.8 x 17.7 cm).
The Noguchi Museum, New York.

Lunar, 1943–44.
Magnesite cement and electric lights on wood mount;
27 x 20 x 10³/₄ in. (68.5 x 50.8 x 27.3 cm).
The Alan Groh/Buzz Miller Collection, University of
Virginia Art Museum, Charlottesville, Virginia.

Lunar Infant, 1943–44.
Magnesite cement, electric light with cord and metal;
22¹/₂ x 16 x 16 in. (57 x 40.6 x 40.6 cm).
The Noguchi Museum, New York.

Light Sculpture (*Lunar*), 1944.
Magnesite cement, electric light, colored plastic,
and wood; 19¹/₂ x 27¹/₂ x 5 in. (49.5 x 69.8 x 12.7 cm).
Private collection, New York.

Floating Lunar, 1944–45.
Magnesite cement, electric light, and plastic;
32¹/₂ x 23¹/₂ x 10 in. (82.5 x 59.7 x 25.4 cm).
Private collection, courtesy of The Noguchi Museum,
New York.

Remembrance, 1944.
Mahogany; 50¹/₄ x 24 x 9 in. (127.6 x 60.9 x 22.8 cm).
The Noguchi Museum, New York.

Worksheet for Sculpture, 1945.
Pencil on graph paper mounted on black craft paper;
17 x 22 in. (43.2 x 55.9 cm).
Whitney Museum of American Art, New York;
purchase with funds from
Howard and Jean Lipman Foundation, Inc.
[SHOWN AT THE WHITNEY ONLY]

Worksheet for "Figure," 1945.
Black craft paper and pencil on graph paper;
10¹/₂ x 16⁵/₈ in. (26.7 x 42.2 cm).
The Noguchi Museum, New York.

Worksheet for "To the Sunflower," 1945.
(later signed 1946).
Black craft paper and pencil on graph paper;
12 x 16 in. (30.4 x 40.6 cm).
The Noguchi Museum, New York.

Strange Bird (*To the Sunflower*), 1945.
Green slate (5 elements);
55³/₄ x 22¹/₂ x 20 in. (141.6 x 57 x 50.8 cm).
The Noguchi Museum, New York.

Man, 1945.
Wood; 52⁵/₈ x 19³/₄ x 12⁵/₈ in. (133.7 x 50.8 x 33 cm).
Private collection, New York.

Trinity, 1945.
Black slate (3 elements);
55 x 22 x 20 in. (139.7 x 55.8 x 50.8 cm).
The Noguchi Museum, New York.

Worksheet for Sculpture, 1945–46.
Black craft paper and pencil on graph paper;
20¹/₂ x 20 in. (52 x 50.8 cm).
The Noguchi Museum, New York.

Humpty Dumpty, 1946.
Gray ribbon slate (5 elements);
59 x 20³/₄ x 17¹/₂ in. (149.9 x 52.7 x 44.5 cm).
Whitney Museum of American Art, New York;
purchase with funds from the
Howard and Jean Lipman Foundation, Inc.

Worksheet for Sculpture, 1946.
Black craft paper and pencil on graph paper;
13¹/₈ x 17¹/₄ in. (33.2 x 43.8 cm).
National Gallery of Art, Washington DC;
gift of Regina Slatkin, Carole and Laura Slatkin.
[SHOWN AT THE HIRSHHORN ONLY]

Worksheet for Sculpture, 1945–47.
Black craft paper and pencil on graph paper;
17 x 22 in. (43 x 55.8 cm).
The Noguchi Museum, New York.

Worksheet for Sculpture, 1945–47.
Black craft paper and pencil on graph paper;
18 x 23 in. (45.7 x 58.4 cm).
The Noguchi Museum, New York.

Hanging Man, 1945, cast 1946.
Aluminum; 60 x 6 x 7 in. (152.4 x 15.2 x 17.7 cm).
The Noguchi Museum, New York.

Gregory (Effigy), 1946.
Black slate (7 elements) on artist's plaster and wood
base; 67¹/₂ x 15³/₄ x 12 in. (171.4 x 40 x 30.4 cm).
The Noguchi Museum, New York.

Worksheet for "The Gunas," 1946.
Black craft paper and pencil on graph paper;
8¹/₂ x 3 in. (21.6 x 7.6 cm).
The Noguchi Museum, New York.

The Gunas, 1946.
Brown marble (3 elements);
73¹/₄ x 26¹/₄ x 25¹/₂ in. (186.1 x 66.7 x 64.8 cm).
Whitney Museum of American Art, New York;
purchase with funds from the
Howard and Jean Lipman Foundation, Inc.

Drawing after "The Gunas," 1947.
Ink on paper; 8¹/₂ x 3 in. (21.5 x 7.6 cm).
The Noguchi Museum, New York.

The Ring, c. 1945–48.
Black granite; 12 x Diam. 22 in. (30.5 x Diam. 55.9 cm).
Whitney Museum of American Art, New York;
gift of the artist.

Cronos, 1947.
Balsa wood with string;
86¹/₄ x 22 x 31 in. (219 x 55.8 x 78.7 cm).
Walker Art Center, Minneapolis; gift of the artist.

Cronos, 1947, cast 1962.
Bronze (edition of 3);
85 x 24¹/₈ x 26⁷/₈ in. (215 x 61.2 x 68.3 cm),
on artist's limestone base 4⁵/₈ x 31¹/₂ x 17³/₄ in.
(11.9 x 80.1 x 45.1 cm).
Hirshhorn Museum and Sculpture Garden,
Smithsonian Institution, Washington DC; Regent
Collections Acquisition Program and Thomas M. Evans,
Jerome L. Greene, Joseph H. Hirshhorn, and Sydney and
Frances Lewis Purchase Fund.
[SHOWN AT THE HIRSHHORN ONLY; NOT ILLUSTRATED IN
CATALOGUE]

Avatar, 1947.
Bronze (4 elements);
78 x 33 x 24 in. (198 x 83.8 x 60.9 cm).
Milly and Arne Glimcher, New York.

Drawing after "Avatar," 1948.
Ink on paper; 6³/₄ x 3¹/₂ in. (17.1 x 8.9 cm).
The Noguchi Museum, New York.

Night Land (Night Voyage), 1947.
York fossil marble;
22 x 47 x 37¹/₂ in. (55.8 x 119.3 x 95.2 cm).
The Hall Family Foundation Collection,
Nelson-Atkins Museum of Art, Kansas City.

Drawing after "Night Land," 1948.
Ink on paper; 3¹/₄ x 5³/₈ in. (8.2 x 13.7 cm).
The Noguchi Museum, New York.

Drawing after "This Tortured Earth," 1948.
Ink on paper; 2¹/₂ x 2¹/₈ in. (6.35 x 5.3 cm).
The Noguchi Museum, New York.

Drawing after "Bird's Nest," 1948.
Ink on paper; 2 x 2³/₈ in. (5.1 x 6 cm).
The Noguchi Museum, New York.

Drawing after "Lunar Fist," 1948.
Ink on paper; 1¹/₄ x 1¹/₄ in. (3.2 x 3.2 cm).
The Noguchi Museum, New York.

Drawing after "Plus Equals Minus," 1948.
Ink on paper; 2³/₄ x 2³/₈ in. (7 x 6 cm).
The Noguchi Museum, New York.

The Field, 1948.
Redwood and marble;
6 x 10¹/₂ x 11 in. (15.2 x 26.6 x 27.9 cm).
Private collection.

War (Helmet), 1952.
Terracotta; 28¹/₈ x 13 x 12³/₈ in. (71.3 x 33 x 31.4 cm).
Sogetsu Art Museum, Tokyo.

Celebration, c. 1952.
Bronze; 17³/₄ x 20 x 1¹/₂ in. (45.2 x 50.8 x 3.8 cm).
Whitney Museum of American Art, New York;
gift of Howard and Jean Lipman.
[SHOWN AT THE WHITNEY ONLY]

Okame, 1956.
Iron (edition of 4); 9¹/₂ x 10¹/₄ x 3⁵/₈ in. (24 x 26 x 9 cm).
Hirshhorn Museum and Sculpture Garden,
Smithsonian Institution, Washington DC;
gift of Joseph H. Hirshhorn.
[SHOWN AT THE HIRSHHORN ONLY]

Light Sculptures, 1956–57.
Rice paper, bamboo, wire, and electric lights;
approximately H. 8 ft. each (2.4 m).
The Noguchi Museum, New York.

Calligraphics, 1957.
Iron, rope, and wood on steel base plate (edition of 6);
70⁵/₈ x 18 x 3⁵/₈ in. (179.3 x 45.7 x 9 cm).
Memorial Art Gallery of the University of Rochester,
New York; R. T. Miller Bequest.

Solar, 1958.
Stainless steel;
97 x 35 x 9 in. (246.3 x 88.9 x 22.8 cm).
Susan Lloyd.

The Cry, 1959.
Balsa wood on artist's steel base;
86¹/₂ x 29¹/₂ x 20 in. (219.1 x 75 x 49 cm).
Solomon R. Guggenheim Museum, New York.

Integral, 1959.
White marble; 49⁷/₈ x 9³/₈ x 9 in.
(126 x 23.9 x 22.9 cm) on artist's wood and
painted steel base 12³/₄ x 21 x 21 in. (31.1 x 53.3 cm).
Whitney Museum of American Art, New York;
purchase with funds from the Friends of the
Whitney Museum of American Art.

Black Sun, 1960.
Swedish black granite; Diam. 30 in. (Diam. 76.2 cm).
The National Trust for Historic Preservation, Nelson A.
Rockefeller Bequest, Kykuit, Westchester, New York.

Solitude, 1961.
Bronze (edition of 8); 75³/₄ x 11³/₄ x 11³/₄ in.
(192.8 x 29.9 x 29.9 cm).
Whitney Museum of American Art, New York;
gift of Sid Sutter.

Variation on a Millstone No. 1, 1962.
Gray granite; Diam. 24⁵/₈ x 4 in.
(Diam. 62.6 x 10.2 cm) on artist's wood pedestal
47¹/₂ x 9 x 3³/₄ in. (120.7 x 23 x 9.5 cm) and steel base plate
³/₄ x 18 x 18 in. (1.9 x 45.7 x 45.7 cm).
Whitney Museum of American Art, New York;
50th anniversary gift of Mrs. Robert M. Benjamin.

The Uncertain Sea, 1968.
Black granite; 8³/₄ x 42 x 29 in. (22.2 x 106.7 x 73.6 cm)
on artist's wood supports, H. 8 in. (20.3 cm).
Frederick R. Weisman Art Foundation, Los Angeles.

The Sun at Noon, 1969.
French red and Spanish Alicante marble;
Diam. 61 x 8 in. (Diam. 154.9 x 20.3 cm) on artist's
stone base with wood supports.
The Noguchi Museum, New York.

The Bow, 1970.
Yellow Siena marble and black Petit granite;
54 x 17¹/₄ x 31 in. (137 x 43.8 x 78.7 cm).
Neuberger Museum of Art,
State University of New York; gift of the artist.

The Void, 1970.
Portuguese Aurora pink marble; H. 75 in. (190.5 cm).
The Noguchi Museum, New York.

The Inner Stone, 1973.
Basalt; 32¹/₂ x 31 x 15 in. (82.5 x 78.7 x 38 cm)
on artist's pine wood base.
The Noguchi Museum, New York.

Shodo Shima Stone Study, 1978.
Granite (8 elements);
12 x 66 x 69 in. (30.4 x 167.6 x 175.2 cm).
Walker Art Center, Minneapolis; gift of the artist.

To Bring to Life, 1979.
Basalt; 81¹/₂ x 26 x 18¹/₂ in. (207 x 66 x 46.9 cm).
The Noguchi Museum, New York.

Galaxy Calligraphy, 1983–84.
Black Swedish granite;
3¹/₂ x 47 x 32 in. (8.9 x 119.3 x 81.2 cm)
on artist's wood supports H. 8 in. (20.3 cm).
Private collection, Denver, Colorado.

Index

Selected Bibliography

For a complete bibliography, see the Isamu Noguchi Foundation website: www.noguchi.org

Altshuler, Bruce and Diane Apostolos-Cappadona, eds. *Isamu Noguchi: Essays and Conversations.* New York: Harry N. Abrams, in association with the Isamu Noguchi Foundation, 1994.

Altshuler, Bruce. *Noguchi.* New York and London: Abbeville Press, 1994.

Ashton, Dore. *Noguchi, East and West.* New York: Alfred A. Knopf, 1992.

Cort, Louise and Bert Winther-Tamaki. *Noguchi's Ceramics.* Washington DC: Arthur M. Sackler Gallery, Smithsonian Institution, 2003.

Duus, Masayo. *The Life of Isamu Noguchi: Journey without Borders.* Translated by Peter Duus. Princeton: Princeton University Press, 2004.

Friedman, Martin. *Noguchi's Imaginary Landscapes.* Exh. cat. Minneapolis: Walker Art Center, 1978.

Goldberg, Deborah. "Isamu Noguchi: The Artist as Engineer and Visionary Designer, 1918–1939." Diss., New York University, 1990; Ann Arbor: UMI, 1985.

Grove, Nancy. *Isamu Noguchi: A Study of the Sculptures.* Diss., City University of New York, 1983; New York and London: Garland Publishing, 1985.

——. *Isamu Noguchi: Portrait Sculptures.* Washington DC: Smithsonian Institution Press with the National Portrait Gallery, 1989.

Grove, Nancy and Diane Botnick. *The Sculptures of Isamu Noguchi, 1924–1979.* New York and London: Garland Publishing, 1980.

Hunter, Sam. *Isamu Noguchi.* New York: Abbeville Press, 1978.

Cummings, Paul. "Interview with Isamu Noguchi." November–December 1973, original typescript. Washington DC: Archives of American Art, Smithsonian Institution.

Isamu Noguchi: Sculptural Design. Exh. cat. essays by Bruce Altshuler, Anna C. Chavé, R. Buckminster Fuller, Il Kim, Isamu Noguchi, Shoji Sadao, Ingrid Shaffner and Donna Ghelerter, Bert Winther-Tamaki. Weil am Rhein: Vitra Design Museum, 2002.

Isamu Noguchi: Retrospective. Exh. cat. Kyoto: The National Museum of Modern Art, 1992.

Kuh, Katherine. "Interview with Isamu Noguchi." *Horizon* 11 (March 1960), 101–12. Reprinted in Kuh, *The Artist's Voice.* New York: Harper and Row, 1962, 171–87.

Lyford, Amy. "Noguchi, Sculptural Abstraction, and the Politics of Japanese American Internment. *Art Bulletin* 85, no. 1 (March 2003), 136–51.

Noguchi, Isamu. "What's the Matter with Sculpture?" *Art Front* 16 (September–October 1936), 13–14.

——. "Towards a Reintegration of the Arts." *College Art Journal* 9 (Autumn 1949), 59–60.

——. "Meanings in Modern Sculpture." *Art News* 48 (March 1949), 12–15, 55–56.

——. "Astronomical City." *Portfolio* (1951).

——. "New Stone Gardens." *Art in America* 52 (June 1964), 84–89.

——. *A Sculptor's World.* New York: Harper and Row, 1968.

——. "My Sculpture." In *Isamu Noguchi.* Tokyo: Minami Gallery and Bijutsu Design Center, 1973.

——. *The Isamu Noguchi Garden Museum.* New York: Harry N. Abrams, 1987.

Rychlak, Bonnie. *Zen no Zen: Aspects of Noguchi's Sculptural Vision.* New York: The Isamu Noguchi Foundation Museum, 2002.

Rychlak, Bonnie and Ian Buruma. *Noguchi and the Figure (Noguchi y la figura).* Exh. cat. Monterrey, Mexico and Mexico City: Museo de Arte Contemporáneo de Monterrey and Museo Rufino Tamayo, 1999.

Torres, Ana Maria. *Isamu Noguchi: A Study of Space.* New York: Monacelli Press, 2000.

Tracy, Robert. *Spaces of the Mind: Isamu Noguchi's Dance Designs.* New York: Proscenium Publishers, 2000.

Winther-Tamaki, Bert. "Isamu Noguchi: Conflicts of Japanese Culture in the Early Postwar Years." Diss. New York University, 1992.

——. *Art in the Encounter of Japanese Culture in the Early Postwar Years.* Honolulu: University of Hawaii Press, 2001.